Modigliani Beyond the Myth

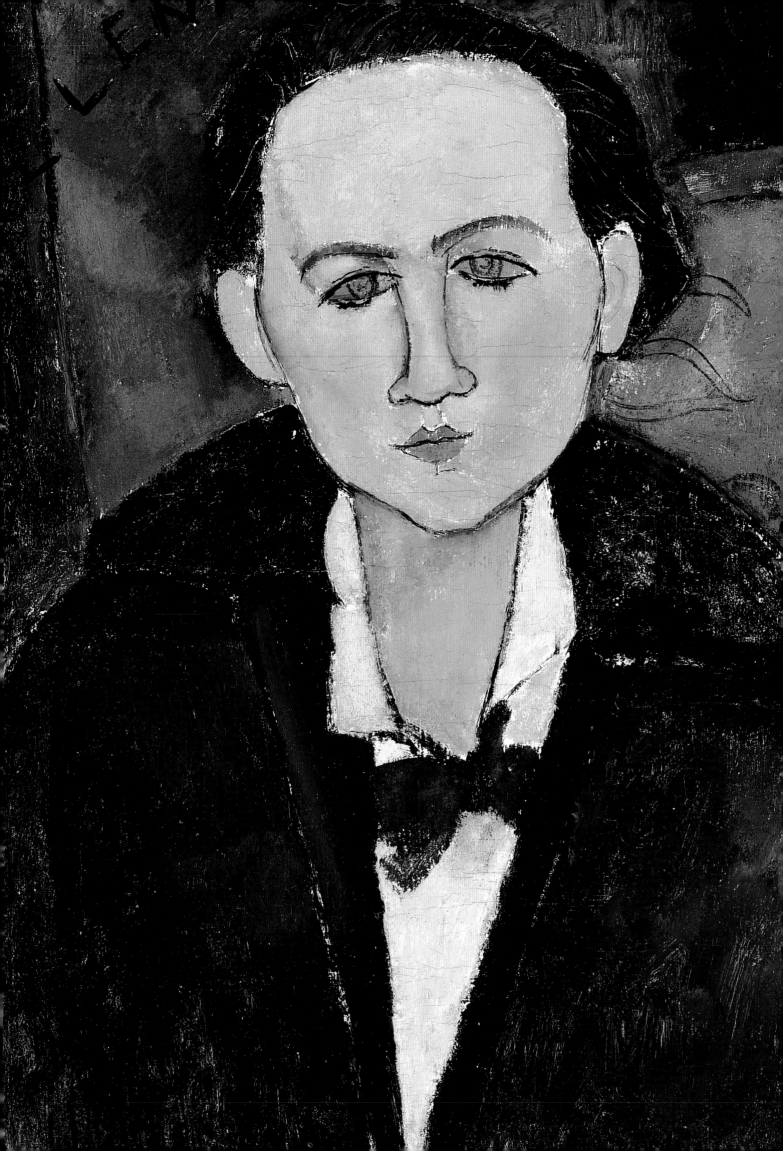

Modigliani

Beyond the Myth

Edited by Mason Klein

With essays by Maurice Berger, Emily Braun, Tamar Garb, Mason Klein, and Griselda Pollock

The Jewish Museum
New York

Yale University Press
New Haven and London

This book has been published in conjunction with the exhibition *Modigliani: Beyond the Myth*, organized by The Jewish Museum, 1109 Fifth Avenue, New York, New York 10128 (www.thejewishmuseum.org).

The Jewish Museum, New York
May 21–September 19, 2004

Art Gallery of Ontario
October 23, 2004–January 23, 2005

The Phillips Collection, Washington, D.C.
February 19–May 29, 2005

Modigliani: Beyond the Myth was made possible by the Jerome L. Greene Foundation. An indemnity has been granted by the Federal Council on the Arts and the Humanities.

Exhibition Curator: Mason Klein
Manager of Curatorial Publications: Michael Sittenfeld
Project Assistant: Suzanne Schwarz Zuber
Manuscript Editor: Anna Jardine
Exhibition Catalogue Assistants: Ivy Epstein and Beth Turk
Exhibition Design: Imrey Culbert Architects, New York

Publisher, Art & Architecture, Yale: Patricia Fidler
Assistant Editor, Art & Architecture, Yale: Michelle Komie
Manuscript Editor, Yale: Jeffrey Schier
Production Manager, Yale: Mary Mayer
Photo Editor, Yale: John Long

Designed by Tsang Seymour Design, New York
Set in Adobe Bembo by Tsang Seymour Design, New York
Printed in Italy by ContiTipocolor

Jacket illustrations: (front cover) Amedeo Modigliani, *Beatrice Hastings in Front of a Door* (detail), 1915. Oil on canvas, 32 x 18 ¼ in. (81.3 x 46.4 cm). Private collection, courtesy Ivor Braka Ltd., London; (back cover) Amedeo Modigliani, *Caryatid*, 1913–14. Oil on cardboard, 23 ⅝ x 21 ¼ in. (60 x 54 cm). Musée National d'Art Moderne, Centre Georges Pompidou, Paris, purchase, 1949 (AM2929P)

Frontispiece: Amedeo Modigliani, *Elena Povolozky* (detail), 1917. Oil on canvas, 25 ½ x 19 ⅛ in. (64.6 x 48.5 cm). The Phillips Collection, Washington, D.C. (1396)

Page 68: Amedeo Modigliani, *Caryatid*, 1913–14. Oil on cardboard, 23 ⅝ x 21 ¼ in. (60 x 54 cm). Musée National d'Art Moderne, Centre Georges Pompidou, Paris, purchase, 1949 (AM2929P)

Library of Congress Cataloging-in-Publication Data
Modigliani: beyond the myth / edited by Mason Klein; with essays by Maurice Berger . . . [et al.].
p. cm.
Catalogue of an exhibition at The Jewish Museum, New York, May 21–Sept. 19, 2004; the Art Gallery of Ontario, Oct. 23, 2004–Jan. 23, 2005; and The Phillips Collection, Washington, D.C., Feb. 19–May 29, 2005.
Includes bibliographical references and index.
ISBN 0-300-10264-X (hardcover: alk. paper)
ISBN 0-300-10573-8 (pbk.: alk. paper)
1. Modigliani, Amedeo, 1884–1920—Exhibitions. I. Klein, Mason. II. Berger, Maurice, 1956– III. Jewish Museum (New York, N.Y.) IV. Art Gallery of Ontario. V. Phillips Collection.
ND623.M67 A4 2004
759.5—dc22
2003026696

A catalogue record for this book is available from the British Library.

The paper in this book meets the guidelines for permanence and durability of the Committee on Production Guidelines for Book Longevity of the Council on Library Resources.
10 9 8 7 6 5 4 3

Contents

Donors to the Exhibition

The Jewish Museum extends deepest gratitude to the Jerome L. Greene Foundation for leadership support of *Modigliani: Beyond the Myth*.

An indemnity has been granted by the Federal Council on the Arts and the Humanities.

Lenders to the Exhibition

Albright-Knox Art Gallery, Buffalo, New York

Allen Memorial Art Museum, Oberlin College, Ohio

Art Gallery of Ontario, Toronto

The Art Institute of Chicago

Baltimore Museum of Art

Steve Banks Fine Arts, San Francisco

Cincinnati Art Museum

Dallas Museum of Art

Denver Art Museum

Patrick Derom Gallery, Brussels

The Evergreen House Foundation and The Johns
 Hopkins University, Baltimore

Fogg Art Museum, Harvard University Art Museums,
 Cambridge, Massachusetts

Fondazione Antonio Mazzotta, Milan

Galerie Cazeau-Béraudière, Paris

Galleria Nazionale d'Arte Moderna, Rome

Reuben and Edith Hecht Museum, University
 of Haifa, Israel

The Alex Hillman Family Foundation, New York

Hirshhorn Museum and Sculpture Garden, Smithsonian
 Institution, Washington, D.C.

Justman-Tamir Collection, Paris

William I. Koch

Kunstsammlung Nordrhein-Westfalen, Düsseldorf

Frances I. and Bernard Laterman Collection

Latner Family Private Collection

Los Angeles County Museum of Art

The Metropolitan Museum of Art, New York

Minneapolis Institute of Arts

Musée Calvet, Avignon

Musée d'Art Moderne de la Ville de Paris

Musée de l'Orangerie, Paris

Musée des Beaux-Arts, Dijon

Musée des Beaux-Arts, Rouen

Musée National d'Art Moderne, Centre
 Georges Pompidou, Paris

Musée National Picasso, Paris

Musée Picasso, Antibes

Museo Civico Giovanni Fattori, Livorno

Museu de Arte de São Paulo Assis Chateaubriand

The Museum of Fine Arts, Houston

The Museum of Modern Art, New York

Nagoya City Art Museum, Japan

Helly Nahmad Gallery, New York

Richard Nathanson, London

National Gallery of Art, Washington, D.C.

National Gallery of Victoria, Melbourne, Australia

Norton Museum of Art, West Palm Beach, Florida

Öffentliche Kunstsammlung Basel, Kupferstichkabinett

Osaka City Museum of Modern Art, Japan

The Henry and Rose Pearlman Foundation, Inc.

Philadelphia Museum of Art

The Phillips Collection, Washington, D.C.

Pinacoteca di Brera, Milan

Princeton University Art Museum, Princeton,
 New Jersey

Private collections

Re Cove Hakone Museum, Kanagawa, Japan

The Estate of Evelyn Sharp

The Solomon R. Guggenheim Museum, New York

Statens Museum For Kunst, Copenhagen

Tate Gallery, London

A. Alfred Taubman

Toledo Museum of Art

Yale University Art Gallery, New Haven, Connecticut

Foreword

The Jewish Museum is proud to present *Modigliani: Beyond the Myth*, the first museum survey of the artist's work in New York in more than fifty years. It is remarkable that, in light of his celebrated status, so many years have passed since a retrospective has been mounted. Yet, while the place of Amedeo Modigliani's work in the history of twentieth-century art is secure, he has received relatively little academic and critical attention in America during the last several decades. With *Modigliani: Beyond the Myth*, The Jewish Museum has taken the opportunity to create a restorative examination of this artist, who along with other celebrated Jewish painters and sculptors—among them Marc Chagall, Sonia Delaunay, Jacques Lipchitz, and Chaim Soutine—came to Paris before World War I.

In the last twenty years, The Jewish Museum has presented some seven exhibitions that have explored the work of these émigrés. The first was the 1985 exhibition *The Circle of Montparnasse: Jewish Artists in Paris, 1905–1945*. In 1990, an exhibition on Italian Jewish life included Modigliani's paintings and sculpture, and other works by the artist were seen in the 2000 show *Paris in New York: French Artists in Private Collections*. Monographic exhibitions included two shows in 1996 and 2001 of the early works of Chagall, and retrospectives of the works of Lipchitz in 1991 and of Soutine in 1998. Within the context of these exhibitions, Modigliani was a natural focus for the museum's next exploration of Jewish artists in this dynamic period of cultural efflorescence.

Single-artist exhibitions at The Jewish Museum tend to be highly concentrated, with an emphasis on certain periods or themes within an artist's oeuvre. *Modigliani: Beyond the Myth* moves away from the popular myth of the artist as bohemian or iconoclast. It takes into consideration his Sephardic Jewish heritage and it looks at those traits that set him apart from his fellow artists, such as a virtually exclusive pursuit of portraiture. Refusing to associate with a particular art movement, Modigliani sustained a singular intellectual and artistic agenda throughout his fourteen years in Paris.

My congratulations to the exhibition curator, Mason Klein, for his prodigious efforts in reexamining the work of Modigliani and creating a compelling, beautiful, and fascinating exhibition and book. Together they provide a means of gaining a greater understanding of the brief career of an artist who has enjoyed worldwide popularity. Also, my great thanks to the lenders (listed on p. vii), as well as to the scholars and colleagues in museums around the world, whose collaboration and cooperation were essential to the realization of the project.

Added thanks to the writers who contributed to this splendid publication and The Jewish Museum staff throughout the institution, who, as always, work with extraordinary devotion, energy, and skill. This is a project that both makes a significant scholarly contribution and will no doubt enrich the lives of countless readers and visitors.

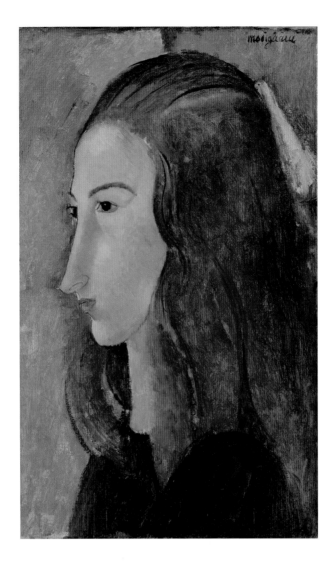

Amedeo Modigliani, Portrait of Jeanne Hébuterne, *c. 1918.* Oil on canvas, 18 x 11 in. (45.7 x 28 cm). Yale University Art Gallery, Bequest of Mrs. Kate Lancaster Brewster (1948.123).

I am exceedingly grateful to Dawn Greene, President of the Jerome L. Greene Foundation, for unstinting and generous support for *Modigliani: Beyond the Myth.* The Greene Foundation continues to distinguish itself as a leading benefactor of the cultural and intellectual life of New York City, and we are honored to be a beneficiary of its philanthropy. Essential support for the exhibition was also provided by an indemnity from the Federal Council on the Arts and Humanities.

As always, I wish to acknowledge the counsel and support of The Jewish Museum Board of Trustees. The continued enthusiasm and encouragement of the board has made possible an ambitious exhibition program, and I represent all of the museum's staff in conveying our gratitude.

Finally, my thanks to Director Jay Gates, Chief Curator Eliza Rathbone, and Associate Curator Elsa M. Smithgall at The Phillips Collection in Washington, D.C., and Director Matthew Teitelbaum, Chief Curator Dennis Reid, and Associate Curator Christina Corsiglia at the Art Gallery of Ontario for their fruitful collaboration on *Modigliani: Beyond the Myth.* I am indebted to these institutions, whose cooperation and creativity made the exhibition and catalogue available to a broader audience in both the United States and Canada.

Joan Rosenbaum
Helen Goldsmith Menschel Director
The Jewish Museum

Acknowledgments

It is appropriate that the first New York museum exhibition of the work of Amedeo Modigliani since the retrospective of 1951 at the Museum of Modern Art has been organized by The Jewish Museum. This is less so because the artist was Jewish, however, than because of the tradition of critical reexamination that has become standard at the museum, largely the result of the initiatives of its Helen Goldsmith Menschel Director, Joan Rosenbaum, who for nearly two decades has encouraged new ways of thinking about the many Jewish artists who came to Paris before World War I. For challenging me to maintain this tradition, I am deeply grateful.

The present effort builds on themes developed in numerous past exhibitions, notably *The Circle of Montparnasse: Jewish Artists in Paris, 1915–45*, presented in 1985, which revitalized the standard perspective on this group of artists, and the 1988 exhibition *An Expressionist in Paris: The Paintings of Chaim Soutine*. My appreciation for such precedents go to Kenneth Silver, Professor and Chair of Fine Arts and Institute of French Studies, New York University, who curated *The Circle of Montparnasse* and collaborated on the Soutine exhibition with Norman L. Kleeblatt, Susan and Elihu Rose Curator of Fine Arts at The Jewish Museum. These exhibitions placed their artists in a particular historical moment by focusing on the critical reception of their work. *Modigliani: Beyond the Myth* acknowledges that in attempting to understand an artist's particular worldview—an attitude often unformulated—requires not only looking more closely at the work itself but also within the broadest social context of its time and making.

I must first extend my immeasurable gratitude to Dawn Greene, President of the Jerome L. Greene Foundation, not only for believing in this project enough to underwrite it but for her enthusiastic and intelligent support of the show from its early stages.

Numerous individuals at The Jewish Museum were instrumental in the organization of this retrospective and publication. First, I would like to thank Ruth Beesch, Deputy Director of Program, both for her sustaining enthusiasm and for her effort in the many negotiations that such an exhibition entails; her resolve was crucial to the realization of the project. I owe an enormous debt of appreciation to my colleague Norman Kleeblatt, who first approached me to curate this exhibition. His confidence in this project has been vital, and his counsel and friendship very much appreciated.

The longevity of such an undertaking has involved many staff members, many of whom are no longer at the museum. I owe a debt of gratitude to Valerie von Volz, the initial Exhibition Assistant who launched the requisite tide of inquiries and requests with ambassadorial spirit. The essential contributions of Suzanne Schwarz Zuber, Exhibition Assistant, have been critical to the completion of both book and exhibition. Having inherited an unusually complex challenge midstream, she has devoted her

remarkable range of skills to all facets of the project. We have also been extremely fortunate to have the additional assistance of special intern Sandra Roemermann.

An immense thanks goes to Michael Sittenfeld, Manager of Curatorial Publications, who has kept careful watch over all aspects of this publication and has patiently guided it to fruition. I want to acknowledge his diligence and reviving sense of humor in keeping the endless particulars of such a task in perspective as we worked out the minutiae of queries posed by the finest editor with whom I have ever worked, Anna Jardine. She accomplished her mission with humbling skill, for which all the essayists should feel fortunate. I am especially grateful to Project Assistant Ivy Epstein for her tireless assistance with the production needs of the catalogue. Project Assistant Rae Dachille and interns Beth Turk and Elana Bensoul also contributed their time at various stages of its production.

To the authors of the essays and the chronology go my special thanks for their patience with editorial details and their contributions to our knowledge and understanding of Modigliani. Their thought-provoking texts help substantiate the need for a revisionist art history. I would also like to thank Alexandra Bonfante-Warren for her translation of the chronology, and acknowledge the superlative efforts of the staff of Yale University Press, particularly Patricia Fidler, Mary Mayer, Jeffrey Schier, Michelle Komie, and John Long.

For their elegant and imaginative installation design, and sensitivity to many of the issues and logistical problems they gracefully faced, I wish to thank Tim Culbert, Celia Imrey, and Jennifer Whitburn of the architectural firm Imrey Culbert. Many thanks also to Catarina Tsang and Patrick Seymour of Tsang Seymour, who created a distinctive design for the book, and to Graham Hanson for the elegant exhibition graphics.

My deep gratitude goes to the Collections and Exhibitions Department, on which so much of the complex mechanics of a museum depend. I wish to thank Jane Rubin, Head Registrar, and her staff, especially Erin Tohill Robin, Associate Registrar, for their time, energy, and unfailing professionalism; and to the preparators, with whom I share the challenge and satisfaction of actually getting the show onto the walls.

There are many others at the museum whom I would like to acknowledge: Katharina Garrelt, Program Coordinator; Emily Hartzell, Assistant Curator of Web Projects; Jody Heher, Coordinator of Exhibitions; Al Lazarte, Director of Operations; Vivian Mann, Morris and Eva Feld Chair in Judaica; Claudia Nahson, Associate Curator in Judaica; Anne Scher, Director of Communications; Fred Wasserman, Associate Curator; Aviva Weintraub, Director of Media and Public Programs; and Carol Zawatsky, Director of Education, and her staff.

Modigliani: Beyond the Myth has evolved over a three-year period, throughout which I have required the cooperation of countless people and institutions from five

continents. While it would be nearly impossible to adequately address each instance, I would like to thank all the overworked museum staffs and academics worldwide who have shared information and services with The Jewish Museum. Organizing this exhibition, in the wake of two international and large Modigliani shows and with the world in such turmoil, was unusually challenging, both because so much work had already been requested and/or lent and because of the complex conservation issues that such demand raised. I therefore thank the many technical museum staff whose considerable consultation was required.

Along with Joan Rosenbaum, I would like to express my appreciation to the private lenders and the staffs of the lending institutions, who are key to any exhibition project. Special thanks go to Marc Restellini, former Artistic Director of the Musée du Luxembourg and founder of the Pinacothèque de Paris, for his help in securing important private European loans.

I wish to especially acknowledge Kenneth Wayne, Curator at the Albright-Knox Art Gallery in Buffalo, and Marcelo Araujo, Director of the Pinacoteca do Estado do São Paulo, for their generous assistance, as well as Pierre Georgel, Director, Musée de l'Orangerie, and Philippe Cazeau and Jacques de la Béraudière of Galerie Cazeau-Béraudière, for their unstinting support.

For their patronage, I thank the Ministry of Foreign Affairs in Rome, especially Dr. Alessandro Nigro; and the Consulate General of Italy in New York, particularly The Honorable Antonio Bandini, Consul General. At the Italian Cultural Institute, New York, we thank Claudio Angelini, Director, and Dr. Amelia Antonucci and Dr. Tina Cervone, attachés for cultural affairs. My gratitude also goes to Mark J. Davidson, Cultural Affairs Officer at the U.S. Embassy in Tokyo, and Midori Ito, Cultural Attaché.

I have relied on the cooperation of numerous museum professionals, scholars, and friends to whom I am greatly appreciative for their advice, help, and generous assistance in securing loans. At Christie's: Nicholas Maclean, Senior Vice President, Impressionist and Modern Art; Christopher Eykyn, Senior Vice President, Impressionist and Modern Art. At Sotheby's, New York: Charles S. Moffett, Executive Vice President, Impressionist and Modern Art; David C. Norman, Senior Vice President, Impressionist and Modern Art; Elizabeth Gorayeb, Cataloguer and Researcher, Impressionist and Modern Art. At Sotheby's, London: Helena Newman, Head of Impressionist and Modern Art; Eva Avloniti, Archivist. At Phillips, de Pury & Luxembourg, Daniella Luxembourg. Elsewhere: Daniel Marchesseau, Director, Musée de la Vie Romantique; Diederik Bakhuÿs, Curator of Drawings and Prints, Musée des Beaux-Arts, Rouen; Didier Schulmann, Curator and Head of Collections Management, and Macha Daniel, Department of Prints and Drawings; Musée National d'Art Moderne, Centre Georges

Pompidou; Joachim Pissarro, Curator, Department of Painting and Sculpture, Museum of Modern Art; Ida Balboul, Research Associate, Modern Art, The Metropolitan Museum of Art; Milu Villela, President of the Museo de Arte Moderna de São Paulo; Paulo Roberto, Registrar, Museu de Arte Contemporânea da Universidade de São Paulo; Karen Barbosa, Conservator, Museu de Arte de São Paulo Assis Chateaubriand; Dr. Pia Mueller-Tamm, Chief Curator, Kunstsammlung Nordrhein-Westfalen, Düsseldorf; Francesca Giampaolo, Museo Giovanni Fattori, Livorno; Janis Staggs, Associate Curator, and Sefa Saglam, Registrar and Exhibitions Manager, Neue Galerie New York; Stéphanie Puissesseau, Galerie Cazeau-Béraudière; Naoko Sasaki and Chie Manabe, Painting Conservators, Tokyo; Keiji Komatzu, Department Manager, Financial Department, and Kumiko Tokio, Supervising Section, Darwin, Inc.; Tsukasa Kumada, Chief Curator, and Tomoko Ogawa, Officer for Overseas Loans, Osaka City Museum of Modern Art; Shiro Onishi, superintendent, Osaka City Board of Education; Linda Nochlin, Lila Acheson Wallace Professor of Modern Art, New York University; Emily Braun, Professor of Art, Hunter College, City University of New York; Donna De Salvo, Senior Curator, Tate Modern; Mr. William Acquavella; Mr. Giorgio Guastalla; Ms. Simonetta Fraquelli; Mr. David Nahmad and Mr. Helly Nahmad; Ms. Hiroko Nishida; Mr. David Nash; Mr. Edward Nahem; Mr. Achim Moeller; Mr. Richard Nathanson; Mr. Noël Alexandre; Mr. Christian Parisot; Ms. Francesca Morelli; Ms. Silvia Guastalla; Ms. Sharon Hecker; Ms. Anneke Rifkin; and Ms. Hélène Desmazières.

For their enthusiastic and accommodating collaboration, which has allowed *Modigliani: Beyond the Myth* to travel, I would like to thank Director Jay Gates, Chief Curator Eliza Rathbone, and Associate Curator Elsa M. Smithgall at The Phillips Collection in Washington, D.C.; and Director Matthew Teitelbaum, Chief Curator Dennis Reid, and Associate Curator Christina Corsiglia at the Art Gallery of Ontario in Toronto.

My thanks to my family and friends, whose support I never take for granted: Susan Agrest, Maurice Berger, Anouk Cézilly, Rebecca Dreyfus, Marvin Heiferman, John and Helga Klein, Deborah Ladner, Ilka Peck, Catherine Abby Rich, Amy Schewel, and Jill Silverman Van Coenegrachts. And lastly, for her complicity in all, Elizabeth Sacre.

Mason Klein
The Jewish Museum

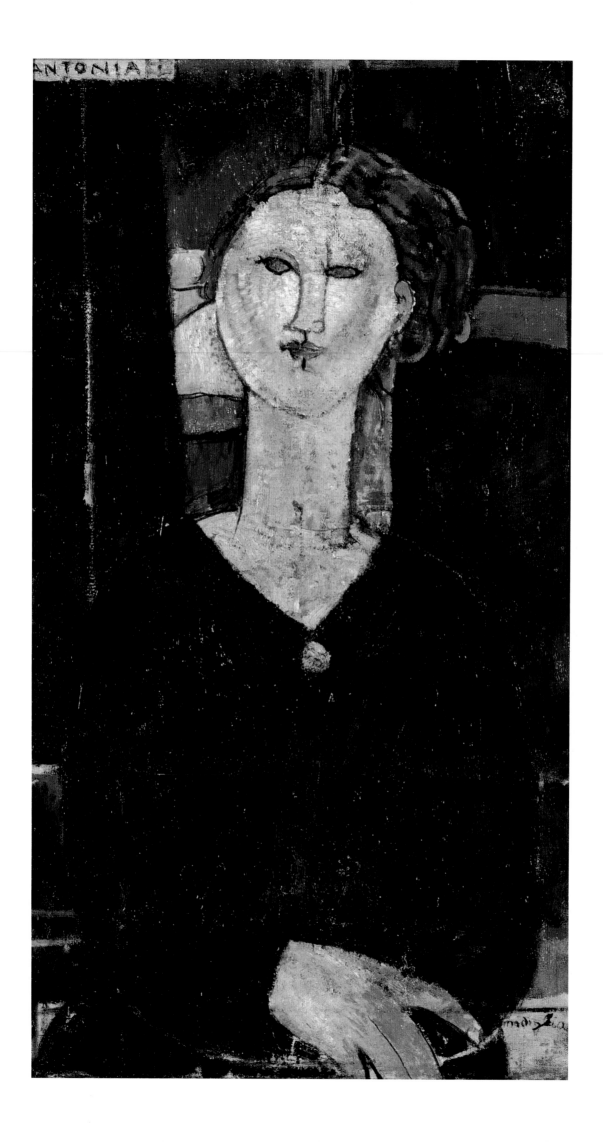

Modigliani Against the Grain

Mason Klein

Always speak out and keep forging ahead. The man who cannot find new ambitions and even a new person within himself, who is always destined to wrestle with what has remained rotten and decadent in his own personality, is not a man.
—Amedeo Modigliani, letter to Oscar Ghiglia

Those who really did most for the spiritual dignity of their people, who were great enough to transcend the bounds of nationality and to weave the strands of their Jewish genius into the general texture of European life, have been given short shrift and perfunctory recognition . . . those bold spirits who tried to make of the emancipation of the Jews that which it really should have been—an admission of Jews as Jews to the ranks of humanity, rather than a permit to ape the gentiles or an opportunity to play the parvenu.
—Hannah Arendt

In late 1919, a few months before he died of tuberculosis, a frail but stoic thirty-five-year-old Amedeo Modigliani, keenly aware of his imminent demise, painted his self-portrait (fig. 2). With palette and brush in hand, as if emulating Diego Velázquez, he refuses to succumb to his condition. As he turns away from the canvas, he assumes the upright posture and facial configuration of many of his portraits of others, in a manner suggesting the consideration of a subject more contemplated than observed. Thus, Modigliani fades from the world bundled against the cold in his signature corduroy jacket and stylishly tied wool sweater, garments that all but overwhelm his skeletal state and contrast with the linear contour of his death mask–like face, its immateriality emphasized by the tilt of his head and the squint of his blank eyes. This studied, analytical self-conception challenges the mythologized image of the artist as bohemian philanderer that the art historical mill continues to advance. And this rare self-depiction suggests not the bitter, failed artist Modigliani supposedly had become, but instead someone who remained noble and elegant, poised in his lofty vocation to dignify and elevate a humble human subject.

This idealizing tendency, which is crystallized in his characteristic masked countenance and attenuation of form, belies the scrutiny with which the artist confronted the matter of identity and individualism as an Italian Sephardic Jew. Far from being rooted in aesthetics and the history of art, however, his art and portraiture originate elsewhere: from sources as diverse as the sociohistorical—in his own country's short-lived utopian erasure of racial difference during the Risorgimento, Italy's unification period (1848 to 1870)—and the religious, in his Sephardic understanding of the indelibility of his Jewishness, regardless of acculturation. Rather than being viewed as allegorical, the artist's stylistic integration has prompted many to see his ultimate formalism as an end in itself, in a Neoplatonic sense.

Fig. 1. Amedeo Modigliani, Antonia, c. 1915. Oil on canvas, 32 ¼ x 18 ⅛ in. (82 x 46 cm). Musée de l'Orangerie, Paris, Walter-Guillaume Collection (RF: 1963–70).

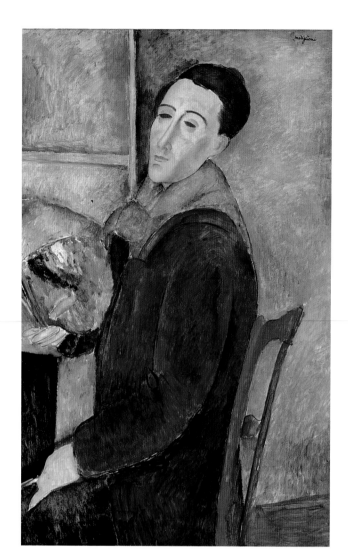

Fig. 2. Amedeo Modigliani, Self-Portrait, 1919. Oil on canvas, 39 ⅜ x 25 ⅜ in. (100 x 64.5 cm). Museu de Arte Contemporânea da Universidade de São Paulo.

That Modigliani searched for an ideal form that melded classicism with an expressionist, or modernist, sensibility is a commonplace among art historians. One need only look at the study for the *Portrait of Diego Rivera*, of 1914, with its circularity both exploding outward and drawing the viewer into the center, or at any number of his large caryatid drawings to see these basic instincts wedded. That he refused to define or align himself with any faction of the avant-garde is equally well known, as are his good looks, volatile personality, womanizing, preference for hashish and wine, and the penury in which he lived and died. But the fact that he was Jewish and frequently made a point of it is a surprise to many. It was not as an observant Jew that Modigliani came to Paris from his seaport hometown in Tuscany, but as a young, philosophical idealist soon to confront an unprecedented urban artistic melting pot. But in Paris he encountered a society far less tolerant of cultural and religious pluralism than he had known in Livorno.[1]

The view of Modigliani as the paradigm of the émigré, mostly Jewish, artists whose collective cultural breadth defined the circle of Montparnasse endures. After all, his cosmopolitanism personified the cultural diversity of the community. He brought to this mix not only a Sephardic strain of Judaism but also a Latin culture, so that his artistic traditions differed distinctly from those of his predominantly Eastern European colleagues.[2] Specifically, his Sephardic heritage endowed him with an understanding of "otherness" drawn from his identification with the Diaspora, which

he would fortify through the global purview of his sculpture. What, then, are the peculiar qualities and character of the *work* of this artist, who referred to himself as *"un juif du patriciat,"* a Jew of the patrician class, and whose romanticized yet incisive self-portrait reveals an extraordinarily willful individual who reconciles his ill health with dignity and an aristocratic intellectualism with compassion?[3]

Instead of considering the artist as the exemplary cosmopolitan of the School of Paris, as a recent exhibition has done, I will examine Modigliani's work as an expression of his unique identity within the foreign ranks of the School.[4] This identity rested in part in the unusual ability of Italian Jews to assimilate and embrace diversity, particularly because of their country's history of cultural pluralism and the longevity of its Judeo-Christian past. Indeed, according to Modigliani's daughter, it was only after he arrived in post-Dreyfus Paris that he first encountered anti-Semitism, in the writings of the French critic Édouard Drumont.[5] Modigliani's art therefore cannot be understood fully without acknowledging the complex ways in which he responded to such social realities, and to the xenophobia and cultural hegemony that he faced in Paris.

The Italian Jewish community that shaped Modigliani differed from other Jewish communities throughout Europe, which for the most part remained isolated and resistant to change. Cultural fusion developed naturally in Livorno, which, unlike Venice, did not have a ghetto and so invited an enlightened pluralism. It is significant that such artists as Marc Chagall and Chaim Soutine were perceived primarily as Jewish rather than Russian or Lithuanian.[6] In contrast, the invisibility of Modigliani's Jewishness—the fact that he was identified first as Italian (or simply as Western European, given his fluent French)—made him ponder such cultural differences and identify with social and religious advances achieved during the nineteenth century in Italy.

Although art historians have tended to limit discussion of Modigliani's art (perhaps more than that of any other artist of the circle of Montparnasse) to questions of style or biography, neither focus has been woven into a broader context. Besides signifying rigid distinctions germane only to an art historical logic, such conventional means fail to engage a body of work that simply does not fit into the stylistic categories that emerged in Paris before and during World War I. This puts Modigliani in an art historical position apart from other members of the group, Soutine or Jacques Lipchitz, for example, whose work can be more readily subsumed under the rubrics of Expressionism or Cubism. Moreover, Modigliani resisted standard artistic practice: he left only four known landscapes and no still lifes. Portraiture constitutes virtually the entire oeuvre, including the sculpture, which—apart from a standing figure and a caryatid—are all heads, multiple versions of a stylized bust (pl. 13).

What are we to make of a portraitist whose scrutiny of the individual gradually becomes so stylized as to effect a succession of seemingly indifferent faces echoed in the impassive mien of his stone caryatids? How does such a body of work, repetitive and limited in range, reflect a sense of intellectual, religious, and political history to which the artist felt bound? These other "histories" have been essentially ignored in favor of the more accessible—yet, in the case of Modigliani, barely illuminating—history of art.

Indeed, the range of Modigliani's ethnographic interest derives not merely from Italy's political history of social inclusion but also from the religious idealism that became entwined with the political during the Risorgimento. Many of the artist's principles, in which he believed with a complacency that was to be pierced in Paris,

were founded in the revolutionary ideals espoused in Livorno, and by Italy's republican ideologist and agitator Giuseppe Mazzini. The Modigliani family had been fervent supporters of Mazzini, whose political program sought to ground republicanism in a religious context.

Moreover, it is in Livorno that the history of Sephardic intellectual inquiry and synthesis reached its zenith in the nineteenth century, and where one finds a model for an integrated, radical triangulation of discourses—religious (humanism), political (Italian nationalism), and social (pluralism)—united in the teachings of a mystical rabbi, Elia Benamozegh.[7] This Sephardic Jewish humanism dovetailed with Mazzini's utopian philosophy and gave further spiritual and social support to the period's universalist religious republican ideals. And within this legacy the roots of Modigliani's idealism can be traced, his will to integrate the seemingly endless litany of dualisms that pervade and overlap in his universe: acculturation and tradition, modernity and tradition, individual and universal, painting and sculpture, classicism and expressionism, line and volume.

The Risorgimento brought about the full legal and civil emancipation of Jews, which also led to a dissolution of tradition, but such loss was inevitable during a cultural epiphany when social, religious, and political ideals conjoined in the writings of people like Mazzini, Benamozegh, and Sabato Morais (a Livornese rabbi who came to the United States and founded the Jewish Theological Seminary in 1886). Although this period of acceptance, which represented the high point of Italy's eighteen centuries of vacillation between persecution and tolerance of Jews, has been almost forgotten in the wake of the Holocaust, it was a time when Jewish religious humanism

prospered. Its sudden disappearance may explain the elision from memory: hindsight has nullifying effects on historical perspective.[8]

What has been ignored in discussions to date about Modigliani's eclecticism or historicism, even when the impact of Italian culture is taken into account, is its reflection of the cultural advances of Livorno, specifically the religious and philosophical thought that grew out of the rabbinical academies there, as far back as the sixteenth century. An observation of this context, while absent in the literature, was made by the esteemed historian Arnaldo Momigliano, who wrote that Livorno "remained the easiest Italian town to live in during at least two centuries and developed that Jewish style of its own which is preserved in the books of Benamozegh and of which perhaps the paintings of Modigliani show traces."[9] In contrast to his Futurist compatriots, for Modigliani the glory of Italy lay not in the present but in the recent past—with the idealism of such intellectual spiritualists as Benamozegh and Morais calling for the advocacy of an ecumenical rapport based on the underlying unity of all religions.[10]

It is no coincidence, then, that one of Modigliani's first paintings exhibited in Paris, in 1908, was a portrait titled *The Jewess* (*La juive*; pl. 2), whose solemn, haunting face shows, as does the watercolor and pencil drawing *Portrait of a Woman Taking Part in a Spiritualist Séance* (fig. 3), a lingering Symbolist melancholy in the young Modigliani.[11] Like the Symbolists, he chose to reveal reality through images that were subtle, complex, and encoded with meaning. He shared their preoccupation with spiritualism and was equally drawn to penetrating the surface of his subjects, their visible masks. As with vanguard artists moving toward abstraction—Wassily Kandinsky, František Kupka, Piet Mondrian, among others—Modigliani's sympathy for his subject's veiled and ulterior presence evinced the Bergsonian idea of the primacy of the creative role of intuition over analytical thinking—an idea that challenged the empirical pragmatism of the nineteenth century to which Modigliani the portraitist still felt attracted. Henri Bergson's philosophy, which Modigliani read, encouraged his implementation of geometry within the strictures of portraiture, as well as the natural desire within this genre to merge empathically with his sitter.

The intensity of the inner-directed Jewess and the charged aura of the woman at the séance converge in another spiritually endowed work, *Suffering Nude*, of 1908 (see Pollock essay, fig. 3). Beyond the pained psychological mood of this gaunt figure one can see another Symbolist-derived characteristic emerge, namely, the importance of the "eyes" as a visionary organ that can be outer- or inner-directed. Aside from its debt to the Symbolists, the emaciated figure's agonized posture may be related to another spiritual tradition of martyrdom—which Modigliani would develop and continue to symbolize in his fixation on the sacrificial context for the caryatid—in its allusion to Christ.

Both religious openness and the associated female-identified perspective were ingrained in Modigliani as he grew up. From birth, it was his maternal province, the bed on which he was born, that determined his well-being and rescued a vestige of respect for the family. The story goes that Eugenia Garsin Modigliani's fourth child, Amedeo ("beloved of God"), was aptly named for his timely birth: The family, which had just declared bankruptcy, was protected by a legal provision that precluded creditors from impounding the bed of a new or expectant mother, as well as any possessions that could be piled onto the bed. Modigliani's idealized cosmopolitan worldview was formed largely by his mother. Notwithstanding her lifelong need to

accommodate others, Eugenia Modigliani had cultivated a degree of independence. As a child, she had had an English Protestant governess, and although she returned to a patriarchal Jewish home, she attended a French Catholic school.

Despite the reversal of fortune experienced by the Modiglianis shortly before the artist's birth, the degree of success they enjoyed had earlier been enough to impress his mother's less mercantile family. When, in 1870, the fifteen-year-old Eugenia Garsin met her future husband, Flaminio Modigliani, who was twice her age, her family had long since moved from Livorno to Marseilles. And when, after a typical two-year engagement, the arranged marriage brought Eugenia to Italy for the first time, the youthful bride, while intimidated by signs of affluence, found her husband's family "uncultivated, overbearing and authoritarian."[12] The Garsins, while less well-off, were liberal, cultivated, and intellectual.[13] Eugenia's family, even with their less observant religious training, provided Modigliani the foundation for his spiritual and philosophical artistic approach. Eugenia's marriage to Flaminio, who was mostly away from home trying to salvage a business, ultimately failed, and it seems he exerted little or no influence on their youngest son.

When Modigliani arrived in Paris in 1906, attired in Italian corduroy suit, red scarf, and brimmed hat, he was proud of his dual Italian and Sephardic roots, his intellectual upbringing, and the leftist leanings of his family. Although he had been raised in a cultured environment, reading Gabriele D'Annunzio and Friedrich Nietzsche, he was, after the unusually privileged Jewish community of Livorno, relatively naive as to the social realities of the rest of Europe.[14] In letters written from Florence and Venice, before his move to Paris, Modigliani discloses a youthful artistic idealism that scarcely anticipates the melancholy that would, before long, enshroud his solitary portraits, such as *The Italian Woman* (pl. 68) or *Little Girl in Blue*.[15] His outlook nevertheless was both sparked and tempered by politics: at fourteen, he saw his brother Giuseppe Emanuele imprisoned for his Socialist beliefs.[16]

Giuseppe Emanuele's political activism testifies to the social immersion of Jews in the wake of Italy's independence and reunification. The period's emancipatory ideals, which were reinforced by his family, inform Modigliani's attitude and sense of freedom, along with the generally more complex multiple national identity that most post-Risorgimento Jews felt.[17] In a letter from Venice to his friend Oscar Ghiglia, a passage of which is used as an epigraph to this essay, a passionate seventeen-year-old Modigliani expresses his optimism and underscores his need to remain unconstrained by the past so he can always be ready to change. The artist's explicit self-determination is doubly ironic when one considers his ostensibly obdurate artistic path, and the fictive populist niche and concomitant academic oblivion to which he has been relegated.[18]

Modigliani's exclusive practice of portraiture became a vehicle for his egalitarian vision, the democratic principles that underlay contemporary Socialist currents, which had been verbalized throughout his childhood. The philosophical context for such ideals may have been nurtured by his close relationship to his maternal grandfather, Isaac Garsin, who joined the Modigliani household in Livorno in 1886.[19] Eugenia's father read widely in literature and philosophy; was fluent in Italian, French, Spanish, and Greek; and spoke some English and Arabic. Her sister Laura, with whom she opened a language school in their home in Livorno, and who would later write sociological and philosophical papers with young Amedeo, introduced him to the writings of Nietzsche, Bergson, and the Russian anarchist Pyotr Kropotkin.[20] According

to numerous accounts, it was his grandfather's intellectual eccentricity and his heroic accounts of the Garsin family lineage—going back to the seventeenth-century Dutch-born philosopher Baruch Spinoza—that Modigliani held dear, and that may have inspired his youthful artistic commitment.

These intellectual/religious individuals whom the Garsin family idealized—Spinoza, Uriel da Costa, and Moses Mendelssohn—questioned the inflexible a priori truths of organized religion in favor of interpreting spiritual values within a personal context. Spinoza contributed mightily to the secularization of Judaism and defended the cultural tradition of Jews. The sixteenth-century rationalist da Costa, born to a Portuguese Jewish family who had converted to Catholicism, was himself a convert to Judaism who, after being excommunicated three times for his criticism of the faith, was publicly vilified; he eventually committed suicide. The German Jewish philosopher Mendelssohn was a leading force in the Haskalah movement of cultural assimilation during the eighteenth century.

This marked influence manifests well beyond the artist's philosophical bent; it can be traced in his defiant nonconformity, in his stubborn character, in the idiosyncrasies of his oeuvre, and, especially, in the preponderance of the solitary figure. These historical proponents of religious and cultural free will, despite being reviled, cast aside the security of a "fixed" identity in favor of the right to question the artificial imposition or restriction of nationality or religion. They also contributed to the philosophical broadening of the civil status of Jews and Judaism, and laid the groundwork for secularism, a distinction between Jewishness and Judaism.

Before he found himself settled within the émigré artistic enclave of Montparnasse, Modigliani could not have foreseen the need to reassess his Jewish identity. Although coming to terms with his Italian Sephardic heritage was hardly a matter of balancing acculturation with the maintenance of tradition, it intersects perfectly with that period in which questions of national identity and of the "Jewish question" were being played out in the modern world, and in the city that harbored the first modern international artistic community. While his cultural, social, and religious identification was unique, the problem of distinguishing Modigliani's position within the circle of Montparnasse is one that art historians and critics have neglected. This is all the more notable in view of the fact that almost twenty years have elapsed since Kenneth Silver examined the early-twentieth-century influx of Jewish artists within the mainstream of modernism.[21] Yet the question remains as to why so little attention has been paid to the matter of Modigliani's individualism or, more pointedly, to how his complex sense of identity was challenged not in spite of, but as a result of, his racial invisibility in Paris.

As others have noted, with the exception of Chagall, Emmanuel Mané-Katz, and some lesser-known figures, most Jewish artists welcomed the freedom to assimilate. Modigliani goes against the grain of emancipatory secularism that characterizes the lack of Jewish self-consciousness in most Jewish émigré artists in Paris before World War I. But for Modigliani, as I have suggested, such social conditions proved retrograde, and instead of expanding his range of subject, he restricted himself to portraiture; rather than assimilate, Modigliani "unmasked" his Jewishness by assuming the ideological position of the pariah.

"He seems to have regarded religious differences," Silver has written, noting Modigliani's extensive use of Christian imagery, "much as he saw artistic distinctions, as being located on a continuum rather than contained in mutually exclusive

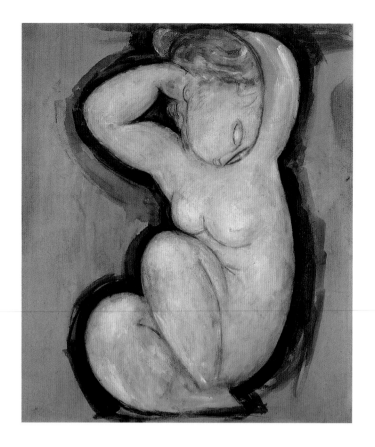

Fig. 4. Amedeo Modigliani, Caryatid, 1913–14. Oil on cardboard, 23 ⅝ x 21 ¼ in. (60 x 54 cm). Musée National d'Art Moderne, Centre Georges Pompidou, Paris, purchase, 1949 (AM2929P).

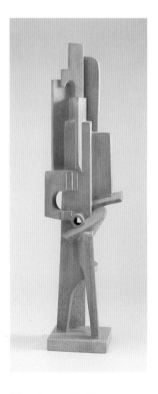

Fig. 5. Jacques Lipchitz (Lithuanian, 1891–1973), Man with a Guitar, 1915. Limestone, 38 ¼ x 10 ½ x 7 ¾ in. (97.2 x 26.7 x 19.5 cm). The Museum of Modern Art, New York, Mrs. Simon Guggenheim Fund (by exchange).

compartments."[22] Historical inclusiveness defines the two worlds always present in Modigliani—Italy and Judaism. It also identifies a relative premise throughout the oeuvre that sheds light on his limited range (portraiture), and why this virtually exclusive practice is marked by repetition (similarity of pose, mostly single figures), replication of type (caryatid), and increasingly reductive patterns (geometric).

The more he perceived the subliminal theme of race, the more focused and symbolic the artist's method became. As Modigliani encountered fellow émigré artists, his hitherto latent Jewish identity became for him the subject of philosophical inquiry. It was with pride that his family claimed direct descendance from Spinoza.[23] The Dutch philosopher perceived the inability of Jews to escape their condition, an impasse that in Modigliani is given literal, formal, and symbolic expression: literally, in the case of the caryatid locked in its column (fig. 4); formally, as in the 1915 *Portrait of Juan Gris*, with the embrace of elemental geometric forms within whose deceptively simple universality the artist introduces the specificity of the individual (see Garb essay, fig. 2); and symbolically, in Modigliani's real-life assumption of the role of pariah. For one who chose to be an outsider, who chose the antagonist role of the bohemian, who preferred not to be understood than to be perceived as a parvenu or assimilated bourgeois, who opined against those who arrogantly ignored history, and who came to declare himself as other in common salutation *("Je suis Modigliani, juif")*, self-identification was extremely important. And in contrast to the Eurocentric, if not racist, views of his fellow Italians the Futurists, Modigliani's appropriation of culturally diverse forms was precipitated by his own self-conscious status as other, specifically his own sense of exile and of the Diaspora that defined Sephardic Jews.

Given his identification with the Jew as a marker of difference, Modigliani's openness to history and cultural distinction, and the manner of his appropriation of non-European art, can scarcely be compared with the attitudes or practices of the

Futurists (none of whom was Jewish), who generally abhorred "exoticism," invested as they were in the restoration of their own culture. The French propensity to embrace an "abominable eclecticism" had, in the words of Carlo Carrà, led to such "atavistic and morbid aberrations" as "Dadaism," "Fauvism," "Negrism," and "Cubism."[24] Exhibiting more than just cultural superiority, Umberto Boccioni wrote in 1913: "Gauguin's journey to Tahiti, and the appearance of Central African fetishes in the ateliers of our Montmartre friends, are a historical inevitability in the destiny of the European sensibility, much like the invasion of a barbaric race into the organism of a people in decadence."[25]

Although the subject of Western European poaching of African tribal culture is beyond the scope of this essay, Modigliani's specific adoption of innumerable cultural styles was surely not lacking in deference. Yet some have diminished the empathic nature of his relationship to his sources. Jacques Lipchitz claimed that, while Modigliani "admired African Negro and other primitive arts as much as any of us, [he] was never profoundly influenced by them—any more than Cubism. He took from them certain stylistic traits, but was hardly affected by their spirit."[26] If anything, though, Modigliani's work, when compared with the analytic and formalist objectives to which most if not all Cubist-related appropriation was applied, suggests the contrary.

As is true for the Romanian sculptor Constantin Brancusi, Modigliani's direct carving and his predilection for certain archaizing elements in the manner of medieval sculpture contrast vividly with, for example, the Cubo-Futurist–inspired formalist play of convex and concave forms in Lipchitz's 1915 *Man with a Guitar* (fig. 5) or Ossip Zadkine's 1918 *Mother and Child* (Hirshhorn Museum and Sculpture Garden, Smithsonian Institution, Washington, D.C.). Modigliani's gradual stylization and the linear archaizing aspect of his works reflected his own programmatic agenda, which he would soon incorporate into his painting. The underlying geometric simplification of his series of sculpted heads indicates his determination to extract from the various ancient ethnographic models a mysterious, and enduring, elemental quality, and moreover to bracket a universal visual language against the individual conceits of portraiture. In addition, his attendant, almost ritualistic and religious, preoccupation with the caryatid and its temple environment evince a sensitivity to and respect for the originating magical or votive function of his sources.

By the time Modigliani met Brancusi in 1909, and initiated his brief career as a sculptor, he had succeeded in reconciling various ostensibly opposed styles, from the expressionism of Edvard Munch to the analytical process of Paul Cézanne. And in parrying the wrought emotion of the one against the detached objectivity of the other, he had begun to synthesize a more modulated linear, stylized subject. Such facile use of geometry was developed in part in the linearity of both drawing and sculpture, which Modigliani pursued seriously for five or six years after meeting Brancusi.

During this period, Modigliani investigated the possibilities of a more abstract, "depersonalized" face, a principal feature of his later portraits. He produced a series of carved heads that charts a veritable lexicon of styles—Archaic Greek and Cycladic, African and Egyptian, early Christian and Khmer—altering anatomical details with the perseverance of an aesthetic geneticist: rounding the face (fig. 6); elongating it (fig. 7); extending a chin; enlarging the eyes (fig. 8). By examining identity against an array of cultural types, the artist contemplated the nature and ambiguity of identity—a meditation that addresses the dislocation within the Diaspora, his own secular Jewish identity, and Spinoza's historic loss of religious and cultural identity.

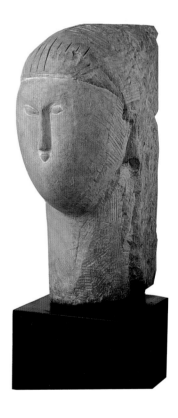

Fig. 6. Amedeo Modigliani, Head, *1910–11. Limestone, 26 ⅝ x 14 ¾ x 10 ¾ in. (67.6 x 37.5 x 27.3 cm). Collection of Gwendolyn Weiner.*

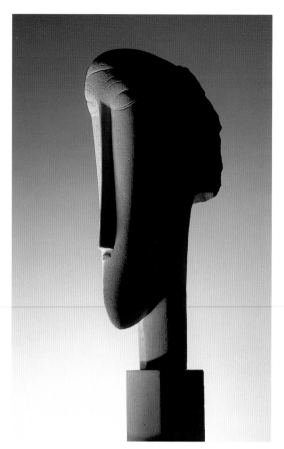

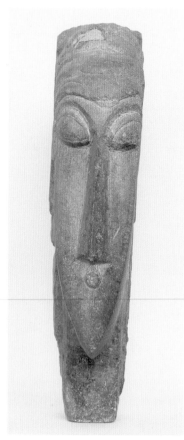

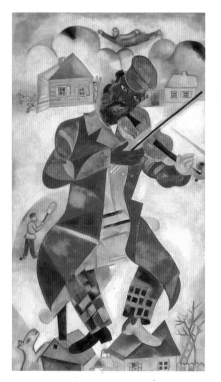

Fig. 9. Marc Chagall (Russian,
1887–1985), Green Violinist
(Violoniste), 1923–24. Oil on
canvas, 78 x 42 ¼ in. (198 x
108.6 cm). The Solomon R.
Guggenheim Museum, New York,
Gift, Solomon R. Guggenheim,
1937 (37.446).

The broad range of influences on Modigliani—from African to Cambodian art—allowed him to meld the old with the new, in ways far more radical than in the work of other School of Paris artists. A comparison of Chagall's *Green Violinist (Violoniste)* (fig. 9) and Modigliani's *The Cellist* (see Garb essay, fig. 3) illustrates how differently the two responded to the avant-garde in Paris. In relation to Chagall's aesthetic embodiment of the attitudes and icons of Jewish life or Russian folklore, Modigliani's identification with a Jewish subject is abstract, philosophical, and Western. The emergence of these two artists within the Parisian avant-garde illustrates not only the extent of their spiritual identification, but also how they diverged from their own traditions. The euphoric melodies that resound in Chagall become mute and timeless in Modigliani. While Chagall presents us with a musician whose exuberance exclaims a visual liberation, Modigliani's somber cellist conveys the artist's reflective connection to music, and perhaps the nostalgic silence just as the bow finishes its chord.

Both artists address the subjects of migration and change: the former by forging a synthesis between modernism and Hasidic mysticism, the latter by portraying a sense of loss and displacement, and a lack of specific cultural reference. Not surprisingly, Chagall was part of a collective effort in the arts to develop a "Jewish national" style based principally on the need to compensate for the disintegration of the traditional Jewish community. Modigliani, on the contrary, was determined to remain independent (think of his refusal to sign the Futurist manifesto, his aberrant historicism, and the exclusivity of his portraiture) and challenge the restrictive nature of identity.

For Modigliani, artistic, cultural, and spiritual expression could not be dictated by external dogma; following Spinoza, he believed that this had to emerge from the self. His art of portraiture balances a universal language of geometric form with the personal, emotional, and political concerns of the individual. Mirroring his own

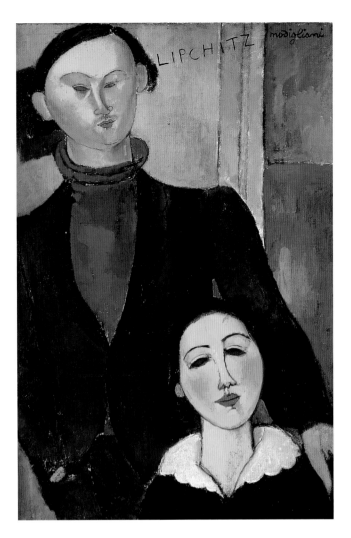

Fig. 10. Amedeo Modigliani, Jacques and Berthe Lipchitz, 1916. Oil on canvas, 31 ¾ x 21 ¼ in. (80.7 x 54 cm). The Art Institute of Chicago, Helen Birch Bartlett Memorial Collection (1926.221).

experience of racial anonymity, Modigliani's abstracting pictorial terms confer on his sitters an enigmatic quality. Through such distancing devices, if not outright masks, he allows and protects the private individual's persona, as in an actor's mask (*persona* is related to *personare*, "to speak through"), and at the same time enables his sitters to relate to the world outside themselves.

A wonderful example of this balance can be found in the double portrait of Jacques and Berthe Lipchitz, of 1916 (fig. 10). Despite Berthe's more masked, bland face, the telling benign symmetry of her drooping eyes and calibrated eyebrows helps us sense her fragile, bourgeois manner. Her haughty airs are further articulated in her perfect, delicate egg-shaped face, poised self-consciously high on her neck, and in the pronounced scallop of her dainty collar, whose segmentation echoes the pert curl of her nose. Her domineering sculptor husband, turtleneck sweater casually unfurled, hair asymmetrically parted, right hand suavely tucked in pocket, stands protectively, definitively above his spouse.

This dynamic of pitting type against specificity, a characteristic of so many of Modigliani's portraits, developed in large measure in the artist's carved stonework, in which he synthesized various cultures within the caryatid model that he drew and redrew hundreds of times (figs. 11 and 12). Among the long-standing views of critics regarding the caryatid model are that it was an appropriated classical model or that, with its assorted art historical, architectural, and literary contexts, such a form thus "burdened" with meaning may have served merely as a vehicle for formal purposes,

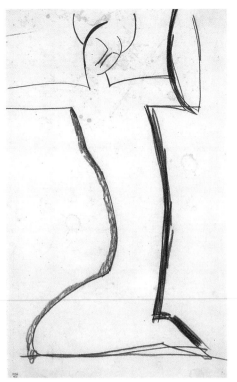
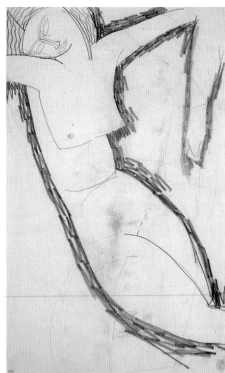

emptied of significance. A typical blanket dismissal and formalist reduction of Modigliani's work by one expert merits quoting at length:

> What was it about the caryatid theme that fascinated Modigliani during his period of exclusive concentration on sculpture? It is true that the female human body was a lifelong preoccupation of his; but then, this can hardly be described as the body of a woman. This caryatid is not a nude. It is not a representation of an unclothed woman, although it is a female figure consisting of torso, limbs and head. The figure works primarily in a "formal" way: its form exhausts its meaning. Under the pretext of carrying an—invisible—burden, the body and its component parts are forced in specific directions, generating a complex rhythm of horizontals, verticals, diagonals and curves. The artist has chosen his theme solely for the sake of this formal structure.[27]

The ways in which Modigliani synthesizes the caryatid archetype—especially its ambiguous status as both decorative and structural element—parallel other instances of his blurring of boundaries, which on occasion assumes a religious aspect in his work. Such a Judeo-Christian alignment accompanies a simplification of style in *Portrait of Paul Alexandre in Front of a Window*, of 1913, in which the caryatidlike form of the figure merges sculpture with painting, and the cruciform with the Kabbalistic encoded hand (fig. 13). The hand, which Dr. Alexandre places as frankly as possible over his heart, as though taking a vow, is an obvious expression of the artist's deference, appreciation, and spiritual kinship. This, the last of three portraits of his first patron and supporter that Modigliani painted over a five-year period, during which he essentially concentrated on sculpture, personifies perhaps better than any other

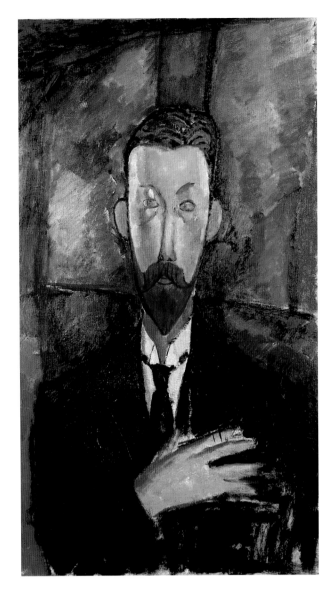

Fig. 13. Amedeo Modigliani, Portrait of Paul Alexandre in Front of a Window, 1913. Oil on canvas, 31 ⅞ x 18 in. (81 x 45.6 cm). Musée des Beaux-Arts, Rouen.

work the resolved direction in which the artist was moving; it distills his willful ideal-ization, his desire to reconcile both media, as I imply above, and more important, to effect a religious unity.

The same year that Modigliani arrived in Paris, the Anglo-Jewish artist Solomon J. Solomon was elected a full member of London's Royal Academy of Arts, only the second Jewish artist to be so honored, and some sixty-six years after the first.[28] As a marker of contemporary Jewish artistic success and as one who sought to reconcile classicism with Hebraic tradition, Solomon provides an instructive counterpoint from which to rethink Modigliani's conceptual engagement of the subject of Jewish iden-tity. Solomon's professional stature and assimilation represented a token endorsement by a decaying Academy, whose conservative Victorian and literary aestheticism the fashionable portrait painter staunchly advocated. Yet despite his conventional subject matter, Solomon attempted, albeit gently, to comment on the dilemma of being a "Jewish painter." Decorous as always, he articulated his ideas in a paper entitled "Art and Judaism." "How far he can assimilate what is best of Hellenic influence without prejudice to his individuality is clearly one of the chief problems that beset the mod-ern Jew," Solomon observed. "We know that the reproduction of natural forms, more particularly the human form, was forbidden to the Jews. Art in such conditions could

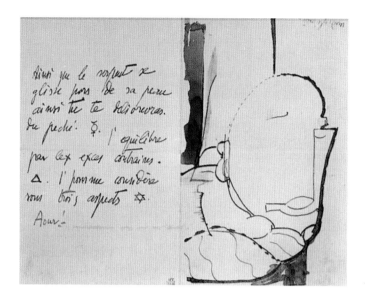

not flourish. All design is based on natural form and the key to the highest inspiration and appreciation of art is the knowledge of the human form."[29] This overriding, conciliatory position—bringing together Jewish and Christian worlds—is seen best in his 1904 painting *An Allegory,* an ambiguous work in which Moses, bearing a tablet of stone, leans over a recumbent Christ, whose body is borne aloft by two angels and a bevy of cherubs.

The tentative, awkward idealization of Judaic–Christian union is to be expected in an artist whose professional standing depended on veiling his Jewish identity. Solomon safely couched his narrative within the sanctioning genre of history painting, whose grandiosity often concealed ulterior information in order not to ruffle anyone's academic robes. Such was not the case elsewhere, a quarter-century earlier, when other assimilated artists, such as Maurycy Gottlieb and Max Liebermann, had depicted Christ wearing a traditional Jewish prayer shawl in *Christ Before Pilatus* (1877) and *Christ in the Temple* (1879). These initiatives attempted to introduce Christ's Jewish identity, and the efforts would increase in Paris after the turn of the century, when Chagall (*Calvary*, 1912, The Museum of Modern Art, New York) and other artists associated Christ with Jewish martyrdom.[30]

But the intent was to connect to Christianity, if not absorb it within the broad scheme of mysticism, an alliance that had already been made within the Symbolist movement.[31] This ideal synthesis, a component of the then vogue Theosophical movement, functioned in such a manner for Modigliani, although one should keep in mind that the Kabbalah, central to Theosophy, had been embraced throughout the nineteenth century in Elia Benamozegh's writings. The meager number of Modigliani's handwritten notes invariably refer to his well-acknowledged interest in the esoteric sciences. Art historians have given such citations, such as a famous sketchbook note of 1907, scant analysis:

> What I am searching for is neither the real
> nor the unreal, but the Subconscious,
> the mystery of what is Instinctive in the human Race.

Noël Alexandre, son of Modigliani's first collector and patron, Paul Alexandre, is one exception, placing this rare declaration of belief by the artist in the broadest context

to date.[32] In his book *The Unknown Modigliani*, Alexandre moors the artist's sense of "Race" to the pride Modigliani felt as an Italian Jew.

In another note, written in 1913 on the right of the drawing *Head in Profile* (fig. 14), the artist discloses his interest in the esoteric science of alchemy, which allows for a comparable Judaic perspective. Introduced to the study of the occult in a more serious manner by his close friend the poet and sometime painter Max Jacob, Modigliani shared this taste with his lover Beatrice Hastings, a journalist, Theosophist, and student of Helena P. Blavatsky. Many of the idealized notions of Theosophy, which took its name from the Neoplatonic term *theosophia*, or "knowledge of the divine," clearly intrigued Modigliani, whose penchant for holistic ideas, in accordance with Spinoza, coincided brilliantly with Blavatsky's reduction of the world's varied religious truths to one common denominator. Her writings employed a diagram of Hindu cosmogony in which the six-pointed star, or hexagram, is emblematic of the macrocosm, before its realization as the Star of David, or Solomon's seal.

The 1913 note, on whose importance several writers have remarked, carries implications that articulate, however cryptically, some of the ideals that Modigliani eventually elaborates in his portraiture, and offers a host of meanings that open onto both alchemy and the Kabbalah:

> Just as the snake slithers out of its skin
> So you will deliver yourself from sin
> Equilibrium by means of opposite extremes
> Man considered from three aspects
> Aour!

The initial meaning is obvious: the allegory of rebirth in the serpent's shedding of its skin, in the transformative status of gaining knowledge, which cancels out ignorance (sin). The other signs that accompany the text—circle, half-moon, and cross—suggest female and male aspects, and their combination suggests the universal meaning of the androgynous concept as the unity of antitheses.[33] During this period when Modigliani's fascination with the occult becomes more acute, drawings like *Hermaphrodite Caryatid* (pl. 113) recur among his caryatids.[34]

This predilection toward the occult was encouraged by both Jacob and Hastings, whose significant presence in Modigliani's life is attested by the numerous portraits he painted of her during their tempestuous involvement in 1914–15; the influence of the occult has been eclipsed by the gossip surrounding their well-known public trysts. Jacob, who would die at the Drancy deportation camp in 1944, converted to Catholicism during World War I, although questions concerning his intentions and sincerity have never been fully resolved.[35] Jacob was an intimate also of Pablo Picasso, André Salmon, and Guillaume Apollinaire, and his spiritual pursuit, sense of persecution, and status as jester within the Cubist camp aligned him with Modigliani, especially during the war.

Their closeness and ideological solidarity is made vivid in Modigliani's famous portrait of the poet, now in Düsseldorf (pl. 41). While the painting acknowledges Jacob's role within the Cubist circle in its powerfully refracted planar composition, a naturalism shines through as, in top hat, crisp white dress shirt, and checkered tie, he assumes a dignity he often lacked in reality. This is in part due to the portrait's sculptural aspect, the massive, weighty and rough-cleaved face, with a nose that "looks as if

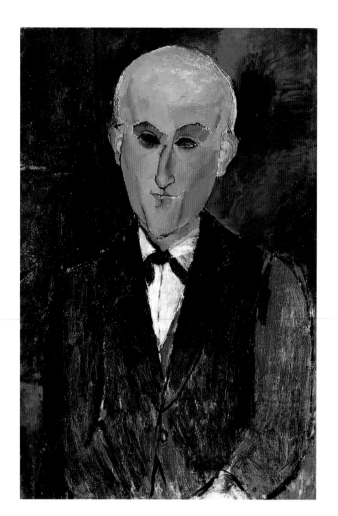

Fig. 15. Amedeo Modigliani,
Portrait of Max Jacob, *c. 1920.*
Oil on canvas, 36 ½ x 23 ¾ in.
(93 x 60 cm). Cincinnati Art
Museum, Gift of Mary E.
Johnston (1959.43).

hewn from a plank with an ax."[36] No less trenchant are the eyes, one of which, crosshatched in green, sparkles, its luminous depths intense as embers, as though Modigliani wanted to convey the passion of one of Jacob's ecstatic visions of Christ (which had led him to convert). The other eye, blank and meditative, is a foil heightening the portrait's inner-directed focus. Modigliani painted a second portrait of Jacob, much lighter in tone, consistent with its more revealing, less visionary purpose: the gentleness of the poet, now bald and vulnerable, looms large despite his legendary timidity and unprepossessing stature (fig. 15).

After the Church refused his repeated attempts to convert to Catholicism, Jacob was finally baptized in 1915; his godfather was Picasso. But it is Jacob's conception of Christ and of Christianity in a pre-Christian, Hebraic context that is relevant to the religious (if not messianic) tradition in which the Livornese Sephardic Modigliani was schooled—and to the increasing identification in his work with Christ as martyr. The literary critic Gerald Kamber has written of Jacob's need to "return to an originally humble Christianity":

> The young cubist revolutionaries equated the romantic esthetic
> with the bourgeois social ethic and, in turn, with Catholic religious
> orthodoxy. Since they had set out to outrage and deprecate the first
> two, it followed that they extended their animosity to the third. . . .
> But Jacob, in some ways the most idealistic and yet the most revolu-
> tionary of them all . . . tried to find a higher expression. The

Catholic church had already rejected Jacob as a social undesirable. . . .
For this reason Jacob tended to hark back to an earlier and more
modest version of the Christian religion, materially poor, socially
revolutionary, politically persecuted . . . as it emerged from an ancient
Hebrew messianic tradition.[37]

During the difficult war years, when belief systems were strained, and many in the Paris art world came of age, the spiritual bond between Jacob and Modigliani is noteworthy, a convergence that expresses their shared desire to hebraize Christ. As Kamber puts it, "Jacob in no way relinquished the Jewish theological heritage in favor of some newer faith, but merely retraced a path back to that Messiah whom his people had given to the world and then refused to accept."

While numerous circumstances contributed to Modigliani's cessation of sculpture (the war, the cost of stone, his failing health), Jacob claimed to have influenced the artist to return to painting in the course of introducing him to Paul Guillaume, who had opened a gallery in the spring of 1914. The savvy Guillaume became the artist's first bona fide dealer, replacing Paul Alexandre, with whom he had lost contact after the outbreak of the war. During this crucial transitional period, Modigliani was approaching a more reductive sculptural form in his painting, in which a less isolated figure occupies a more integrated, shallower space. But it was Jacob's admixture of the spiritual and the abject, together with Hastings's Theosophical beliefs, that helped propel Modigliani toward a greater symbolic investment in geometric simplicity and purity of form.

By the time Modigliani returned to painting, these ideas replenished his own, affirmed the premise of universal ideals already developed in his sculpture, and renewed his belief in a spirituality and ecumenical rapport among all religions. Such elemental universal truths could not only transcend the individualistic, but also express—in the attenuated geometry of his painting—the Theosophical idea of a higher plane penetrating the physical world. This Neoplatonic notion, which underscores the faith placed by Mondrian and other early abstractionists in primary forms as those most removed from physical reality, is an idea that, as has been suggested about Mondrian, Modigliani may have become acquainted with through Theosophy.

It is therefore not coincidental that in 1916, shortly after Jacob's conversion, Modigliani painted his first major nude painting (fig. 16), which would lead to the celebrated series of some twenty the following year.[38] The painting, *Seated Nude*, is pivotal not just for what it spawns, however, but perhaps more for what it stunningly encapsulates at a transitional moment, when an expressionist subject becomes recontextualized within an Italianate Judeo-Christian idealism.

The work, done not long after Modigliani stopped making sculpture, is a key to the artist's integration of the caryatid ideal and its incorporation within his painting. It is also his historical reflection on the Renaissance, in that the caryatid model is explicitly endowed with the ideals of grace and innocence once associated with the period's quasi-religious works. Modigliani translated these ideals into a modernist idiom in which the woman reclaims her body on her own terms. Yet there is more to the painting than this sexually empowered Madonna. It can be seen to allude to a Deposition—and what more appropriate theme for Modigliani to seize at this moment of spiritual synthesis in his work when he is immersed in looking at the historical nude. Especially powerful is the general attitude of the body, the fact that

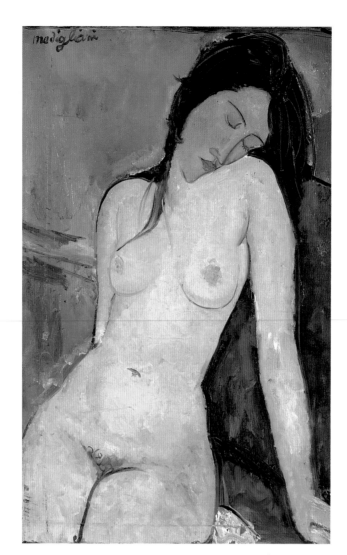

Fig. 16. Amedeo Modigliani, Seated Nude, c. 1916. Oil on canvas, 36 ⅜ x 23 ½ in. (92.4 x 59.8 cm). Courtauld Institute of Art Gallery, London.

despite the downward weight on the supportive left arm, the figure conveys a direction of movement that is instead a rising one, typical of the symbolism resonant in many Deposition scenes, where an ethereal quality is conveyed in both the weightlessness of Christ and that of the group surrounding him. The allusion is all the more credible with the stigma, a streak of red on the nude's left hand, and the outstretched arm, conventional for the religious theme.

Seated Nude reaffirms the particular symbolic role of the female figure for Modigliani, as it had for Charles Baudelaire, whose alienation and sense of impotence in the face of modernity find an allegorical dimension in the various constellations of metaphors and images around the figure of the feminine. A not dissimilar symbolic resolution occurs in Modigliani's work, as he seeks another gendered model, Dante's Beatrice, to express his own experience of alienation in the modern urban world.

Modigliani profoundly identified with Dante and quoted him endlessly. Dante's journey, like that of Orpheus, or Christ, who had to descend in order to rise, paralleled Modigliani's struggle to remain true to his ideals. The spiral paths laid out by the poet, representing the mythic passage from descent to regeneration, are constantly in evidence in the artist's work: the caryatid, whether painted, drawn, or in stone, declares her metaphorical struggle against confinement and stasis.[39] She, like the women of *Seated Nude* or *Suffering Nude*, assumes a redemptive role, symbolizing the renewal or elevation of the spirit.

This theme was especially dear to the artist, who had been beset by health problems since he was a child—pleurisy in 1895, then typhoid three years later, at the time an untreatable disease.[40] Such experience informs two of the few works by the younger Modigliani that survive today. The first, *Young Male Nude* (fig. 17 and pl. 81), drawn when he was twelve, retains a self-assertiveness similar to that of his late self-portrait (fig. 2). Like another work, *Small Tuscan Road* (fig. 18 and pl. 1), which he painted two years later, it reflects an identification with mortality distinguishing it from a youthful dispassionate fascination with death. The drawing includes two figures, the space between them bisected by a horizontal line. The work may be seen as two independent studies of a standing model; it would make sense that the figure below was drawn first and that Modigliani reoriented his sketchbook to create another figure above.[41] Regardless of the order, it is clear that the drawing, a typical academic male study, serves to contrast the robust full-bodied male in the upper register, one arm akimbo, with the horizontal body lying prostrate below, which, even when viewed vertically, appears gaunt and listless. The uprightness and vigor of the healthy figure is deceptively unmoored, though, by its curiously partial rendering. With his fragmentary legs faintly transgressing the horizontal border, this otherwise hardy youth shares the indeterminate state of the figure below.

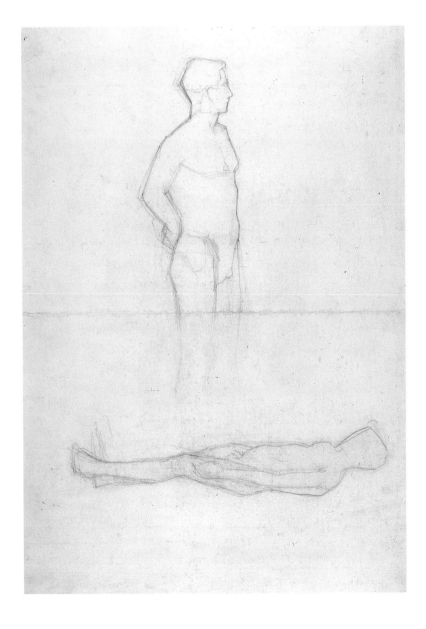

Fig. 17. Amedeo Modigliani, Young Male Nude, 1896. Pencil on cardboard, 23 ⅜ x 16 ¾ in. (59.3 x 42.5 cm). Museo Civico Giovanni Fattori, Livorno.

A likewise revealing, and possibly allegorical, meditation on mortality enlightens the other youthful work, *Small Tuscan Road*. Modigliani had suffered the loss of his grandfather, with whom he was close. He left school after contracting typhoid, and began a studio apprenticeship with Guglielmo Micheli, a follower of the Italian plein-air movement the Macchiaioli. Modigliani injects into an otherwise traditional pastoral subject a hint of the heightened psychic state that he would articulate in his Symbolist-derived work. A straightforward depiction of the Tuscan countryside, the painting is dominated by a simple farm road, whose expansive opening in the foreground exploits the conventions of linear perspective as it subtly replicates the viewer's position. While one might judge it merely a traditional exercise, the work, as its title makes clear, depicts a road, which for a child is never just a road. And indeed, *Small Tuscan Road* has compositional elements suggesting a psychological reading. The road loses its visibility in the slightly blurred dusk of the painting's middle ground, an area marked by a solitary tree, which functions not only as the middle-distance support of the illusory depth of linear perspective but also as a bearing in an otherwise ambiguous spatial determination. Does the road simply curve along with the field? Does it end? Is its arrangement, like that of the figurative drawing, an allegory? Can the juxtaposed states of the figures, or the precipitous positioning of the tree—overlooking what the viewer cannot see and therefore cannot know—be considered as more than youthful academic exercises, indicating his obviously felt mortal preoccupations?

Seen as the young artist's instinctive reckoning with fate, *Small Tuscan Road* may be read literally and symbolically as a crossroads, a juncture of the artist's overriding adolescent insecurities and premonitory sense of an inevitably premature death, as well as his compensatory commitment to be an artist and, moreover, to define himself. This early landscape becomes, then, a meditation on the psychological process of individuation. It reflects the young artist's desire to reconcile the conflict between the imperfection of nature—and thus of appearance (illness)—and the ideal—that which is not apparent, not seen in things, but is only an idea (his artistic potential).

Modigliani's sustained preoccupation with religious symbolism in general, and with Christ in particular, tends to be either literal, in which case the figure or saint is identified, or symbolic, as in numerous drawings like the study for *The Cellist* (fig. 19 and pl. 116), where Modigliani perhaps deliberately renders imprecise both musician and instrument in order to allude to martyr and cross. But in the case of the portrait of his

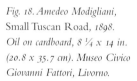

Fig. 18. Amedeo Modigliani, Small Tuscan Road, 1898. Oil on cardboard, 8 ¼ x 14 in. (20.8 x 35.7 cm). Museo Civico Giovanni Fattori, Livorno.

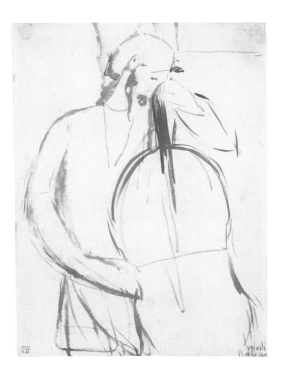

Fig. 19. Amedeo Modigliani, The Cellist, *c. 1909. Ink on paper, 10 ⅝ x 8 ¼ in. (27.1 x 21.1 cm). Musée des Beaux-Arts, Rouen.*

dealer and friend Leopold Zborowski (pl. 45), the reference to a saintly figure, replete with halo, is as unquestionable as a sunlit Byzantine mosaic, after which it is styled.

Far less worldly than his previous dealer, Paul Guillaume, whom the artist had depicted as slick and streetwise, Zborowski, according to Moïse Kisling (another of his clients), was "essentially the poet, always with his head in the clouds."[42] The artist identified with this idealist, whose "anarchistic principles," impracticality, and poor business habits often worked against him. Beyond the obvious gratitude Modigliani felt toward him, he may well have projected onto his dealer the attributes of artistic sainthood, given Zborowski's unrewarded efforts as a poet, since poetry was an interest they shared. It was Zborowski who persuaded Berthe Weill to give Modigliani his first (and only) one-person show, in December 1917. The publicity value of the exhibition's succès de scandale—the show was closed by the police because the nudes were found to be obscene—was unappreciated by the protagonists, who considered the affair a debacle.

Despite their historical references, Modigliani's nudes reject the traditional Western European manner of representing the female figure. Among his most well-known works are the more than two dozen female nudes he painted between 1916 and 1919. These again exemplify his position between tradition and modernism. The figures are displayed boldly, with only the faintest suggestion of setting. Languorously outstretched, neither demure nor provocative, they are depicted with a degree of objectivity. Yet the uniformly thick, rough application of paint—as if applied by a sculptor's hand—is more concerned with mass and the visceral perception of the female body than with titillation and the re-creation of translucent, tactile flesh.

Yet it was the way in which Modigliani reduced the female body to its essential sculptural aspect, to abstract it while focusing on its details, that shocked contemporary viewers. Through his ability to aestheticize and at the same time eroticize the nude, to present the female as voluptuous and distant, individual and generalized, he restores for the nude her real sexualized body (as flesh, with nipples, pubic hair, and teeth), and at the same time, paradoxically, appropriates a grace and innocence associated with the quasi-religious nudes of the Renaissance.

The philosophical impasse of identity felt by Modigliani disturbed this artist whose Sephardism enveloped otherness. Yet as one who experienced an imaginary exclusion from his race as did few others of the circle of Montparnasse, his portraiture became a field in which he could sublimate the racial inequities of the modern era, which he could escape no more than he could his own racial otherness. Despite the invisibility of Modigliani's Jewishness, he reclaimed it from beneath his Gentile mask, as he realized the indelibility of his "Race."

Modigliani's symbolic reemergence as a Jew is a medium that helps provide him with the formal and conceptual means of expressing new relations between the visible and the invisible—of who could be identified, and who could not—between the pariah who maintains his otherness, and the parvenu who suppresses individualism in order to conform and succeed. It also clarifies the increased attenuation of his "abstract style" and its accompanying mask during and after World War I, as he grew increasingly disillusioned.

His engagement of Western Christian culture, and its problematic positioning of the Jew, precipitates his challenge of the genre of portraiture—not in terms of the failure or success of its verisimilitude, but in terms of whether or not it could function as an allegory of the modern, and of the ultimate failure of modernity's utopian vision, social beliefs that were a part of his own nineteenth-century Italian heritage. If it can be said that Modigliani reformed portraiture, he did so at the crossroads of history, conjoining the archaic and the modern. After the war, as even his sitter's gender grew ambiguous, and as it was ever more difficult to abstract the sitter when others, led by Picasso, were reviving a conventional and sobering portraiture, the more opaque Modigliani's masked and universalized portraits became.

The view that Jewish artists before World War I merely embraced the freedom to be whatever they wanted to be, as Arthur Cohen has written, "to choose when, where, and in what way to combine—or not to combine—origins and art," defines the very distance such artists had come from the old world. But it does not really address the question of a Jewish art, and certainly not a body of work that went against the grain by seeking to reconnect with historical roots, to face the experience of the Jew in the Diaspora, in dispersal. Modigliani might be seen as an early-twentieth-century precursor of what the painter R. B. Kitaj, in treating the subject of exile as "a way of life and death—consonant with Jewishness itself," has called a Diasporist art. Cohen goes on to observe that "the Jewish artists in Montparnasse wanted first and foremost to be 'Parisian' artists . . . to be equal to the world-standard for artists. Which is not to say that these painters and sculptors lost their Jewish identity. A few did attempt to deny or ignore their origins, but for the most part the Jewish artists of Montparnasse simply lived as artists and as Jews, without a necessary relationship between those two identities (although the rapport between the two identities was by no means immutable)."[43]

To continue to view Modigliani as paradigmatic of this group only perpetuates an overriding tendency in art history to absorb cultural difference in order to preserve a particular narrative of historical or stylistic cohesion.[44] Such homogenization undermines a discrete consideration of the subject and constructs an analogue to the discipline's unabashed and unapologetic appropriation of "tribal art" in the first place, in presenting ethnicity itself, of Jews and non-Jews, as a subject that can be reduced to a common denominator. In being subsumed within a monolithic reading of the period, a leveling of artistic practice such as Modigliani's only masks the discursive practice

that art history has tended to resist. That the artist's stylistic diversity can be a microcosm of the cultural amalgam of Montparnasse says very little about his work; it fails to tell us that behind Modigliani's ostensible inclusiveness was an artist who insisted on difference, on individualism, and whose habitual unwillingness to join "others" related to his refusal to assimilate. While what was called the School of Paris was meant to separate and protect nationalistic interest from foreign impurity, such a "school" of course had no agenda, and its identity was externally imposed.[45]

Similarly, the artist's reversion to classic archetypes may be seen as emerging from his sense of cultural displacement and alienation in Paris; certainly his "classicism" is distinct from what erupted chauvinistically in France in the wake of World War I.[46] With the need to cleanse the perceived dilution of its pure artistic tradition—from Nicolas Poussin and Jean-Auguste-Dominique Ingres to Paul Cézanne—the backward glance of the École Française was diametrically opposed to Modigliani's universally democratic evocation, founded in his Italian Sephardic heritage. As opposed to the École's need to redeem its "individual" character, that is, to render a pure identity of France, Modigliani's idealism is born of his Livornese heritage and based on a cultural pluralism and religious humanism eloquently espoused among nineteenth-century intellectual circles of Sephardic Livornese.

The assimilationist ecumenicalism of the reformed Livornese tradition from which Modigliani came, which Benamozegh promoted, advocated universalism. Although inclusiveness was central to Benamozegh, his vast vision of the universal ideals of Israel (whose religion he refers to as *"Hebraïsme"*) was intended to demonstrate the grandeur of Israel in terms of its originating universally religious complexity, and the derivative nature of Christianity and Islam.[47] In this worldview, Judaism related to all humanity, and was relevant beyond its ecclesiastical constraints and no less meaningful for non-Jews than for Jews. The political consequences of the Risorgimento cut through conventions, as the utopian principles of its constituents defined a philosophical alignment in which religious imperatives merged with an acute sense of social duty. Modigliani's secularism must be seen against the historical background of this expanded field of allegiance and its shift from religion to state, from the individual to the social, from exclusion to inclusion.[48]

Modigliani understood this universality in the Spinozan sense, that a radical Jewish universalism was wedded to a respect for the individual.[49] Yet beyond echoing Spinoza's own futile struggle with race, through his metaphor of the impasse of the caryatid or the geometrized individual, Modigliani's increasingly bolder stylization paralleled his nostalgia for his homeland, which naturally grew with his disillusionment and sense of exile during the war years. Throughout this period, however, it seems as though Modigliani responded to class and social issues by instinctively identifying with his Livornese cultural legacy and its revolutionary egalitarian ideals espoused by its mystical rabbinical elite. It is this principled position that is evident in his late self-portrait, where he depicts himself as a paradigm of moral duty, investigating the larger philosophical issues that define, unite, and separate us. Such a reading surely is just a facet of a complex individual, but it is one whose considered depth refutes the myth of Modigliani as a profligate. Indeed, reflected in his triangulation of the Christian, the Theosophical, and the moral, conceived together under the unifying umbrella of an Italian Judaism, his body of work represents a set of values that echoes one of the high notes of Sephardic humanism in Italy's long religious history.

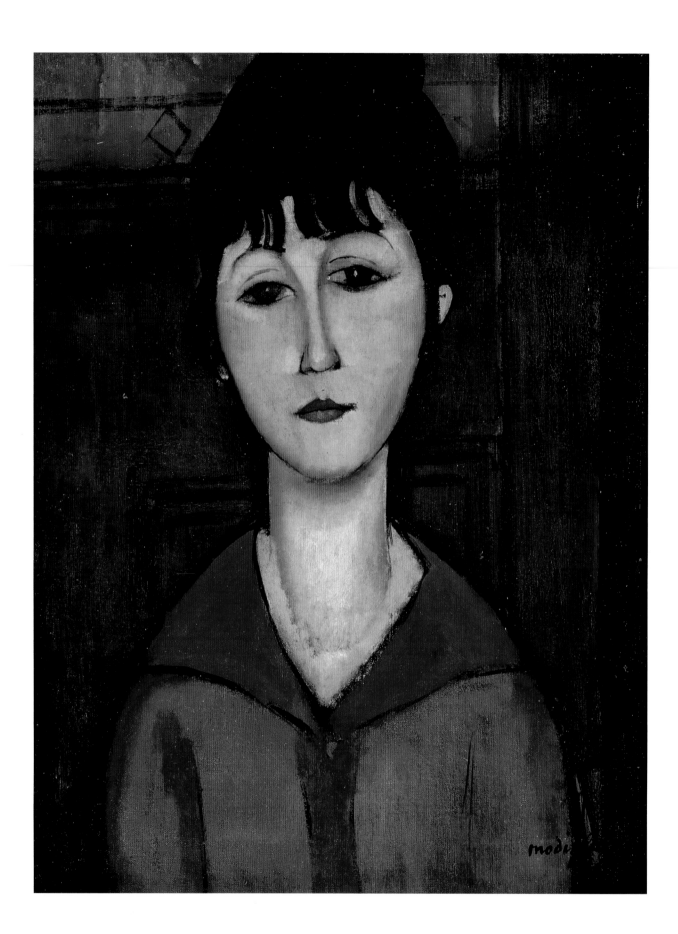

The Faces of Modigliani
Identity Politics Under Fascism

Emily Braun

At first glance, Modigliani's art gives the impression of monotony, of faces rendered according to a common template and uniformly resigned in mood. Yet it is a mistake to assume that his style is one of sameness, for the types he depicts are explicitly marked by difference. Amedeo Modigliani was a painter of faces from diverse national, ethnic, religious, and class backgrounds. Read the titles of his portraits and the names inscribed therein: Poles (Leopold Zborowski, Lunia Czechowska [see fig. 17]), Russians (Léon Bakst, Oscar Miestchaninoff), Lithuanians (Jacques Lipchitz, Chaim Soutine), Ukrainians (Léon Indenbaum), Catalans (Pablo Picasso, Manuel Humbert Estève [fig. 2]), Spaniards (Juan Gris), Mexicans (Diego Rivera), South Africans (Beatrice Hastings), Algerians (*Almaisa: The Algerian Woman*), Swedes (Thora Klinkowström), Roma (*The Gypsy Woman*), and Greeks (Mario Varvoglis). One also finds Americans (Morgan Russell) in search of their identity on the continent. Modigliani's bohemian friends defined the melting pot of modernism that was Montparnasse, a quarter in Paris where foreigners and émigrés felt at home, even if they did not belong to the French nation-state. Modigliani painted the French, too, but comparatively few, and more women than men, and mostly the working class of domestics, and peasants at that. His portraiture can be read as an ethnographic project that pointedly asks: Who is defined as "European" in the years around World War I?

Modigliani represented his multicultural subjects with a hybrid of non-Western and Western styles that still defies categorization. Contemporary critics duly acknowledged his various sources in Paul Cézanne and the Pre-Raphaelites, early Renaissance and Cubist painting, Cambodian reliefs, and Japanese prints. His mature style emerged from yet another layer of cultural epidermis: the African sculpture he saw in Parisian studios, which inspired the asymmetrically placed blank or black almond-shaped eyes, the ovoid mouths, and the rudimentary angled noses of his sitters. Modigliani shunned the masculine, aggressively sculptural approach to painting and the racial and misogynist content of scarification and bodily violence that marked Picasso's appropriation of African art. There is no grafting of masklike colonialist stereotypes onto Modigliani's faces, but rather the miscegenation of the sub-Sahara with individual features of European origin.[1]

Furthermore, Modigliani graced his sitters, men or women, with stereotypically feminine qualities. He privileged languid, serpentine line over sculptural mass, and used poses passive and demure, including the submissive tilt or decanting of the head. The dominant arabesque of Modigliani's art embodied the exotic Oriental, as did the Slavic ethnicity Modigliani painted more than any other foreign identity—Poles, Lithuanians, Russians—many of whose surnames were also recognizably Jewish. In the names and non-Western stylistic mix of his images, the constellation of the feminine, the Slav, the Jew, and the bohemian emerges as a portrait of otherness within

Fig. 1. Amedeo Modigliani,
Ritratto di ragazza (Portrait of
a Young Woman), 1916. Oil on
canvas, 26 x 20 in. (66 x 51 cm).
Private collection.

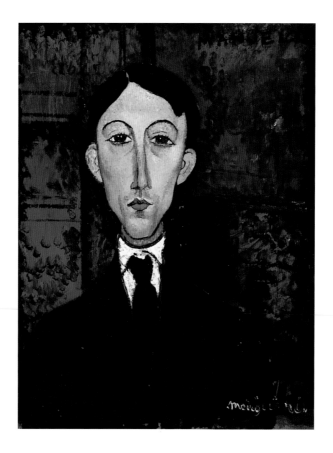

Fig. 2. Amedeo Modigliani,
Portrait of Manuello, *c. 1916.*
Oil on canvas, 26 x 20 ⅛ in.
(66 x 51 cm). Los Angeles County
Museum of Art, Gift of Mr. and
Mrs. William Wyler (51.22).

modern Europe. Here we have beatific effigies of the Jew, the Slav, the Gypsy, and the homosexual (Jean Cocteau, Max Jacob)—specifically those "types" that would soon be the object of systematic extermination.

Born in Livorno into a once comfortable, but recently impoverished, family of Sephardic Jews, Modigliani was an Italian who made his international reputation in France. Moreover—and this is the interesting twist—his art was completely unknown in his native land during his abbreviated life. It was only after his death in 1920, at the age of thirty-five, that Modigliani was embraced as a native son, through two retro-spectives at the Venice Biennale. The first of these, in 1922, occurred just months before Mussolini's rise to power; the second, in 1930, during the middle years of the dictatorship and the Duce's height of popularity. Modigliani's posthumous reception in Italy created a most awkward case of national self-representation for the Fascist regime. Given his stylistic nomadism, his choice of otherness as subject, how could he possibly be turned into an essentially Italian artist after the fact? How could Modigliani, known for his cosmopolitan portraiture of internationals, let alone his mythic life of debauchery, take on the face of Fascist Italy?

In Paris, Modigliani was a Jew with a difference: he was Italian. His Mediter-ranean background and his language distinguished him from the Eastern Europeans, whether of shtetl or assimilated origin. Yet his status as an Italian created a different sort of tension, since France had repeatedly snubbed Italy in the diplomatic arena, considering it a subaltern nation. In geopolitical terms, Italy was a liminal land between north and south, its extreme Mediterranean boundaries dangerously close to "backward" Byzantium and "savage" Africa. Southern Italy in particular bore the image of a lascivious "paradise inhabited by devils."[2] Long before Paul Gauguin painted his ripe Tahitian women, French Salon painters captured the Neapolitan peasant as a backward, if picturesque, creature of fecundity. Of all the peoples

Modigliani painted in Paris, only the unnamed sitter for *The Italian Woman* (pl. 68) can be securely identified as a compatriot. Those most characteristically Italian are his anonymous nudes, whose rose-flushed brown skin, dark hair, and full lips and bodies conform to the "primitive" Mediterranean type, contrasting with the pale and urbane Parisian *grisette*. Modeling was the occupation of choice for Italian immigrants in Paris, and the indolence ascribed to the profession served to reinforce the southern stereotype. Nowhere does Modigliani draw the fault line between north and south more clearly and knowingly than in his depictions of the naked female body. That the *femme italienne* was merged in the French public eye with the image of the Oriental *belle juive* merely reinforced Modigliani's identification with his immigrant models as foreigners like himself.[3]

Modigliani, however, was no southerner. Livorno was a major port in Tuscany, the geographical and historical center of the humanist tradition. He laid claim, by birthright, to the illustrious art of the Renaissance—a cultural patrimony that made even the French genuflect. His contemporaries in Montparnasse never failed to mention his Tuscan elegance and aristocratic bearing, descriptions whose subtext affirmed the artist's good breeding. Modigliani's harmonious, Latin good looks were at furthest remove from the anti-Semitic racial type—epitomized by the hooked Jewish nose.[4] With a visage often compared to that of a Roman emperor, and as a Jew versed in Dante, Modigliani could never be a parvenu: a rooted, "authentic" culture coursed through his veins.

For Italians, in turn, Modigliani was a contemporary artist with a difference: He had made it big in France. As Giorgio de Chirico once quipped, "There is no modern Italian painting. There is Modigliani and me, but we are really French."[5] Italian intellectuals smarted at the idea of their cultural inferiority by comparison with the rest of Europe, and numerous artists and writers shed their parochialism by residing in Paris. In the years before the war, Modigliani, de Chirico, and Gino Severini were the most famous Italians abroad, but Severini alone was known in Italy at the time, because of his association with the widely publicized Futurist movement. Despite Severini's solicitations, Modigliani never joined the Futurists. His style had little to do with their Analytic Cubist language or with their aggressive brand of Italian nationalism. After the rise of Fascism (which the Futurists ardently supported), de Chirico and Severini exhibited their works regularly in Italy. Throughout the 1920s and 1930s they participated in shows organized by the regime for tour abroad, and they accepted state commissions. Of course, Modigliani did not live to see Benito Mussolini's "Fascist revolution" (one of his brothers, the Socialist deputy Giuseppe Emanuele Modigliani, became an anti-Fascist and in 1926 fled to France).[6] Precisely because Modigliani was not alive, and his art newly arrived, the art establishment used his legacy to a variety of ends. Fascist critics of every ilk—progressive, conservative, even Jewish—fought over Modigliani's Italian identity. The French imprimatur made his repatriation imperative, most pointedly to make gains for Italy in the European modernist movement. As one enthusiast phrased it, Modigliani became "an Italian whom Italy needs to glorify."[7]

Italian exhibitions and criticism on Modigliani between the wars neither hid nor impugned his Jewishness, but set out to construct, instead, the indigenous qualities of his art (Severini, for one, claimed he never knew Modigliani was Jewish until the artist was on his deathbed).[8] How Modigliani's background was integrated with the Italian and Christian traditions tells much about Fascist cultural policy and the status

of Jews under the regime. Assimilated nationals since the mid–nineteenth century, Jews in various regions of the peninsula had been at the forefront of the creation of the new Italian state. Ethnically and linguistically, they blended in with their fellow citizens, and little besides religious observance set them apart. Moreover, Modigliani was from Livorno, a cosmopolitan city without a ghetto, where Jews had enjoyed the largess of the Tuscan dukes since the end of the sixteenth century. In the posthumous literature on the artist, a curious pattern emerges: he is referred to as a Livornese, a Tuscan, or an Italian; or as a Livornese Jew, a Tuscan Jew, or a Jew; or as Jewish *and* Italian; but never as an *Italian Jew (ebreo italiano)*. The latter term, in English or Italian, uses "Italian" as a qualifier, emphasizing racial over national identity, whereas for critics of Modigliani—pro and con—his allegiance was unproblematically dual. If anything, the emphasis on Modigliani's Tuscan origins reveals the tension between regionalism and nationalism that erupted during the Risorgimento and heightened under Fascism. As Modigliani himself once remarked to an Italian colleague, "There is no Jewish question in Italy," as there was, by implication, in France.[9]

For the record, the Futurists were the first to claim Modigliani for the patriotic cause, when they hung his works in the Italian section of the Exposition Internationale d'Art Moderne, held in Geneva from December 26, 1920, to January 25, 1921.[10] Only with the XIII Biennale of Venice in 1922, however, did Modigliani appear before the Italian public, in a small exhibition of twelve canvases organized by the progressive and Francophile critic Vittorio Pica. Among the exhibited works were *The Baroness d'Oettingen (Roch Grey), Portrait of Jeanne Hébuterne, Gypsy with Child*, and *The Little Servant Girl*.[11] That year the Biennale hosted ten posthumous retrospectives of Italian artists, including the sculptor Antonio Canova, the Ingres-like Francesco Hayez, Modigliani, and another Jewish artist, Mosè Bianchi. International in scope but hardly contemporary in its tastes, the Biennale exhibited Cézanne (with twenty-eight pictures) for the first time just two years earlier; for the 1922 Biennale French officials chose Maurice Denis and Pierre Bonnard, among other Post-Impressionists, for their national pavilion. In this context, the novelty—and aesthetic affront—of Modigliani's work was equaled only by the installation devoted to African sculpture—the first temporary exhibition of its kind at the Biennale, and anticipating that at any Italian fine-art museum. This fortuitous occasion allowed critics to make vivid the connection, mostly to Modigliani's detriment, between *l'arte negra* and the artist's modernist primitivism.

Modigliani's debut met with derision, but no greater than the standard hostility directed toward modernism by the general public in Italy, as in France, who dismissed the avant-garde as charlatans or marketing hucksters. Leading critics of a certain generation, for whom Post-Impressionism marked the threshold of acceptable taste, sensationalized the "elongated necks," attributing Modigliani's vision to an astigmatism, or deliberate farce. Good to give the public a shot of this kind of artistic bolshevism, wrote Enrico Thovez, in order to immunize it from further monstrosities.[12] Although the most negative attacks drew from the fin-de-siècle discourse of cultural degeneracy, of the modernist artist as madman, none of the reviews associated this pathology with race, nor did they mention that Modigliani was Jewish. The more up-to-date critics Ardengo Soffici and Ugo Ojetti gave qualified assessments, acknowledging his natural talents but bemoaning his regression into African art. Of the rare laudatory reviewers, the Futurist Carlo Carrà defended the artist's "blessed ingenuity," and laid out the main arguments for Modigliani's critical apotheosis almost a decade later. Modigliani

was "one of the few young Italian artists who brought honor to Italy abroad," wrote Carrà. A truly "spiritual artist" of exquisite refinement, Modigliani painted images of women that invoked those of Sandro Botticelli. Carrà was the first to link Modigliani with the Italian tradition of the early Renaissance, where feminine grace and other-worldly vision were considered the norm, not an aberration.[13]

After the debacle of the 1922 Biennale, Modigliani continued to be ignored in the Italian press, save the very rare notice of a book or a show abroad. One of the first to write on the artist's vagabond but creative existence in Paris was the critic Paolo D'Ancona, member of a venerable Jewish Florentine family. His comment that the artist was "alone and abandoned" in the vice-ridden metropolis prompted an indignant response from the artist's sister, Margherita Olimpia. In order to dismiss this "absurd legend generated from north of the Alps," she detailed her mother's material sacrifices on Modigliani's behalf.[14] But they never mentioned Modigliani's Jewish background. It subsequently came into play in 1927, when the Italian press ran an excerpt, in translation, from Adolphe Basler's book *La peinture . . . religion nouvelle*. Basler highlighted the "Jewishness" of contemporary French art and depicted Montparnasse as a modern "Tower of Babel," referring to Modigliani in this heady context as one of his own race, a "Jew from Livorno."[15] From then on, Modigliani's Jewish identity—when addressed—was considered favorably or, most important, distinguished from the foreign Jews of Montparnasse and from the "corrupt" nature of Parisian life.

Modigliani's repatriation began in earnest in 1927 with the publication of the first Italian monograph, written by Giovanni Scheiwiller, a leading editor and one of the few to publish on contemporary art. Scheiwiller issued the volume as part of his series on modern Italian artists, thereby assuring Modigliani's position as part of the national patrimony (even though no Italian collectors or museums yet owned his work). Scheiwiller was responsible as well for the 1930 *Omaggio a Modigliani*, a limited-edition volume of thirty-five personal reminiscences by French, Italians, and other internationals.[16] In his 1927 monograph, Scheiwiller established the critical agenda of thrashing out the mutually exclusive influences of Paris and Tuscany, while avoiding chauvinistic or parochial denigrations of French culture. After all, for sophisticates like him the preeminent role of Paris in the development of modernism had to be affirmed in order to trump Modigliani's accomplishment.

In what became a standard interpretation of Modigliani's experience abroad, we read that the artist found his true self in an intoxicating atmosphere of misery, vice, and ecstasy; his "purity came shining through." After he absorbed various contemporary trends, the artist's *italianità* revealed itself through his elegant line, in his masterly ability to penetrate to the essence of things, formally and spiritually. The "aristocratic" Modigliani captured the grandiose sorrow and the tragic nobility of a common humanity. Scheiwiller went on to shape a dominant trope in the Modigliani literature: For their sheer emotional power of humility, Modigliani's magisterial portraits of women rivaled old master paintings of the Madonna. Scheiwiller ended his monograph by reporting the artist's last words, *"Cara Italia!"* (Beloved Italy!), thus propagating for the Italian public an indelible image of the artist's deathbed allegiance to his homeland.[17]

Not once did Scheiwiller factor in the Jewish background of the now famous *peintre maudit*. He displaced his interpretation of an unwholesome yet inspirational decadence and Modigliani's restless personality onto the contemporary Parisian

Figs. 3–4. Installation views of the Modigliani room (Sala 31) at the XVII Esposizione Internazionale d'Arte di Venezia, 1930.

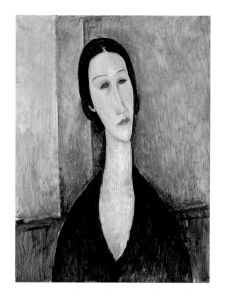

Fig. 5. Amedeo Modigliani (?), Ritratto di donna (Portrait of Hanka Zborowska), n.d. Oil on canvas, 26 1/16 x 20 1/16 in. (66.2 x 51 cm). Museum of Art, Rhode Island School of Design, Providence, Anonymous gift (33.069). Previously "attributed" to the artist, this work was exhibited in the 1930 Modigliani retrospective; see fig. 4, far left.

environment (with an accurate appraisal of Charles Baudelaire's aesthetics), avoiding the subtext of the stereotypical angst-ridden or unhealthy Jew. An accounting of Modigliani's racial "qualities" was left to the critic Lamberto Vitali in his book on the artist's drawings, produced by Scheiwiller two years later. Vitali maintained that Modigliani owed little to his adopted country in forging his distinctive style. "Indeed, in this Livornese," Vitali wrote, "the typical characteristics of two great races—the Italian and the Jewish—were combined and augmented. And so he carried inside him, as do all new artists, a blood that could not have been transfused from anyone else." Vitali's prose revealed more about his own self-conscious identity as both an Italian and a Jew than about the actual development of Modigliani's style. Significantly, Vitali was also the first Italian critic to promote stereotypes (albeit positive) of Jewish religion and culture. About the frank eroticism of Modigliani's nudes, he claimed, as did others later, that the carnal "weight of the flesh" was "transfigured" into chaste emotion. Modigliani's refined sensuality drew from "that great, though weary race that had always worshipped woman on an altar with the most ancient and beautiful of hymns." With a sleight of art historical hand, Vitali concluded by likening Modigliani's "spiritual" use of arabesque line to that of the fourteenth-century Sienese painter Simone Martini, thereby further linking his Jewish and Christian antecedents, the modernist and the Tuscan primitives.[18]

Modigliani's reputation reached its height at the Venice Biennale of 1930, which sponsored a retrospective exhibition of thirty-eight canvases, two sculptures, and forty drawings, his largest show to date (figs. 3–5).[19] Lionello Venturi (1885–1961), the preeminent art historian and professor at the University of Turin, curated the show. Among the major lenders were the French collectors Jones Netter and Roger Dutilleul and, most noteworthy, the Turinese industrialist Riccardo Gualino, who had made a fortune after World War I in the production of artificial silk (fig. 6). With Venturi as his art advisor, Gualino had acquired seven Modiglianis by the end of the 1920s (see figs. 1, 7, and 17–20). He had already amassed an impressive collection of old masters, which he eventually donated to Turin's Galleria Sabauda. Only upon meeting Venturi, however, did he direct his businessman's taste for risk toward the patronage of modern art, particularly the nineteenth-century Tuscan Macchiaioli.

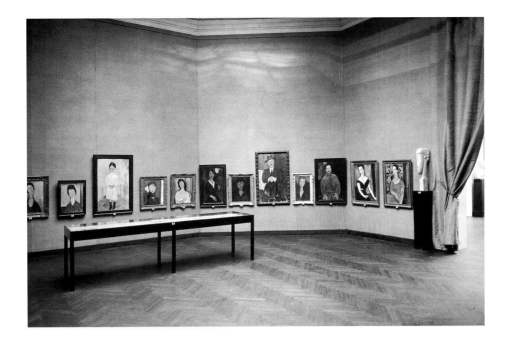

(Gualino was the first Italian to own a work by Édouard Manet, *La négresse*, a study for *Olympia*.)[20] A prodigious scholar of aesthetics and Italian Renaissance art, Venturi was no chauvinist. French art, he acknowledged, led the way in the nineteenth and twentieth centuries and was the wellspring of modernism from which all artists— especially contemporary Italians—needed to drink. As he seriously recommended: "In 1666, France offered its artists an academy in Rome; I can only hope that in 1930, Italy will establish a similar institution in France."[21]

For Venturi, modern art reached its finest expression in French Impressionism, especially in the work of Cézanne (for which he wrote the first catalogue raisonné, in 1936). Venturi held Modigliani as the best model for contemporary Italian artists, since he had distilled the lessons of Cézanne to form his own individual style. Radical art (including Cubism), the cult of novelty, and belligerent ideologies did not fall into Venturi's humanist and liberal model (although he was an ardent supporter of abstract art after World War II). Nor did he view revolutionary change as suitable in the Italian historical and political context. His refusal to pander to imperialist and nationalist movements, namely Fascism, inevitably led to polemics with Filippo Tommaso Marinetti, the Futurist leader and impresario. Marinetti took exception to Venturi's support of Modigliani, in large part because it threatened to eclipse the role of the Futurists as Italy's leading moderns. In Marinetti's opinion, Modigliani (whom the Futurists first recognized, Marinetti proudly recalled) was no innovator; his art brought to conclusion a now outmoded Impressionism, and hence was not avant-garde enough.[22]

Rather than the Futurists, whose antics "could not even rouse the curiosity of deadbeats,"[23] Venturi and Gualino supported local artists in Turin, namely Felice Casorati and the Gruppo dei Sei (Group of the Six)—Carlo Levi, Francesco Menzio, Jessie Boswell, Gigi Chessa, Enrico Paulucci, and Nicola Galante. Influenced by the city's liberal politics and by Venturi's Impressionist orientation, the Gruppo dei Sei exhibited together between 1929 and 1931. They cultivated an antimonumental, anti-classical style with delicately painted, hazily rendered glimpses of everyday life. Long before the rest of Italy, these artists had privileged access to the Modigliani works that Gualino "hung serenely amidst his Titians and Botticellis."[24] While Scheiwiller, in

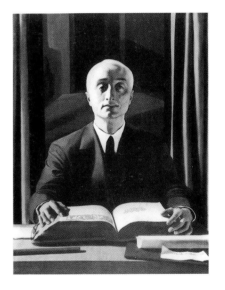

Fig. 6. Felice Casorati (Italian, 1883–1963), Riccardo Gualino, 1922. Oil on canvas. Private collection.

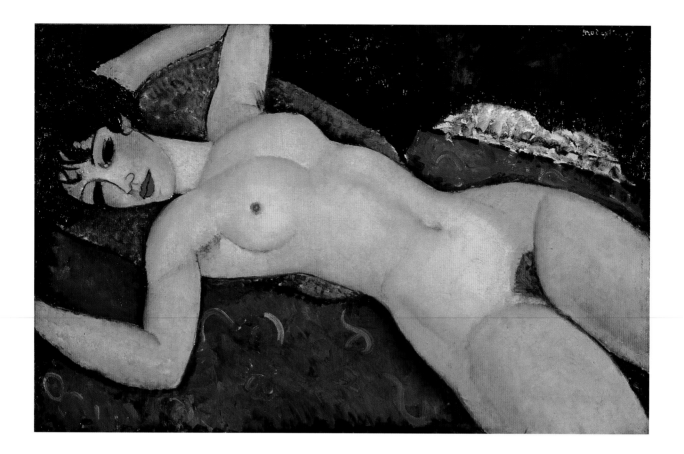

Fig. 7. Amedeo Modigliani, Nude
(Nu couché, les bras ouverts)*,*
1917. Oil on canvas, 23 ⅝ x
36 ¼ in. (60 x 92 cm). Private
collection.

1927, refrained from reproducing a single Modigliani nude for fear of violating
obscenity laws, some two years later Chessa, Levi, Paulucci, and Menzio paid open
homage to the sensuous line and languor of the brazenly erotic *Nude (Nu couché, les
bras ouverts)* in Gualino's collection (figs. 7–9).[25] In an article published in Venturi's
periodical *L'arte,* Chessa rebutted as scurrilous the view of Modigliani as but a mar-
keting invention of Parisian art dealers, and rehearsed Venturi's interpretation of the
Livornese's inspirational style: Modigliani, the "outsider of the art world," exuded
qualities of the Italian (as well as the French) tradition not by following a given pro-
gram, but by remaining open to any and all influences.[26] A month later, in February
1930, Gualino exhibited his collection of Modigliani portraits in the foyer of the
Teatro di Torino (which he had built); this generated a local succès de scandale, in
anticipation of the Biennale that spring.[27]

The timing of the Modigliani retrospective in Venice proved critical, for in 1930
the Biennale implemented changes in administration that politicized its role as a vehi-
cle of Fascist cultural policy. The new secretary general of the Biennale, Antonio
Maraini, a conservative sculptor and bureaucrat, wrestled the event from local Venetian
control and reorganized it as an autonomous state institution with the agenda of pre-
scribing official tastes. Maraini initiated prize competitions to encourage more didactic
images of overt propagandistic content among younger Italian artists. (With submis-
sions few and lackluster, the competitions were deemed a failure the first year.) While
Fascist cultural policy remained pluralistic throughout the 1930s (in distinct contrast to
that of Nazi Germany), the regime increasingly resorted to "benign" coercion, such as
prizes, acquisitions, commissions, and official favors, as a means of encouraging a uni-
fied and more realistic "Fascist" style. Willingly or under pressure, modernist painters
couched their works in terms of classical or Latin traits. In the same Biennale of 1930,
the French critic Waldemar Georges put his name to "Appels d'Italie," a show of

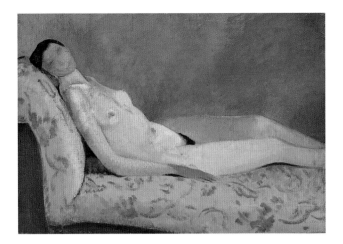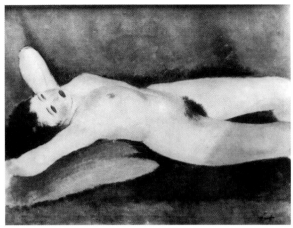

Italian, French, and "foreign" artists working in Paris—among them Severini, Massimo Campigli, Filippo de Pisis, and de Chirico's brother Alberto Savinio—whose work, Georges proclaimed, heralded a return to Rome and "eternal" humanist values.[28] In this climate of intensified chauvinism, Modigliani's exhibition held the future of modern Italian art in the balance, as critics weighed his various identities: national and international, Italian and French, classical and expressionist, Latin and Jewish.

Curiously, it was Maraini who commissioned the Modigliani retrospective from Venturi, early in 1930, just months before the opening: "The reasons for this exhibition are so evident that I do not need to repeat them here. Thanks to you, above all, in Italy the public's interest in the artist has been highly stimulated. On the occasion of the tenth anniversary of his death, it would be singularly propitious for the Fatherland to do him justice."[29] Venturi's father, Adolfo—the other famous art historian in the family—warned him against curating the exhibition, since the Italian public would never understand Modigliani's work and would see the long necks only as "caricatures of swans": "I think that Maraini wants to compromise you so that he doesn't compromise himself and can throw the wrath of the public on your shoulders. . . . Even I don't get the geniuses of today. I'm too antique!"[30]

The commission was politically loaded, and not just for reasons of artistic style.[31] Turin—the city of Venturi and Gualino—was a center of liberal activism and militant anti-Fascism.[32] Venturi's rigorous defense of creative freedom predisposed him against the regime. And while Gualino did not work against Mussolini, he did not fall into line, as did another powerful Turinese industrialist, Giovanni Agnelli. According to the Duce, Gualino was indifferent to Fascism, too independent in his tastes, and too heavily financed by foreign capital.[33] The affiliation of Gualino, Venturi, and the *déraciné* Modigliani posed an implicit challenge to official cultural politics. Venturi's essay on Modigliani in the Biennale catalogue notably refused to play the ethnic or nationalist parlor game, and presented the artist's work in strictly formalist terms. With his foundation in Cézanne and innate love of decorative line, Venturi said, Modigliani uniquely reconciled construction in depth and surface arabesque, the sensuality of nature immediately perceived, and the higher reality of the imagination.[34] Although he did not fail to mention the Italian primitives among Modigliani's diverse interests, for Venturi (and by extension Modigliani) national identity had an ethical dimension: "There are two ways of being a good Italian," Venturi declared. "One is to speak positively about everything to do with us, and speak badly of everything foreign; the other is to assimilate everything possible of

Fig. 8. Carlo Levi (Italian, 1902–1975). Nudo disteso, 1929. Oil on canvas. Carlo Levi Foundation.

Fig. 9. Francesco Menzio (Italian, 1899–1979). Nudo sdraiato, c. 1929. Oil on canvas. Location unknown.

Fig. 10. Simone Martini (Italian, 1284–1344). Madonna with Child, 1321. 34 ¼ x 20 in. (88 x 51 cm). Pinacoteca Nazionale, Siena.

Fig. 11. Ambrogio Lorenzetti (Italian, c. 1290–1348). The Virtues of Good Government (detail of Temperance), 1337–39. Fresco. Palazzo Publico, Siena.

Fig. 12. Sandro Botticelli and workshop (Italian, c. 1445–1510). Ecco Homo or The Redeemer, c. 1500. Tempera on wood, 18 ½ x 12 ⅝ in. (47 x 32 cm). Accademia Carrara, Bergamo, Italy.

things foreign in order to become better than before and better than all the others. I prefer the latter."[35]

Modigliani's faces—the thirty-seven portraits (and one landscape) identified here for the first time—were overwhelmingly well received.[36] Critics lauded Venturi for his curatorial enterprise, but roundly ignored or debunked both his formalist interpretation and his European perspective. They stressed Modigliani's Italian heritage through biographical facts (his youthful apprenticeships in Livorno, Florence, and Venice), his stylistic debts to indigenous old masters (above all, the trecento primitives Simone Martini, and Pietro and Ambrogio Lorenzetti; and Botticelli; figs. 10–12), and last, the emotive spirituality of his art. Critics frequently read "Jewish" content in details of his close family ties, his melancholic disposition, the sensuality of his nudes, and his respectful adoration of women. That some of these same stereotypical attributes could also be applied to the Italian national character contributed to the perception of the artist's dual identity. To be sure, Modigliani's portraits appeared as but infantile deformations to some, the product of a languid sensuality, and his success was attributed to a conspiracy of venal (read: Jewish) dealers. But the anti-Semitic remarks remained tellingly couched in anti-Parisian terms: the unhealthy life of the cosmopolitan French capital—corrupted by Oriental Slavic culture and other nefarious influences—accounted for Modigliani's grotesque stylistic pastiche.[37]

Although negative reviews proved the minority, Modigliani's supporters had to counter one prejudicial discourse prevalent in European fin-de-siècle literature: the inability of the "wandering Jew," who lacked roots in a native soil, to generate an indigenous culture. Jews were "assimilators" but not "originators," and their diaspora had spread modernism—for better or worse—throughout the European capitals.[38] For Italians, of course, the Jews had lived on the peninsula for two thousand years: hence Modigliani was an "Italian flower, cut before its time, and transplanted in Paris," and not an opportunistic weed.[39] He was as much "melancholic Jew" as "nostalgic Italian in exile," who found himself in the "fetid ghetto of the French art world," his work exuding longing for his beloved homeland.[40] His art balanced the classical tradition with assimilating tendencies, as befitted the dual heritage of his genius. "In the same way that Simone Martini departed Siena for Avignon, bestowing traces of his

THE FACES OF MODIGLIANI

Fig. 13. Sandro Botticelli, La Primavera *(detail of the Three Graces), 1477. Tempera on wood, 80 x 123 ⅝ in. (203 x 314 cm). Galleria degli Uffizi, Florence.*

Fig. 14. Simone Martini, Annunciation *(detail of St. Mary), 1333. Tempera on wood, 104 ⅛ x 120 in. (265 x 305 cm). Galleria degli Uffizi, Florence.*

art on the French primitives, so after six centuries, Modigliani left Tuscany to die on French soil, bequeathing a body of work equally influential."[41] Yet Modigliani's style, "nurtured in blood and soil," had its price, one paid in racial currency, for Italian critics unanimously agreed that he could have no true followers, merely "imitators of his exterior forms."[42] Despite the glory he brought to Italy, no one, except Venturi, advocated his progeny.

Still others—the journalist Margherita Sarfatti, for example—spun his story of exile and assimilation as a patriotic artistic quest rather than a racial malaise. One of the most powerful critics of the time, and Mussolini's cultural advisor, the Venetian-born Jewish Sarfatti had her own agenda: she perceived Zionism (a competing allegiance) as a threat to the status of Jews in Italy and a catalyst for Mussolini's incipient political anti-Semitism. Sarfatti not only ignored Modigliani's Jewish identity but insisted that he had realized his Italian self by exploring and rejecting diverse foreign influences, ultimately becoming the finest ambassador of the Tuscan spirit abroad.[43] Sarfatti left it to others to distance Modigliani from the international and Eastern European profile of the Jewish circle in Montparnasse. Although he was Jewish, one critic observed, "it was not for nothing that Modigliani was Italian"; his art was clearly "alien" from the abstractions of Marc Chagall and the tormented brushwork of Chaim Soutine.[44]

For the majority of progressive Italian critics, Modigliani's portraits bore the venerable lines of old masters in the skin of an avant-garde style, conforming to the regime's own double-faced cultural policy. Above all, these critics found native affinities in the elongated features, tilted heads, submissive gestures, and "sorrowful gazes." The "chaste eroticism" of his nudes compared favorably with the women of Botticelli (fig. 13), while the gendered quality of his serpentine line paid homage to the trecento primitives, in whose works "feminine meekness and mildness prevail over the masculine elements."[45] Moreover, art history conveniently linked the Sienese school, like Modigliani (the Jew), to the Oriental Byzantine tradition. The bittersweet melancholy of his sitters resurrected the inner solitude displayed in the faces of beatific virgins and Madonnas [fig. 14]. As the writer Giuseppe Marchiori elaborated, "The saints of Simone [Martini] raise themselves, like statues, immobile in the heaven of

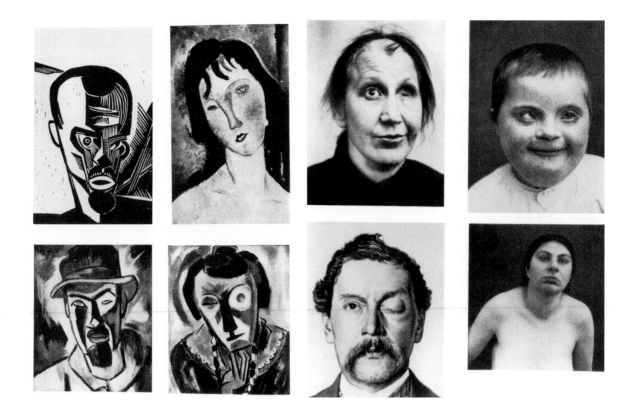

Fig. 15. *Modigliani's* Portrait of a Young Woman (Ragazza) *(second column, top) juxtaposed with works by Karl Schmidt-Rotluff (first column, top and bottom, and second column, bottom) and photographs of facial deformities, from Paul Schultze-Naumburg's book* Kunst und Rasse *(1928).*

immortality; their gaze is at once severe and sad. Yet the face of Saint Clare of Assisi bears the same resigned sorrow as [Modigliani's] *Huguette*; the neck of the Madonna, who kneels on a marble choir stall, bends with the same rhythm as the *Haricot rouge*; while the good *Madame Hébuterne*, the sweet companion of Modigliani, is overcome by the same stirrings of maternity."[46] The centrality of the arabesque to Modigliani's style went beyond mere formal analysis; as Venturi himself admitted, line embodied the antinatural and thus the "spiritual" value in art—"synthesis, simplification, liberation from the contingent, and passion for the essential."[47]

And so, Italian critics welcomed their prodigal son home from the vice-ridden studios of Paris by converting him: they merged stereotypes of Jewish suffering with Christian *misericordia*, the mystic Jew with the Christian mystery. "Amedeo Modigliani, Israelite, was perhaps the most 'Christian,' that is, the most humanely spiritual painter of his time. By means of ascetic castigation, he achieved a style of expressive pathos, dominated by the qualities of candor, kindness, and sorrow," Mario Tinti pronounced.[48] Modigliani's sanctification in the press occurred the year after the regime signed the Concordat with the Vatican, which signaled a new alliance between Fascism and the Catholic Church.

New Testament allusions abound in the Italian criticism, as we read of how Modigliani endured his Parisian experience like the "road to Calvary." He trod a *via dolorosa*, where despite the temptations of drugs and alcohol, he never veered from the spiritual path of his art. His work exuded a rare "aesthetic and moral rectitude," and "innocence and purity," evident in the sitters marked by the "stigmata" of their suffering and humility. Modigliani cultivated neither public nor followers, because he was the "hermit of beauty, not its apostle." The diasporic Jew and the expatriate Italian came together in this "martyr for art," now reborn through the "miraculous power" of his style, and "baptized with success."[49] As Alberto Savinio observed, "To him, men and things appeared sub specie doloris. Jewish and Italian, not in the least pharisaic, he

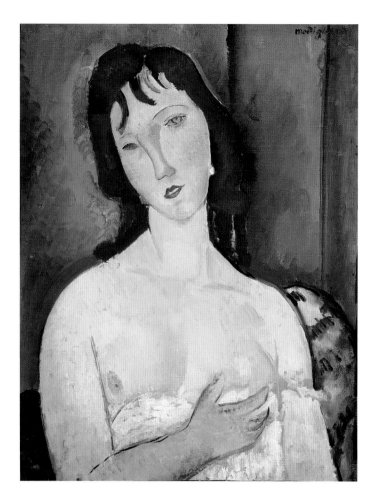

shared the destiny of all 'good' Jews, that is, to relive the tragedy of Christ—to be Christianized. His paintings, and even more so his drawings, are nothing but the expression of a limpid Christianity."[50]

The 1930 retrospective enjoyed great success in the press, but Modigliani's proponents did not fare as well. The next year Venturi was one of thirteen university professors (out of twelve hundred throughout Italy) who refused to swear the oath of allegiance to Fascism; he fled to Paris, where he joined an anti-Fascist group in exile, Giustizia e Libertà, led by two Jewish brothers, Carlo and Nello Rosselli. That same year, Riccardo Gualino was taken into custody, ostensibly for "grave damage to the Italian economy," his holdings seized and his collections dispersed. He was sentenced to five years of confinement on the island of Lipari. In 1934, Fascist authorities arrested Carlo Levi, of the Gruppo dei Sei (whose "ethical" approach to painting was most akin to Modigliani's "for reasons of race," one critic observed).[51] A clandestine member of Giustizia e Libertà, Levi was exiled to Lucania, where he wrote *Christ Stopped at Eboli*.[52] And what of the Modiglianis from Gualino's collection? Through forced sale, several went to private Italian collectors, but none entered a national museum—indicating the still-unorthodox dimension of Modigliani's art in the Italian and Fascist context. As fate would have it, the National Gallery in Berlin acquired *Head of a Woman* (fig. 18); an object of the Nazi degenerate-art campaign, it was sold at auction by the Galerie Fischer in Lucerne in 1939.[53]

One work in the Biennale retrospective—*Ragazza*—had already been disparaged by the Nazi ideologue Paul Schultze-Naumburg in his 1928 book *Kunst und Rasse*, on the biological degeneracy of modern art (figs. 15–16).[54] Modigliani's image was

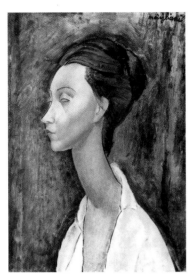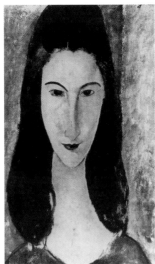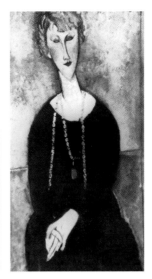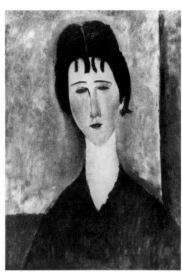

Fig. 17. Amedeo Modigliani,
Profilo della Signora
Czechowska (Profile of Mrs.
Czechowska), *1918–19. Oil
on canvas, 18 ½ x 13 in. (47 x
33 cm). Private collection.*

Fig. 18. Amedeo Modigliani, Testa
di donna (Head of a Woman),
*1918. Oil on canvas, 18 ⅛ x
11 ⅜ in. (46 x 29 cm). Private
collection, Switzerland.*

Fig. 19. Amedeo Modigliani,
Ritratto di signora (Portrait of
a Lady), *1917. Oil on canvas.
Location unknown.*

Fig. 20. Amedeo Modigliani,
Ritratto di donna (Portrait of
a Woman), *n.d. Oil on canvas.
Location unknown.*

compared to photographs of the mentally and physically "diseased," in an attempt to connect the "sickness" of modernist artists with their subjects. In 1930 neither the rhetoric nor a sincere belief in biological degeneracy made inroads into the Italian literature on Modigliani. From the closing of that year's Biennale well through the mid-thirties, Modigliani held his position as the most brilliant of modern Italian artists, the one who brought the most glory to his country abroad. As late as 1935, the regime chose eleven of his canvases in a feat of international cultural diplomacy—an exhibition of modern Italian art "from Canova to de Chirico" organized for the Jeu de Paume in Paris.[55] All the Modigliani works came from French collections, and none depicted Italians or recognizably Mediterranean types, for that matter, thus revealing the historical stretch in claiming the artist's essential *italianità*. On this occasion, the French press acknowledged his dual artistic "citizenship" (French and Italian), while explicitly attributing his brilliance to his Parisian experience. The party bureaucrats who organized the show—lead by Antonio Maraini—also hung works by the anti-Fascist Levi, already under arrest. The duplicity of the regime's promotion of Italian artists abroad mirrored the shifty faces of its opportunistic cultural policy.

Racial discourse in the culture wars between modernists and conservatives increased with the Fascist invasion of Ethiopia in 1935, and began in earnest with the racial laws instituted three years later. The most ludicrous, yet virulent, rhetoric was issued from a fanatical group bent on mimicking the Nazi degenerate-art campaign. The Italian version of this anti-Semitic, antimodernist genre was considerably unoriginal and intent on slandering foreign influence, principally French, rather than "Bolshevik," art. Fascist fanatics writing for incendiary cultural presses set out to bait living Italian modernists, such as de Chirico, Lucio Fontana, the geometric abstractionists, and Rationalist architects. They especially vilified the Jewish artist Corrado Cagli and the young Roman artists around the Galleria della Cometa. Among avant-garde circles a more disturbing strategy emerged, of defending modernism against accusations of "Jewishness" instead of denouncing the racial policies themselves. Ugo Bernasconi, who had contributed to Scheiwiller's *Omaggio a Modigliani*, defended the artist's "deformations" as sincere and therefore artistically valid, but then equivocated, excusing the "caricatural style" as a product of Modigliani's "Israelite blood."[56]

In 1937, Modigliani's infamous *Nude (Nu couché, les bras ouverts)* (see fig. 7) was displayed in a state-sponsored exhibition of contemporary art in Rome; Giuseppe

Pensabene, a prime instigator of racial hatred, disrupted the inauguration, heaping anti-Semitic slurs and other verbal abuse on Modigliani's painting.[57] *Nude (Nu couché, les bras ouverts)* survived the indignities: it was later acquired by the collector Gianni Mattioli, but not before Mattioli had helped Lamberto Vitali escape to Switzerland during the Nazi hunt of Italian Jews in the fall of 1943. Vitali carried his own Modigliani, *L'enfant gras*, with him in flight.[58]

A survey of the anti-Semitic literature shows that Modigliani appeared rarely in the art press during these years, and not as a sitting target for antimodern, anti-Semitic propaganda.[59] In one instance, Pensabene reproduced the detail from *Kunst und Rasse* that paired Modigliani's *Ragazza* and a "pathological human subject," but without any caption identifying the artist's work.[60] In another example, Italian Rationalist architects defended modernist deformation by claiming that "Umberto Boccioni was no Jew," and that "portraits with long necks were not invented by the Jew Amedeo Modigliani, but by the Etruscans, the Byzantines, and the early Christians."[61] Conversely, other publications gladly remarked on, without fear of repercussion, the presence of Modigliani's work in Italian private collections.[62] One finds also anti-Semitic writers who nonetheless vaunted Modigliani, "the most faithful Gesù of painting."[63] Dead, and having made his reputation as a great international abroad, Modigliani escaped the worst degradation by those attempting to cleanse current Italian art of modernist impurities.

The case of Modigliani and of modern Italian Jewry complicates more than confirms the thesis of recent cultural studies that see in Jewish stereotypes the construction of a threatening or diseased racial other.[64] Though a foreigner in France, Modigliani was no alien to classical culture or the Latin world. His "otherness," when perceived, depended on the context, and failed to materialize in his repatriation by Italian critics determined to make him belong. They deflected the negative connotations of the feminine and the Oriental by linking his style to a prestigious cultural patrimony. As to whether or not Modigliani himself felt estranged or "different," we can only conjecture. Did his affinity for African masks derive from the acute self-awareness that Jews, like blacks, were considered racially and culturally inferior by many Western Europeans? Or did Modigliani, as an Italian, feel part of the collective identity of what the writer Caryl Phillips has called the "European tribe," that exclusive club of white Christian nations that have written history as we know it and created monuments in the name of Western civilization?[65]

The answer lies perhaps in his art, in the depiction of the eyes. Modigliani evoked the common lack of belonging of his sitters through his signature blank or blacked-out gaze. Cézanne similarly obscured the eyes, impeding viewers' psychological connection with the sitter, while Matisse used masklike faces to increase the perception of exoticism and eroticism. But Modigliani alone used the African-inspired dark and asymmetrical "non-gaze" consistently, in a form of suppressed expressionism or as the locus of a prophetic multiculturalism. His ethnically diverse subjects lose their individual personalities in a collective portrait of the socially marginal. Not merely stylized heads, Modigliani's faces represent the hybridization of the European tribe, a challenge to monolithic classical and Christian visages that perhaps only an artist both Italian and Jewish, an insider *and* an outsider, could conceive. Modigliani's acanonical style, singular within modernism itself, generated astonishingly paradoxical readings of his art, especially when nations and critics had their own identity politics to promote.

APPENDIX

The list below identifies the paintings and sculptures from the Modigliani retrospective (Sala 31) curated by Lionello Venturi in 1930 for the XVII Esposizione Internazionale d'Arte di Venezia. Numbers and Italian titles correspond to the Biennale catalogue checklist; names of lenders appear as given in the catalogue. Ceroni numbers refer to Ambrogio Ceroni's *I dipinti di Modigliani* (Milan: Rizzoli, 1970); the current location of the work follows the Ceroni number. This list does not include the forty drawings exhibited.

1 *Autoritratto (Self-Portrait)*
 Riccardo Gualino, Turin
 Ceroni 337; Museu de Arte
 Contemporânea da Universidade de
 São Paulo

2 *Nudo (Red Nude)*
 Riccardo Gualino, Turin
 Ceroni 198; private collection

3 *Ritratto di signora (Portrait of a Lady)*
 Riccardo Gualino, Turin
 Ceroni 233; present location unknown

4 *Testa di donna (Head of a Woman)*
 Riccardo Gualino, Turin
 Ceroni 223; private collection, Switzerland

5 *Profilo della sig.ra Czechowska (Profile of Lunia Czechowska)*
 Riccardo Gualino, Turin
 Ceroni 320; private collection, United States

6 *Ritratto di donna (Portrait of a Woman)*
 Riccardo Gualino, Turin
 Not in Ceroni; private collection

7 *Ritratto di ragazza (Portrait of a Young Woman)*
 Riccardo Gualino, Turin
 Ceroni 138; Anna Bolchini Bonomi, Milan

8 *Ritratto di donna (Portrait of a Woman)*
 Pier Giuseppe Gurgo Salice, Turin
 Not in Ceroni; Museum of Art, Rhode Island School of Design, Providence

9 *Ritratto di donna (Portrait of a Woman)*
 Carlo Frua De Angeli, Milan
 Ceroni 129; James Roundell, London

10 *Fanciulla in piedi (Standing Girl)*
 Jones Netter, Paris
 Ceroni 245; private collection

11 *La signora Modigliani (Mrs. Modigliani)*
 Jones Netter, Paris
 Ceroni 260; private collection

12 *Nudo (Nude)*
 Jones Netter, Paris
 Ceroni 197; William I. Koch Collection, United States

13 *Nudo (Nude)*
 Jones Netter, Paris
 Ceroni 324; private collection

14 *Ritratto del pittore Soutine (Portrait of Chaim Soutine)*
 Jones Netter, Paris
 Ceroni 141; private collection

15 *Ritratto dello scrittore [sic] Rivera (Portrait of Diego Rivera)*
 Jones Netter, Paris
 Ceroni 42; private collection

16 *Ritratto del dott. X (Portrait of Dr. X)*
 Jones Netter, Paris
 Ceroni 273; private collection

17 *Almaisa (Almaisa)*
Jones Netter, Paris
Ceroni 132; private collection

18 *Paesaggio (Landscape)*
Jones Netter, Paris
Ceroni 290; private collection

19 *Maternità (Maternity)*
Roger Dutilleul, Paris
Ceroni 334; Musée National d'Arte
Moderne, Centre Georges Pompidou, Paris

20 *Ritratto della signora Zborowska (Portrait of
Hanka Zborowska)*
Roger Dutilleul, Paris
Ceroni 314; private collection, Paris

21 *Ritratto della signora Czechowska (Portrait of
Lunia Czechowska)*
Roger Dutilleul, Paris
Ceroni 322; private collection

22 *Fanciulla in azzurro (Young Girl in Blue)*
Roger Dutilleul, Paris
Ceroni 299; present location unknown

23 *Nudo accovacciato (Crouching Nude)*
Musée Anversa [*sic*]
Ceroni 188; Koninklijk Museum voor
Schone Kunsten, Antwerp

24 *Ritratto d'uomo (Portrait of a Man)*
No lender listed
Ceroni 280; Mr. and Mrs. Sainsbury,
London

25 *"La colerette" [sic] (Anna [Hanka] Zborowska)*
Michaux [*sic*], Paris
Ceroni 160; Galleria Nazionale d'Arte
Moderna, Rome

26 *Ritratto del sig. Zborowski (Portrait of Leopold
Zborowski)*
Max Pellequer, Paris
Ceroni 158; The Museum of Fine Arts,
Houston

27 *Ritratto di Mario (Portrait of Mario)*
Castaing, Paris
Ceroni 336; Ancienne Collection, Franz
Meyer, Switzerland

28 *Marie (Marie)*
Sabouraud, Paris
Ceroni 253; Öffentliche Kunstsammlung
Basel, Switzerland. Bequest of Dr. Walther
Hanhart, Riehen 1975

29 *Ritratto di donna (Portrait of a Woman)*
Signora Monteux, Paris
Ceroni 283; private collection

30 *Nudo (Nude)*
Sig. Marcel Monteux, Paris
Ceroni 196; Staatsgalerie Stuttgart

31 *"La jolie épicière"*
Paul Guillaume, Paris
Ceroni 256; private collection, Paris

32 *Ragazza (Girl)*
Georges Bernheim, Paris
No Ceroni number; Dallas Museum of
Art. Gift of the Meadows Foundation,
Incorporated

33 *Il mendicante di Livorno (The Beggar of
Livorno)*
Dott. Alexandre, Paris
Ceroni 24; private collection

34 *Ritratto di donna (Portrait of a Woman)*
C. Mori, Paris
Ceroni 209; present location unknown

35 *Ritratto d'uomo (Portrait of a Man)*
Stettiner, Paris
Ceroni 252; present location unknown

36 *Ritratto del pittore spagnolo Hubert [sic]
(Portrait of the Painter Manuel Humbert)*
Reid and Lefevre, London
Ceroni 136; National Gallery of Victoria,
Melbourne

37 *Ritratto di donna (Portrait of a Woman)*
Moos, Geneva
Ceroni 216; Museu de Arte, São Paulo

38 *Ritratto del pittore Mauroner (Portrait of Fabio
Mauroner)*
No lender listed
Ceroni, p. 85; private collection, Italy

39 Fabio Mauroner, *Ritratto di Amedeo
Modigliani nel 1905 (Portrait of Amedeo
Modigliani in 1905)*
Collection Mauroner, Venice

40 *Testa (Head)*
Victoria and Albert Museum, London
Ceroni XXIV; Tate Gallery, London

41 *Busto di donna (Portrait of a Woman)*
Max Pellequer, Paris
Ceroni IX; private collection

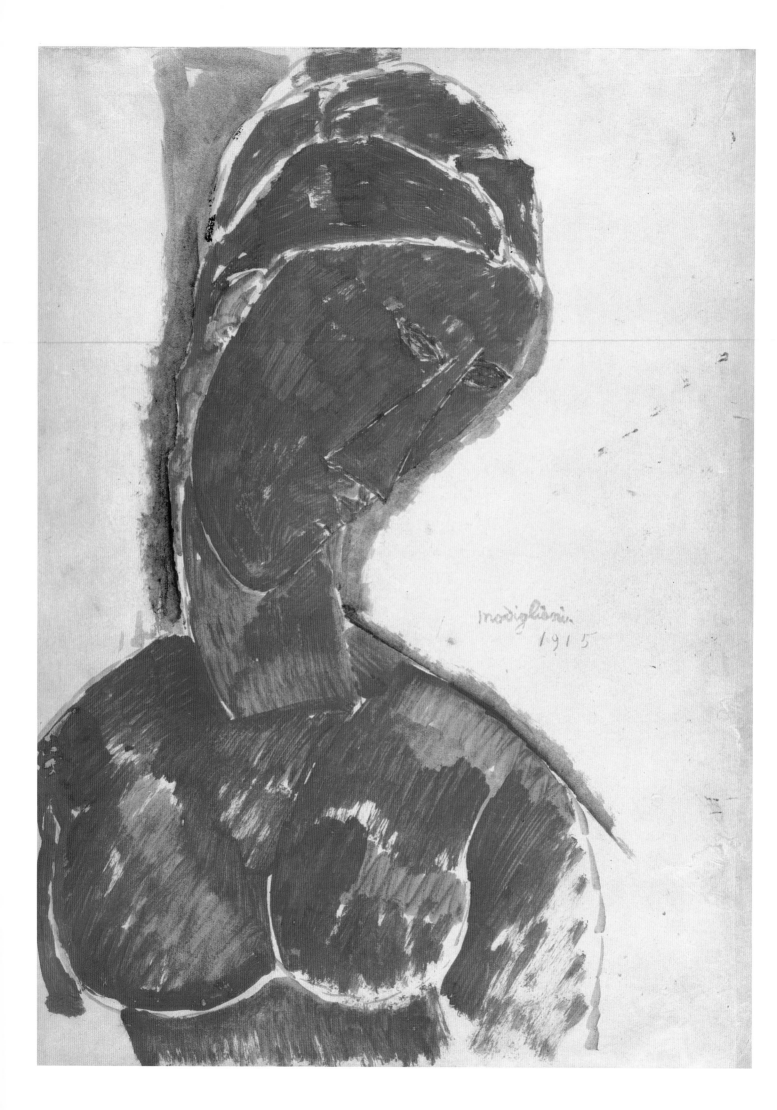

modigliani.
1915

Making and Masking
Modigliani and the Problematic of Portraiture

Tamar Garb

If his models end by looking like one another, this is in the same way that Renoir's models all look alike. He adapted everyone to his own style, to a type that he carried within himself, and he usually looked for faces that bore some resemblance to that type, be it a man or a woman.
—Jean Cocteau (1950)

So wrote one of Modigliani's most famous models, invoking the generic quality of his portraits, their abstracted anonymity, orchestrated simplicity, and distilled, stylized pictorial quality. Constructing his images in line, alternately sweeping and searching, and scrubbed-in, muted color, Modigliani pulled and pushed his sitters into position, stretching, elongating, distorting, and disrupting their contours to suit the exigencies of picture making and the imperatives of his imagination. Generalized and simplified, the countenances and bodies of his sitters inhabit the painted field as if in a world apart, isolated and yet contained by the carefully balanced compositions that enfold them. Hieratic, frontal, and framed, their impassive faces and formal postures fixed in solemn stasis, neither breath nor bodily emission appears to animate his models. Made in paint, their detached demeanors and expressionless bodies speak of painted portraits rather than living subjects, types perhaps, as Cocteau claimed, but prototypes, too, derived from art's rich storehouse of precedents and predecessors.

And yet, for all their absent anonymity, their distant gazing, vacant eye sockets and blanked-out refusal of the empathic regard of a putative spectator, Modigliani's portraits retain something of the sitter's specificity, registered in such corporeal details as the hunch of a shoulder, the clasp of a hand, the tilt of an eyebrow, the turn of a head. Generic and specific vie for prominence, the formal demands of painting and the ego-driven desires of the painter negotiating the alterity of the portrait subject, whose "difference," or specificity, must be registered and relayed through the work. Resemblance or likeness, the traditional purview of portraiture, is the primary locus of the portrait subject's identity. Emerging as an important genre in the early Renaissance, the independent portrait depended for its development on the growth of individuality as a concept and a value.[1] It is the peculiarity and distinctiveness of the individual that portraiture was invented to celebrate.

Unlike the nude, a genre that deals in anonymity and uniformity—the model functioning primarily as a screen for the projection of fantasy and as a seductive type, cipher, or conduit—the portrait purports to picture the "self" by capturing the uniqueness of the subject and representing both external appearance and interior life. Portraiture confirms the integrity of the subject, its "wholeness." With the nude, it is not the person portrayed who is at stake, but rather "nudity" itself (or its analogues,

Fig. 1. Amedeo Modigliani, Nude (Portrait in Red), *1915. Oil and ink wash on paper, 14 x 10 ⅜ in. (35.6 x 26.2 cm). Minneapolis Institute of Arts, Bequest of Putnam Dana McMillan, 1961 (61.36.22).*

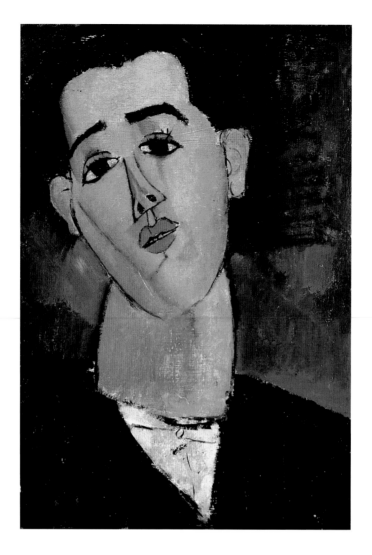

*Fig. 2. Amedeo Modigliani,
Portrait of Juan Gris, 1915. Oil
on canvas, 21 ⅝ x 15 in. (54.8 x
38.1 cm). The Metropolitan
Museum of Art, Bequest of
Miss Adelaide Milton de Groot
(1876–1967), 1967 (67.187.85).*

Art, Truth, Beauty).[2] The identity of the model is, of necessity, inconsequential, even obstructive. Subsumed into the generic languages of art, the model's identity, if asserted, disrupts the symbolic power of the nude. We do not want to know "her" name. Not so with portraiture. Without the specificity of the sitter, portraiture does not exist.

If portraiture is to retain its specificity, generic qualities need to be balanced by signs of individuality, inscriptions of identity that construct the sitter as a unique subject, not merely a "type." Portraiture in the first half of the twentieth century, having been dealt the double death-blow of Cubism on the one hand, with its radical refusal of mimesis and naturalism, its fragmentation of the integral body and redistribution of its parts, and African sculpture on the other, with its highly conceptual representational strategies and its use of a coded shorthand of referents and symbols, struggled to find a means of incorporating these fundamental insights while remaining committed to the depiction of discrete, named individuals. Modigliani's portrait practice internalized the iconoclasm of Cubism and the liberatory power of primitivism at the same time that it affirmed its commitment to the conventional function of the portrait: the adumbration and celebration of the named individual.

A delicate balancing act between the generic and the specific, the abstracted and the naturalistic, is enacted in Modigliani's 1916 portrait of the elegant Jean Cocteau himself (pl. 52). The work was painted soon after Modigliani had abandoned sculpture, where he had experimented with the archaic and African languages of the head,

MAKING AND MASKING

denuded of individuality and reduced to a pared-down set of volumes and inscriptions.[3] Modigliani used the abstracted, simplified shape of the face derived from African sources, but modeled and manipulated its surface to achieve a likeness, emphasizing Cocteau's chiseled features and hollowed cheeks, his distinctive bone structure and pinched mouth. As is typical, the sitter is frontally and centrally placed, and is framed here by a chair that has been lengthened behind the head to support and echo his body shape and frame his presence, adding substance to his significantly slender form (this was not necessary when the sitter was the portly Diego Rivera, depicted a number of times by his friend Modigliani) while providing a series of arched lines that help break up the rectangular ground. Extended and stretched, the long chin forming an exaggerated triangle at its base, Cocteau's illuminated head is simplified and placed at an angle to the characteristically columnar neck, which acts as a plinth for his abstracted bony countenance, worn like a mask surmounting a pole. The separation of the face from the body by a demarcating line or shadow that makes an incision beneath the chin creates the impression of a puppet or doll, a barely animated human toy or paper cutout, twisted and turned to effect. A further slit appears above the collar, produced by a heavy black line that signifies the separation of the neck from the torso and emphasizes the pole-like, cylindrical quality of the head's support. Possessing an illusory wholeness, the fissures and joins—the very seams of subjectivity—so obviously visible on the surface, the sitter resembles a ventriloquist's dummy, a doll that has no voice except that conferred on it by the puppeteer/artist who animates or depletes it at will. The body, in Modigliani's portraits, is invariably an accretion of parts, composed and constructed on the surface, the subject a series of conjoined fragments, separated by lines and combined and recombined to constitute the figure in representation. In his 1915 portrait of the artist Juan Gris (fig. 2), the head is tilted at an impossible angle, mounted on a neck that functions as a swollen plinth, propped on the flattened plane of the shoulders. Detached from the body, the disjointed head and neck do not grow out of the shoulders but seem pasted over them, as if to take up their allotted places as components of the portrait bust. In an earlier painting, *Antonia* (see Klein essay, fig. 1), a profile nose and ear sit awkwardly on a frontal face with pasted lips, surrounded by detachable wavy hair. Where Cubism dealt in fragments, dispersed and rearranged on the picture surface so that no illusory wholeness could be sustained, Modigliani saw the body as a precarious assemblage of parts, holding the subject in fragile balance, always on the brink of disaster.

But Modigliani's commitment to the conventional role of portraiture meant that individuality is nevertheless imprinted on the parts themselves, as well as in the way in which they are combined to constitute the subject in representation. Gris's swarthy complexion, full lips, thick eyebrows, black hair, and dark eyes are unmistakably "his." Cocteau's particular physical presence and individual identity, his social class and aspirations, are registered in the flush of his cheeks, the caricatural exaggeration of his features, and his haughty demeanor and dandified attire. What could be more characteristic than the neat bow tie perched on the pristine white shirt, the handkerchief arranged decorously in the breast pocket, the buttoned-up stiffness of the slim-cut suit with its padded shoulders and artificially orchestrated breadth? The man is tailored to perfection, erect and self-contained, and his vanity is made manifest, his fine-tuned sensibility stressed in the aquiline features (the nose just a little too long), high forehead, and emaciated limp hand draped like a glove in his darkened lap.

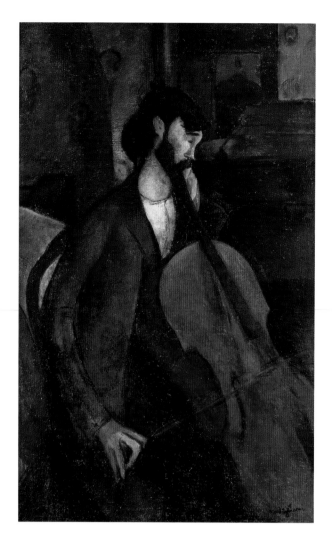

*Fig. 3. Amedeo Modigliani,
The Cellist, 1909. Oil on canvas,
51 ¼ x 31 ⅞ in. (130 x 81 cm).
Private collection.*

Commanding the picture space from the tip of his coifed head to the angular extremes of his jutting elbows and carefully crossed knees, Cocteau's refined masculinity is staged in a double-edged homage that radiates ambivalence. Cocteau is constructed as the sensitive aesthete, polished, punctilious, and effete, and his identity, although assembled in parts, reads as coherent, his own, of a piece. In contrast with the ruddy virility of the full-lipped Gris, not only Cocteau's appearance but his sexuality and sensibility, too, are inscribed in the pictorial synthesis that is his portrait.

Such constructed coherence is the hallmark of Modigliani's portraiture. Never seamless, his figures appear to have been assembled on the picture plane, stitched and pieced together in paint, their parts demarcated and defined in line. Asymmetry and curious disjunctions, most markedly expressed in the frequently mismatched eyes, while positing a subject that is divided and riven from within—literally split apart— are nevertheless subsumed in a fabricated, precariously balanced pictorial whole. The integrated subject of Modigliani's portraits links him to a world before Cubism, most notably that of his mentor Paul Cézanne, with his famous spatial disjunctions and decomposition of the world of visual sensation, his breaking apart of the structure of things so that their very physical makeup could be conveyed in an accumulation of separate colored patches, each visible on the painted surface. Modigliani's devotion to Cézanne is well documented.[4] The younger artist is known to have carried a reproduction of the master's *Boy in a Red Vest* (1888–90) in his pocket[5] and to have been

 MAKING AND MASKING

able to reproduce it from memory; his early figure studies, such as *The Cellist* (1909; fig. 3), read as barely concealed reworkings of Cézanne's compositions. Still haunting *The Little Peasant* (c. 1918; fig. 4) and other late paintings of Modigliani's is Cézanne's palette, muted and tonal, together with the characteristic separated dabs of paint and simple single-figure placement in an indeterminate setting, broken only by the occasional horizontal or vertical accent. Devoid of distinguishing facial characteristics or the quirky individuality of *Jean Cocteau* (pl. 52), the unnamed model of *The Little Peasant*, like that of *The Young Apprentice* (pl. 64), reads as generic, rural prototype rather than portrait subject. He lacks the distinctiveness of the portrait sitter. He is all type, emblematic rather than unique. The picture's status as a portrait, for all the boy's solitary monumentality and dignified gravitas, is problematic. The same is true for the first painting Modigliani exhibited in a public forum, *The Jewess* (*La juive*; 1908; pl. 2), a fin-de-siècle fantasy of rouged lips, sultry sensuality, and fashionable femininity in keeping with contemporary cultural stereotypes and ethnic assumptions. Made up

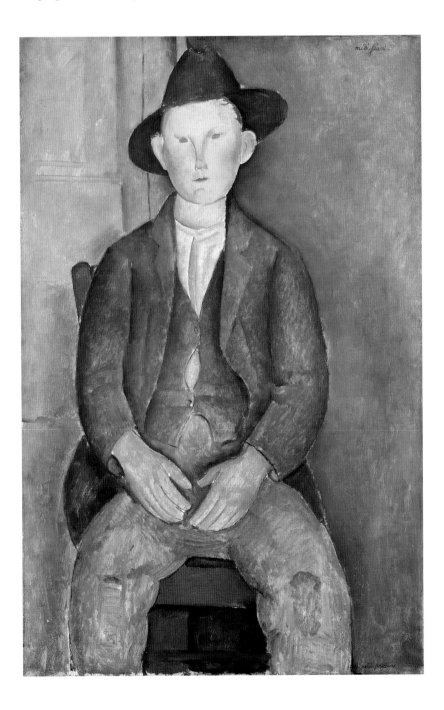

Fig. 4. Amedeo Modigliani, The Little Peasant, *c. 1918. Oil on canvas, 39 ⅜ x 25 ⅜ in. (100 x 64.5 cm). Tate Gallery, London, Presented by Miss Jenny Blaker in memory of Hugh Blaker, 1941.*

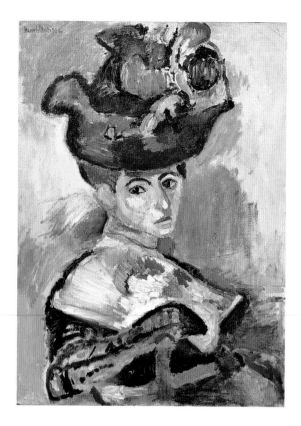

Fig. 5. Henri Matisse (French, 1869–1954), Femme au chapeau (Woman with Hat), *1905. Oil on canvas, 31 ¾ x 23 ½ in. (80.7 x 59.7 cm). San Francisco Museum of Modern Art, Bequest of Elise S. Haas.*

doubly in paint, first by the layer of cosmetics applied to the surface of the sitter's skin and then by the bold sweeps of oil covering the canvas, *The Jewess* is all artifice, embodying the figure of the "painted woman" as modern social type while it allegorizes the artifice of painting itself, much as the scandalous portrait of the flamboyantly hatted Madame Matisse had done at the Salon d'Automne of 1905 (fig. 5).[6] Sharing with that infamous predecessor a bold use of arbitrary color, mauves and greens alternately describing highlights and shadows, and broad, visible brushstrokes, *The Jewess* can be understood as an expressive painting in which the identity of the model is immaterial, in fact incidental to her construction as femme fatale.

Traditionally portraiture, as we have said, although dealing in types, needed to transcend the typical and the generic in order to render the individuality of the sitter. It is the relationship between the generic and the unique that portraiture holds in such fragile balance, and Modigliani's practice, more than most, dramatized the tension that the modern assault on the subject and attempts to reassert it produced.[7] Cocteau was not the only one to accuse Modigliani of imposing his own view on his portrait subjects, suppressing their individuality and subordinating the particular features of their physiognomies to an abstract faciality of the kind most securely represented in his extraordinary heads carved between 1909 and 1915, during his intense friendship with the sculptor Constantin Brancusi.[8] Here eyes are etched, noses are chiseled into elongated columnar or pyramidal ridges, mouths are represented by simple circles, semicircles, or rectangles, raised or incised on the surface of the stone (see pls. 10–16). Placed on rectangular plinths, these heads invoke classical portrait busts while refusing their depictive and commemorative functions. Instead they suggest the abstraction of African masks, made for ritual purposes and, of necessity, anonymous and generalized. This masklike quality characterizes many of Modigliani's painted portraits, for instance *Woman with a Velvet Ribbon* (1915; fig. 6), an empty-eyed, nameless creature whose

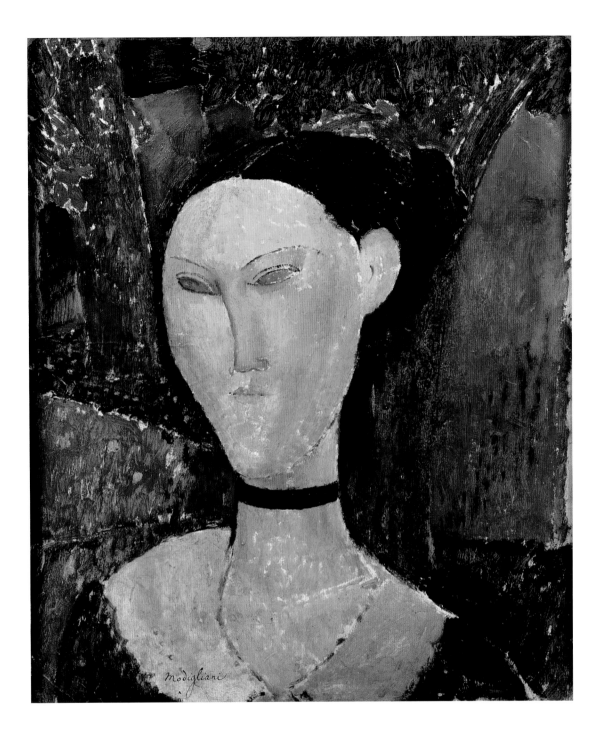

Fig. 6. Amedeo Modigliani,
Woman with a Velvet Ribbon,
1915. Oil on canvas, 21 ¼ x
17 ⅞ in. (54 x 45.5 cm).
Musée de l'Orangerie, Paris,
Walter-Guillaume Collection
(RF:1960–45).

drawn features echo the incised lines of the carved busts and whose social specificity
is secured more firmly in her plain collared dress and black choker than in her general-
ized features and blanked-out vacuity. Cool in temperature, this veiled figure is all sur-
face. In contrast, the searing, blood-red *Head of a Young Woman (Tête rouge)* of 1915 (fig.
7), while disclosing no more of its specific sitter, presents a horrific specter of facial dis-
tortion and blocked vision, pasted in crude blotches onto a darkened ground. The sub-
ject seems shrouded in the theatrical mask of Greek tragedy, elegiac and generalized
in meaning. The mask, used in the theater to embody abstract ideas and emotions,
covers individuals, shields them from view; it occludes rather than discloses, revealing
universal truths rather than individual attitudes. As such, it stands in direct opposition
to the portrait. While it may represent the head, the mask does not describe it. All sur-
face, it reveals little of the interiority of the wearer. Indeed, it conceals and obscures

Fig. 7. Amedeo Modigliani, Head of a Young Woman (Tête rouge), 1915. Oil on cardboard, 21 ¼ x 16 ⅜ in. (54 x 42.5 cm). Musée National d'Art Moderne, Centre Georges Pompidou, Paris (AM4286P).

identity, offering a surrogate and substitute for it. Its role is performative, public, declamatory. Behind it the subject is hidden, protected.

In mobilizing the mask as a way to reinvent the language of portraiture and expand the possibilities for constructing a likeness, Modigliani was in tune with his predecessors. Ten years earlier, after nearly one hundred sittings in front of his patron Gertrude Stein, Pablo Picasso famously had erased his sitter's head and was able only later, in her absence, to represent "her" by recasting her physiognomy in the terms of an Iberian mask, thereby enabling radical simplifications of shape and contour as well as distortions and disjunctions of features and face (fig. 8).[9] In subsequent years Picasso would represent many faces, particularly those of female nudes in the form of African masks (*Les demoiselles d'Avignon* being the most famous example), filtering features through a primitivizing lens that assured the anonymity of the figures, and thereby affirming them as vectors and vehicles for modernist experimentation.

But for Modigliani, the mask, whether in the form of the made-up mask of femininity, or the abstractions and artifice of African carving, was a useful means through

which to mediate his encounter with his sitters. Acutely aware of the artifice of external appearances, the artist represented himself in the guise of the popular clown Pierrot, a character from old French pantomime, in the same year that he dressed up his anglophone lover, Beatrice Hastings, in the trappings of Madame de Pompadour, the legendary eighteenth-century mistress of Louis XV often painted by François Boucher (pls. 35–36). In Modigliani's own self-image, with the familiar ruffled collar and skullcap of the comic character, the word "Pierrot" is brushed in hesitantly in childlike capitals across the bottom of the picture, as if to label the figure and affirm its identity. The identification in *Madam Pompadour*, too, is secured through writing, the words pointedly emblazoned in English on the left, behind the head of the figure, who seems visibly weighed down by her stylish feathered hat, a sign of her showy femininity. Omitting the "de" and leaving out the *e* from "Madame," in effect anglicizing the word, Modigliani subtly implied both his own foreignness and that of his model, and perhaps pointed to the presumption of her parading as a sophisticated Parisienne. In neither of these paintings do the inscribed words name the sitters themselves. Instead they label the masks they adopt (the maudlin mask of masculinity or the fashionable face of French femininity), subsuming the generalized features, drawn in black line and simplified contours, and the unseeing eyes of the models into the roles they are called on to play.

In both cases, words disrupt the illusionism of the pictures, exposing both the artifice of painting and the arbitrariness of language. During the years 1915–16, Modigliani frequently surrounded his sitters with words, sometimes, as in the case of *Portrait of Pablo Picasso* (fig. 9), using the proper name as a decorative, curvilinear

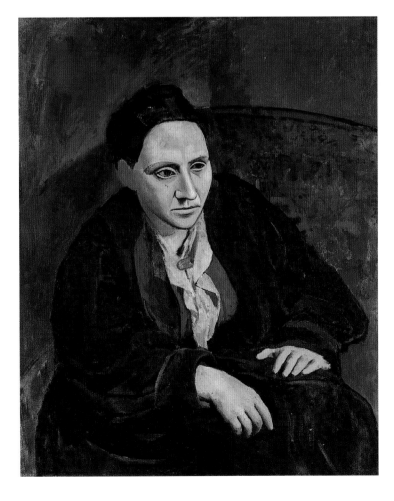

Fig. 8. Pablo Picasso (Spanish, 1881–1973), Gertrude Stein, 1906. Oil on canvas, 39 ⅜ x 32 in. (100 x 81.3 cm). The Metropolitan Museum of Art, Bequest of Gertrude Stein, 1947 (47.106).

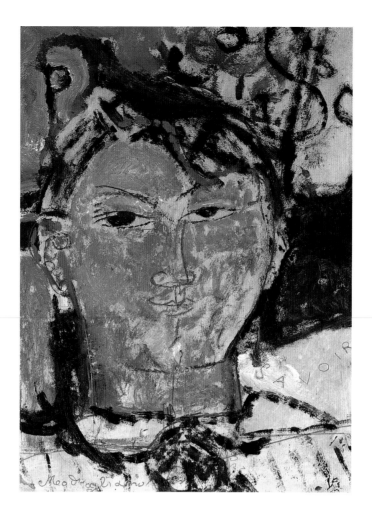

Fig. 9. Amedeo Modigliani, Portrait of Pablo Picasso, 1915. Oil on paper mounted on card, 13 ½ x 10 ⅛ in. (34.2 x 26.3 cm). Courtesy Galerie Schmit, Paris.

design while including a descriptive word, in this case "*savoir*," scratched, perhaps ironically, in pencil onto paint and canvas. Labeling his sitter by name and reputation, Modigliani proffered more than just his appearance, opening up to question the capacity of words to denominate or describe their referents and simultaneously encoding something of his own attitude toward his sitter. At the moment when Picasso himself was beginning to revisit the rigors of naturalism, turning his back on Cubism's radical refusal of pictorial illusionism, Modigliani was exploring the integration of text and image in the fabrication of a credible and coherent portrait subject.[10]

It is the integration of words into the project of portraiture that characterizes one of Modigliani's most ambitious portrayals, that of the art dealer and collector of African art Paul Guillaume (pl. 37).[11] Here the sitter's specificity is assured, both iconically and linguistically. Occupying the center of the canvas, the authoritative and declamatory figure, dressed in typical bourgeois day-garb—dark suit, white collar, knotted tie, and black hat—is shown casually smoking a cigarette, his head tilted slightly to one side. Somewhat top-heavy, Guillaume's slightly enlarged head, with its square jawline and spread-out face, sits rather heavily on his slender body and sloping shoulders while his features are crowded into the center of his face, leaving a large expanse of painted flesh on either side of his narrowed eyes. The face sports a diminutive pink mouth, neatly trimmed mustache, and distended nostrils drawn on a triangular nose, and is flanked by obtrusive ears that turn to face the front. As with the portrait of Jean Cocteau, simplification, exaggeration, and caricatural effects combine to create a personalized, identifiable image.

But Guillaume's identity is assured through writing as well as resemblance. While capturing a likeness was the conventional function of portraiture, the inclusion of letters to name sitters rather than provide illusionistic or trompe l'oeil analogues or witty references (as Jean-Auguste-Dominique Ingres had done, for example) was not so common. The placing of words on the painted surface disrupts the impression of spatial depth central to Renaissance and subsequent European painting and asserts the fabricated, synthetic nature of picture making. It was not until the late nineteenth century that a Symbolist artist like Paul Gauguin used letters in his canvases to counter pictorial illusionism (and mimic the hieratic and decorative flatness of medieval icons), but it was the later Cubists who exploited the potential of letters to function as independent pictorial elements and linguistic signifiers. Where the Cubists used letters, though, as cryptic clues and allusions, decontextualized fragments in need of deciphering and unraveling, much like the parts of the body itself, Modigliani retained the integrity of words, employing them as a source of information or direct reference to the subject portrayed.

In the case of *Portrait of Paul Guillaume (Novo Pilota)* (pl. 39), words, like the image of the sitter himself, are recognizable. Modigliani includes three inscriptions other than his signature on the canvas. At the top left, the sitter's name is inscribed in faltering capitals, the shaky handwriting of the artist serving as an index of his own authorial presence while naming the object of his attention. At the bottom left, the words "Novo Pilota" are scrawled over the sitter's sleeve, disrupting any illusion that it might belong to a three-dimensional figure in space, while on the top right, the faintly written "Stella Maris" is all but disguised in the dark brown and green background surrounding Guillaume. The inserted words are not arbitrary. Modigliani seems strategically to flatter his new patron and supporter by ascribing to him the role of guide or navigator. While "Novo Pilota" (new pilot) suggests someone who steers a course through unknown territory, as the audacious dealer and collector was thought to do, "Stella Maris" (star of the sea) is a title usually conferred on the Virgin Mary as protectress or guiding spirit. Picturing his patron as a benevolent and beneficent supporter, Modigliani constructs a canvas in which the specificity of the model, his social status, and his physical appearance are consummately invoked. Yet at the same time, Guillaume's insubstantial, flat torso disappears at the bottom of the canvas, while his right hand, which might be expected where the inscription "Novo Pilota" appears, is nowhere to be seen. Here the body is displaced into an indeterminate colored field in which drawing, like writing, amounts to so many marks on a flat surface, a matter of paint alone.

Modigliani was at his most self-critical at this moment. In subsequent years he would relinquish the awkward verbal inscriptions of individual identity that characterize this portrait, and yet he would never succumb to pure illusionism. Precariously poised between description and disguise, making and masking, portraiture in early-twentieth-century France had been stripped of its traditional function, but in Modigliani it found a protagonist who, while registering the rupture, nonetheless redeemed its role.

The power of Modigliani's portraits lies in their capacity to render the tensions between the generic and the specific, the mask and the face, the endemic and the particular—indeed, to thematize the problematic of portraiture for this generation. Composed from the materials of history and the parts of the body, they leave all their seams visible, awkward yet eloquent, on the painted surface.

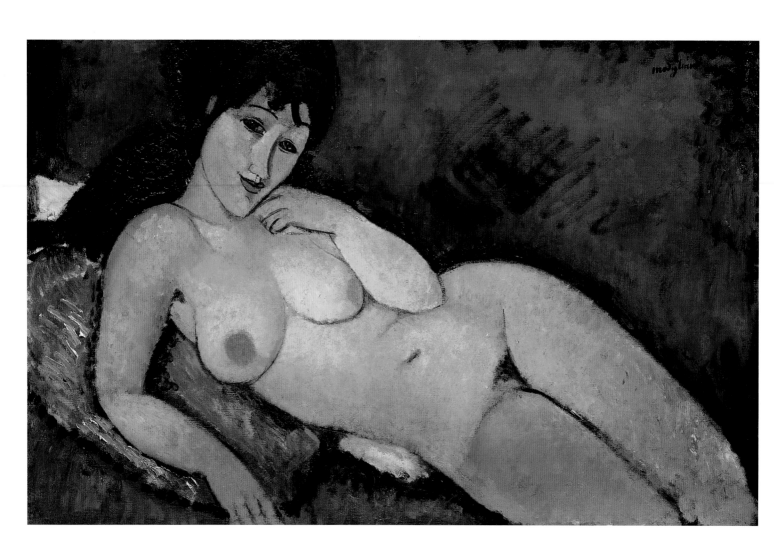

Modigliani and the Bodies of Art
Carnality, Attentiveness, and the Modernist Struggle

Griselda Pollock

There is only one painter of the modern nude.
—André Salmon

To paint a woman is to possess her.
—Amedeo Modigliani

What kept Modigliani from being a full-fledged Cubist was most likely his interest in Old Master painting, specifically Italian Renaissance portraiture, and his interest in being a Jewish artist.
—Kenneth Wayne

NEW YORK, 1928

Nine paintings by Amedeo Modigliani, including *Nude on a Blue Cushion* (1917; fig. 1), were first exhibited in the United States, as part of the Chester Dale Collection, in New York in 1928.[1] Conservative critics found such images outrageous, coy, beefy, and "not unlike an uncensored movie queen."[2] But Maud Dale, a key force in the shaping of this important collection of modernists, was a major advocate of Modigliani; she published a book on the artist in 1929. Her efforts notwithstanding, as late as the 1950s the Guggenheim Museum in New York was still pressed by some of its outraged public to withdraw from sale a postcard of *Nude with Coral Necklace* (1917; pl. 47). Why have these paintings of nudes—hardly luscious in their paint work, carefully underpinned by the drawing that Modigliani's early British appreciators, Clive Bell and Roger Fry among them,[3] found fundamental and sculptural in his oeuvre—caused a public problem?

Is it the proximity of the artist to bodies that almost slide toward the spectator in the airless confinement of the uncluttered studio couch? Is it an encounter with bodies of women that offer their physicality to the viewer with a pose of self-awareness hovering at knowing sexual invitation? Or is it our response to female bodies that, in apparently remaining unconscious, seem vulnerable to a hungry and unmediated looking at such untransformed nakedness? Is it the tension between vibrant carnality and the seeming indifference of the painter, who in his modernist preoccupation with form attends to the logic of the body and its place in his highly structured painting?

Fig. 1. Amedeo Modigliani, Nude on a Blue Cushion, 1917. Oil on linen, 25 ¾ x 39 ¾ in. (65.4 x 100.9 cm). National Gallery of Art, Washington, D.C., Chester Dale Collection (1963.10.46).

PARIS, 1917

During his lifetime, Modigliani had a single one-person exhibition. Organized for him by his loyal patron the Polish poet and dealer Leopold Zborowski, the show was held at the gallery of the vanguard dealer Berthe Weill (1865–1951; fig. 2), at 50 rue Taitbout in Paris, December 3–30, 1917.[4] Featuring a few "sumptuous" nudes, several "juicy" portraits, and numerous drawings, this exhibition has become notorious in the history of modern art.[5]

On the day of its opening, a crowd gathered at the window of the tiny shop-front gallery, where one of the nudes was displayed. The numbers of people pressing their noses to the pane, and their agitated behavior, attracted attention at the police station opposite the gallery. In her confusing memoir, Weill reports being summoned by the chief of police and ordered to remove the offending painting from the window.[6] Its offense was, according to her, the visible presence of pubic and underarm hair on the painted female body. Unexposed to the regular display of frank nudity that was increasingly part of the avant-garde art scene, the police chief—like his predecessor in 1913, who demanded the removal from the Salon d'Automne, on grounds of obscenity, of Kees van Dongen's *The Spanish Shawl* (1913; Musée National d'Art Moderne, Centre Georges Pompidou, Paris), a painting of a half-dressed, frontally explicit female body—was forced to intervene in the similar breach of public morality evident in the nonconnoisseurial ogling of naked, albeit painted, flesh by excitable passersby on the Parisian streets. As ever, questions of obscenity are matters of the law, which tries to regulate the proper, mostly private, places and the reasonable, mostly public, limits of the visual representation or invocation of sexual desire and the erotic. But even in their directness, Modigliani's bronze-toned, facially stylized, highly formal nudes were nothing like the Fauvist van Dongen's knowing play with fetishism and contemporary pornography. For all the explicitness of their bodily parts and the vibrant carnality of the representation of sexually self-conscious women, Modigliani's paintings were, if anything, extremely traditional in their indebtedness to a history of both European and non-European painting and sculpture. So what, if anything, was the issue? What is a "Modigliani" when it is a nude, or what is a nude when it is a "Modigliani"?[7] The only contemporary review of the exhibition, by the critic Francis Carco, who in 1924 published a major study of the nude in modern art,[8] makes it clear that although the show may have been closed on its opening day by the police intervention, the exhibition continued throughout its run, possibly without the provocative window display.[9]

The heightening of the artist's avant-garde credentials by a scandal that pits the daring honesty of the defiant modernist against the hypocritical prudery of the bourgeoisie is a distraction. Diligent art historical research has dismissed the spurious aura of controversy around the short-lived exhibition of outrageously forthright nudes.[10] We can now investigate the emergence of the painted female body in Modigliani's practice as a strategic move or as the realization of long-fermenting artistic necessity at that date, around 1917, and in that milieu, Montparnassian Paris.

Having played dispassionate art historian rather than sensational journalist to this famous episode, I will ask questions of responsibility and meaning, not out of alliance with the outraged police chief, keeper of wartime bourgeois public morals, but from the dual space of contemporary feminist and Jewish studies. Even if fewer people today are troubled by images of female bodies in art exhibiting their secondary sexual

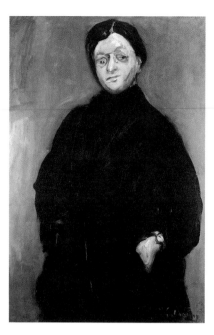

Fig. 2. Émilie Charmy (French, 1878–1974), Berthe Weill, c. 1917. Oil on canvas, 35 7/16 x 24 in. (90 x 61 cm). Private collection.

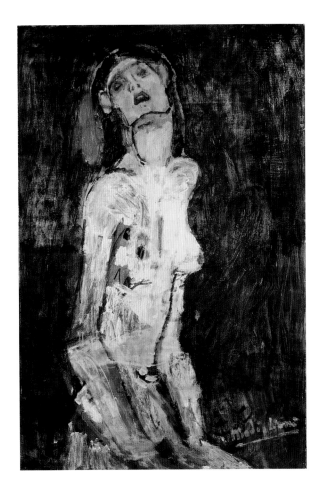

characteristics,[11] the debate about representation, sexuality, and viewing is by no
means over. To reconsider well-established feminist analyses of the gender politics of
sexuality and vision in the light of Jewish cultural analysis of modern bodies and sub-
jectivities will allow us to revisit the studios and galleries of Montparnasse in the early
twentieth century and propose less one-dimensional responses as we encounter these
works in the gallery or catalogue.

PARIS, 1908

Modigliani arrived in Paris in 1906. By 1908 he was persuaded by an early admirer,
Dr. Paul Alexandre, to exhibit at the Salon des Indépendants. Modigliani showed five
paintings, including two nudes and *The Jewess* (*La juive*; 1908; pl. 2). Her thin face,
with straight nose and almond eyes, and her long neck are painted à la Matisse in
many greens and violets, while the mood engendered seems closer to works from
Pablo Picasso's Blue Period, doleful in their depictions of the desolately poor. Another
representation of this ethnically identified model, in the manner of Henri de
Toulouse-Lautrec, but with the full, bare breasts of Édouard Manet's half-length nudes
(*Nude*, c. 1908; private collection), adds up to a chaotic jumbling of too many re-
sources not yet digested and resolved. On the back of the nude with the rakish black
hat was another image of the same model, identified by some art historians as Maud
Abrantes, who seems to embody in the heavily outlined eyes and stark contours of an
angular face the dolorous quality of Picasso's images of society's marginal figures, a
quality that here acquires a specific ethnic or cultural marking. Of a larger contempo-
rary painting of a seated nude, sometimes titled *Suffering Nude* (fig. 3), the art historian

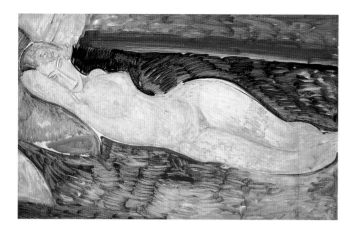

Carol Mann comments on "the mood of introspection and anguished uncertainty so typical of this period." She continues: "This painting is particularly interesting because it is [Modigliani's] first explicit sexual statement about women; the straining taut figure is sexually expressive and has nothing to do with the conventional nudes of traditional painting. The nude is shown here responding to Modigliani's desire and becoming identified with it. It was precisely this sentiment that Modigliani was to paint in this great series of nudes in 1916–1917."[12]

Built up in scratched paint strokes over a dark ground mapped by broad outlines, the angular body rises through the long neck, from which the head with opened mouth is thrown back in an emotionally charged gesture emphasized formally by a superimposed stroke of black that plots, decisively and undecoratively, the curve of the jutting chin and the tense line of the stretched neck. A danger for art history lies in its perpetual desire to instate an author whose persona the paintings reveal to us. What has been painted—here the model who, according to Mann, "identifies" with her author's desire—is then animated by the model to further lend support to the emergence of a coherent artistic subject as the anterior creator. Against this biographical impulse to install an artistic subject—the desiring man Modigliani—in order to give meaning to the paintings as the sign of his sexuality, we might read the painting's mix of the visual rhetoric of Western painting for anguish and ecstasy with the overt processes of picture making that insist on their materiality and fabrication as the sign of a modernist struggle with and against such iconographic inheritances. Nowhere will this ambivalence of modernist art's filial battle with classical, Renaissance, and Western Christian visual traditions be more intense and creative than in this genre: the body in art we call the nude that crossed the divide of a disclaimed academic tradition and an assertively new modernist project.

Accounting for some ten percent of the artist's paintings, about thirty oils by Modigliani confront the female nude, most of them done in one or two intense campaigns, notably 1916–17. Supported by a plethora of rapid diagrammatic sketches and a more limited number of studied and accomplished drawings, this "corpus" is both overfamiliar and extremely strange. Typical of modernism as a deeply ambivalent strategy, seeking at once to break all ties with the past and to claim its place as successor to an overturned tradition, this body of painting also undoes our almost too easy recognition of the artistic project we know under the author name "Modigliani" through certain stylistic features: elongated necks, masklike faces, and a warm, brown-toned Egyptian palette.[13]

Fig. 6. Giorgione da Castelfranco (Italian, c. 1477–1511), Sleeping Venus, *c. 1510. Oil on canvas, 42 ¾ x 68 ⅞ in. (108.5 x 175 cm). Gemäldegalerie Alte Meister, Staatliche Kunstsammlungen, Dresden.*

Why was the female nude so central to early-twentieth-century modernism? In what terms can we look at these paintings now, in the light of the many critiques of sexuality and the possessive, desiring, sadistic, voyeuristic gaze? In what sense can "Modigliani's" refusal of the visual violence of Picasso's painting of the prostitutionally modern nude, *Les demoiselles d'Avignon* (1907; The Museum of Modern Art, New York), be seen as a countermodernist move that remained closer to the Italian tradition Picasso tried to massacre in his painting? Has Modigliani's Jewishness anything to do with his fidelity to the portrayal of the "organically intact human form"?[14]

Dated to 1919, two related paintings of the nude appear to close the chapter of Modigliani's intense engagement with the subject begun in 1916. Repeating pose and model, the paintings each explore one pole of his work: eyes open (fig. 4); eyes closed (fig. 5); blond-haired, the tresses flowing over the pillow beneath an upraised arm; brunette, the line of the arm to the torso flowing unencumbered by such Venetian plenitude. The painting of the sleeping brunette has a more subdued surface, with lively painterly textures muted to ensure no distraction from the bold masses of the framing maroon and black coverlet that crisply set off the lighter-toned sweep of the body lying across the center of the painting and terminating in a fine rendering of retiring legs and feet. In the other painting, the features are stylized, in the manner developed in the artist's sculpted heads of 1911–14, although topped by the contemporary fringe. The laying in of the paint on both the body and the ground of maroon (below) and black (above) retains a regular pattern of brush marks that dynamize the painting in confluence with the liquid flow of the body's sweeping lines. These two works are at once the most obvious invocation of the founding form of the Western erotic nude in Giorgione's *Sleeping Venus* (fig. 6). They are its most rigorously formal translation into a modernist excision of all extraneous detail, revealing a serious knowledge of Manet's traumatic gesture *Olympia* (1863; Musée du Louvre, Paris). Modigliani's response in this pair of paintings measures the distance between his beginnings in painterly mannerisms half learned and tending to citation, and his hard-won resolution of the nude into his own signature compromise as a child of the Italian tradition confronted with its violent rewriting by the cosmopolitan Parisian modernists. Rather than fantasize about the mythical Modigliani behind or before the paintings, we must read these works as a practice, an intellectual artistic project deducible only from the evidence of what takes place in the paintings as events of art making and as elements in the dialogues that constitute its histories. There are many anecdotes about Modigliani the man and his intense involvement in the painting

Fig. 7. Amedeo Modigliani, Draped Nude, 1917. Oil on canvas, 45 ⅝ x 28 ¾ in. (116 x 73 cm). Koninklijk Museum voor Schone Kunsten, Antwerp.

process, which one fellow artist, Tsugouharu Foujita, even called "orgasmic." But Foujita then stressed the utter orderliness and delicacy of the paintings that resulted from Modigliani's harrumphing and panting.[15] It is what the works stage as effect that this essay addresses, in the context of what can be plotted of their conditions of production within the avant-garde.

Early-twentieth-century modernism was Janus-like, facing simultaneously back to the older traditions of art treasured in the museum as an open textbook for the emerging artist to use and negate, and forward, or rather laterally, into the competitive game-play of the self-declared avant-garde with its accumulating generations and emerging tendencies that themselves called out for dialogue and the tripartite gambit I have named "reference, deference and difference."[16] This model helps focus on the strategic moves of Modigliani, who had actively to invoke (reference and deference) the tradition of peers and produce a difference that marked his singular contribution to the shared artistic discourse that defined itself as avant-garde precisely through the double engagement with past and present, museum and contemporary studio. Modigliani's debt to the grand heritage of Italian art, from the late medieval sculptor Tino di Camaino to the Michelangelo of the Louvre's *Dying Slave*, is as well documented as his relationships to the populous community of artists in Paris among whom he worked between 1906 and 1920.

As a paradoxical result of this structural oscillation between the paternal tradition of the great masters and the rivalry of the sons of the new modernist fathers, the

female nude, one of the most emblematic signs of the classical, academic, and thus pre-modern art world, persisted as the recurring ground of contestation, identification, and realignment within the avant-garde. Each contestant for the leading place in the sub-cultural fraction we know as the emergent Parisian and later New York avant-garde made a play over the body of a working-class, and often non-European, woman.[17] Henri Matisse's *Blue Nude* of 1907 (The Baltimore Museum of Art) was challenged by Picasso's monumental *Les demoiselles d'Avignon*, of the same year, which also took on Manet's *Olympia* (1863), itself the object of a differencing move by Paul Gauguin in 1893 with *Manao Tupapau* (Albright-Knox Art Gallery, Buffalo).[18]

By the time, therefore, that the Jewish Italian Modigliani, deeply rooted in a pre-modern Italian art culture and trained in life classes in Florence, Venice, and Paris, turned his concentrated attention to the "body" of Art in 1916–17, this territory of painting had undergone a complex series of reconfigurations that suspended it between diverse signifieds. The painting of the female nude could signify the artist's formal experimentation (the nude body being the basic grammar of Western art). It could also index the formation of a colonial imaginary (the colored body of the Other marking a liberating difference from that inherited Western grammar and its Christian freight associating flesh with sin). Through the trope of artist and model in the studio, the painting of the naked model could stand indirectly for the self-fashioning of the artist—installing relations and hierarchies of gender and creativity. Playing with the possibilities of this form, the nude could signify art historicism: what has been, and where we are going. Finally, as the Paris police chief saw in December 1917, there can be no doubt that the painting of the female nude was a key signifier for sexuality and its problematic modernization in novel social and gender relations, and in cultural fantasy. All of these variables involve competing pressures and drives, tending toward perhaps incompatible extremes of violence and competition on the one hand, and intimacy and desire on the other; discipline and formality on the one hand, and excess and fantasy on the other. Such oscillations produced the complex position that the controversial paintings of the female nude by a heterosexual but culturally marginal man, Modigliani, occupied in this struggle over the modernist body.

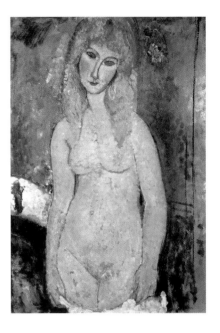

Fig. 8. Amedeo Modigliani, Standing Blonde Nude with Dropped Chemise, *1917. Oil on canvas, 36 ¼ x 25 ⅝ in. (92 x 65 cm). Private collection.*

PARIS, 1917: AGAIN

Kenneth Wayne has published his list of the thirty-two works exhibited in Berthe Weill's gallery in 1917, of which only four are titled *Nu*.[19] Osvaldo Patani's catalogue raisonné places seven nudes in the exhibition: two seated, two standing, and three reclining (see figs. 7–11 and Klein essay, fig. 16).[20]

The show featured as nudes four upright and three horizontal canvases, all roughly the same size, with what I identify as only three models. In three paintings, the models gaze directly at the spectator; in two, they have their eyes closed. On one canvas, the model has eyes of a pale blue-green that fills the entire socket, marking the site of sight and evacuating the gaze at the same time. In two cases, the models touch or cover their sex. In three, pubic hair is visible, but it is spare and unemphatic. Faces betray signs of stylization but are never masklike; they balance a humanizing self-presence with a declaration of artistic translation.

The nudes were chosen from twenty produced in an intense period of artistic activity funded by Leopold Zborowski, who gave Modigliani the use of a room in his new apartment at 3 rue Joseph Bara, found him the models, supplied the paints and

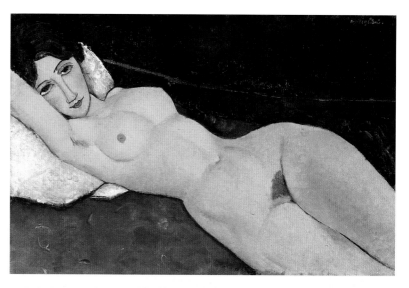

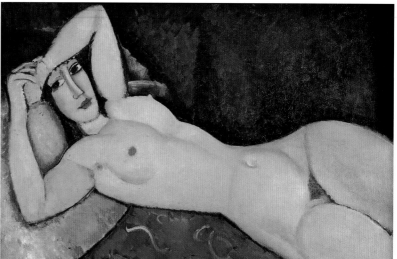

canvases, and paid him fifteen to twenty francs a day for the outcomes. The works produced are all catalogued by Patani, with two exceptions, as first owned by Zborowski. These are, therefore, commissioned paintings and must reflect the contract between the purchaser-patron and the painter, if not for personal acquisition, at least for potential commercial promotion and financial support of the indigent artist. Painting nudes entailed the expense of the model and was a different project from Modigliani's earlier preoccupation with portrait or figure painting, which involved friends, lovers, and acquaintances who sometimes paid the artist for the privilege of being painted by him—or to help their impoverished and charming associate.

We know that Modigliani insisted on being alone during his sessions painting from the model. The story is told that once, after Zborowski disturbed him, Modigliani became violently agitated, threw the model out, and threatened to destroy the canvas.[21] Such tales belong to a mythology surrounding the painters of Montparnasse, and it is hard to assess their reliability or their value. This anecdote functions to suggest an intensity of engagement in a task that, like sex itself, required privacy. Yet the result is not sex. The paintings offer a distanced engagement of the painter by eye and hand, by the movements and gestures of his body, with an unknown, unfamiliar, and im(de)personalized other, presenting herself in her most personalized and vulnerable undress for a professional purpose that perpetuates this initial moment of exposure before the

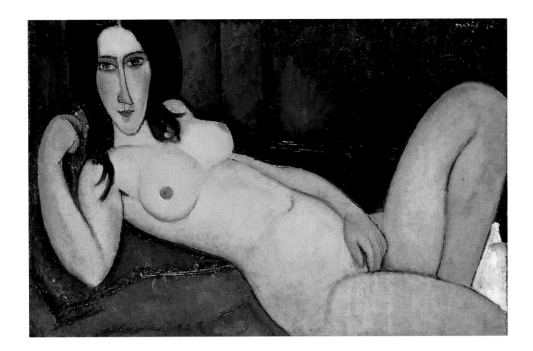

Fig. 11. Amedeo Modigliani, Reclining Nude with Loose Hair, 1917. Oil on canvas, 23 ⅝ x 36 ¼ in. (60 x 92.2 cm). Osaka City Museum of Modern Art, Japan (125).

artist in a public "publishing" of her body as his work of art, signed by a name that is the product of this working process.

What does this information about the conditions of making mean? A man pays his friend to paint and procures for him the working women willing to undress and be painted naked in Paris during World War I. He exchanges his money for means and materials for the paintings. Whose desire do the works embody? Why did Leopold Zborowski want twenty paintings of naked ladies? Did he realize that Modigliani wanted to paint the female nude but did not have the means? Did he want to help his friend, steady him to regular, salable work? Did he think the paintings' commercial potential might secure his artist friend an income, a career, more commissions?

We simply do not know. There are stories and memoirs, each set told by someone with a personal version of the common history, an individual take on the remembered situation, individual forgetfulness and interested recall. Much of this chitchat passes for art historical evidence, but it merely plays into the mythologizing of the enclave of wild men and easy women that is one popular picture of early-twentieth-century Paris. The book *Kiki's Paris: Artists and Lovers 1900–1930* is typical in supplementing the formal narratives of art history with gossip and copious photographs.[22] It does, though, reveal something significant. Montparnasse was a community in a fluid moment of social transition. Artists from many countries and cultures used parts of the French capital as a social experiment in sexual mores, modes of sociability, and access to an informal process of artistic practice based on friends and lovers. Among the many couples formed by this flux, women and men alike were aspiring artists. Drawn to the city by economic necessity, artists of both sexes mingled, painted one another, socialized, and, if so inclined, often married. In the Montparnassian avant-garde, love, sex, and art led to a series of artist couples for whom paintings of the female by the male (or female) partner were open declarations of a "modern" embodiment and visual acknowledgment of female sexuality.[23]

We can easily deconstruct the mythic view of the "wild men" and their nameless sexually available models, as we are dealing with a more sociologically interesting phenomenon of artistic partnerships and the kind of social/sexual/artistic exchanges

that become the topic of their paintings. In this context, Modigliani's attention to the formally hired unknown model for the production of a series of paintings of the female nude without any reference to his personal social or sexual world is untypical of his milieu. Between 1908, and his nudes of models picked from among Dr. Paul Alexandre's down-and-out patients, and 1916, he had painted or drawn a few nudes of women he knew, loved, or desired. His lover, the Russian poet Anna Akhmatova (1889–1966), tells us in her memoirs that Modigliani did sixteen nude drawings of her, but not from life. He did them at home and gave them to her as a gift.[24] His South African–born companion Beatrice Hastings appears in a small pencil sketch of 1915 (private collection).[25] The atypical and somewhat formal conditions of their making must inform the nudes of 1916–17 and shape their reception.

NEW YORK, 2004: WHAT ARE WE LOOKING AT?

Nudes are what artists paint. But what is a nude? A study of anatomy? A statement of aesthetic principle? A declaration of heterosexual masculine desire? What is the female naked body when painted by a woman artist? Many of Modigliani's contemporaries were women artists for whom the female body, which was their own, was a significant and necessary topic. Women artists such as Paula Modersohn-Becker and writers such as Virginia Woolf insisted on asking: How can a woman be an embodied artist without some deep affirmation of that meeting of corporeality, desire, fantasy, and art? Suzanne Valadon explored the female body repeatedly in her painting, enabled by her close readings of the works of Edgar Degas, Paul Gauguin, and Paul Cézanne. Her *Future Unveiled*, or *The Fortune Teller*, of 1912 (fig. 12), is a monumental painting of a reclining female nude without any classical erasure of body hair. Strangely attired for a reading of the cards, this body is a persona, engaged in an elaborate relation to the fortune-teller, and her nudity seems part of the constructed narrative of self and futurity. If we set aside most of the narratives with which we are burdened before we arrive at the paintings, we have to ask as an open question: What was Modigliani trying to do in the series of paintings of the female model that he did in 1916–17 at 3 rue Joseph Bara?

Exhibited at Berthe Weill's in 1917, *Seated Nude* is a three-quarter-length, frontal view of a model with loosened hair, seemingly asleep; her head rests on one slightly

Fig. 12. Suzanne Valadon (French, 1865–1938), Future Unveiled, *or* The Fortune Teller, *1912. Oil on canvas, 51 3/16 x 64 1/8 in. (130 x 163 cm). Petit Palais, Musée d'Art Moderne, Geneva.*

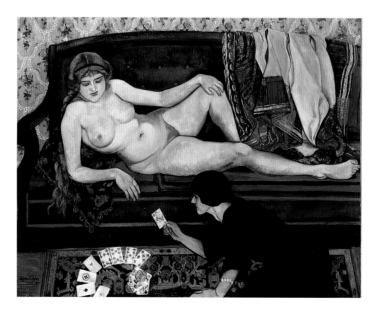

uplifted shoulder, and her eyes are closed (see Klein essay, fig. 16). The model cannot be asleep and still sitting upright, and this immediate contradiction charges the painted figure with an inconsistency and reminds us of the nonrepresentational fact of its being a painted model. Sliding from upper right to lower left, the three-quarter view of this frontally positioned body, sliced through at the thighs, is at once very close to the viewer/painter, slipping toward "him," and yet entirely withdrawn through the resting head that leads attention down the long line of the unbent arm on which it rests, to end in a Picassoesque paw at the lower right edge of the canvas. The body divides the canvas into two zones. The right side is a deep mixture of browns and reds into which the flowing hair of the brunette model easily dissolves in a manner reminiscent of Manet's *Olympia*. In complete contrast, the left side of the canvas is painted a cool, pale sea-green blue that haloes around the top of the model's tilted head. The upper body is lighter in tone, in keeping with this higher color key, while the lower darkens and tones in with the deeper hues of the red-brown chair against which "she" leans. The colors of the ground are used within the face, itself darker-toned than the upper body.

The dislocation between the upright body that confronts us at close range and in physical detail and the much more stylized drooping head and sleeping features is only the beginning of a process of destabilization and defamiliarization. It promises us access to the formal and painterly logic at work that the very banality, the taken-for-grantedness, of the nude as the object for artistic self-definition and self-discovery alone can expose.

Contrast *Seated Nude* with a larger, horizontal painting of a recumbent female figure cut off at the knees, *Reclining Nude (Le grand nu)* (fig. 13). Neither a whole body typical of the tradition epitomized by Giorgione's *Sleeping Venus* nor a candidly modernist torso that might be found in the sculpture of Auguste Rodin, the painting shows a woman whose eyes are closed. She, too, seems to sleep. Her full breasts blossom on a torso that is, however, stretched almost painfully across the black cloth on the couch where she lies, the black a disturbing void that her elongated torso bridges before yielding to the rising curve of her severely twisted hips. These present, at the opposite end of the canvas to the face, arms, and breasts, the pubic triangle created by a tuft of hair at the converging lines of her thighs, whose crossing marks the closed promise of the invisible sex. This body is ostensibly at rest, yet the tension of the torso and the twist of the hips on a body deprived of the remainder of its legs are, again, inconsistent, creating extreme alternations of tension/relaxation, lying/turning, profile/facing.

The nude becomes strange: left side and right side of the canvas redraft the body as a whole composed of two different, possibly incompatible zones of radical otherness linked by the stretch of the torso. The zones are not just the breasts versus the pubis (the painting does not actually show a genital dimension). The breasts belong structurally to the formal arrangement of the sleeping head and thrown-back arms. The face is only in profile and is closed in on itself through the appearance of sleep. Yet the nonface but "private" part of the body faces the viewer in a movement made almost anatomically unbearable to contemplate by the formalization of the almost profiled belly and the twisted frontality of the hips and thighs.

The possible referents for this refusal of liquid undulations of the organically whole classical Venetian female nude are Gauguin, with his turn to Buddhist and Javanese aesthetic sources, and Degas, with his modernizing of the anguished Grünewaldian body. Gauguin's *Nevermore* (1897; Courtauld Institute of Art, London)

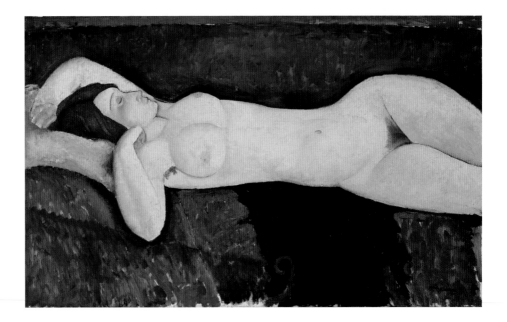

also places the body on its side so that the extreme rise of the hips is exaggerated at the visual heart of the painting, thus reinstating as its focal point the sexual center of the reclining figure. Degas depicted his dancers and models in ways that likewise refused the fluid grace of the Renaissance nude, stretching their athletic bodies into painful poses whose purpose was to disrupt the equation of the female body with an easy beauty without allowing affects such as pathos or suffering to emerge (or emerge too obviously). The most extreme use of the contorted body is perhaps the German Expressionist Ernst Ludwig Kirchner's *Under a Japanese Umbrella* (c. 1909; Kunstsammlung Nordrhein-Westfalen, Düsseldorf), where the body twists back on itself. Modigliani's *Reclining Nude* seems to invoke, if only to refute, the freight of these possible mentors. Contrast it with another reclining nude (fig. 14), which may be painted from the same model. This painting is dynamic exactly where the *Reclining Nude* has been stilled. The energy of the body twisted on its central axis is intensified by the thrown-back head with its Cycladic flatness, the swell under the stomach, and the clench of the fisted hand. Various modes of shading generate a sense of volume at odds with the underlying search for a purity of line and design in the painted body that is evident also in the *Reclining Nude*.

There is another, more perplexing reference for the *Reclining Nude* of 1919: one of the grand nudes of the Salon painter Alexandre Cabanel, *The Birth of Venus* (1863; fig. 15). Under the rubric of an Alexandrian classicism, Cabanel created a female body rising sensuously on the surface of impenetrably hard ocean waves in a semiconsciousness that close inspection renders, to our eyes, disturbingly aware of its alluring exposure. Alongside the Cabanel, the Modigliani is revealed in its radical economy, without the semipornographic distractions of putti, ocean foam, sea, and sky, to repeat this body posture, reversed in reference to Manet's *Olympia* and with a formalizing geometry that speaks of the relation of art to sexuality in quite another manner. Equally, Modigliani dispenses with Gauguin's Polynesian alibis and decorative framing and Degas's Baudelairean attempt to find a modern situation for the naked female body washing itself in a possibly closed brothel.

Dense with a jostling crowd of avant-garde specters and Renaissance forebears, Modigliani's paintings could be read as intense exercises in excision, precision, and

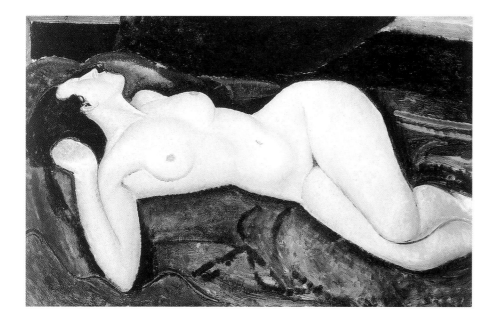

Fig. 14. Amedeo Modigliani,
Reclining Nude, 1917. Oil on
canvas, 25 ⅝ x 39 ⅜ in. (65 x
100 cm). Private collection.

Fig. 15. Alexandre Cabanel
(French, 1823–1889), The Birth
of Venus, 1863. Oil on canvas,
51 ³⁄₁₆ x 88 ½ in. (130 x
225 cm). Musée d'Orsay, Paris.

formality. While that is an important level in the works, this sign is too overdeter-
mined and laden, as is Modigliani's reported declaration about painting as possessing
the female body, with the subjectivity of the moment of its making, a man in a studio
with a naked woman, for us to accept the hypocrisy that pervades a literature that
talks only about inner form, aesthetic perfection, poetry, and purity. How do we bal-
ance the pictorial evidence of a rigorously formal attention to an inherited trope with
the carnality of the resulting report from the artistic laboratory?

Writing of the 1860s struggle between the crisis of traditional representations
of the female nude and the attempt to produce a modern discourse on sexuality in
art, which was marked by Manet's balked and traumatizing *Olympia*, T. J. Clark has
observed how the nude allowed painting to present sex and its bodies.[26] The nude
could say: This is the female body, this is the heterosexual masculine culture's sign
of sex. This is how we reveal and veil in one and the same moment. Yet sex and its
body signs were managed within a frame of conventions and traditions, so that the
once significant relation of the erotic female nude to the power of vision, temptation,
or concupiscence—as in Titian's founding works of the genre, for instance—was

etiolated by seemingly pornographic Salon displays of the mid-1860s such as Cabanel's. The problem from Manet and Charles Baudelaire onward was to modernize the encounter with the bodies of sex in such a way as to reformulate this inevitable domain of painting. Both the manner of painting the female body and the arrangement of the image for its spectator would become critical means of escape, not from the fundamental relation of masculine heterosexuality to the visual image, but from the tiredness of its formulaic repetition. The line between pornography and sexuality would have to be seriously redrawn in a way that would trouble the Paris police chief: with more frankness rather than less.

Clearly the classical nude was displaced, but as sexual sign the nude could not disappear without a cultural revolution more profound than artistic modernism. Carol Duncan has convincingly argued that the nude was in fact remade as the central symbolic motif for the early-twentieth-century artistic vanguard, along with the studio in which the naked model posed for each artist's manifesto painting.[27] The nude acquired an additional signification: as the model whose representation would now signify the modernist artist's indirect *self*-representation. In the work of the German Expressionists particularly, and in the much more artistically and personally measured series of paintings by Matisse after 1900, the artist with the model in his studio was the means by which the nature of the modernist project in all its social, cultural, personal, and even political complexity could be articulated. There, in the social spaces of artistic production represented in the paintings and in the symbolic spaces of the pictorial representation, the body of the female model became one of the signs of modern art.[28]

Of what was she a sign? Of the male artist's identity as creator in contrast to her passive materiality? Of *his* sexuality or *her* animality? Of an equation between artistic license and sexual freedom as a metaphor for its opposite—the regimentation and regulation of bourgeois masculinity and domestic life? All this, Duncan says. And more. The fact that the model herself played before his eyes and paintbrush her status as model, not local Lorette dressed up as Venus being born on the waves of Cyprus, was crucial. This was how the new endeavor of modernization could be signified as a deep engagement with the actual; the real of life or the real of art making, it did not matter which. Both coalesced at a refutation of fancy, folly, and the literary. The frank undressedness of the model in a recognizable singularity was a signifier for a disrobing of art by means of its most sacralized and, by the 1860s, banalizing convention for its aesthetic otherness. Classicism was undone by apparent realism—while artistically, the formal questions raised by a human body (organic whole or its opposite, fragmented dislocation), one that was the site and sight of desire, allowed a smuggling back of what had always informed classical engagements with the body to produce the form we know as the modernist nude.

The nude offered the sexual body to the visual arts in a managed form.[29] The modernist rupture would have to take place through this body form. Thus it would sexualize it, in realist mode as the prostitutional body (Manet to Picasso). But there was another modernist trend: the private body in the studio, where the model presented herself for the modernist artist's reworking. Such prosaic contractual terms were the conditions for a formal experimentation that was imaginatively resourced by an artistic tourism of the most colonially eclectic kind.

By 1907, to find the modernist body through the studio meant frequenting not the brothels and the coulisses of the ballet, as had the first generation of new painters,

Manet and the Impressionists, but the colonial exhibitions and the ethnographic and grand-survey museums of the metropolis. Hindu and Buddhist sacred art, Japanese prints, and the booty despoiled from colonial rapine of the African continent would mingle with the other bodies on offer in the Etruscan and Egyptian halls of the Louvre. Anna Akhmatova, who was involved with Modigliani during his first years in Paris, recorded his passion for the museum's Egyptian rooms, to which he took her repeatedly.[30] The coloration of his painted nudes confirms a perpetual debt to a non-Greco-Christian aesthetic.

Between his arrival in Paris in the critical moment of 1906 and the campaign of painting the nude in 1916–17, Modigliani had been a sculptor. Working with Constantin Brancusi, he refined his direct stone-carving to produce a series of highly stylized heads that synthesized a profound study of the aesthetics of the African masks to be seen in Paris studios, shops, and museums, and of the Mediterranean Cycladic culture just emerging into Western knowledge and collecting. In drawings that demonstrate his visual experimentations with signs derived from sculpted art forms of many cultures, Modigliani played with the varied proportional systems of Egyptian, African, and Cycladic sculpture, tracing their economy in the drawn line that could, with practice, allow his hand to create what he was after with the absolute justness of the most reduced but perfected of graphic means.

In *Nude Woman with Cat* (1909–10; private collection), the derivation from Egyptian fresco painting evident in the elongated body and the profile head shows the artist searching for a compositional simplicity and sureness of line that can define the intersections of the body's core elements: torso, head, arms, legs. The relation between the features deployed from masks and sculptures of non-European societies and the stylized linearity of the body is logical but points to something almost impossible for the European artist to relinquish from his own tradition: a bodily eroticism to which the nude as the sign of carnality drags back, while the non-European is working not with "the nude," but with a symbolic-aesthetic stylization of the human body, whose gender may be invested with semiotic values other than eroticism. Thus the masking comes—as in Picasso's most dramatic attempt to confront the conflicting intersection of his tradition and his modernity, *Les demoiselles d'Avignon*—to risk introducing a violence that exists neither in the source of non-European art nor in the Venetian model of the erotic nude.

The body of otherness to which the avant-garde artists strained through their artistic tourism was rooted in all the complex and terrible structures of European ethnocentrism and Europe's desperate search to renew its own aesthetic possibilities by joining the non-Christian art worlds that had always found relations between the symbolic and the aesthetic untroubled by the realist drives of Christian incarnation theology. The moment Modigliani arrived in Paris from his formal studies in the art academies of Florence and Venice was a crucial and disturbing one in European culture. How to escape the burden of both academic and early modernist bodies and create a new syntax in which carnality and its many possible meanings could be opened to painters and sculptors with the formal inventiveness that beckoned from the cultures of Asia, India, and Africa, while forging renewed links to Europe's own Greco-Italian tradition?

In 1913–14, Modigliani explored a particular mode of female nude: the caryatid, whose sources can be connected with both the Greeks and the Africans (notably the

sculptural heads of the Luba-Lembe of the Congo). He drew and painted in wash and watercolor a considerable number of solutions to the problem of a kneeling or seated figure that must logically find itself within a columnar form. His explorations indicate a search for a way to defy the linear uprightness of the column with twisting, volumetric, dynamic bodily form in which the organic integrity of the figure is constantly disturbed by the fascination with the phallic volumes of its two major zones: head, arms, and breasts versus pelvis, hips, and legs. The female anatomy is denaturalized in radical but logical ways, with the torso becoming the necessary holding point for the volumes of thighs and bent knees at one extreme, and breasts, bent arms, and head at the other. Perhaps in this visualization we can see the structure that will be reworked by a less self-advertising foreignness in the *Reclining Nude*. To find what he was seeking, the artist had to draw and draw again to see the lines needed to refigure this other body. In some of the caryatid studies, color has to come to the rescue, creating what are the voids in the drawing as active shapers of the washed and barely incised configuration of kneeling, twisting, sleeping upright figures. Here Modigliani's project echoes that of Matisse, where the distillation of movement, volume, and form into the sureness of a single line negotiates the tightrope between the decorative and the minimal.

The long apprenticeship Modigliani served to the avant-garde through his patient repetitions and persistent search for a line his hands and mind could internalize and confidently repeat reveals that he was not working from the model, from life, from women's bodies. He was working conceptually, from the museum of long and culturally diverse histories of art.

Modigliani returned to painting, and the record of his work from 1913 on demonstrates another series of experiments with the very processes of the medium— deeply Cézannean in his desire to construct paintings with color, built up in a dense weave of marks and strokes, dabs and deposits. The period 1913–16 reconnects the economy and stylization of the drawing and sculptural period with the features and personalities of the artist's emotional and social network. Facing his friends, lovers, patrons, and fellow artists, Modigliani's paintings puzzle over human specificity and artistic style, the particularity of the sitter in his or her otherness, and the style of the painter in his singularity and his need to mark this world with his vision of it.

Out of these constructed paintings breaks an especially important one for this analysis: the 1915 *Chaim Soutine* (see Berger essay, fig. 10). Vibrant in color, built up with a dense tissue of brush marks, some of which have worked hard to resolve the transitions (what Cézanne called *passage*), others needing to be fixed by a bounding or defining line, this portrait seems exuberant in its assertion of a singular human presence in living flesh. The tiny touches of white in the otherwise blankly colored eyes endow Soutine with character and personality. His rough features and flop of thick, dark hair sit atop an elongated neck in a manner at odds with almost all of Modigliani's paintings of this year and the next.

This painting of a fellow Jewish artist offers one route into the dissidence of the corpus of female nudes that Modigliani undertook in 1916–17. Somehow, the purity of the sculptural carving of stone, the assimilation of other cultures' aesthetic orders into a few confident lines, and the ever more accomplished combination of his own linear signature style with the colorist constructivism of Cézanne, mediated by a profound awareness of the art of so many of his contemporaries, give way to paintings of a vividly glowing carnal intensity of direct engagement with the bodily enfleshment

Fig. 16. Amedeo Modigliani, Almaisa: The Algerian Woman, *1917. Oil on canvas, 21 ⅝ x 13 in. (55 x 33 cm). Museum Ludwig, Cologne.*

of a female model. There is perhaps another link between the Soutine portrait and the 1916–17 nudes. Is the portrait of Soutine a knowing image of a Jewish artist? That is to say, is there any attempt to mark the portrait beyond its singular "Soutine-ness" with an ethnic, religious, or cultural referent, to catch specificity rather than difference?

To begin to answer such a question, we can look at a nude of 1916. Modigliani did two portraits of a named subject, both referred to as *Almaisa* (fig. 16). Richly painted surfaces in a range of ochers, browns, and warm body colors, these portraits adapt Modigliani's signature of swooping nose and almond eyes to the specific ethnicity of the sitter's curling hair and strong gaze. This named sitter appears in the 1916 painting (fig. 17), naked except for her serpentine bracelet, her necklace, and a cigarette, which she holds also in one of the two clothed portraits. A drawing exists for the nude painting, showing the model asleep with closed eyes.[31] In the painting, she is awake and alert, her deep brown eyes gazing at the painter/spectator, the cigarette near her face. Her petite body, barely reaching the halfway point of the sofa on which she reclines, creases at the waist as her hips rise in a single line that follows down her right leg, which falls forward over her left. The painter has used another single brush line to follow the inner line of the right leg from the groin to the edge of the canvas. There are no feet. Her breasts have been drawn in with two black lines: the first coming down from her outstretched arm, and the second beginning in the middle of her chest and ending at her elbow. This armature of line is visible in the drawing, which is hardly a sketch or study. Rather, it sets in motion the flows that define the dynamics of the body, which the painting will enflesh through carefully built-up textures of warm-toned paint through which the fluid, decorative line that defines the body will be allowed to peek. As challenging as Manet's *Olympia* in the attentive stare of the painted figure atop a body so amply present in its own nakedness, the painting stages the sitter's cultural specificity and both her difference from and similarity to the Jewish Italian painter, also an ethnic outsider in Paris.

The three reclining nudes shown at Berthe Weill's gallery in Paris in 1917 (see figs. 9–11) retain this structure of a head, its open-eyed gaze directed to the viewer, atop a body located close to the edge of the canvas, frontal, undraped. It is difficult to deny the evident invitation resulting from all these painterly decisions; the upraised

arms that lift and shape the breasts will become, already had become, a standard pornographic pose borrowed from Francisco Goya's infamous duet of clothed and naked Maja. Modigliani's languid, self-possessed, and invitational nudes, with that oblique reference to the ethnically marked body and features of his Algerian sitter Almaisa, were shown beside two equally ethnically marked bodies posed in direct reference to the classical Venus Pudica (see figs. 9–10).[32] One painting shows a blond and pale-skinned model with the classically crossed arms that shield and index pudenda and breasts. Beside her, in a painterly sea of Venusian green, the same model is forced to stand with her chemise slipping around her hips. The melancholy and the innocence of these exposed bodies contrast starkly with the carnal self-knowledge created for the darker-skinned and brunette bodies. Is there a discourse being enacted here? Does the artistic tourism that took the artist beyond the classical rooms of the Louvre and the prototypes of the academic life class yield a hybrid artistic formula for generating a modernist body that intersects with something we can term "biographical," but not anecdotally so, about who is painting?

To call Modigliani a Jewish artist *before* his paintings come into being is to impose a fixed and homogeneous notion of cultural identity—whose contents we cannot know or even imagine—onto a man because he was born into a certain family and faith community. We could ask how the lived experience of Jewish presence/difference in Paris, which had erupted in public anti-Semitism during the Dreyfus affair, just concluded in 1906 (when the falsely accused Dreyfus was finally released) as Modigliani arrived, might trace itself within an artistic project so hungry for and receptive to the manifold resources on offer in Montparnasse in the first two decades of the twentieth century. But to do so is to set out on an open-minded investigation into the art practice as it was created year by year. Modigliani avowed his Jewishness to others and showed solidarity with other artists of his faith/cultural community who shared with him the historic adventure of being the first generation to participate fully, without the obligation of conversion to Christianity, in European modernist culture as artists who were Jewish in myriad ways and from diverse historical communities—Minsk, Kraków, Jerusalem, Sofia, and Livorno.[33]

There is a touching portrait drawn of and given to the Ukrainian-born Jewish sculptor Chana Orloff (1888–1968), who met Modigliani in Paris. Modigliani inscribed the drawing with her name in Roman letters, Chana, and in Hebrew, Chana Bat Raphael, a pun on a name that links both with Jewish tradition—Raphael was one of the angels—and with the epitome of European painting, Raphael. Orloff arrived in Paris via the Ukraine and Palestine in 1910. Her serious engagement with Modigliani's work writes his legacy into her sculpture, where his refinement of the body's lines and the purification of its painterly volumes to produce a strictly formal grammar that is nonetheless human in its expressivity brings into view unexpected transactions among artists across gender divisions and cultural identifications (fig. 18). It also underscores the different valence of the body as a modernist sign when claimed by women as their own body, rather than as the landscape of masculine heterosexual fantasy. Because of modernism's struggle with the flesh of desire, in the search for their singular versions of modern sexual identities, women artists practiced an inclusive form of reference, deference, and difference. It is art historically and culturally significant that Modigliani's most intelligent reader and consistent pupil was a fellow Jewish artist, and a woman.

Fig. 18. Chana Orloff (Ukrainian, 1888–1968), Torso, 1912. Cement and stone, 48 ½ x 13 ⅜ in. (123 x 34 cm). Private collection.

In a recent book, Kenneth Wayne has made an intriguing statement that links Modigliani's distinctive negotiation of modernist possibilities with his self-conscious Jewishness: "What kept Modigliani from being a full-fledged Cubist was most likely his interest in Old Master painting, specifically Italian Renaissance portraiture, and his interest in being a Jewish artist."[34] What was it that brought Modigliani back from the trajectory leading from *Suffering Nude* to the experimental caryatids, which, in their reformulation of the human body in modern painting and sculpture, take their place alongside Matisse, Picasso, Jacob Epstein, and Brancusi in terms of formal innovation? Why did he not go through Cubism, as his obvious enthrallment with Cézanne and regular contact with Picasso might have suggested? Why, as a Sephardic Jew and an Italian, did he produce these carnal, brown-skinned bodies with ethnically suggestive faces against rich Venetian velvets, rather than that which flash for a moment in 1916–17 before being banished in his return to placid Giorgionesque tenderness in 1919 (see figs. 4–5)?[35]

The feminist critique of the unequal power relations of gender in this Parisian avant-garde, as advanced in Carol Duncan's 1973 analysis of "virility and male domination in early-twentieth-century vanguard art," remains relevant.[36] The gender, class, and race politics of the artistic violation of the humanity of female models that was the lingua franca of many modernist studios is a serious issue in any discussion of early modernism and the female body. Nor indeed can anyone foreclose the postcolonial critique of European appropriation of the aesthetics of many great cultures under the distorting representation of their aesthetic-symbolic practices as "primitive." But what do these feminist and postcolonial readings of the heroic saga of Western modernism make us see? They breach the self-serving censorship of sex, power, violence, and art in texts that run on about the "poetic truthfulness" and "spiritual purity" of Modigliani's formal exercises.[37] They make us think about why modernism needed the sexual body of the othered woman as its central trope of self-transformation and cultural difference. We may now move beyond, but only when we have accepted the justness of these critiques. We can then read modernist artistic practices, such as Modigliani's, within that frame of historical reference to ask what is actually happening in these works: What do they do in these conditions when we add to feminist critiques the insights of Jewish cultural studies?

I started with relatively formal descriptions of paintings, a necessary exercise in making us see the work of painting rather than merely recognize iconographies. Establishing the sexual body as a recurring and central site of anguished and intense modernist self-fashioning by men and women artists—Catholic, Jewish, Shinto, atheist—which is as much about the historical painter who is becoming himself or herself in making such a work as it is about what is presented now to us—the belated, out-of-time viewers—allows us to set aside the anecdotal and mythic narratives about the artist's persona that may prejudge the encounter with the corpus called "Modigliani" and prejudice us before his sometimes stereotyped work. "Modigliani" can then become the name for a particular practice in artistic thinking about carnality, attentiveness, and the modernist struggle for the bodies of art—gendered, undoubtedly, but also in complex plays of personal desire and artistic fascination. I am also suggesting, however, by using the loaded term "carnality," that this practice was inflected by the self-consciousness of being Jewish at that time and place, as part of the unscripted modernity of Paris in the early twentieth century.[38]

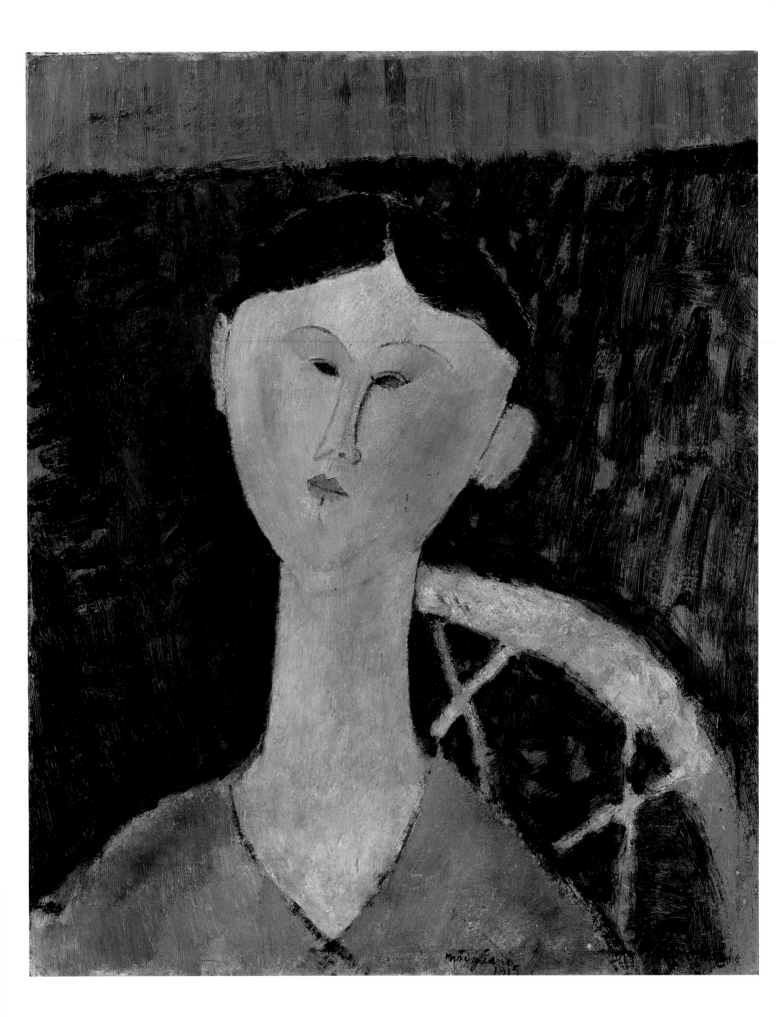

Epilogue: The Modigliani Myth

Maurice Berger

> *A life marked by poverty, worry . . . by thirst for punishment and a willingness to become a target for the supposedly astute. Life of an artist, life of exultations! I shall not recount the picturesque and bohemianism of it, or the paradoxical and constant defiance of rule, or the absence of all traces of domesticity. But for all that, for all the defects and qualities, the taste for unhappiness and the exceptional, the torrent of graces, the deliriousness and the naughtiness, Modigliani leaves a void behind him that cannot soon be filled.*
> —Francis Carco, obituary for Amedeo Modigliani (1920)

> *The legend of the debauched artist is just a legend. What legend gives us is an implausible caricature of a man, a painter who left behind only a body of legends. Amedeo Modigliani left behind a life's work in art.*
> —Jacob Epstein, quoted in Pierre Sichel, *Modigliani: A Biography* (1967)

In the summer of 1909, the painter Amedeo Modigliani (fig. 2) left Paris, his adopted home, for a vacation in his native Livorno, on the western coast of Italy. Modigliani was struggling through one of the most difficult periods in his short life. Undernourished, alcoholic, and weakened from tuberculosis, he craved the comfort of family and the easier, more relaxed life of his hometown. He also wanted to use his time away to explore the possibilities of another medium, sculpture. In Paris, he had grown friendly with the sculptor Constantin Brancusi, and the relationship inspired Modigliani to work in three dimensions. Livorno offered him the hope of restored health and a stronger body to meet the challenges of the physically demanding process of carving stone.

Modigliani spent much of that summer sculpting in a small rented studio. Yet none of the pieces he carved in Livorno is known to have survived. A legendary story, repeated for decades by art historians and biographers, explains their disappearance: The artist, the story goes, mustered the courage to show the sculptures to a group of friends. They were not impressed. They criticized the works harshly, and jokingly dared Modigliani to toss them into the Fosso Reale canal. Angry and defeated, the artist obliged. He loaded the sculptures into a wheelbarrow and dumped them into the canal.

Seventy-five years later, Vera Durbé, curator of Livorno's Museo Progressivo d'Arte Contemporanea, persuaded the Livorno city council to allocate the equivalent of $200,000 to dredge the canal in search of the missing works—a gesture in honor of the hundredth anniversary of the artist's birth. The dredging eventually paid off: three marble elongated abstract heads, their thin features and slit eyes consistent with Modigliani's mature style, were pulled from the water (fig. 3). Art historians and

Fig. 1. Amedeo Modigliani, Portrait of Mrs. Hastings, 1915. Oil on paperboard, 21 ⅞ x 17 ⅞ in. (55.5 x 45.4 cm). Art Gallery of Ontario, Toronto, Gift of Sam and Ayala Zacks, 1970 (71/260).

Fig. 2. Amedeo Modigliani,
c. 1918.

curators were quick to authenticate the pieces. Durbé, viewing their discovery as a personal vindication, wept upon seeing the heads for the first time: "They are so beautiful. I'm sure they are Modì's," she said through her tears. Other art historians were similarly impressed, describing the works as "treasures," "magical faces," "splendid primitive heads," no less than a "resurrection" of Modigliani's genius.

The celebration was short-lived. As the newsweekly *Panorama* reported in September 1984, the heads were recently created forgeries, the work of four men—a medical student, a business student, an aspiring engineer, and a dockworker. The four claimed that, motivated by the media frenzy over the proposed dredging of the Fosso Reale, they had carved the heads with hammers, chisels, a screwdriver, and a Black & Decker electric drill, fashioning them after images of the artist's paintings and few surviving sculptures, and then sunk them in the canal. Some of the art professionals who had earlier verified the sculptures' authenticity demanded that the pranksters give proof that they were indeed the creators of such extraordinary work. Several weeks later, on a television program broadcast live throughout Italy, three of the four self-confessed forgers accurately reconstructed the sculptures in less than three hours. Curator Durbé, watching the event at home, collapsed and was rushed to the hospital. *L'affaire Modì*, as it was dubbed by the European press, became the subject of jokes and parodies—including Italian breads shaped like the infamous heads, and an ad campaign for Black & Decker power tools by the J. Walter Thompson agency that slyly juxtaposed a drawing of an abstract head with the words "It's easy to be talented with Black & Decker."[1]

These parodies were built on a story so widely reported in the media that people relatively unfamiliar with modern art could understand them. But the joke was less on Modigliani and his enterprising forgers than on the discipline that fueled the hoax in the first place: art history. The Fosso Reale incident, while feeding the media's insatiable appetite for scandal and folly, was to a great extent created by art historians. Many of the details of Modigliani's journey to Livorno, based as they were on sketchy eyewitness accounts and conjecture, have never been documented. Yet it was precisely the unproven myth of a troubled, self-destructive artist shamed into destroying his work that motivated and justified the efforts of a respectable curator to raise substantial public funds to dredge the Fosso Reale.

In the end, *l'affaire Modì* can be seen as a cautionary tale, a revelatory, if absurd, story about art history's limitations and failings. Since Modigliani's death in 1920, discussions of his work have been motivated by similar clichés and half-truths about artistic practice and temperament. These histrionic, fundamentally anti-intellectual approaches to the study of the artist and his work, fixated as they are on the biographical triumvirate of debauchery, illness, and tragedy, have helped turn Modigliani into a trivial art historical figure, an artist adored by the public but viewed with condescension by many scholars and curators.

Modigliani is far from an insignificant figure in the history of modern art. He was a deeply intelligent and social being, an iconoclast who pushed himself to challenge the status quo: "Always speak out and keep forging ahead," he wrote. "The man who cannot find new ambitions and even a new person within himself, who is always destined to wrestle with what has remained rotten and decadent in his own personality, is not a man."[2] He was born into a liberal, cosmopolitan home, where French, English, and Italian were spoken with equal fluency and where philosophy, politics,

and sex were freely discussed and debated. He was a risk-taker who left the relative provincialism of Livorno to experience the more intellectually demanding environment of Paris, a place "where life was not taken lightly."[3] He was a "scholarly artist" who studied art, literature, and philosophy—from the paintings of Renaissance masters to the heretical writings of the philosopher and biblical scholar Baruch Spinoza, a distant relative.[4] He was a proud Sephardic Jew who passionately confronted anti-Semitism.[5] He was a critical thinker who entered into a sustained, often brilliant visual dialogue with the work of his most progressive contemporaries, including Pablo Picasso, Chaim Soutine, Henri Matisse, and Brancusi. He was a man who acknowledged and celebrated his own multiple identities, embracing many aesthetic influences—among them African, Cycladic, Greek, Egyptian, early Christian, Cambodian, and Italian Renaissance art—not just for formal ideas but for conceptual and spiritual inspiration as well.[6]

In both art history and the popular culture, though, Modigliani has come to exemplify a decidedly unengaged and isolated modernist character type: the bohemian. The bohemian is the ultimate cultural rebel. He views the institutions of bourgeois society—popular culture, science, business, technology—as impediments to freedom, powers of invincible force that subordinate everyone to the laws of the market. He is a prophet, a wanderer, a "grave-faced angel," as the art historian Marc Restellini has called Modigliani, who struggles to rise above the mundane, repressive lifestyle of the bourgeoisie.[7] He refuses to engage in the routine, repetitive tasks of the laborer or serve the greedy bosses of industry and commerce. Even politics and current events are unworthy of his attention. Instead, he looks to pleasure, passion, and self-expression, through sex, drugs, alcohol, and art itself, to help him find a way out of the tyranny of everyday life, to illuminate a path toward "timeless metaphysical truths."[8] In the end, the bohemian is not a happy figure but a person who suffers for art and pays a steep price for a life of debauchery, poverty, and neglect.

This stereotype has haunted Modigliani, almost from the moment he arrived in Paris in 1906. The nickname Modì, used by many of his friends when he was alive, was both a playful abbreviation and a pun on *maudit*, French for "cursed." In 1924, a few years after his death, the artist's story became the model for the art critic Michel Georges-Michel's *Les montparnos*, a tale of depravity and despair in the artist community of Montparnasse. Georges-Michel thought of his novel as an updated look at the "new bohemia," a popular successor to Henri Murger's 1851 *Scènes de la vie de bohème*, the novel on which Giacomo Puccini's 1896 opera *La bohème* was based.

Yet neither Modigliani nor most of his contemporaries were as disengaged or decadent as the myth of the bohemian might suggest. The avant-garde painters and sculptors of the late nineteenth century and the first half of the twentieth, with their countercultural lifestyles and edgy aesthetics, could easily be labeled bohemian. But for most of them, as for Modigliani, art was more than just a means of aesthetic flight. It was also an intellectual and ideological endeavor, a vehicle for complex and consequential interaction with the world. These artists abstracted and analyzed the world around them not to escape it but to challenge, resist, or transform it: they confronted the profound social and cultural changes of an increasingly modern, urbanized, and industrial world (Édouard Manet, *A Bar at the Folies-Bergère*, 1881–82, Courtauld Institute, London; Georges Seurat, *A Sunday on La Grande Jatte*—1884, fig. 4; Fernand Léger, *The City*, 1919, Philadelphia Museum of Art).[9] They engaged the vanguard

Two Found Sculptures May Be by Modigliani

Second stone head believed to be Modigliani sculpture that was dredged from canal in Leghorn, Italy.

Amedeo Modigliani

By HENRY KAMM

Special to The New York Times

ROME, July 25 — After a week of dredging from a slimy canal in the Tuscan port city of Leghorn a quantity of rocks and boulders, old boots and rusty bicycles, searchers came up Tuesday with what they were looking for — two sculptures tentatively identified as the work of Amedeo Modigliani.

The identification, pending study by specialists and scientific dating tests, rests on biographical accounts that are themselves still subject to verification.

What is established is that during the summer of 1909 Modigliani returned from Paris for a vacation in his native city. He was broke, undernourished, alcoholic and addicted to narcotics and wanted to be with his family. Shortly before, he had grown friendly with Constantin Brancusi, the Rumanian who in Paris had become a master of modern sculpture. Modigliani spent much of his time in Leghorn sculpturing in a small studio that he rented.

Wheelbarrow Also Found

None of the works of that period are known to have survived. The reason for this, believed by some of his biographers but documented by none, is that one evening Modigliani, then 25 years old, showed his sculptures to some friends. They criticized them, perhaps harshly. Furious, the artist loaded his entire production onto a wheelbarrow at his studio, pushed it down Via Gherardi del Testa to the Fosso Reale, or Royal Moat, and dumped sculptures and wheelbarrow into the muddy waters.

It was near there Tuesday morning that the first sculpture was lifted out, and a second followed in the afternoon. The remnants of a wheelbarrow were also fished from the canal, but no necessary connection exists between art and cart.

The works are carved of stone, one nearly completed, the second recognizably in the distinctive style of Modigliani but unfinished, according to Vera Durbé, curator of the Civic Museum. In a telephone interview, Miss Durbé said the heads measured 12 to 18 inches in height. She described one as a definitely female head and called the other an "idealized face" of unspecified sex. Both bear the characteristic Expressionist, elongated, sinuous and slit-eyed traits that mark Modigliani's paintings and sculptures.

The heads were described as blackened by mud and marred by splotches of rust, possibly from having been in

contact with metal at the bottom of the canal. So far, no major cleaning or testing will be performed until experts have studied them. But no doubt remains in Miss Durbé's mind. Since 1970, the 60-year-old curator said, she has been trying to persuade a disbelieving city administration to pursue the search. She stepped up her agitation three years ago, with this month's centennial of Modigliani's birth serving as a special reason to undertake the costly dredging operation.

"I am very happy," Miss Durbé said today. "Until now this seemed impossible. There was much incredulity, but I always believed in it."

Although largely known as a painter, and one of the luminaries of the School of Paris of the early years of the century, many of Modigliani's friends and acquaintances testified that sculpture was his deepest passion. "Sculpture was his only ideal," Adolphe Basler, a noted art dealer and contemporary of Modigliani, wrote.

Nonetheless, only 25 sculptures by Modigliani are known to be in museums and private collections. They are approximately dated from 1909 until 1915. For the remainder of his life, Modigliani devoted himself entirely to painting.

Stone Dust Bothered Him

Alfred Werner, author of the monograph "Modigliani the Sculptor," explained by citing contemporaries of the artist to the effect that he abandoned sculpture because of his constant poverty and chronic illness, alcoholism and narcotics addiction. His lack of money drove Modigliani sometimes to stealing blocks of stone from buildings and always kept him from buying the expensive materials. Moreover, sculptures were even harder to sell than paintings.

Stricken by tuberculosis in his youth, the artist was unable to stand the stone dust of sculpture, and weakened by his bad physical condition, the hard physical labor of carving into stone — Modigliani detested modeling and carved all his sculpture directly into stone — was beyond his strength in his final years.

The Leghorn authorities have acceded to Miss Durbé's urging to continue dredging in the hope of finding more. "We don't know whether the two heads are all there is," the curator said.

Fig. 3. Henry Kamm, "Two Found Sculptures May Be by Modigliani," New York Times, *July 26, 1984, section C, page 9.*

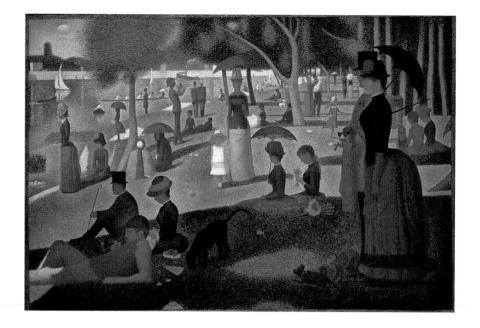

philosophy and science of their day, such as the writings of Maurice Merleau-Ponty and Henri Bergson, in order to rethink artistic assumptions about time, space, and visual perception (Picasso, *Ma jolie*, 1911–12, The Museum of Modern Art, New York; Georges Braque, *Still Life with Harp and Violin*, 1912, Kunstsammlung Nordrhein-Westfalen, Düsseldorf). They painted abstract, poetic elegies to the victims of war (Picasso, *Guernica*, 1937; fig. 5). They tested prevailing attitudes about sex and sexuality (Marcel Duchamp, *Fountain*, 1917, Philadelphia Museum of Art; Meret Oppenheim, *Object*, 1936, The Museum of Modern Art, New York).

Over the past half-century, three biographies—one by the artist's daughter, Jeanne Modigliani, *Modigliani: Man and Myth* (1958); the others, Pierre Sichel's *Modigliani: A Biography* (1967) and June Rose's *Modigliani: The Pure Bohemian* (1990)—have attempted to construct a more complex and accurate picture of the artist. These books undo the effects of decades of hyperbole, stereotypes, and sensationalism by reinstating the intellectual, philosophical, spiritual, and social concerns that shaped Modigliani's life and art.[10] They paint a picture of an artist much like his most progressive colleagues in the avant-garde, someone who was driven by ideological and philosophical concerns, a man in continual dialogue with progressive culture and ideas. Few scholars and curators, however, have gone beyond the most obvious and dramatic aspects of his life story to construct a more complex and resonant picture of the artist and his work. This is not surprising in Modigliani studies, a field that, to a degree unprecedented in the consideration of modern art, has largely ignored the sophisticated art historical methodologies—formalism, structuralism, neo-Marxism, poststructuralism, and the complex identity-based approaches rooted in feminist, race, gay and lesbian, and psychoanalytical studies—that have emerged over the past fifty years.

Modigliani scholarship usually takes one of two methodological forms: connoisseurship or biography. The former, often complicit with the sale of the artist's work, centers on qualitative judgments or authentication. The latter, the art history of "proper names," as Rosalind Krauss sardonically terms it, interprets the art object through the artist's personal relationships, matching up images with the friends, family, colleagues, critics, dealers, and others who "inspired" them. Thus the artist's foundational relationships—say, Modigliani's intense and competitive friendship with Brancusi, or

his courtship with Jeanne Hébuterne, a frequent subject and the mother of their child—are the key to understanding the content and meaning of the work of art.[11]

That Modigliani concentrated on the art of portraiture renders his oeuvre particularly susceptible to this treatment, dependent as these paintings are on a one-to-one association between artist and biographical player. The process of explaining art through these connections, at the expense of all other stylistic, social, and intellectual implications, often permits the identity of the sitter, and the psychological coordinates of his or her relationship to the artist, to act as the sole connotation of the image. The art historian Christian Parisot, arguing for this literalist approach, maintains that the artist's portraits were driven by a desire to "continuously learn about [the] inner selves and [the] motivations" of his friends and lovers. Parisot treats these images as psychological markers, windows onto the personality, sensibility, and state of mind of the sitter. He gazes into their elegant, elongated faces to find the essence of their personalities, a quality so clearly rendered by Modigliani that it is reducible to a word or two:

> To his close friends he gave the best of himself. Thanks to Modigliani's portraits we can better understand Soutine, the young man full of gaiety from the Vilno Ghetto, meditating by a fireplace or on his feet, stupefied by drink. We recognize the solidity of Henri Laurens . . . the slightly precious side of Kisling, Jacques Lipchitz's affection for his wife, the reserve of Leopold Survage, the intelligence of Picasso, and the finesses and friendliness of Dr. Alexandre and Zborowski.[12]

If the biographical method, by its very definition, is limited in its observations, it is further circumscribed by the tendency of scholars to search for associations that confirm preexisting myths and stereotypes about art and its production. These received ideas—preeminently that of the tragic bohemian, but also such notions as the tortured genius, the narcotized dreamer struck down in the prime of his life, and the satyr smitten by his muse—become conceptual templates into which the art historian inserts relevant names and biographical information. This methodology has plagued the scholarship of

Fig. 5. Pablo Picasso (Spanish, 1881–1973), Guernica, 1937. Oil on cloth, 137 ½ x 305 ¾ in. (349.3 x 776.6 cm). Museo Nacional Centro de Arte Reina Sofía, Madrid.

many of modernism's iconic figures, from Vincent van Gogh and Picasso to David Smith and Jackson Pollock.[13] The dozens of articles and books concerned with the identity and implications of Picasso's muses—texts peppered with the proper names Olga, Marie-Thérèse, Dora, Françoise, and Jacqueline—testify to a dispiriting enterprise committed to endlessly proving that beautiful women inspire great art, while ignoring the intellectual or emotional complexity of each of these women or the stylistic or conceptual intricacies of the paintings that depict them.[14]

In a quintessential example of this approach in Modigliani studies, Marc Restellini employs an assortment of biographical characters to substantiate a predictable picture of a tormented genius gripped by an insanity that was destroying him but edifying his art. Restellini maintains that an odd and recurrent detail in Modigliani's portraits—the rendering of the face with one eye open, the other closed—reflects the artist's "schizoid" mental state and manifests a "schizophrenic" aesthetic that served his "metaphysico-spiritual" view of the world.[15] The artists and writers Modigliani chose to paint this way—the painters Léopold Survage and Celso Lagar; the poets Anna Akhmatova, Beatrice Hastings (see fig. 1), and Raymond Radiguet—functioned as both inspirations and surrogates for the artist, sharing with him a psychology that permitted them to see "the outside world with their open eye while turning their other eye inward."[16]

Refusing to stop at the paintings themselves, Restellini calls on other characters to corroborate his theory. Paul Alexandre, a physician and Modigliani's patron, recalls that he introduced the artist to hashish, a drug that intensified his madness.[17] Modigliani's friend Lunia Czechowska insists that his "soul was in endless torment."[18] And letters the artist writes to his friend Oscar Ghiglia, Restellini says, confirm that he was prone to "strange visions, incoherent sentences, an unhealthy degree of introspection, a lack of adaptation to the external world, and a sentiment of superiority."[19]

Restellini's thinking delimits the meaning of the artist's work by implicitly rejecting the idea that his intellectual and aesthetic decisions could have been volitional and thus motivated by rational ideas. "Modigliani never showed any interest in social or political questions," Restellini writes—an assertion contradicted by several biographers and critics.[20] Predictably, the art historian himself turns inward, toward the artist's ostensibly self-contained and ideologically neutral psychological state, to prove an esoteric argument that "turns militantly away from all that is transpersonal in history—style, social and economic context, archive, structure."[21]

There are a number of reasons for the biographical imperative in Modigliani studies. For one, Modigliani's life, colorful and dramatic as it was, provided writers with a good story and an easy hook on which to hang a variety of aesthetic speculations and observations. Conceptually, the tragedy and alienation that marked his life played into abiding myths of the artist as tormented bohemian genius. Another reason, rooted in the earliest use of biography to explain Modigliani's art, was spurred less by scholarship than by greed. As the art historian June Rose has noted, interest in Modigliani's work, lukewarm at best when he was alive, began to rise shortly after his death. In collusion with art dealers, critics wove ever more incredible tales about Modigliani's passionate, star-crossed life, their eye always on impressionable collectors. They adeptly repositioned the handsome artist as a mysterious and sexy prophet, the creator of irresistibly powerful and visionary art. The promotional campaign was so cynical and calculated that in late 1919 a consortium of Parisian dealers who were hoarding works by the gravely ill artist sent a telegram to his principal dealer, Leopold

Zborowski, imploring him to suspend all sales until Modigliani was dead. The dealers'
henchmen in the art press fed "a mammoth, money-spinning Modigliani industry"
so immediately profitable that "writers told and retold his story through witnesses
who remembered, misremembered, embroidered, or distorted" the details and events
of his life.[22] The distortions and clichés created by this mythmaking set into motion
an art historical mindset that survives to the present day.

The scholarly view of Modigliani is rarely more sophisticated or complex than
that fashioned by popular culture. Dennis McIntyre's *Modigliani: A Play in Three Acts* of
1968, most recently staged in New York in the fall of 2002, for instance, presents the
artist as a pitiable figure whose self-destructive behavior undermines his career (fig. 6).
The play's overwrought tone is established in its opening scene: Modigliani, fleeing an
altercation in a restaurant, crashes headfirst through the establishment's front window.
In the ensuing three acts, we learn about the artist's crippling self-doubt, his painter's
block, his flight from the police (for destroying the restaurant window), his fantasy of
escaping to Martinique, his desire to learn how to swim, his bitter and competitive
feelings toward Picasso, and his plot to burn down the Louvre. The play has little to
convey in the way of psychological or philosophical insights that might help its audi-
ence better understand the artist and his work.[23]

Similarly, in Jacques Becker's 1958 dramatic film *Montparnasse 19* (fig. 7), which
recounts the last years of Modigliani's life, his ideas about art and culture are for the
most part ignored. (Its screenplay was adapted from Georges-Michel's *Les montparnos*.)
Modigliani is portrayed as an embittered hedonist, an artist dissolute over public indif-
ference to his paintings. He indulges in drugs and alcohol. He beats his girlfriend. He
battles illness. He stops making art. He meets a beautiful young artist who abandons her
privileged life to live with him, bear his child, and rekindle his passion for art. He suffers
the indignity of a final, once again ignored exhibition. At film's end, the disillusioned,
emaciated artist collapses on a Paris street, and dies a few hours later in a hospital.[24]

It is not the use of biography per se that is the problem with Modigliani studies,
but rather the tendency of the biographical method to treat the art historical text as a
simplistic detective story or roman à clef, in which the narratives of friendship, colle-
giality, or love, in and of themselves, supply the art object's only meaning. In his book
Patterns of Intention: On the Historical Explanation of Pictures, the art historian Michael

*Fig. 6. Timothy O'Hare as
Modigliani in The Colony Theatre
Company's production of Dennis
McIntyre's* Modigliani: A Play
in Three Acts.

*Fig. 7. Gérard Philipe as
Modigliani selling his drawings
in a café in the 1958 film*
Montparnasse 19, *directed
by Jacques Becker.*

Baxandall argues that, although it can be a valuable adjunct to the visual and concep-
tual interpretation of pictures, biography is only a node in a network of resources and
methods available to the art historian. Paintings, he reasons, are complex organizations
of forms and ideas motivated by multiple forces, personal and social. It is the responsi-
bility of the art historian to examine the art object in relation to these forces, to
understand the intentions of an artist living in a different culture and the social and
cultural milieu out of which these intentions arise.[25]

Baxandall's concept of intention differs from that of most Modigliani scholars.
He views the artist's motives broadly, as reflecting the biographical—personal experi-
ences, intellectual and aesthetic interests, associations with other artists and intellec-
tuals—and as impelled by and commensurate with wider social and cultural forces.
In his analysis of Jean-Baptiste-Siméon Chardin's *A Lady Taking Tea* (1735; fig. 8),
Baxandall refuses to stop at the painting's biographical signification. If he had con-
fined himself to a strictly interpersonal reading of the painting—that, say, it is a med-
itation on the transience of life—his conclusions would have rested on the fact that
it shows the artist's first wife just weeks before her death. But Baxandall, in augment-
ing his analysis with stylistic and compositional analysis, a close examination of the
historical archive and popular literature, and other art historical resources and meth-
ods, is able to isolate another, more inclusively cultural, level of meaning: The paint-
ing, he maintains, functions also as a demonstration of visual perception according
to the prevailing and most advanced theories of the day, especially the popular ideas
of the empiricist philosopher John Locke.[26]

Baxandall says further that even if the meaning of a work appears to be restricted
to the identity of a specific person, as in the affiliation between portraitist and sitter,
it is the responsibility of the art historian to understand this relationship as well as the
art object itself within a larger social and cultural context. Baxandall conceives of
influence and motivation not simplistically, as a limited, one-on-one relationship
between the artist and a single biographical source, but as an "affinity" between an

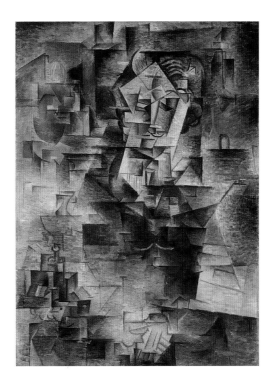

Fig. 9. Pablo Picasso, Daniel-Henry Kahnweiler, *1910. Oil on canvas, 39 ¾ x 28 ¾ in. (101.1 x 73.3 cm). The Art Institute of Chicago, Gift of Mrs. Gilbert W. Chapman in memory of Charles B. Goodspeed (1948.561).*

inherently social artist and contemporary beliefs, ideas, and movements, a "web of intellectual preoccupation," as he calls it. Painters, he writes,

> cannot be social idiots: they are not somehow insulated from the
> conceptual structures of the cultures in which they live. If one sup-
> poses they ever reflect on painting at all, then concepts and groups
> of concepts will have some part in it; and a man with a critical or
> self-critical concept is a man with an operative theory. However, it
> seems to me important that if the concept is active in the mind it is
> directed to some object, and this is so too of the more evolved sort
> of idea taken from a philosophy or science. If Picasso took on some-
> thing of Bergson's sense of the part played in perception by duration
> of experience through time, as has been suggested, then that would
> bear first on his sense of relation to the object of representation. If,
> as has been suggested, he took on something of Nietzsche's sense of
> the superman who imposes an idiosyncratic vision of the world on
> other people, that would bear first on his sense of relation to an
> audience. Active ideas do not float, they are brought to bear.[27]

Thus the art object is never entirely independent of its social and cultural milieu. Baxandall's analysis of Picasso's portrait of the progressive art critic and dealer Daniel-Henry Kahnweiler (fig. 9) underscores this point, as it explains how the image was informed and influenced by their generative dialogue and by an aesthetic and intellectual environment that was conducive to their shared reconsideration of visual perception and representation.[28]

Baxandall's intellectual largesse, exemplified by his holistic understanding of the relationship between portraitist and subject, is particularly instructive to the study of Modigliani, an artist who devoted more time to painting his friends and colleagues

Fig. 10. Amedeo Modigliani, Chaim Soutine, 1915. Oil on wood, 14 ⅛ x 10 ¹³⁄₁₆ in. (36 x 27.5 cm). Collection Staatsgalerie Stuttgart.

than to any other artistic activity. Art historians and curators have, for the most part, remained indifferent to the greater cultural and social implications of this work, despite the fact that his extensive output—he drew or painted some 160 subjects, including Guillaume Apollinaire, Brancusi, Blaise Cendrars, Jean Cocteau, André Derain, Juan Gris, Max Jacob, Jacques Lipchitz, Chana Orloff, Anna Pavlova, Picasso, Diego Rivera, and Chaim Soutine (fig. 10)—directly addresses the question of intellectual affinity and context.[29]

The case of Beatrice Hastings, one of Modigliani's most important subjects and love interests, is exemplary in this regard. To many writers, she remains little more than a fiery muse or a sexually driven vamp who was incapable of love or commitment and who encouraged the artist's addictions. Yet Hastings was a far more complicated and constructive figure. To many, she was a respected poet and critic. She was a member of London's intellectual elite. She was an outspoken Socialist and a spirited campaigner for women's rights and abortion rights. She was an ardent follower of Theosophy and the occult. Significant to Modigliani, she was also "a stimulant, irritant, and catalyst" for his work, a conduit to new ideas and beliefs, an intellectual and philosophical soul mate.[30]

The artist's portraits, which capture Hastings in a number of poses, costumes, and moods, are imbued with multiple connotations. She is shown as an assertive grande dame in a fur collar; as Madame de Pompadour, the infamous courtesan and mistress of Louis XV; as a Christian icon situated in front of the cruciform panels of a door; as a demure singer beside a piano; and as a weary nude who shyly conceals her pubic hair

with a sheet, an image likened by Hastings herself to the "Virgin Mary, without worldly accessories."[31] Such images are neither ideologically nor psychologically neutral, but instead project levels of meanings, personal, cultural, and historical. They reverberate with many stylistic sources and art historical allusions (the iconoclastic courtesans of Manet's *Olympia* and Picasso's *Les demoiselles d'Avignon* come to mind). They juxtapose religious imagery, such as Christian and Theosophical iconography, with explicit sexuality, thus making a single person signify both the sacred and the profane. They employ masquerade, words, and props to mark, alter, or question the sitter's identity. The conceptual density of these images, together with the intellectual nature of Modigliani's relationship with Hastings, suggests that they were driven by more than sexual attraction, fascination, or self-destruction. Obviously there are many more stories—about Modigliani's motivations, about Hastings's influence, about the cultural and social milieu that underwrites both—waiting to be discovered in his portraits of her. But art historians, spellbound by the idea of the intoxicating power of female beauty, cannot transcend their own sexist and moribund thinking to find them.

Modigliani scholarship is not entirely shallow and uninventive, as several essays written over the past thirty years affirm. Werner Schmalenbach, for example, speculates that Modigliani had a deep sense of "artistic responsibility" that impelled him to analyze and embrace numerous art historical influences, including Francisco Goya, Manet, and Paul Cézanne.[32] Alan Wilkinson studies the artist's fascination with African tribal art and the ways he assimilated and transformed his sources.[33] Kenneth Silver, examining the Jewish presence in the French avant-garde of the early twentieth century, reasons that Modigliani's Sephardic ancestry helped him become a role model for Ashkenazi immigrant artists who saw him not only as a Jew but also as an important, if figurative, link to the Greco-Roman and Italianate roots of Western art.[34] Tamar Garb contends that his portraits represent a "delicate balancing act between the generic and the specific," a coherent synthesis of content and form meant to communicate many ideas about the sitter and the world around him.[35] Mason Klein explores the artist's fusion of multiple art historical styles and sources in connection with his perception of his own identity as multifarious and outside traditional nationalist boundaries.[36]

These essays, however, represent the exceptions, not the rule. The dismal state of Modigliani studies speaks to the tendency of many art historians and curators to see themselves as the agents of art dealers or as the hapless chroniclers of a provincial, self-contained art world and not as active intellectuals working within a larger cultural community. Art history is an essentially rational and "sociable" practice, to quote Baxandall, a discipline engaged in "conversation" with its own past and with the history of the artists, art objects, and cultures that are its subject.[37] Indeed, the paradigmatic text of modern art history and criticism, Giorgio Vasari's *Lives of the Artists* (1550), began as a conversation: many of its stories and observations originated not at the author's desk or in the archive, but in dialogue with other thinkers and artists, often at dinners organized by Cardinal Alessandro Farnese. These conversations, unlike the exchange of puerile gossip and trite observations that usually passes for serious analysis of Modigliani's art, demanded rigor and insight from their participants. The present-day heirs to Vasari should ask for no less from themselves and their peers. Thus the next *affaire Modì* would best concern itself with the recovery of an even more valuable commodity: the ideas, passions, and influences lost to scholars and writers unable to grasp the true gravity of their subject.

Plates

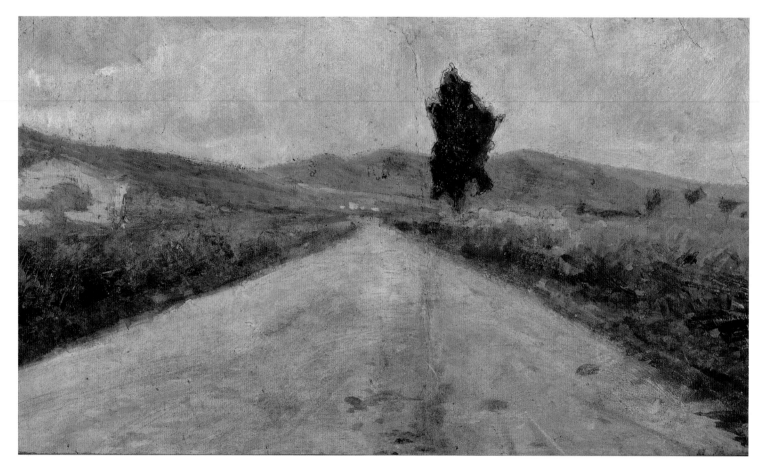

PLATE I
Small Tuscan Road, 1898
Oil on cardboard, 8 ¼ x
14 in. (20.8 x 35.7 cm)
Museo Civico Giovanni
Fattori, Livorno

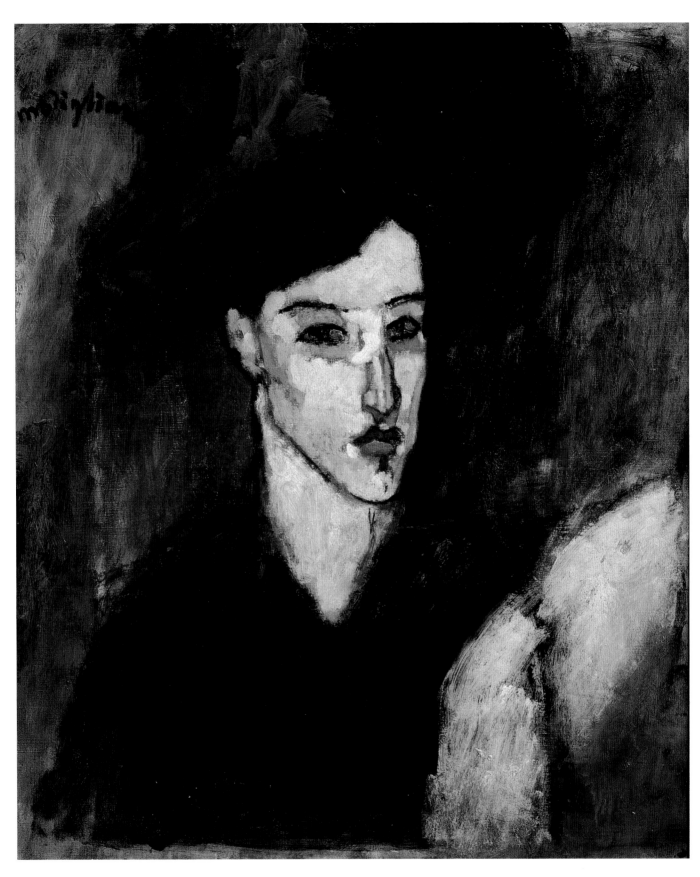

PLATE 2
The Jewess (La juive), 1908
Oil on canvas, 21 ⅝ x
18 ⅛ in. (55 x 46 cm)
Re Cove Hakone Museum,
Kanagawa

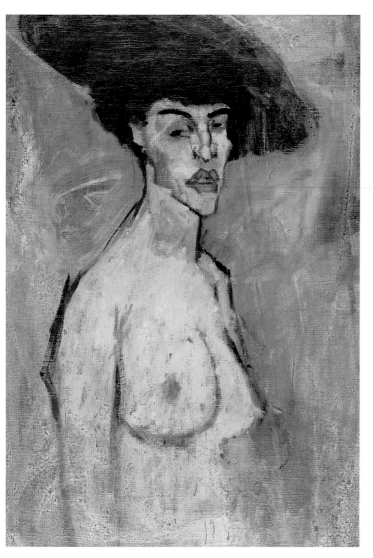

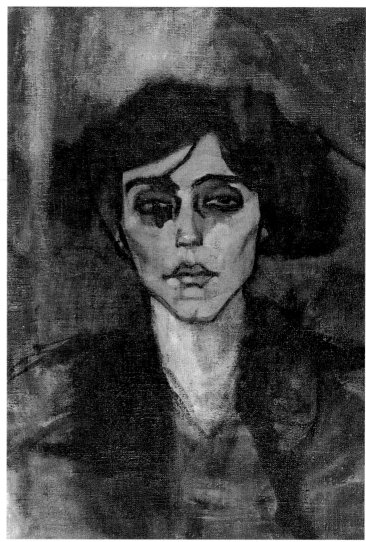

PLATE 3
Nude with a Hat (recto), 1908
Oil on canvas, 31 ⅞ x
21 ¼ in. (81 x 54 cm)
Reuben and Edith Hecht
Museum, University of
Haifa, Israel
(Ca. No. p–226a–b)

PLATE 4
Maud Abrantes (verso), 1908
Oil on canvas, 31 ⅞ x
21 ¼ in. (81 x 54 cm)
Reuben and Edith Hecht
Museum, University of
Haifa, Israel
(Ca. No. p–226a–b)

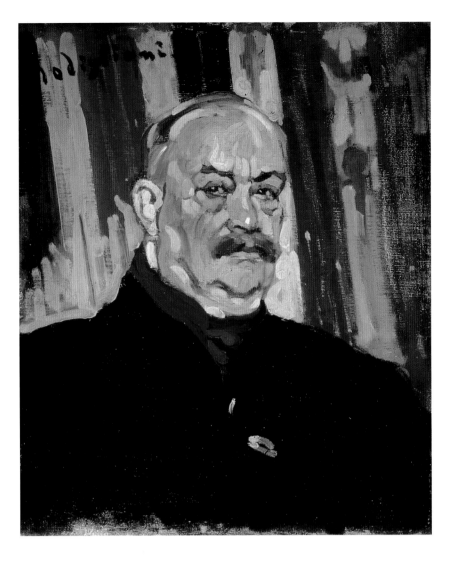

PLATE 5
Joseph Levi, 1909
Oil on canvas, 21 ¾ x
19 ¾ in. (55 x 50 cm)
Private collection, New York

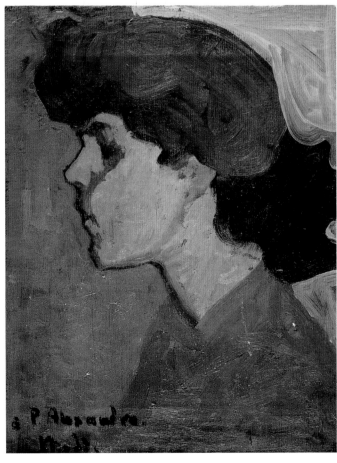

PLATE 6
Head of a Woman in Profile,
1906–7
Oil on canvas, 14 x 11 ⅝ in.
(35.5 x 29.5 cm)
Private collection, Paris

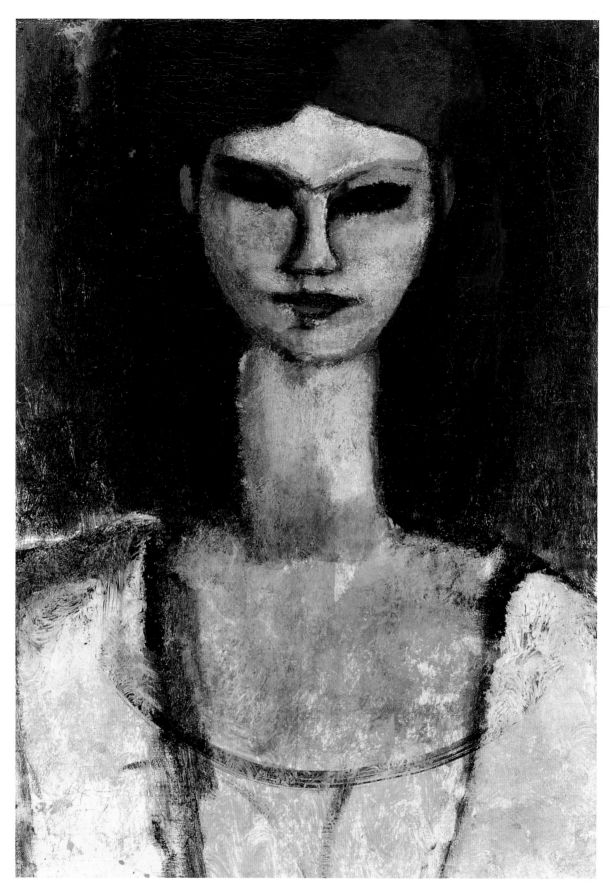

PLATE 7
Bust of a Young Woman, 1911
Oil on canvas, 21 ⅝ x
15 in. (55 x 38 cm)
Frances I. and Bernard
Laterman, New York

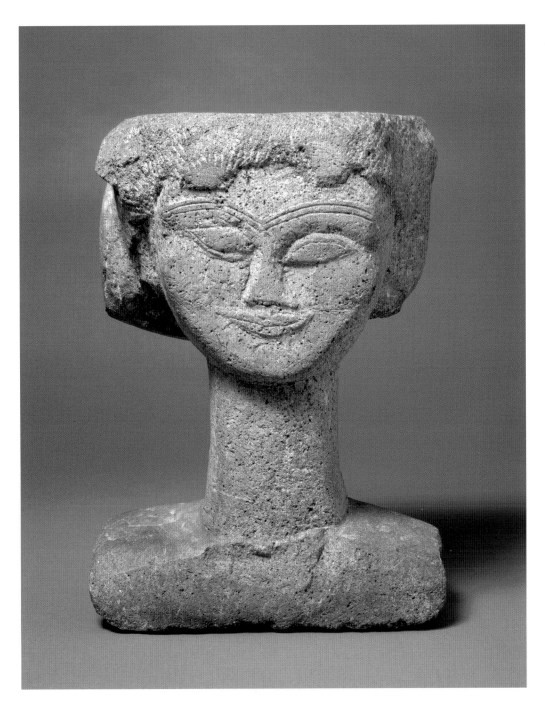

PLATE 8
Head, c. 1911
Stone, 15 ½ x 12 ¼ x
7 ³⁄₈ in. (39.4 x 31.1 x
18.7 cm)
Fogg Art Museum, Harvard
University Art Museums,
Gift of Lois Orswell
(1992.254)

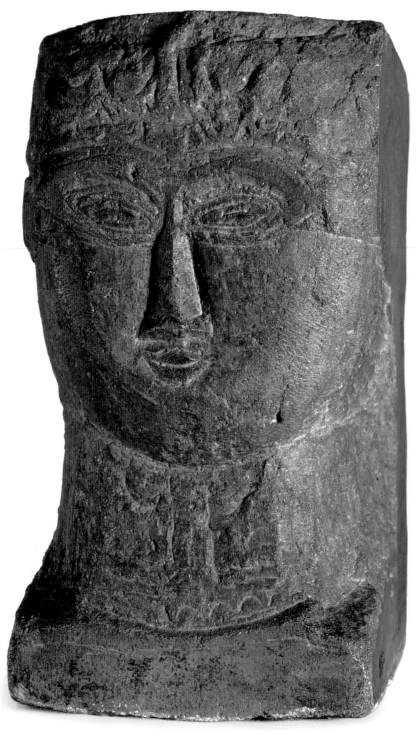

PLATE 9
Head, 1912–13
Stone, 18 ½ x 9 ⅞ x
11 ¾ in. (47 x 25 x 30 cm)
Musée National d'Art
Moderne, Centre Georges
Pompidou, Paris, Purchase
of Melle Contamin (Paris),
1950 (AM 903 S)

94

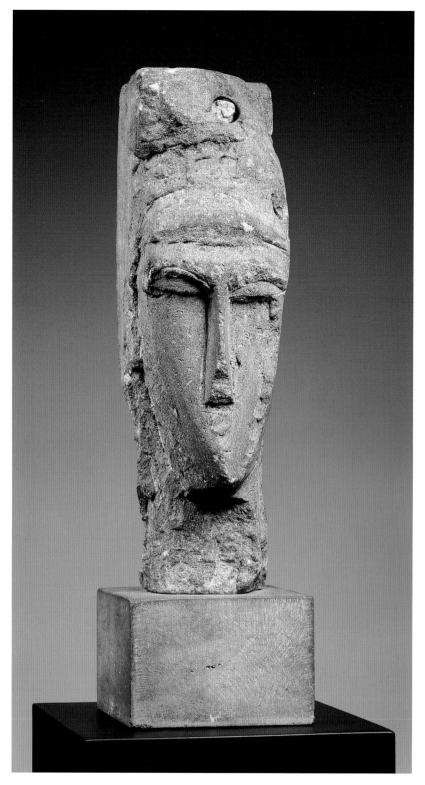

PLATE 10
Head, 1914
Limestone, 16 ½ x 4 ⅞ x
6 ¾ in. (41.8 x 12.5 x 17 cm)
The Henry and Rose
Pearlman Foundation, Inc.

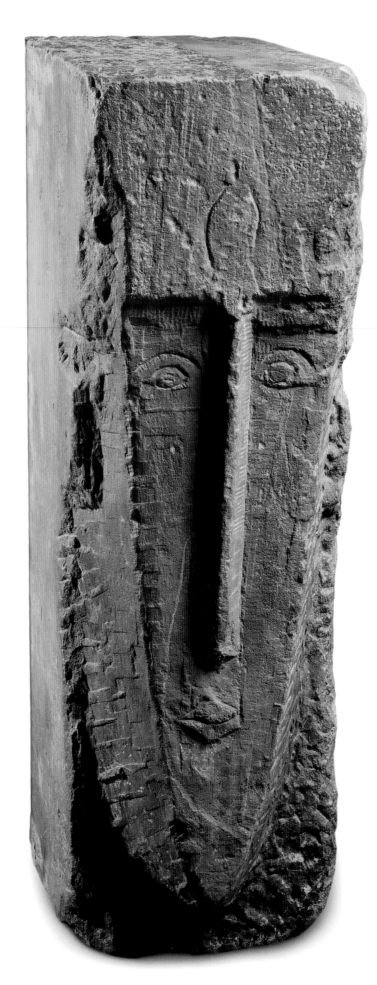

PLATE 11
Head, 1911–12
Limestone, 29 x 12 x 9 in.
(73.7 x 30.5 x 22.9 cm)
Latner Family Private
Collection, Toronto

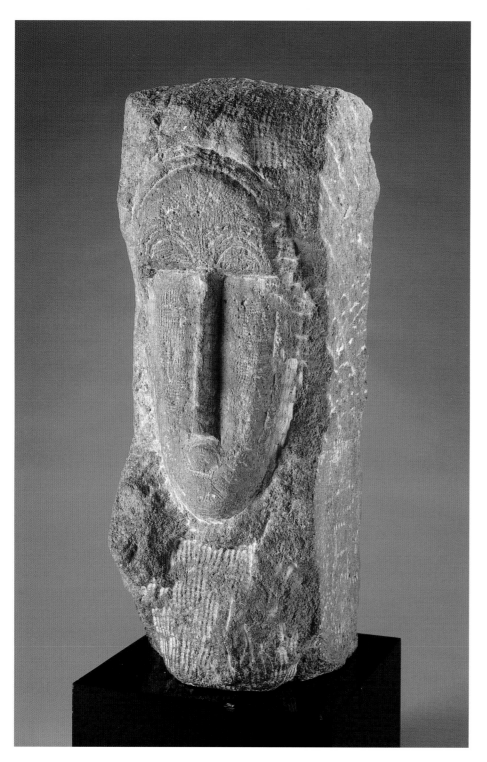

PLATE 12
Head, 1911–12
Limestone, 19 ⅝ x 7 ¼ x
9 in. (49.5 x 18.4 x 22.8 cm)
Hirshhorn Museum and
Sculpture Garden,
Smithsonian Institution, Gift
of Joseph H. Hirshhorn,
1966 (66.3582)

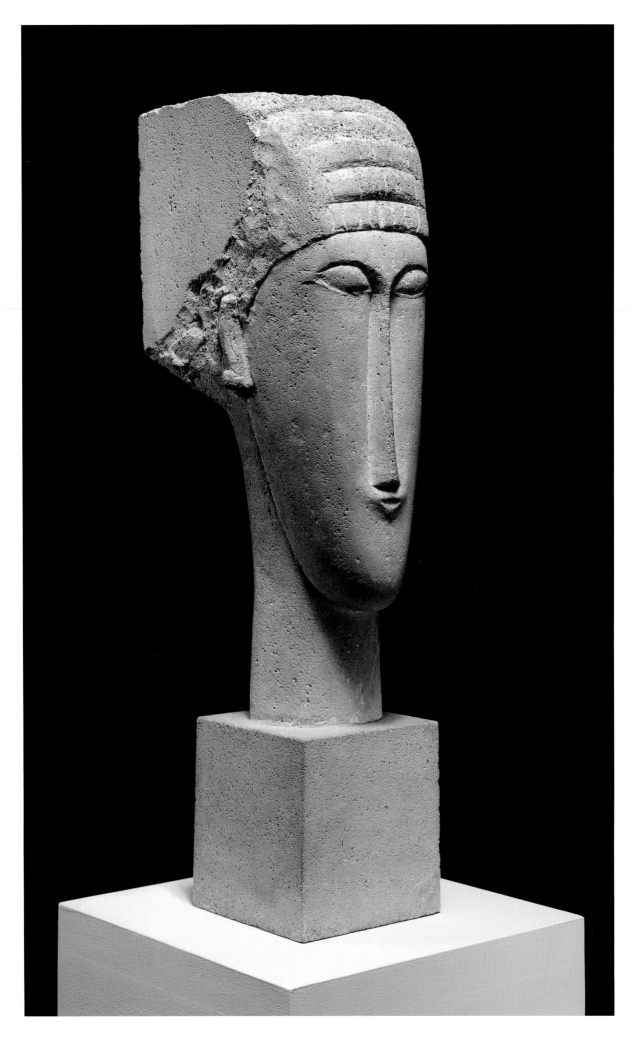

(opposite)

PLATE 13

Head, 1911–13
Limestone, 28 ¼ x 7 ¼ x
8 ⅛ in. (71.8 x 18.4 x
20.6 cm)
The Solomon R.
Guggenheim Museum, New
York, Gift, Solomon R.
Guggenheim (55.1421)

PLATE 14

Head, 1912
Limestone, 27 ¾ x 9 ¼ x
6 ½ in. (70.5 x 23.5 x
16.5 cm)
Philadelphia Museum of
Art, Gift of Mrs. Maurice J.
Speiser in memory of her
husband (1950-2-1)

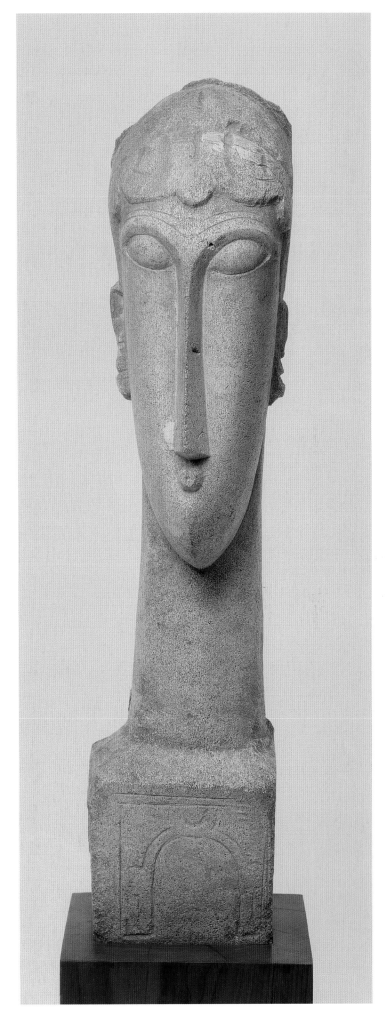

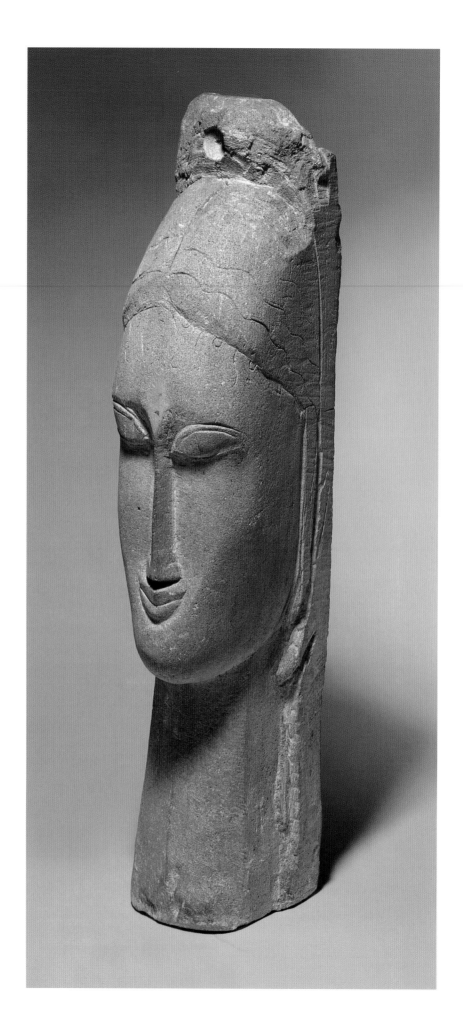

PLATE 15
Head of a Woman, 1912
Limestone, 22 ⅞ x 4 ¾ x
6 ¼ in. (58 x 12 x 16 cm)
Musée National d'Art
Moderne, Centre Georges
Pompidou, Paris, Purchase
of M. Poyet in 1949 (AM
876 S)

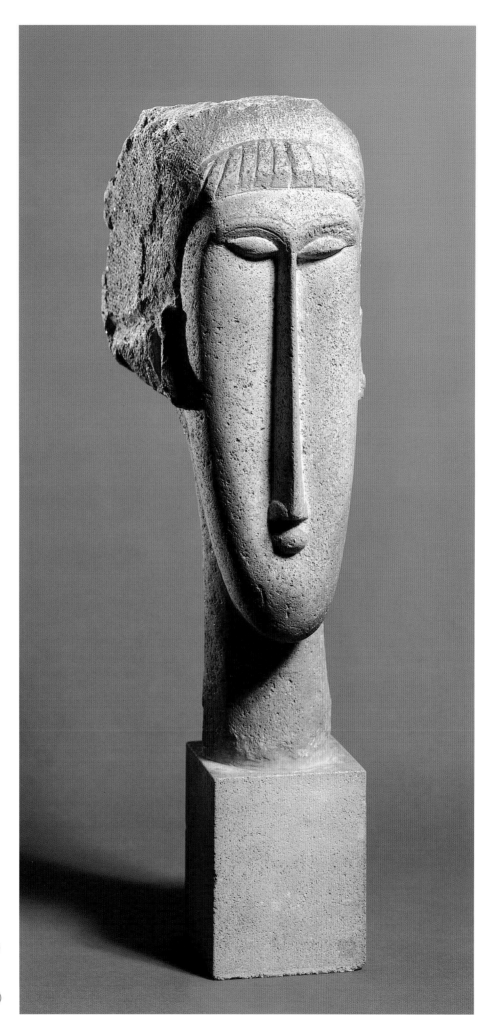

PLATE 16
Head of a Woman, 1910–11
Limestone, 25 ¾ x 7 ½ x
9 ¾ in. (65.2 x 19 x 24.8 cm)
National Gallery of Art,
Washington, D.C., Chester
Dale Collection (1963.10.241)

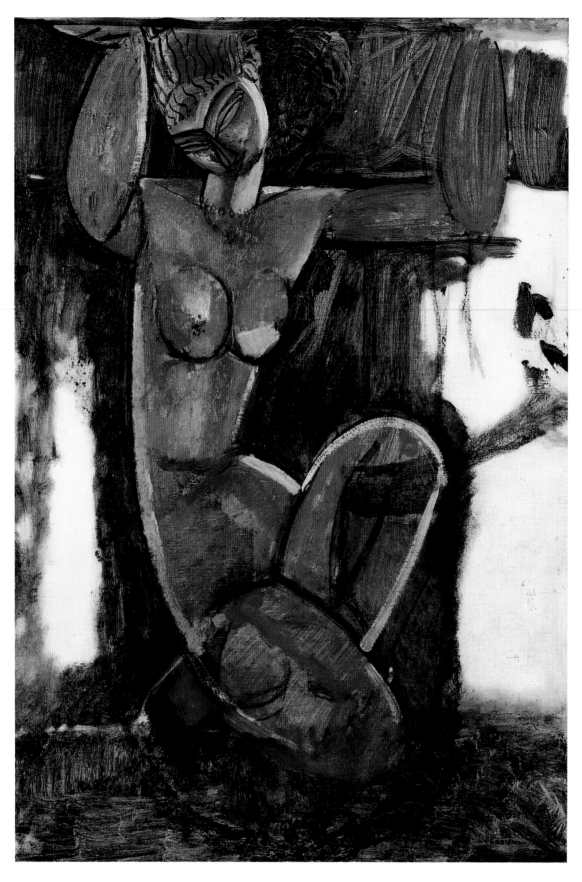

PLATE 17
Caryatid, c. 1911
Oil on canvas, 28 ½ x 19 ¾ in. (72.5 x 50 cm)
Kunstsammlung Nordrhein–Westfalen, Düsseldorf (128)

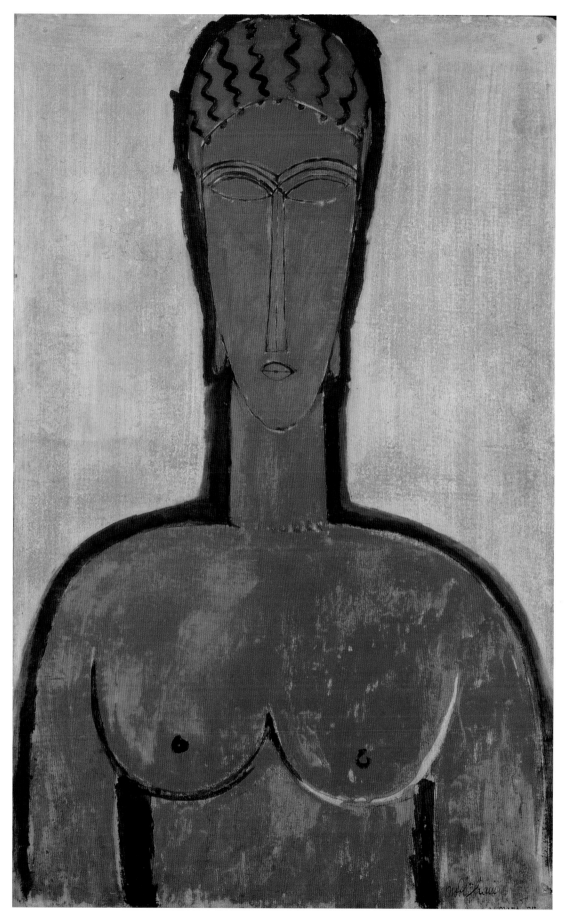

PLATE 18
Large Red Bust, 1913
Oil on cardboard, 32 ⅛ x 20 ⅛ in. (81.5 x 51 cm)
Courtesy Galerie Cazeau-Béraudière, Paris

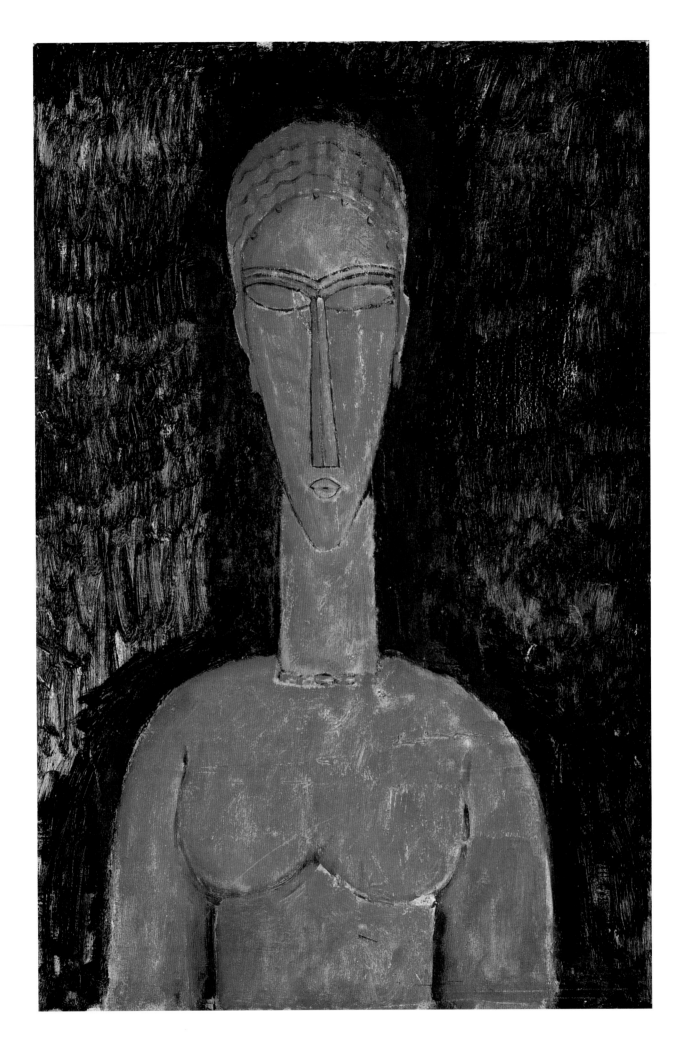

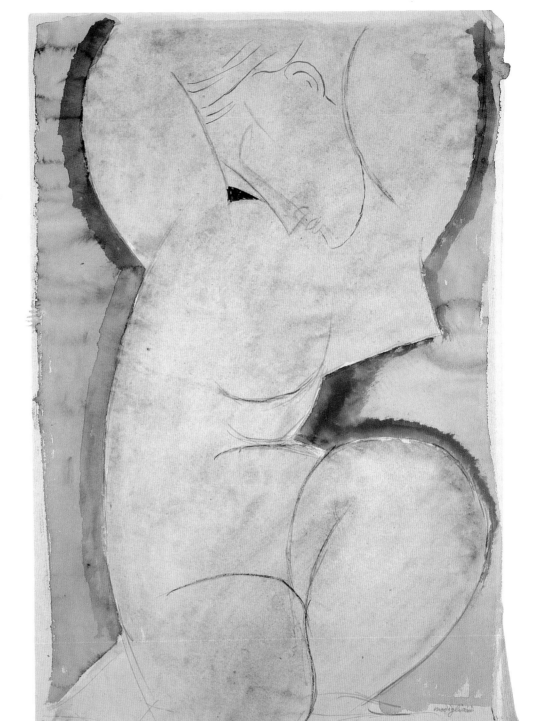

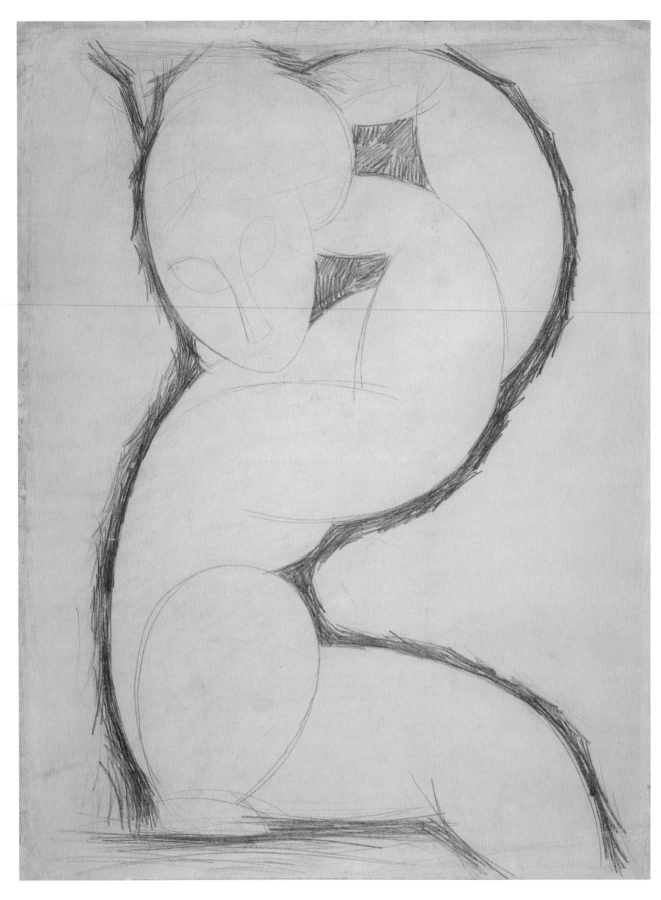

PLATE 21
Caryatid, c. 1912–14
Blue crayon and graphite on paper, 24 x 18 in. (61 x 45.7 cm)
Philadelphia Museum of Art, Given by Arthur Wiesenberger
(1950-134-150)

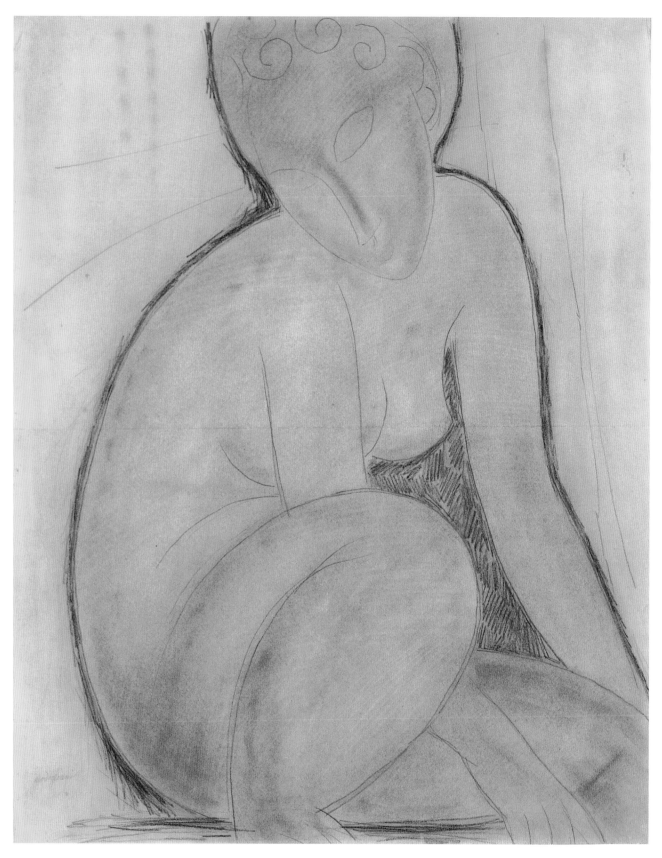

PLATE 22
Crouched Nude, c. 1909–14
Graphite and colored pencil over chalk on paper,
23 ¼ x 17 ¾ in. (59 x 45 cm)
Baltimore Museum of Art, The Cone Collection, formed by
Dr. Claribel Cone and Miss Etta Cone of Baltimore (BMA
1950.12.43)

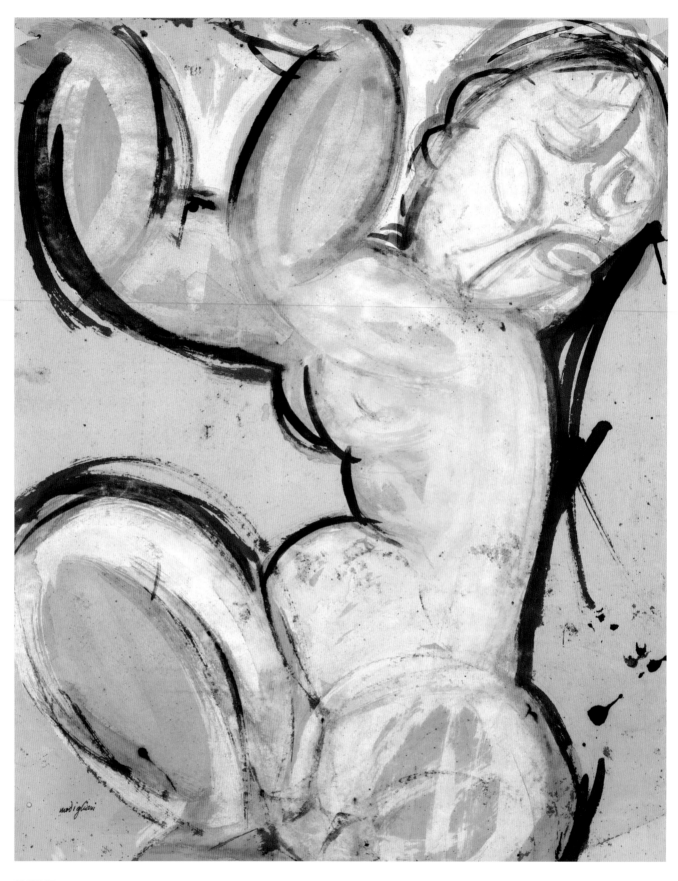

PLATE 23
Caryatid, 1914
Gouache, brush, and ink on paper,
22 ¾ x 18 ½ in. (57.8 x 47 cm)
The Museum of Modern Art, New York,
Mrs. Harriet H. Jonas Bequest (439.1974)

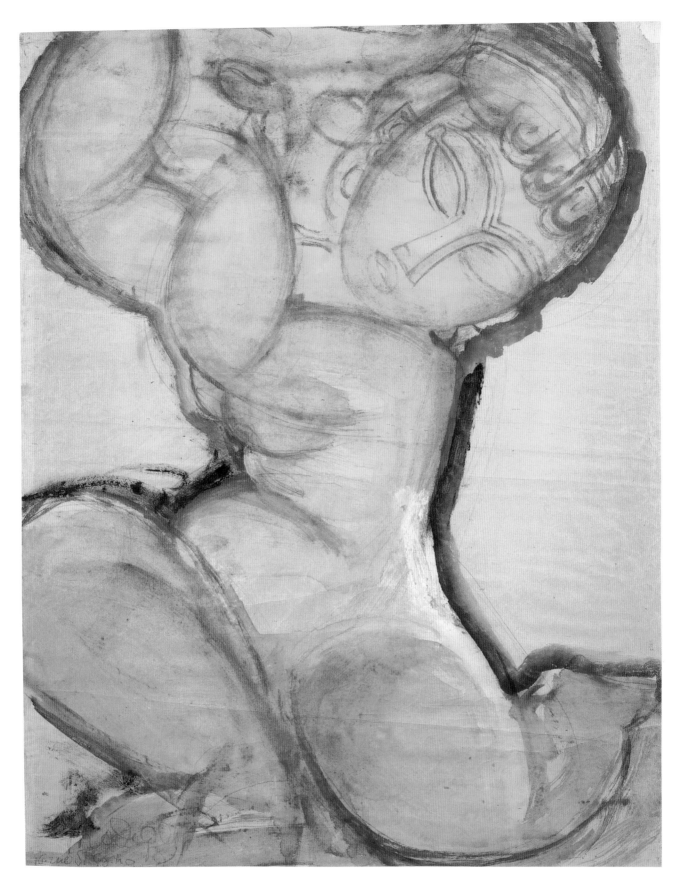

PLATE 24
Rose Caryatid with Blue Border, c. 1912
Watercolor on paper,
21 ⅞ x 17 ¾ in. (55.6 x 45.1 cm)
Private collection

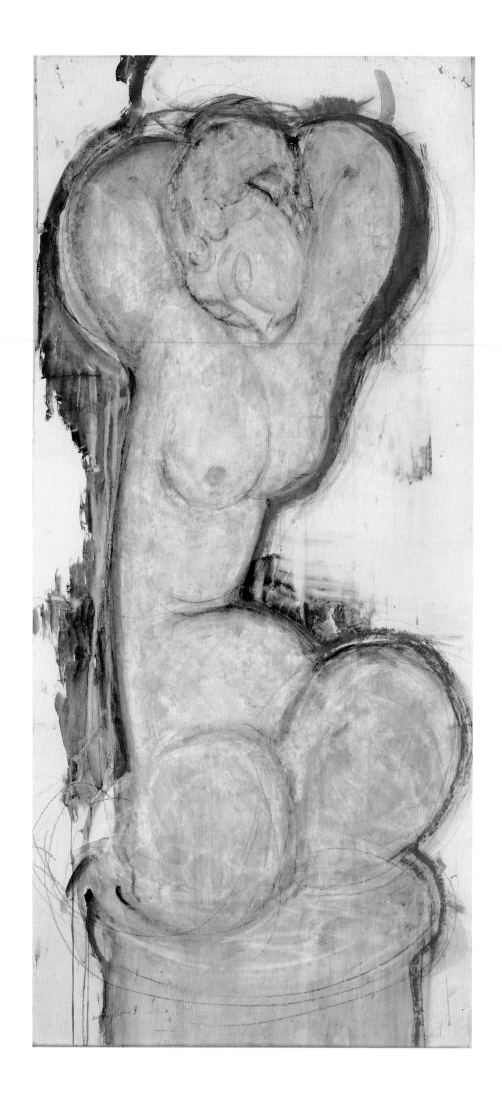

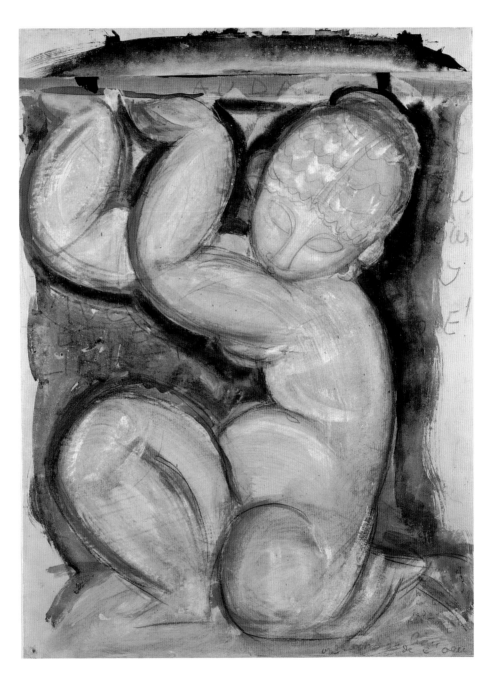

(opposite)
PLATE 25
Caryatid, c. 1914
Gouache on wove paper,
mounted on canvas, mount-
ed on wood panel, 55 ⅜ x
26 ⅛ in. (140.7 x 66.5 cm)
The Museum of Fine Arts,
Houston; Gift of Oveta
Culp Hobby (84.412)

PLATE 26
Rose Caryatid, 1914
Gouache and crayon on
paper, 23 ¾ x 17 ⅞ in.
(60.3 x 45.4 cm)
Norton Museum of Art,
West Palm Beach, Florida,
Bequest of R. H. Norton
(53.132)

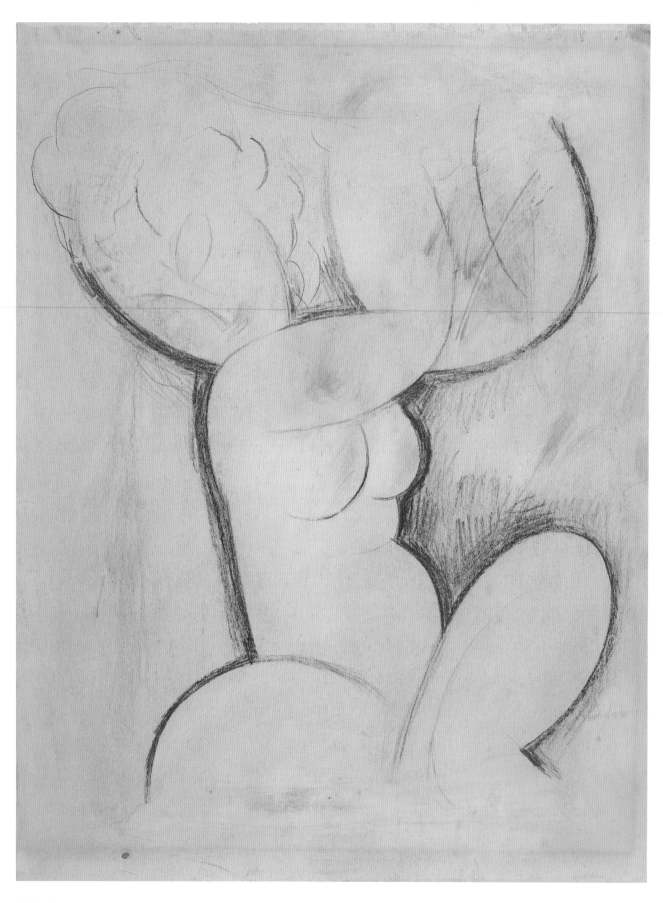

PLATE 27
Caryatid, c. 1914–15
Blue crayon and graphite on
paper, 28 ⅞ x 23 ⅜ in.
(73.3 x 59.4 cm)
Philadelphia Museum of Art
(1943-101-2)

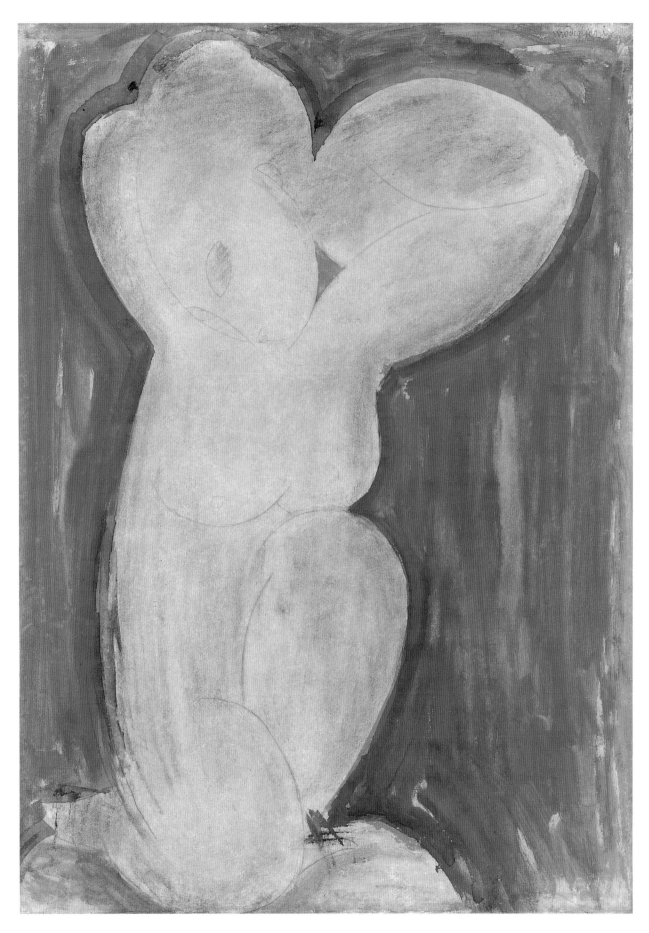

PLATE 28
Caryatid, 1914
Mixed media on cardboard,
29 x 19 ½ in. (73.5 x 49.5 cm)
Private collection

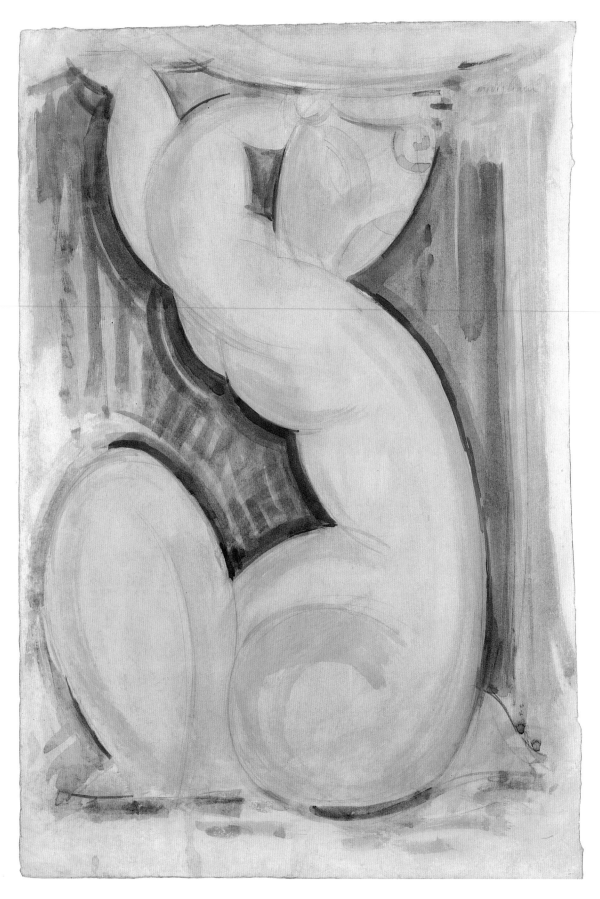

PLATE 29
Caryatid, 1914
Gouache and graphite on
paper, 19 x 12 ½ in.
(48 x 32 cm)
Courtesy Galerie Cazeau–
Béraudière, Paris

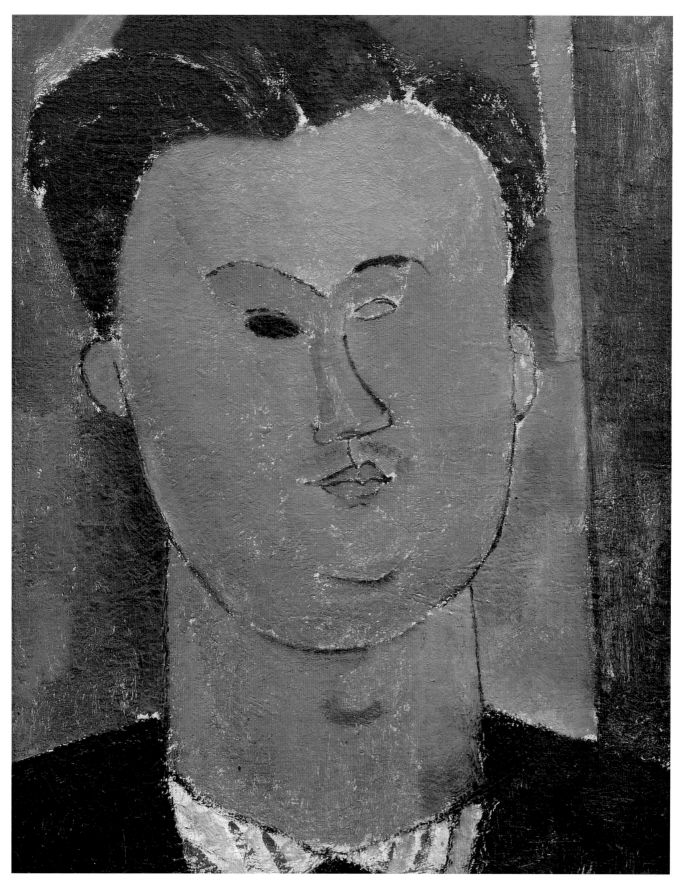

PLATE 30
Pierre Reverdy, 1915
Oil on canvas, 16 x 13 ¼ in.
(40.6 x 33.7 cm)
Baltimore Museum of Art,
Private Collector (BMA
L.1967.10.1)

PLATE 31
Red Haired Girl, 1915
Oil on canvas, 16 x 14 ⅜ in.
(40.5 x 36.5 cm)
Musée de l'Orangerie, Paris,
Walter-Guillaume
Collection (RF: 1960-46)

(opposite)
PLATE 32
La Fantesca, 1915
Oil on canvas, 31 ⅞ x
18 ⅛ in. (81 x 46 cm)
Courtesy Galerie Cazeau–
Béraudière, Paris

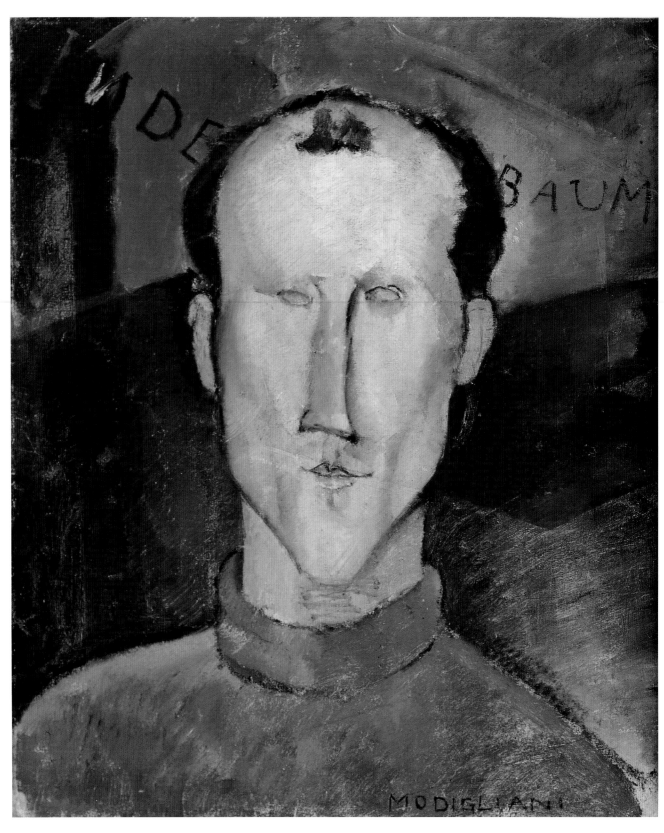

PLATE 33
Léon Indenbaum, 1916
Oil on canvas, 21 ½ x 18 in.
(54.6 x 45.7 cm)
The Henry and Rose
Pearlman Foundation, Inc.

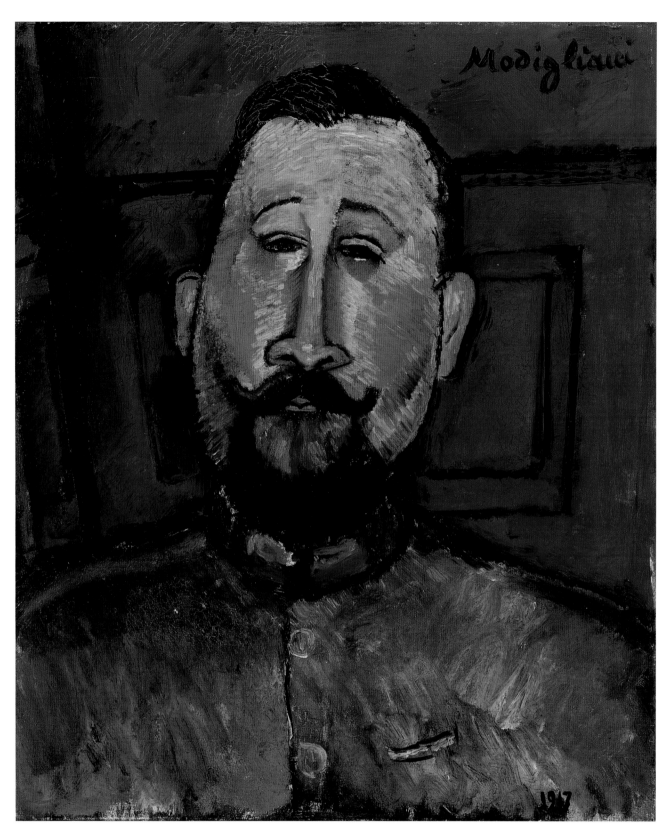

PLATE 34
*Doctor Devaraigne (Le beau
major)*, 1917
Oil on canvas, 21 ¾ x
18 ⅛ in. (55 x 46 cm)
Alice Warder Garrett
Collection, The Evergreen
House Foundation and The
Johns Hopkins University,
Baltimore (1952.1.32)

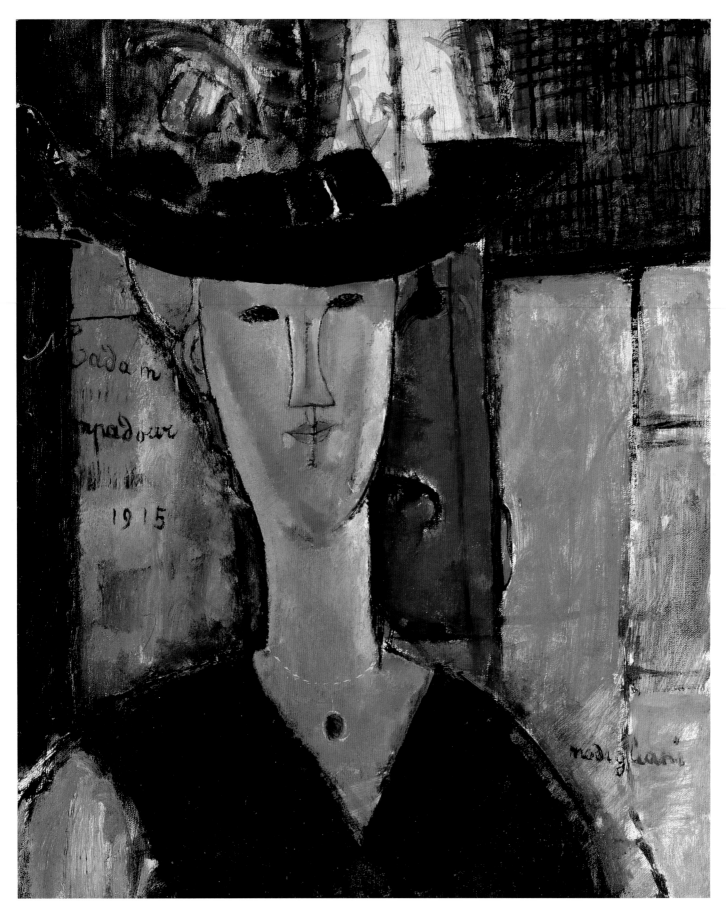

PLATE 35
Madam Pompadour, 1915
Oil on canvas, 23 ⅞ x 19 ½ in. (60.6 x 49.5 cm)
The Art Institute of Chicago, Joseph Winterbotham
Collection (1938.217)

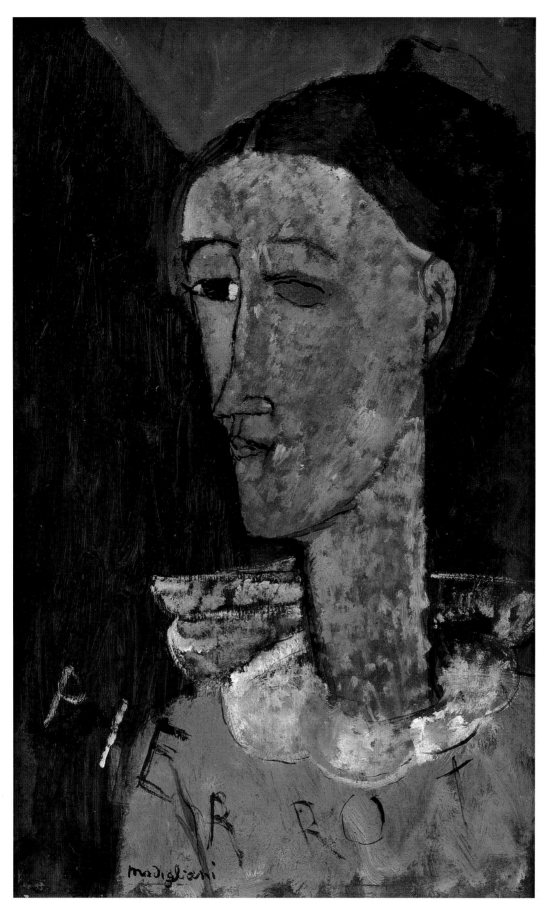

PLATE 36
Pierrot, 1915
Oil on cardboard, 16 ⅞ x 10 ⅝ in. (43 x 27 cm)
Statens Museum For Kunst, Copenhagen, Collection J. Rump
(KMSR88)

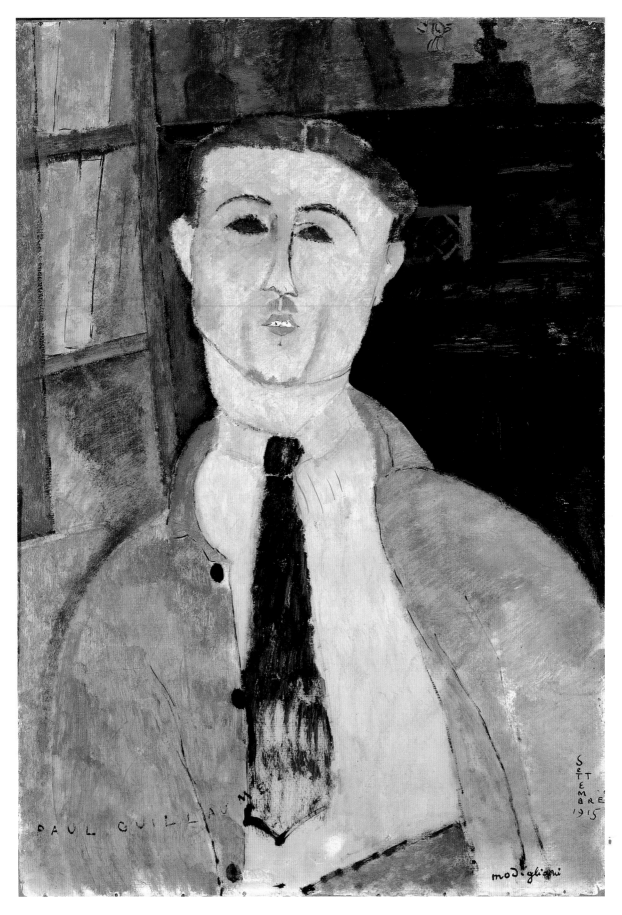

PLATE 37
Paul Guillaume, 1915
Oil on board, 29 ½ x 20 ½ in. (74.9 x 52.1 cm)
Toledo Museum of Art, Gift of Mrs. C. Lockhart McKelvy
(1951.382)

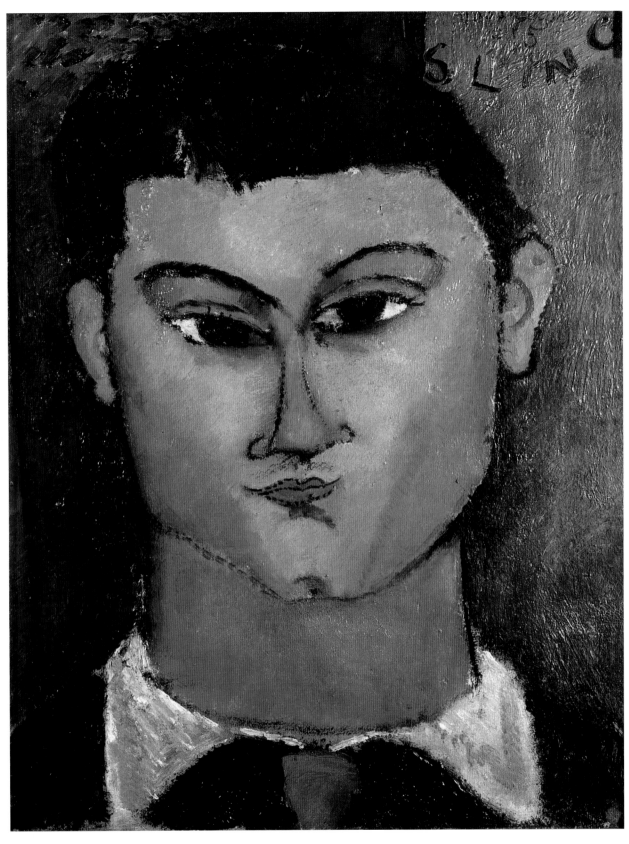

PLATE 38
Moïse Kisling, 1915
Oil on canvas, 14 ⅝ x 11 ⅜ in. (37 x 28 cm)
Pinacoteca di Brera, Milan (Emilio and Maria Jesi Donation)

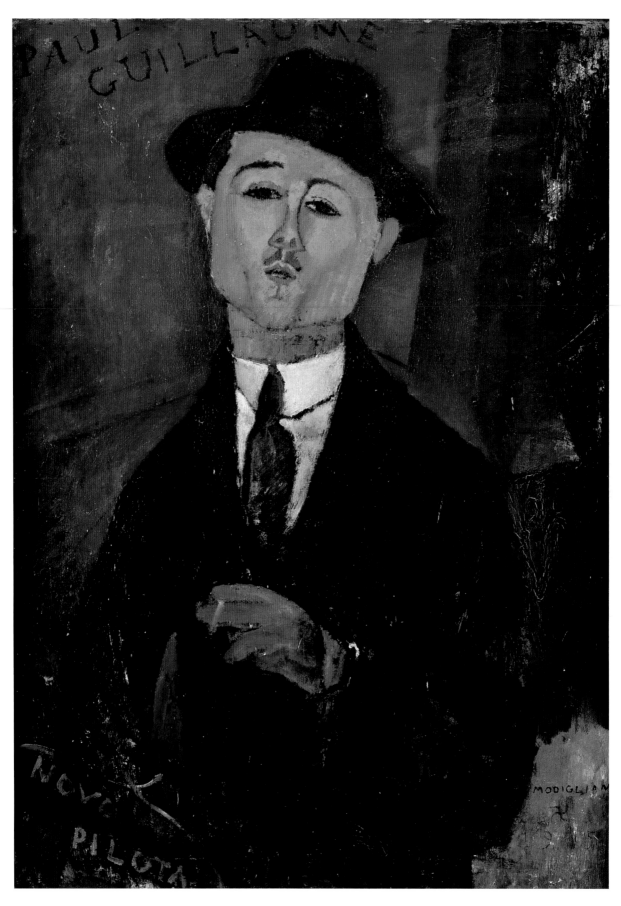

PLATE 39
Portrait of Paul Guillaume (Novo Pilota), 1915
Oil on cardboard mounted on plywood,
41 ⅜ x 29 ½ in. (105 x 75 cm)
Musée de l'Orangerie, Paris, Walter-Guillaume Collection
(RF: 1960-44)

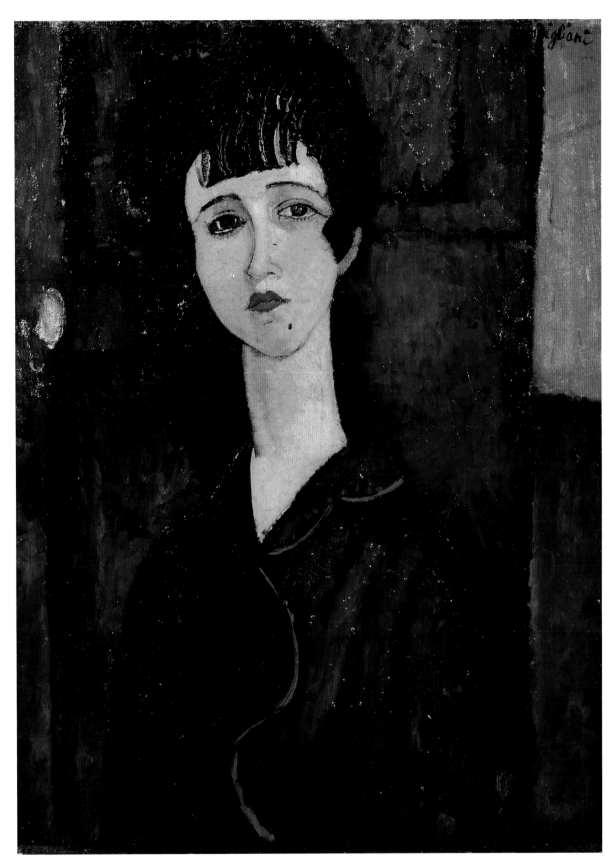

PLATE 40
Portrait of a Girl (Victoria), c. 1917
Oil on canvas, 31 ¾ x 23 ½ in. (80.6 x 59.7 cm)
Tate Gallery, London, Bequeathed by C. Frank Stoop, 1933
(NO4723)

125

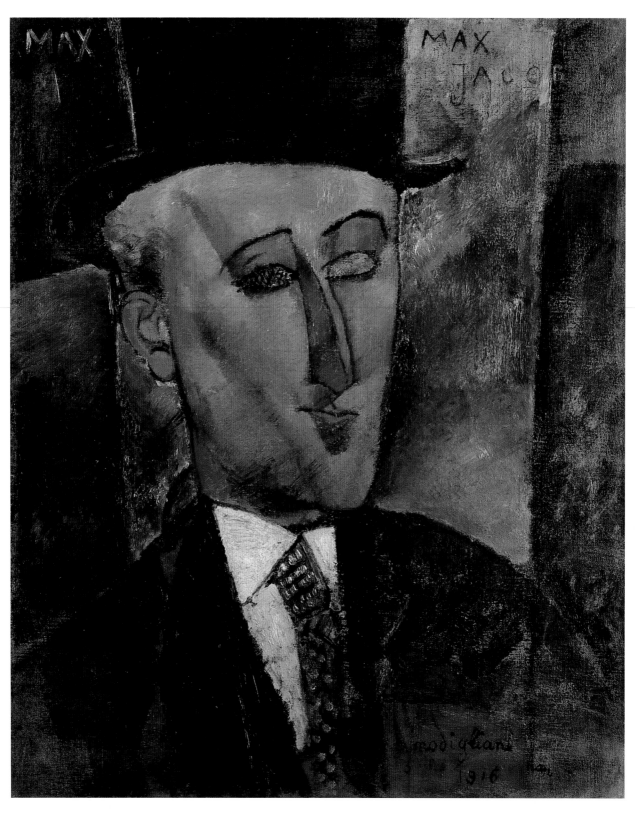

PLATE 41
Portrait of Max Jacob, 1916
Oil on canvas, 28 ¾ x
23 ⅝ in. (73 x 60 cm)
Kunstsammlung Nordrhein-
Westfalen, Düsseldorf (1036)

(opposite)
PLATE 42
Portrait of Anna (Hanka)
Zborowska, 1916
Oil on canvas, 30 x 17 ¾ in.
(76.2 x 45.1 cm)
Courtesy of The Metropolitan
Museum of Art, lent by The
Alex Hillman Family
Foundation, New York
(L.1991.19.24)

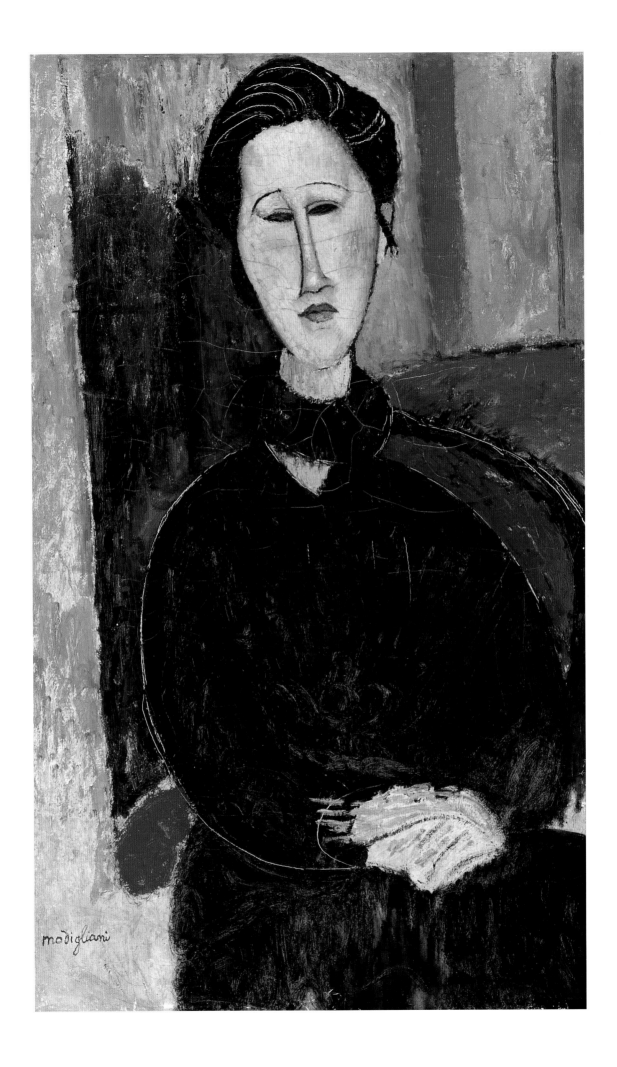

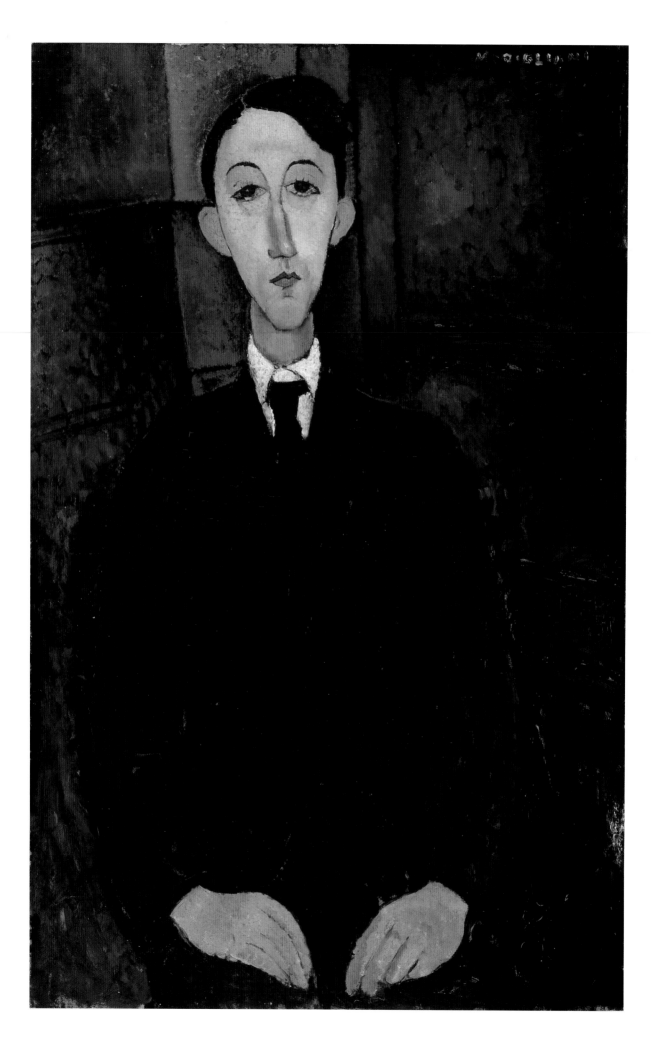

(opposite)

PLATE 43
Portrait of the Painter Manuel Humbert, 1916
Oil on canvas, 39 ½ x
25 ¾ in. (100.2 x 65.5 cm)
National Gallery of Victoria,
Melbourne, Australia, Felton
Bequest, 1948 (1854-4)

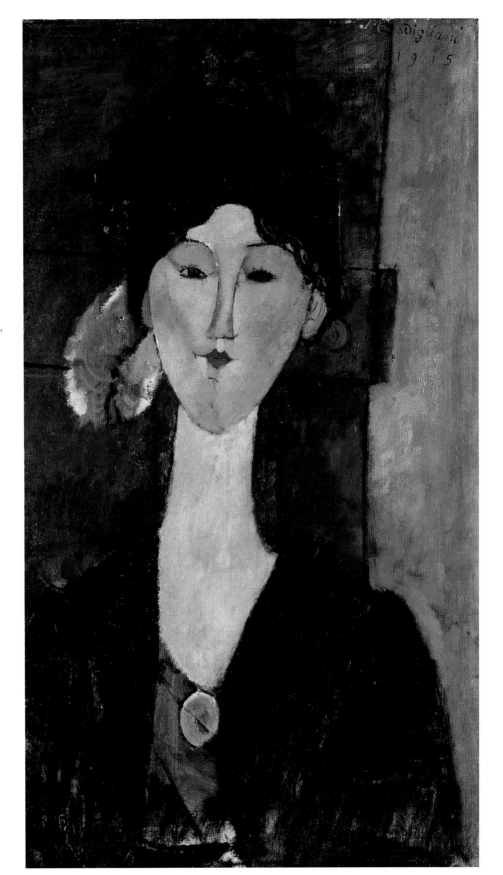

PLATE 44
Beatrice Hastings in Front of a Door, 1915
Oil on canvas, 32 x 18 ¼ in.
(81.3 x 46.4 cm)
Private collection, courtesy
Ivor Braka Ltd., London

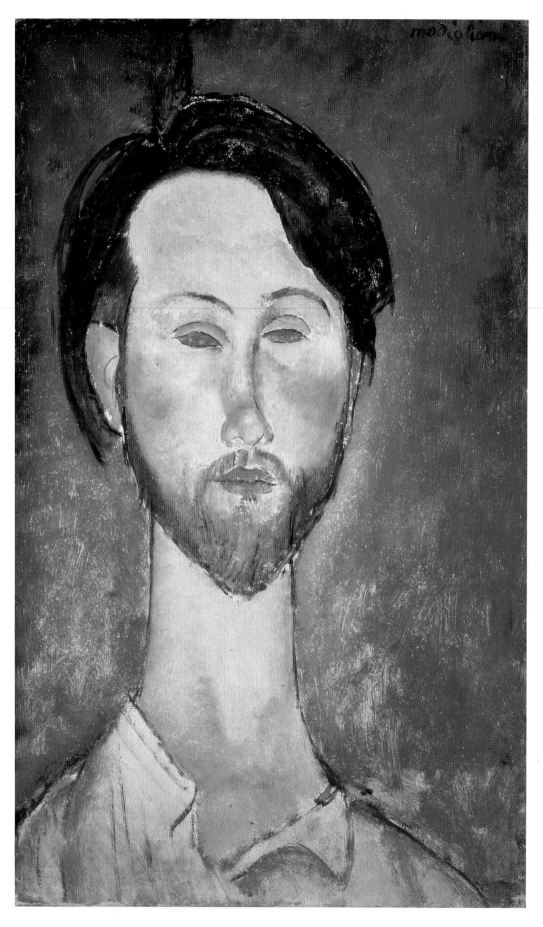

PLATE 45
Leopold Zborowski, 1918
Oil on canvas, 18 ⅛ x 10 ⅝ in. (46 x 27 cm)
Private collection

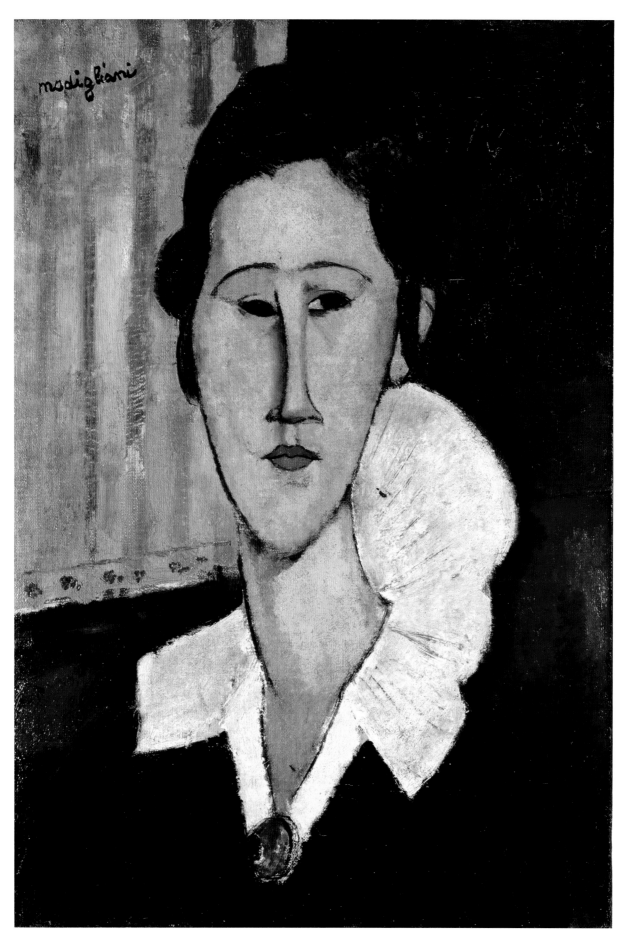

PLATE 46
Hanka Zborowska, 1917
Oil on canvas, 21 ⅝ x 15 in. (55 x 38 cm)
Galleria Nazionale d'Arte Moderna, Rome (4731)

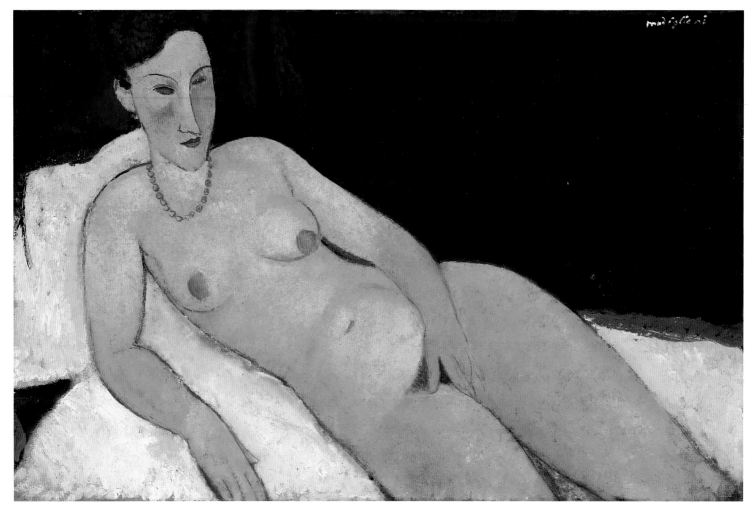

PLATE 47
Nude with Coral Necklace, 1917
Oil on canvas, 26 3/16 x 39 1/8 in. (64.4 x 99.4 cm)
Allen Memorial Art Museum, Oberlin College, Ohio,
Gift of Joseph and Enid Bissett, 1955 (AMAM 1955.59)

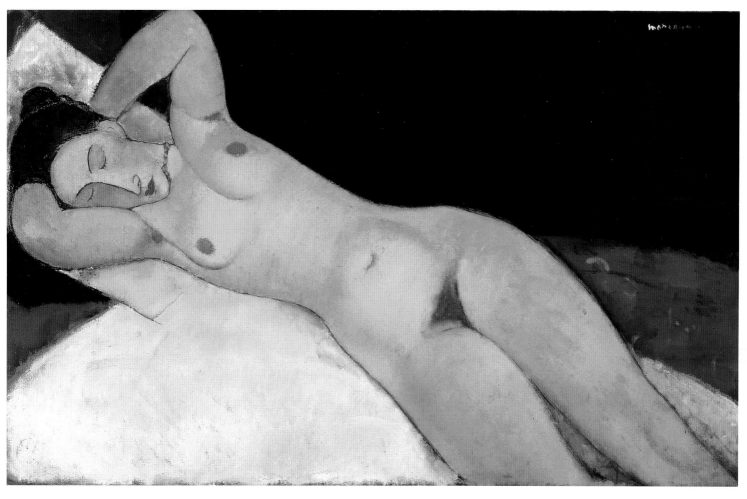

PLATE 48
Nude, 1917
Oil on canvas, 28 ¾ x 45 ⅞ in. (73 x 116.7 cm)
The Solomon R. Guggenheim Museum, New York,
Gift of Solomon R. Guggenheim, 1941 (41.535)

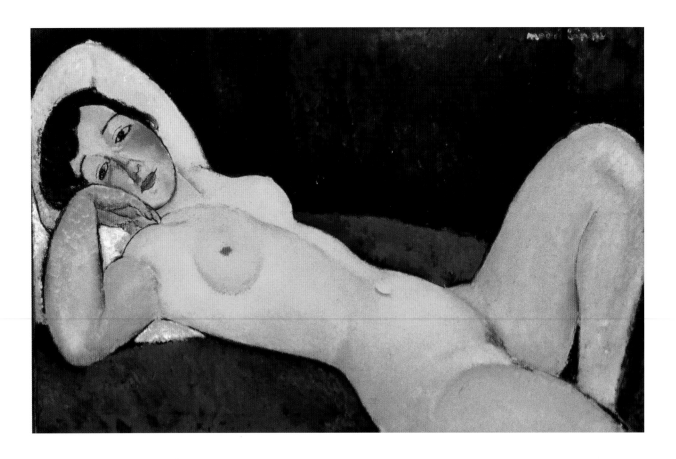

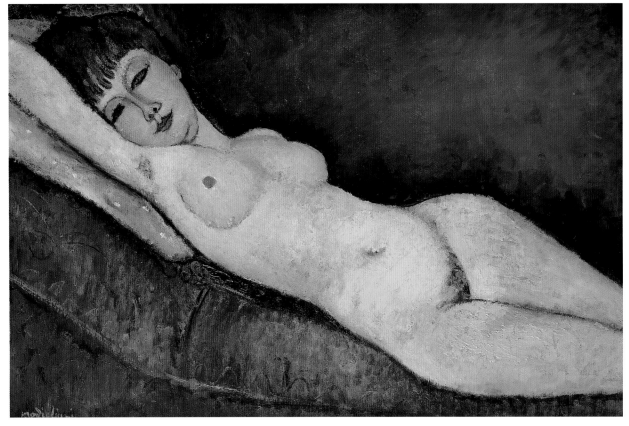

PLATE 49
Reclining Nude (La rêveuse),
1917
Oil on canvas, 23 ½ x
36 ¼ in. (59.7 x 92.1 cm)
Collection of William I.
Koch

PLATE 50
*Reclining Nude on a Blue
Cushion,* 1916
Oil on canvas, 23 ⅝ x
36 ¼ in. (60 x 92 cm)
Private collection

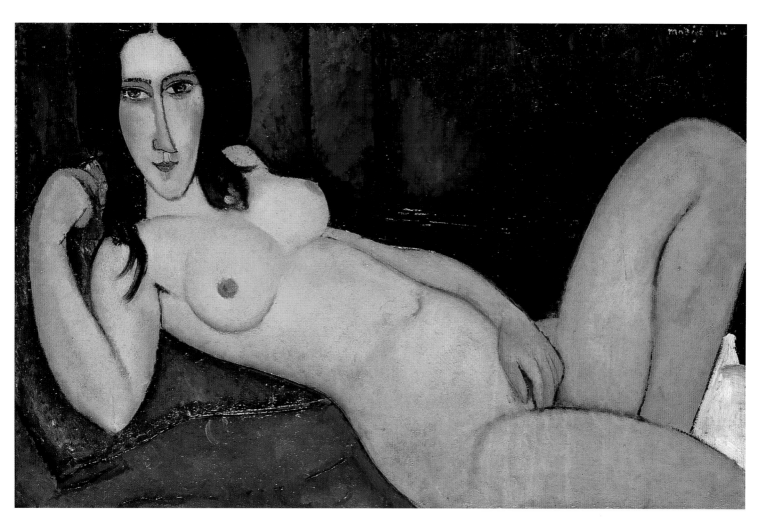

PLATE 51
*Reclining Nude with Loose
Hair*, 1917
Oil on canvas, 23 x
36 ¼ in. (60 x 92.2 cm)
Osaka City Museum of
Modern Art, Japan (125)

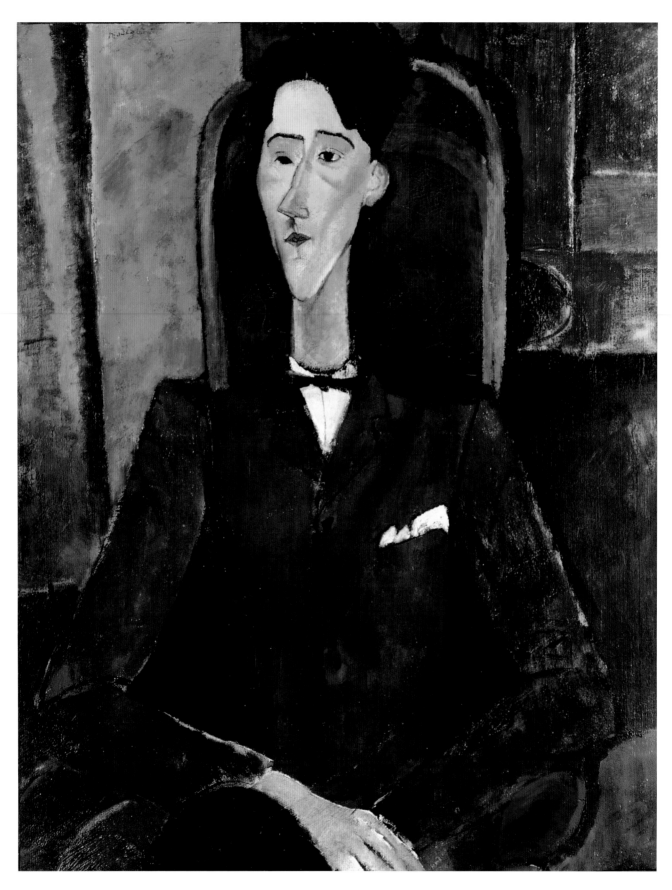

PLATE 52
Jean Cocteau, 1916–17
Oil on canvas, 39 ½ x 32 in.
(100.4 x 81.3 cm)
The Henry and Rose
Pearlman Foundation, Inc.

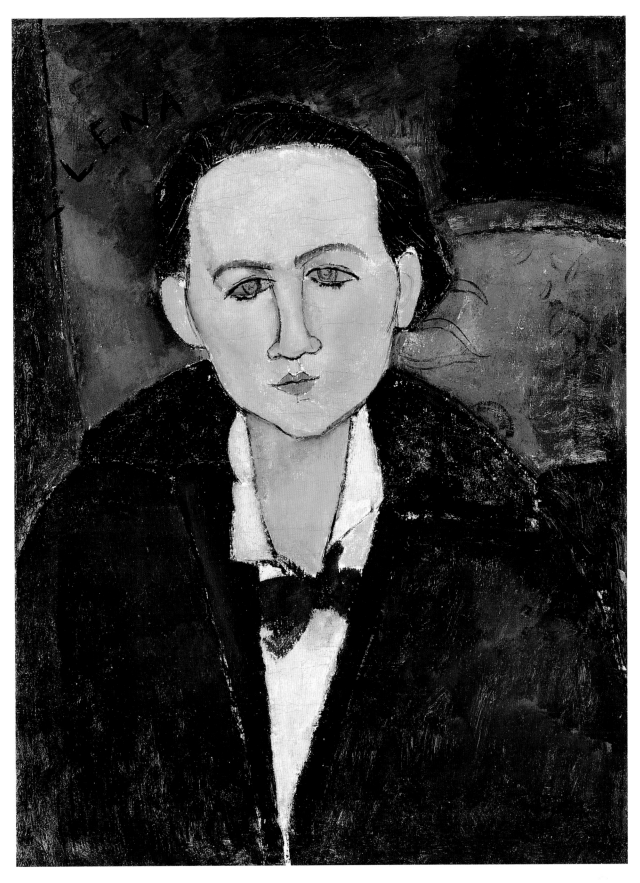

PLATE 53
Elena Povolozky, 1917
Oil on canvas, 25 ½ x
19 ⅛ in. (64.6 x 48.5 cm)
The Phillips Collection,
Washington, D.C. (1396)

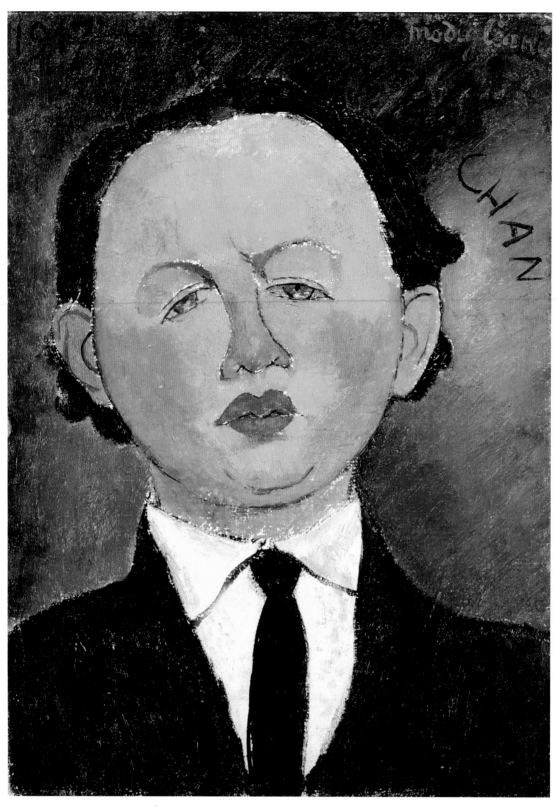

PLATE 54
Oscar Miestchaninoff, 1917
Oil on canvas, 18 ⅛ x 13 in.
(46 x 33 cm)
Helly Nahmad Gallery,
New York

(opposite)
PLATE 55
*Blue Eyes (Portrait of Madame
Jeanne Hébuterne)*, 1917
Oil on canvas, 21 ½ x 16 ⅞ in.
(54.6 x 42.9 cm)
Philadelphia Museum of Art,
The Samuel S. White 3rd and
Vera White Collection, 1967
(1967-30-59)

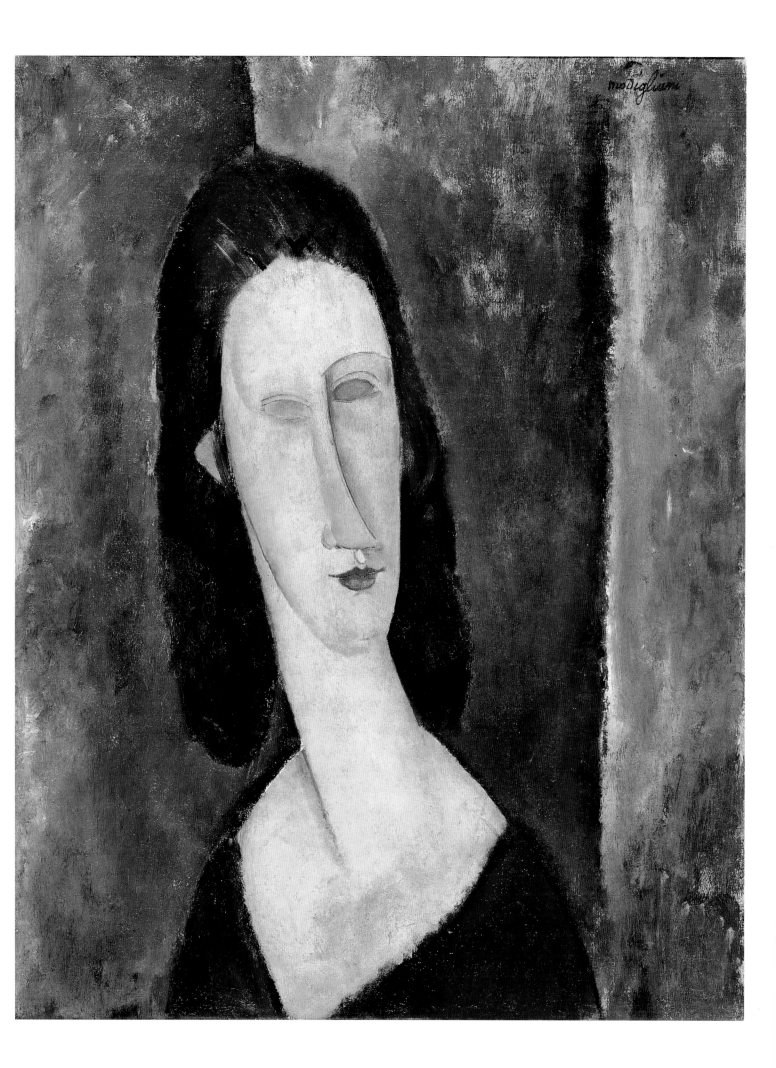

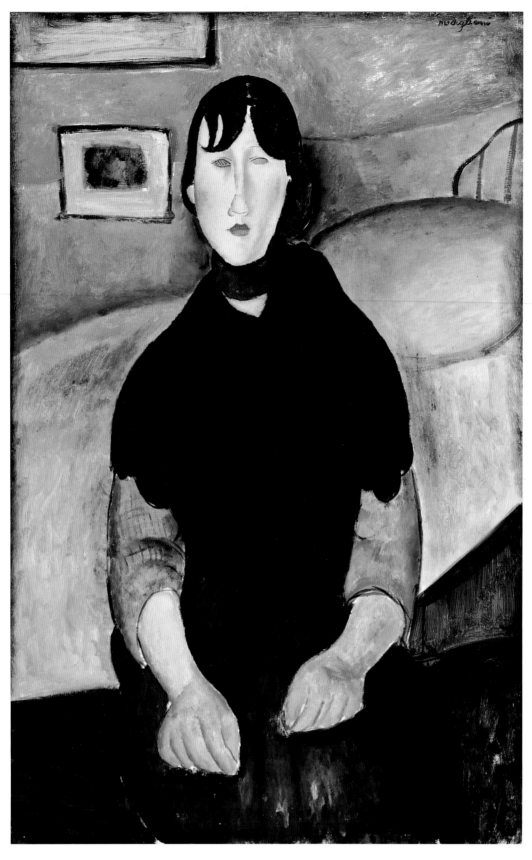

PLATE 56
Young Woman of the People, 1918
Oil on canvas, 39 ³⁄₈ x 25 ³⁄₈ in. (100 x 64.5 cm)
Los Angeles County Museum of Art, Frances and Armand
Hammer Purchase Fund (M.68.46.2)

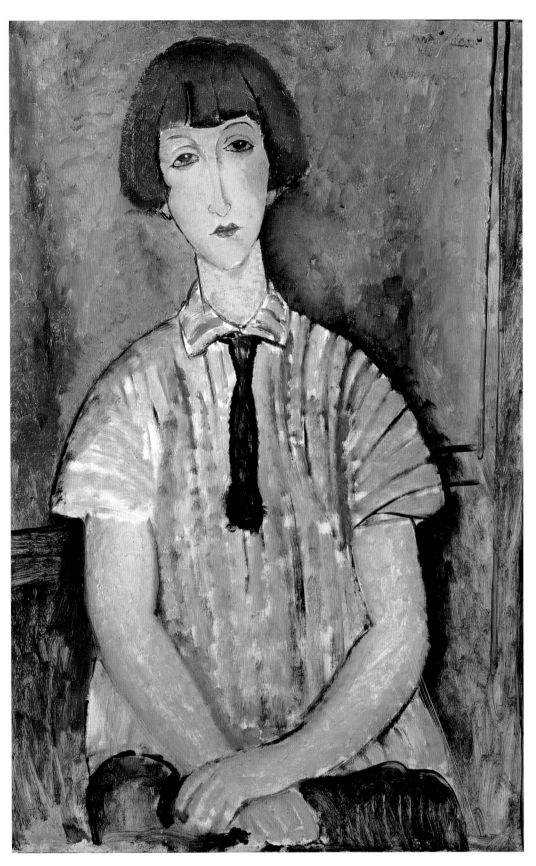

PLATE 57
Young Woman in a Striped Blouse, 1917
Oil on canvas, 36 ¼ x 23 ⅝ in. (92 x 60 cm)
Helly Nahmad Gallery, New York

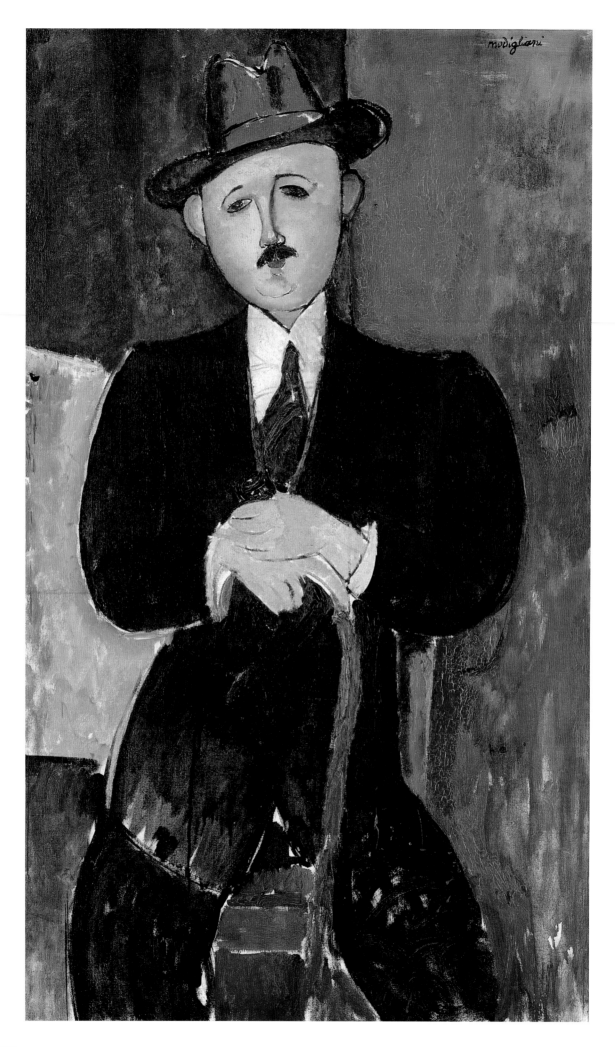

PLATE 58
Seated Man with a Cane, 1918
Oil on canvas, 49 ⅝ x
29 ½ in. (126 x 75 cm)
Helly Nahmad Gallery,
New York

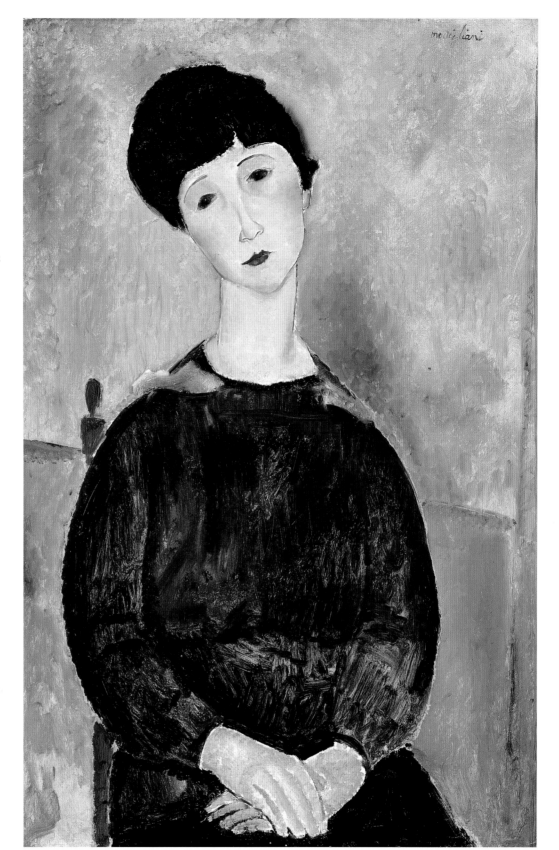

PLATE 59
*Young Seated Girl with Brown
Hair*, 1918
Oil on canvas, 36 ¼ x
37 ⅝ in. (92 x 95.5 cm)
Musée National Picasso,
Paris, Donated by Picasso
(R.F. 1973–81)

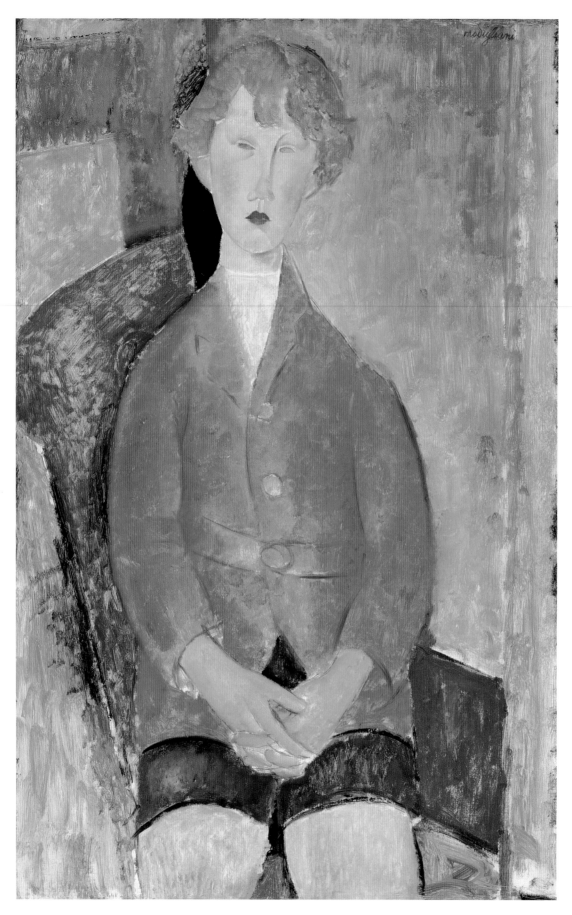

PLATE 60

Boy in Short Pants, 1918

Oil on canvas, 39 ½ x 25 ½ in. (100.3 x 64.8 cm)

Dallas Museum of Art, Gift of the Leland Fikes Foundation,

Inc. (1977.1)

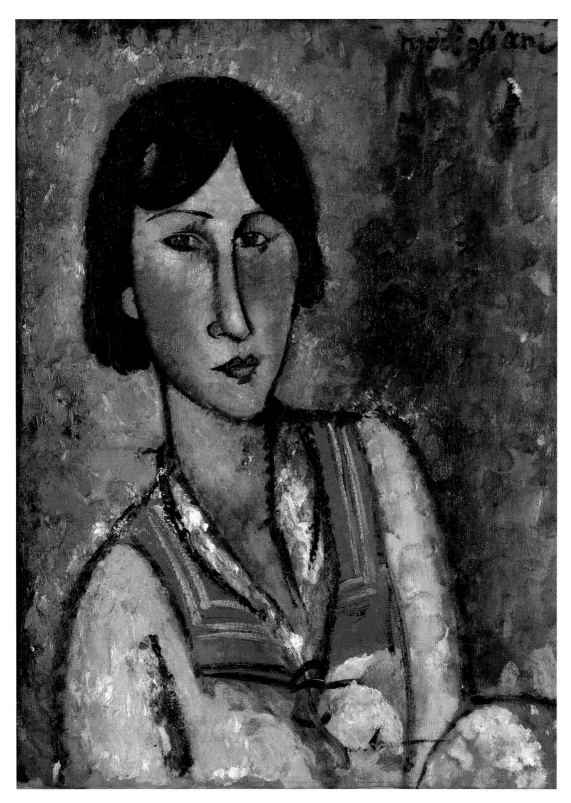

PLATE 61
Portrait of a Woman, 1918
Oil on canvas, 24 x 18 ⅛ in. (61 x 46 cm)
Denver Art Museum, Charles Francis Hendrie Memorial
Collection (1966.180)

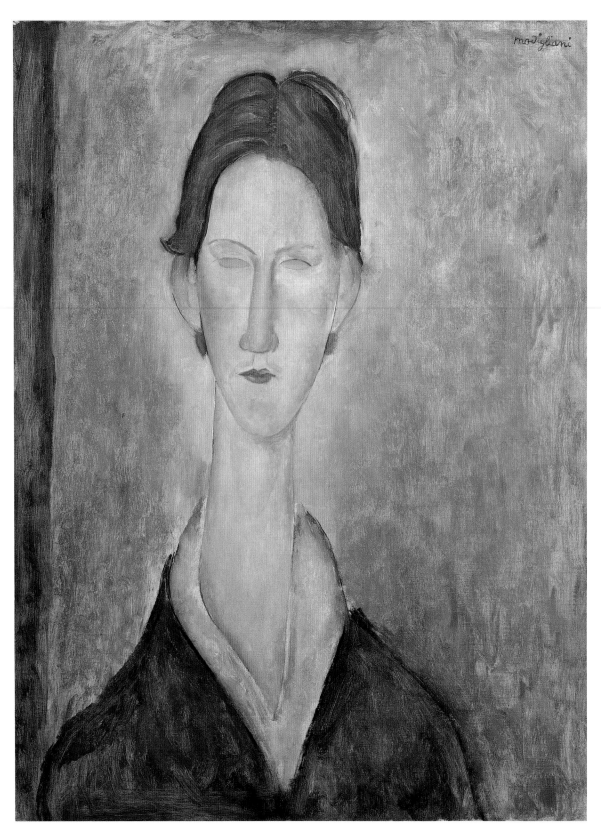

PLATE 62

Portrait of a Student, c. 1918–19

Oil on canvas, 24 x 18 ⅛ in. (61 x 46 cm)

The Solomon R. Guggenheim Museum, New York (94.44.82)

PLATE 63
The Servant Girl, c. 1918
Oil on canvas, 60 x 24 in.
(152.4 x 61 cm)
Albright-Knox Art Gallery,
Buffalo, New York, Room
of Contemporary Art Fund,
1939 (RCA1939:6)

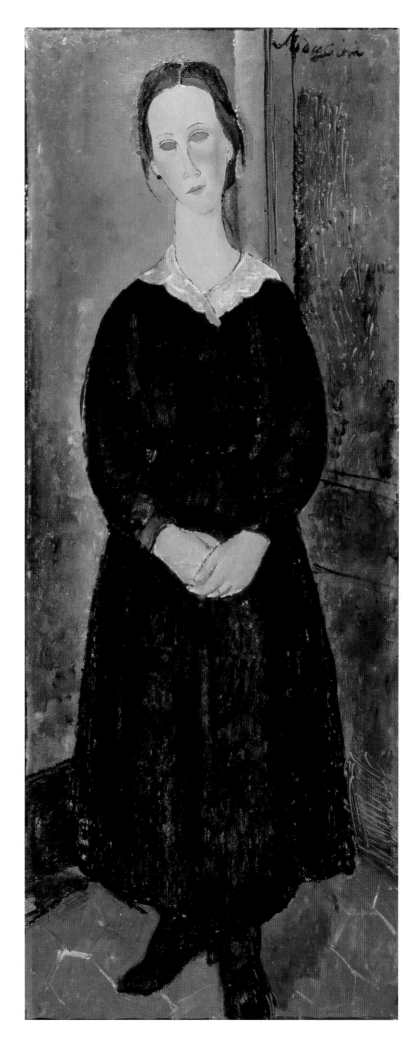

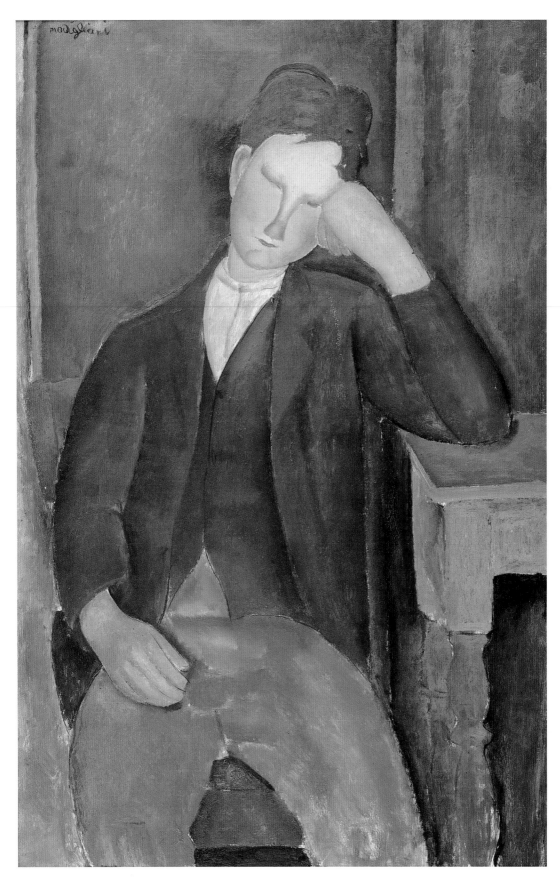

PLATE 64
The Young Apprentice, c. 1918
Oil on canvas, 39 ⅜ x 25 ⅝ in. (100 x 65 cm)
Musée de l'Orangerie, Paris, Walter-Guillaume Collection
(RF:1963-71)

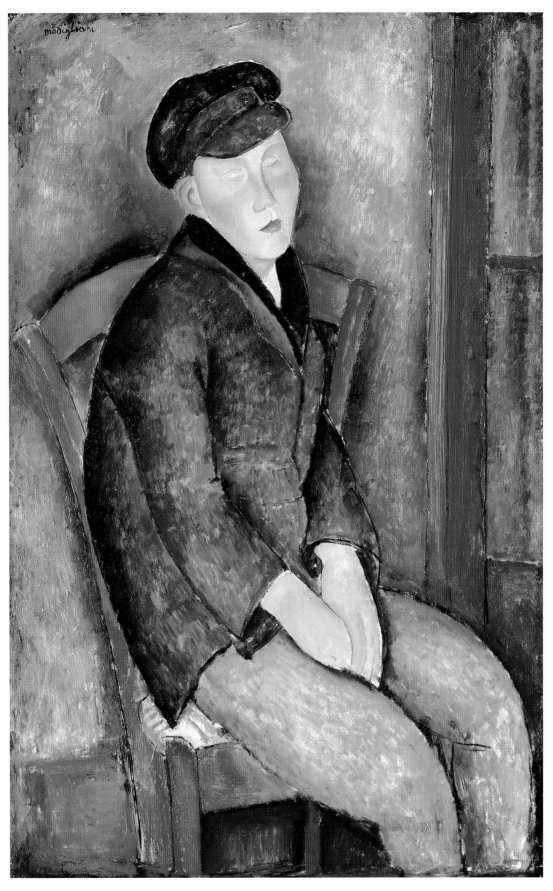

PLATE 65
Young Seated Boy with Cap, 1918
Oil on canvas, 39 ⅜ x 25 ⅝ in. (100 x 65 cm)
Private collection

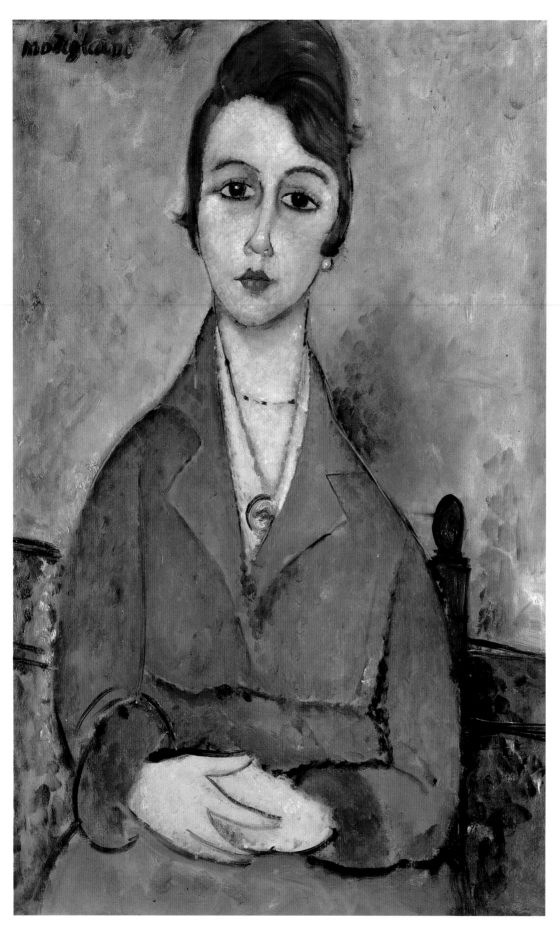

PLATE 66
Young Lolotte, 1918
Oil on canvas, 36 ⅛ x 23 ⅝ in. (92 x 60 cm)
Private collection, Switzerland

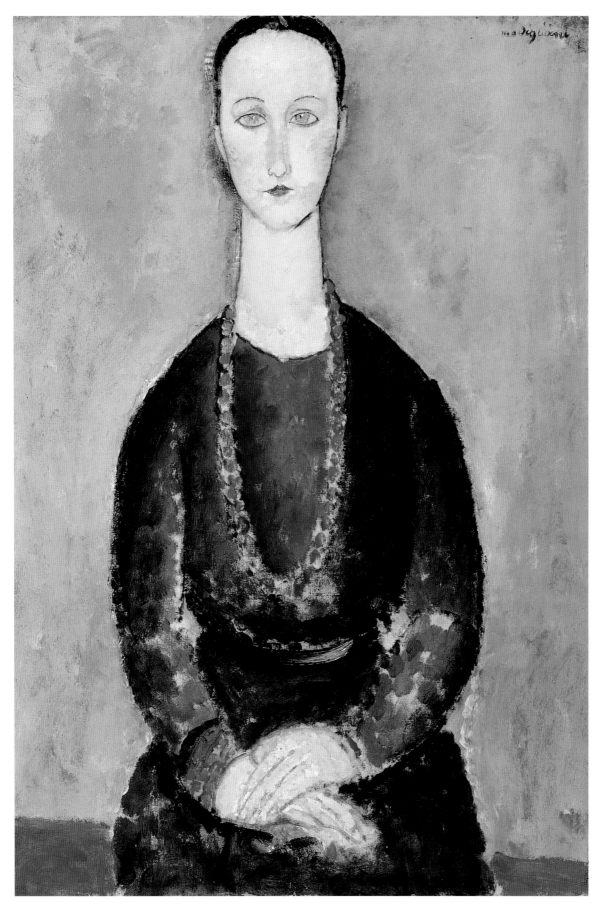

PLATE 67

Woman with Red Necklace, c. 1919

Oil on canvas, 36 ⅜ x 25 ¾ in. (92.4 x 65.4 cm)

Cincinnati Art Museum, Ohio, Bequest of Mary E. Johnston

(1976.1115)

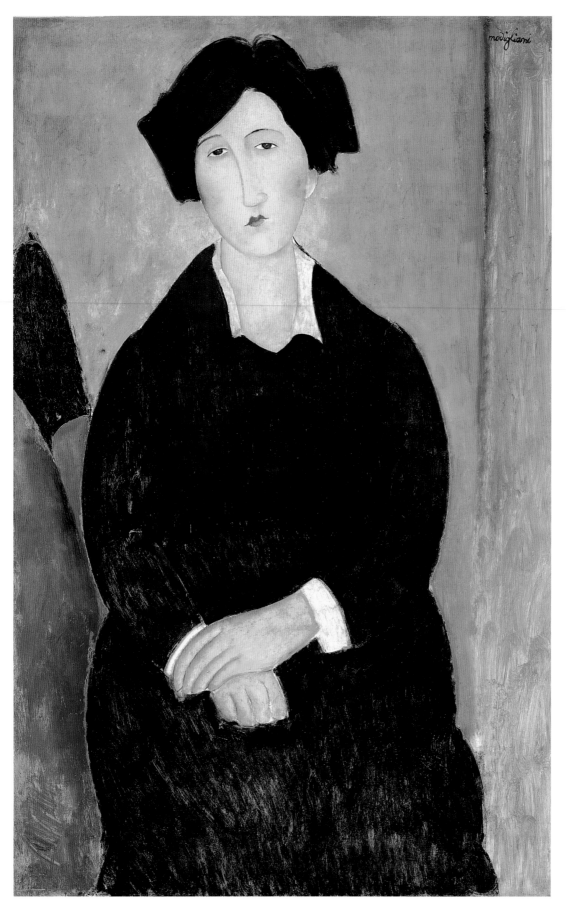

PLATE 68
The Italian Woman, 1917
Oil on canvas, 40 ⅜ x 26 ⅜ in. (102.6 x 67 cm)
The Metropolitan Museum of Art, Gift of the Chester Dale
Collection, 1956 (56.4)

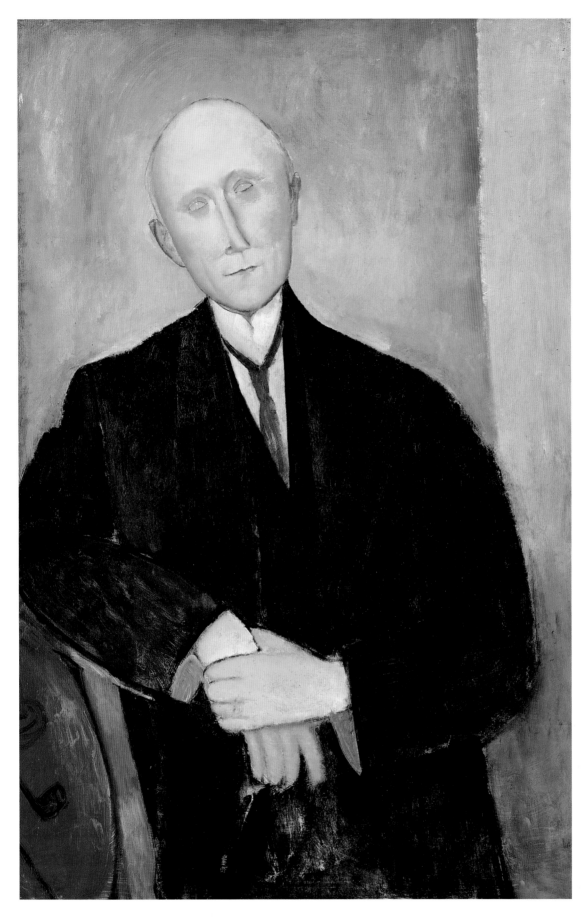

PLATE 69
Seated Man with Orange Background, 1918
Oil on canvas, 39 ³⁄₈ x 25 ⁵⁄₈ in. (100 x 65 cm)
Private collection

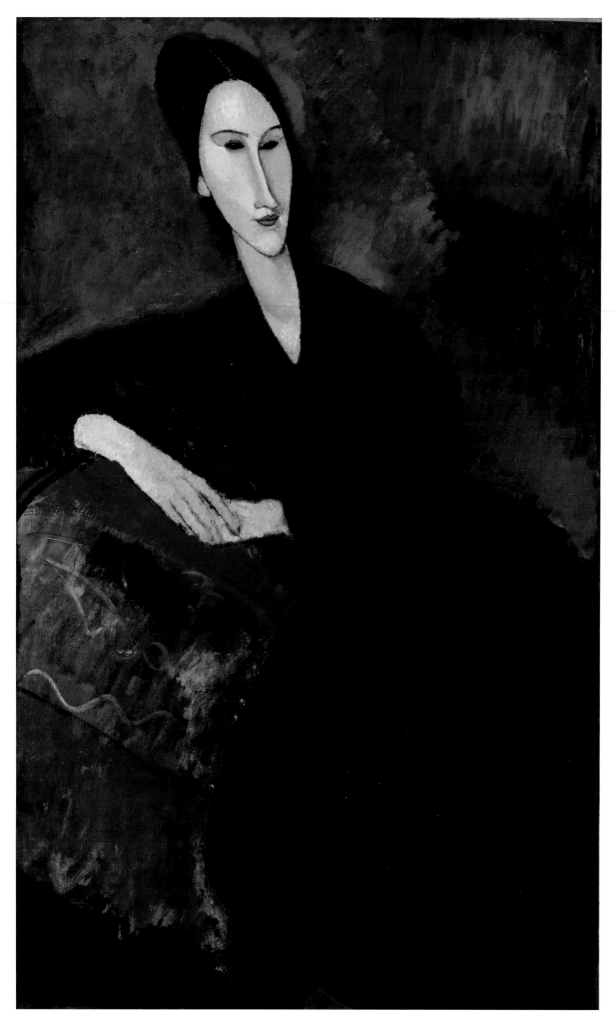

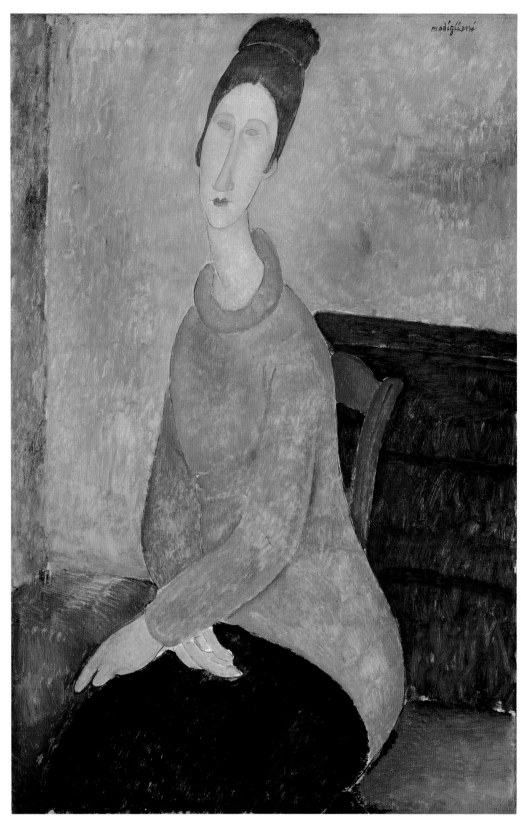

(opposite)

PLATE 70

Anna Zborowska, 1917

Oil on canvas, 51 ¼ x 32 in.

(130.2 x 81.3 cm)

The Museum of Modern

Art, New York, Lillie P. Bliss

Collection, 1934 (87.1934)

PLATE 71

Jeanne Hébuterne with Yellow

Sweater, 1918–19

Oil on canvas, 39 ³/₈ x

25 ½ in. (98.9 x 64.7 cm)

The Solomon R.

Guggenheim Foundation,

New York, Gift, Solomon

R. Guggenheim, 1937

(37.533)

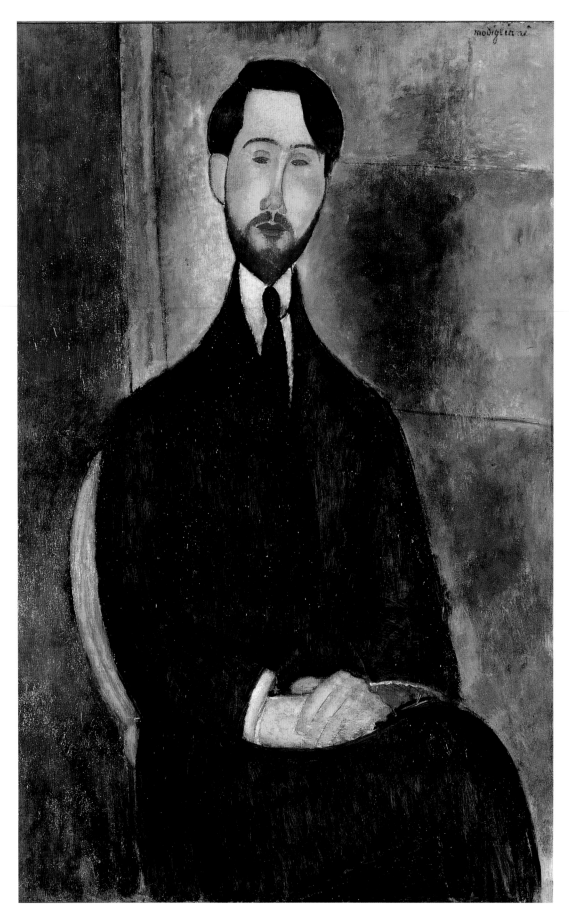

PLATE 72
Leopold Zborowski, 1919
Oil on canvas, 39 ³⁄₈ x 25 ⁵⁄₈ in. (100 x 65 cm)
Museu de Arte de São Paulo Assis Chateaubriand

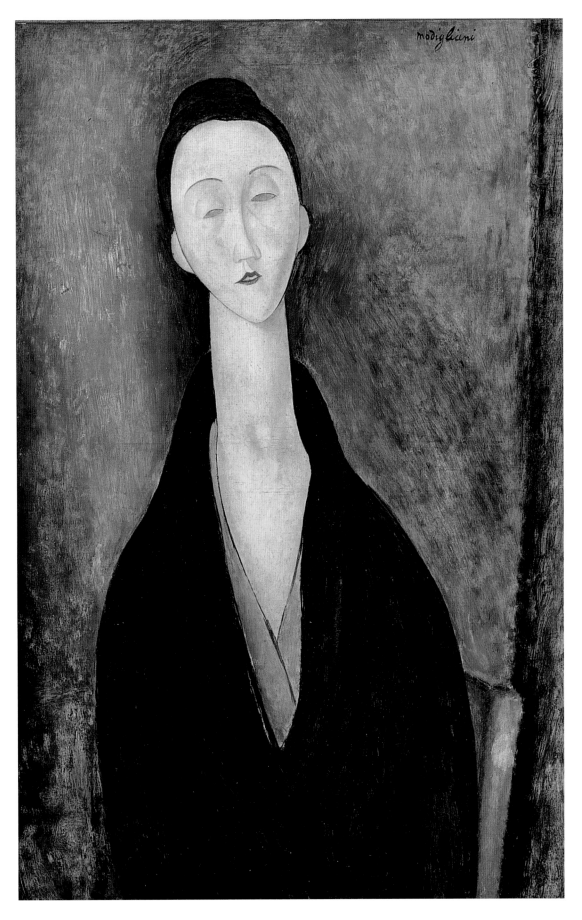

PLATE 73
Lunia Czechowska, c. 1918
Oil on canvas, 31 ½ x 20 ½ in. (80 x 52 cm)
Museu de Arte de São Paulo Assis Chateaubriand

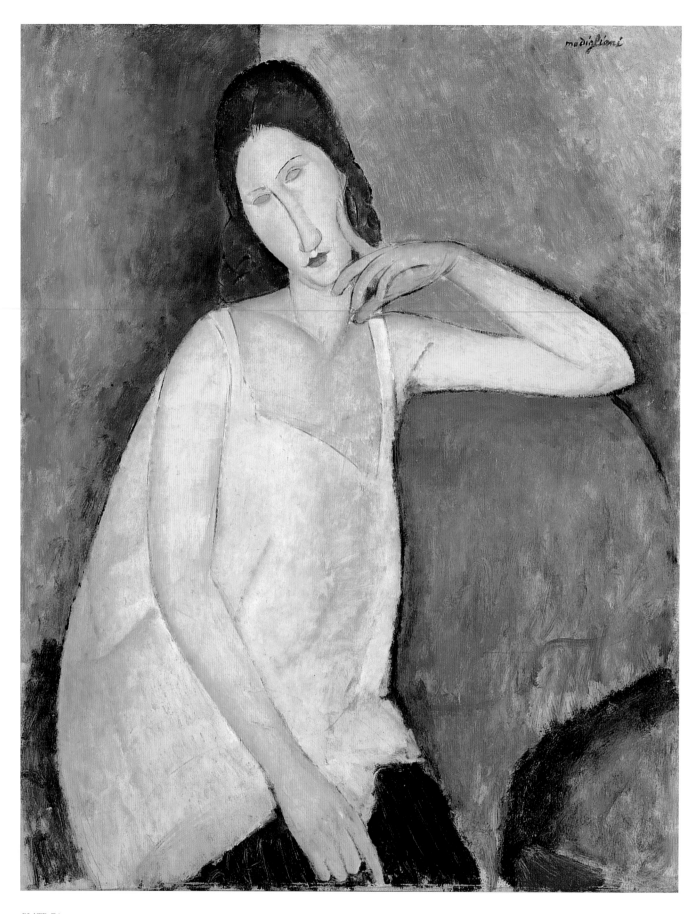

PLATE 74
Jeanne Hébuterne, 1919
Oil on canvas, 36 x 28 ¾ in. (91.4 x 73 cm)
The Metropolitan Museum of Art, Gift of Mr. and Mrs. Nate
B. Spingold, 1956 (56.184.2)

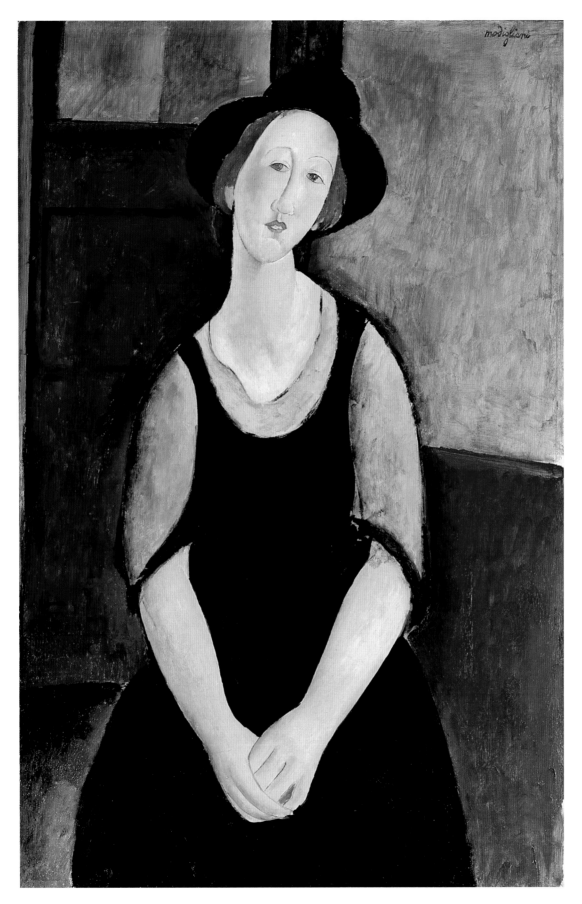

PLATE 75
Portrait of Thora Klinckowström, 1919
Oil on canvas, 39 ¼ x 25 ½ in. (99.7 x 64.8 cm)
The Estate of Evelyn Sharp

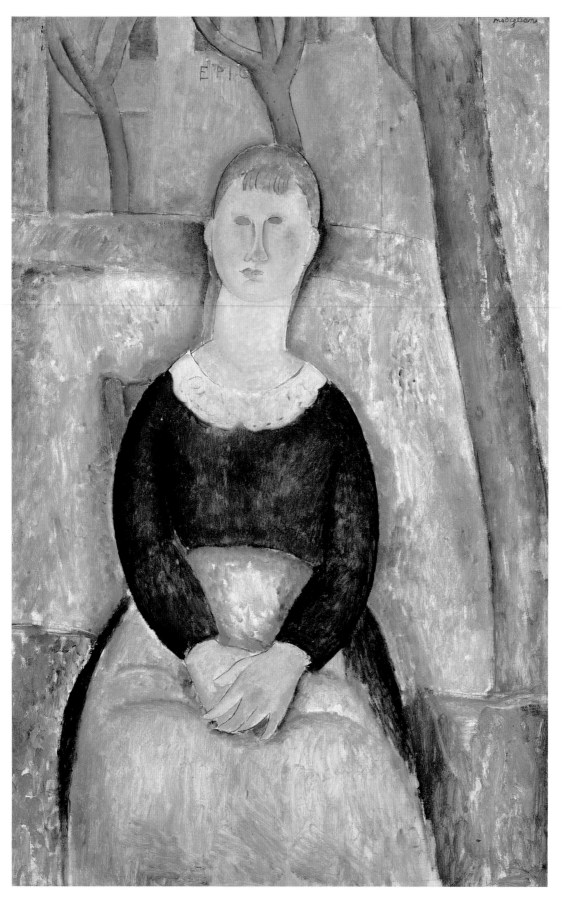

PLATE 76
La belle épicière, 1918
Oil on canvas, 39 ⅜ x 25 ⅝ in. (100 x 65 cm)
Helly Nahmad Gallery, New York

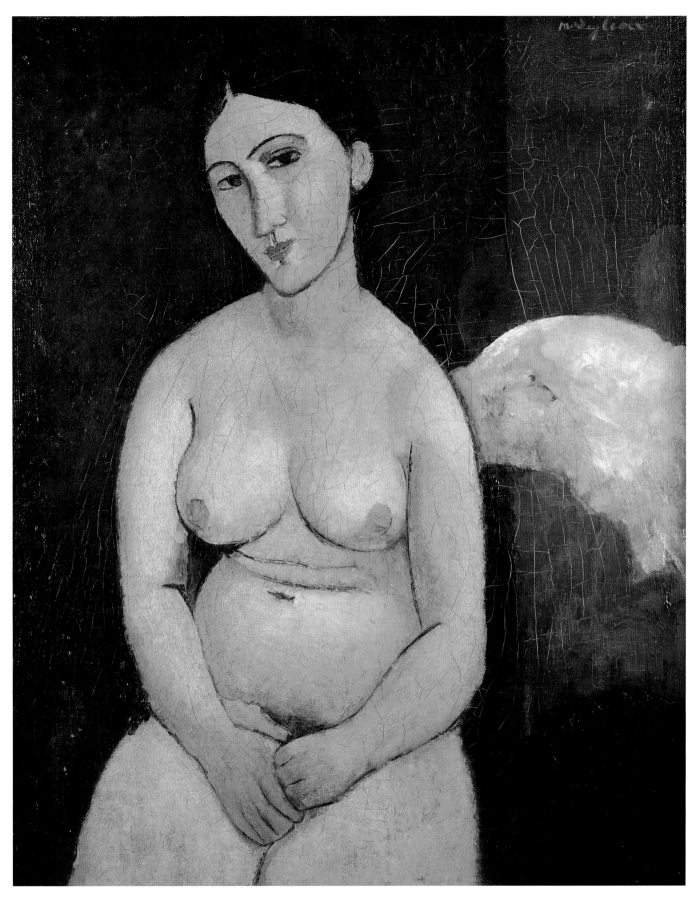

PLATE 77
Seated Nude, 1917
Oil on canvas, 32 x 25 ⅝ in. (81.2 x 65 cm)
Private collection

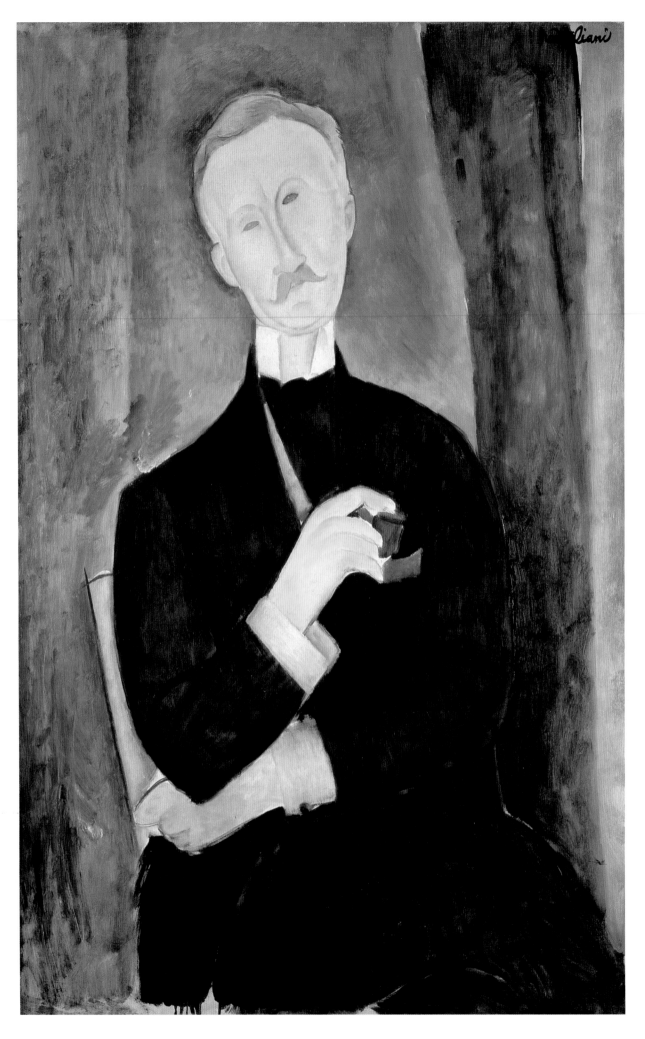

162

(opposite)
PLATE 78
Roger Dutilleul, 1919
Oil on canvas, 39 ⅜ x
25 ⅝ in. (100 x 65 cm)
Private collection

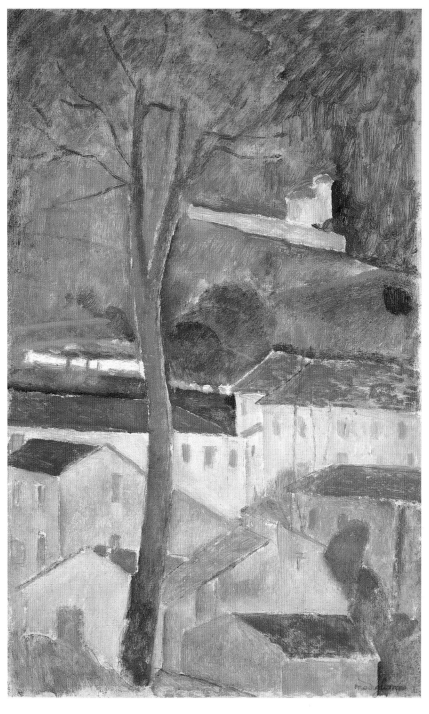

PLATE 79
Landscape at Cagnes, 1919
Oil on canvas, 18 ⅛ x
11 ⅜ in. (46 x 29 cm)
Private collection

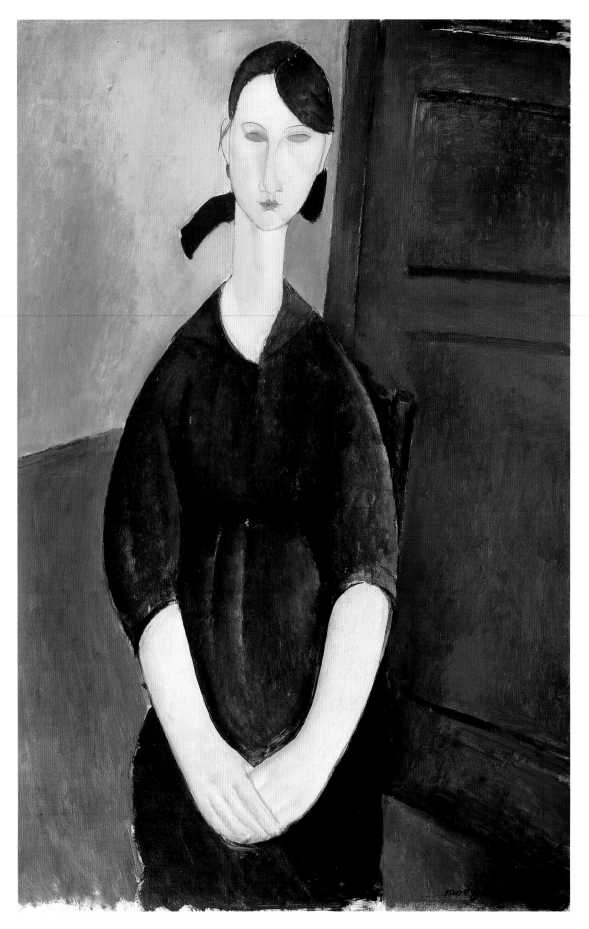

PLATE 80
Paulette Jourdain, 1919
Oil on canvas, 39 ⅜ x 25 ⅝ in. (100 x 65 cm)
Mr. A. Alfred Taubman

PLATE 82
Female Acrobat, c. 1910
Pencil on paper, 20 ½ x
14 ⅝ in. (52 x 37 cm)
Courtesy Galerie Cazeau-
Béraudière, Paris

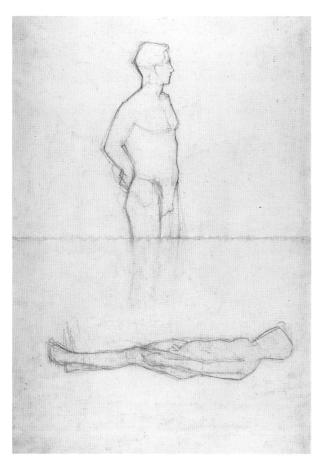

PLATE 81
Young Male Nude, 1896
Pencil on cardboard, 23 ⅜ x
16 ¾ in. (59.3 x 42.5 cm)
Museo Civico Giovanni
Fattori, Livorno

PLATE 83
The Acrobat (Le pitre), c. 1912
Crayon on paper, 17 x
10 ¼ in. (43.2 x 26 cm)
Private collection

PLATE 84
Dancer, n.d.
Pencil on paper, 15 ¾ x
10 ½ in. (40 x 26.6 cm)
Private collection, New York

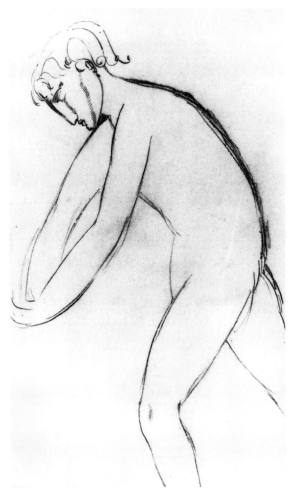

PLATE 86
Woman, Heads, and Jewish Symbols, 1915
Pencil and watercolor on paper, 21 ½ x 16 ⅞ in. (54.5 x 43 cm)
Private collection, Italy

PLATE 85
Faun, n.d.
Crayon on paper, 15 ¾ x
10 ¼ in. (40 x 26.2 cm)
Private collection, New York

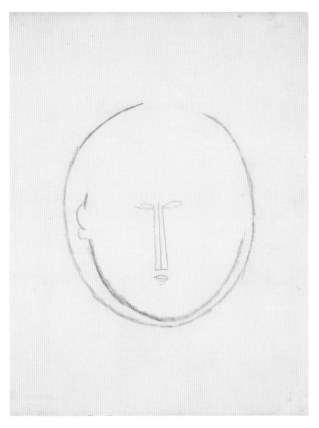

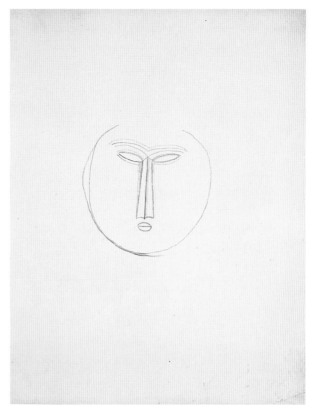

PLATE 87
Round Face in Circle, c. 1910–14
Red chalk on paper, 13 ¼ x
10 ⅜ in. (33.8 x 26.3 cm)
Öffentliche Kunstsammlung
Basel, Kupferstichkabinett,
Karl August Burckhardt-
Koechlin-Fonds (1961.133)

PLATE 88
Round Face, c. 1910–14
Blue chalk on paper, 13 ¼ x
10 ⅜ in. (33.8 x 26.3 cm)
Öffentliche Kunstsammlung
Basel, Kupferstichkabinett,
Karl August Burckhardt-
Koechlin-Fonds (1961.134)

PLATE 89
Face and Column, c. 1910
Black and blue chalk on
paper, 13 ¼ x 10 ⅜ in.
(33.8 x 26.3 cm)
Öffentliche Kunstsammlung
Basel, Kupferstichkabinett,
Karl August Burckhardt-
Koechlin-Fonds (1961.141)

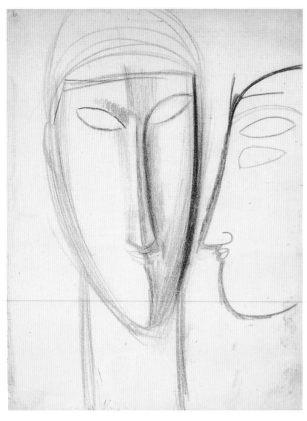

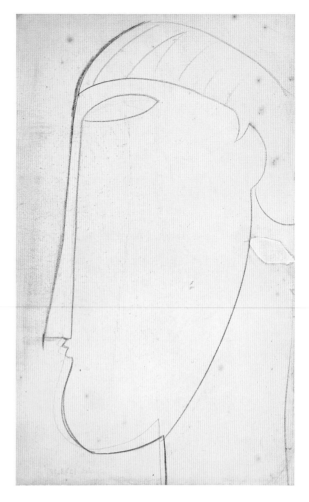

(above)

PLATE 90

Heads, c. 1910

Blue chalk on paper, 13 ¼ x
10 ⅜ in. (33.8 x 26.3 cm)
Öffentliche Kunstsammlung
Basel, Kupferstichkabinett,
Karl August Burckhardt-
Koechlin-Fonds (1961.137)

(above right)

PLATE 91

Head in Profile, 1912

Blue crayon on paper,
17 ⅜ x 10 ½ in. (44 x
26.7 cm)
Musée National d'Art
Moderne, Centre Georges
Pompidou, Paris, Gift of
Marguerite Arp-Hagenbach,
1973 (AM 1973-18)

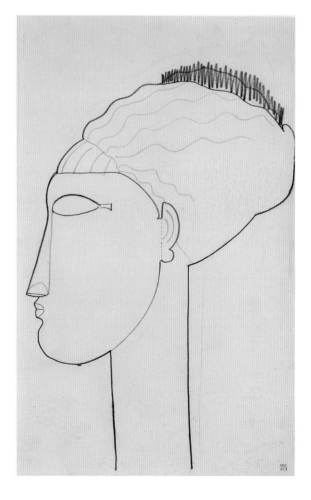

PLATE 92

Head in Left Profile, n.d.

Crayon on paper, 16 ¾ x
10 ¼ in. (42.5 x 25 cm)
Courtesy Galerie Cazeau-
Béraudière, Paris

PLATE 94
*Caryatid, Frontal View,
Half-Figure*, n.d.
Crayon on paper, 16 ¾ x
10 ¼ in. (42.5 x 26.3 cm)
Courtesy Richard
Nathanson, London

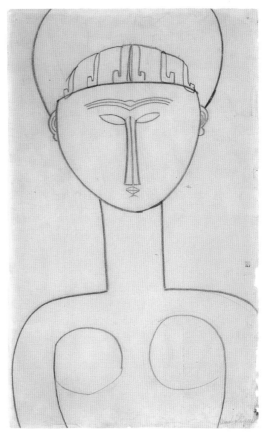

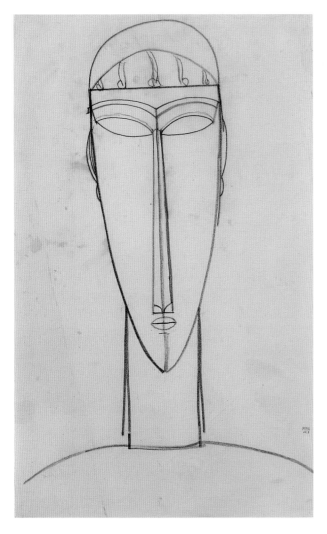

PLATE 93
*Head and Shoulders with
Fringe*, 1911
Crayon on paper, 16 ¾ x
10 ¼ in. (42.7 x 26.2 cm)
Courtesy Galerie Cazeau-
Béraudière, Paris

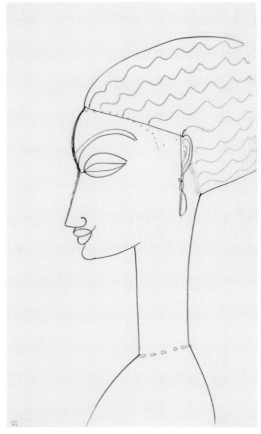

PLATE 95
Woman in Profile, 1910–11
Charcoal and pastel on paper, 17 x 10 ½ in. (42.9 x 26.7 cm)
The Museum of Modern Art, New York, The Joan and Lester
Avnet Collection (134.1978)

PLATE 96
*Sheet of Studies with African
Sculpture and Caryatid,*
c. 1912–13
Pencil on paper, 10 ³⁄₈ x
8 ¹⁄₈ in. (26.5 x 20.5 cm)
Steve Banks Fine Arts,
San Francisco

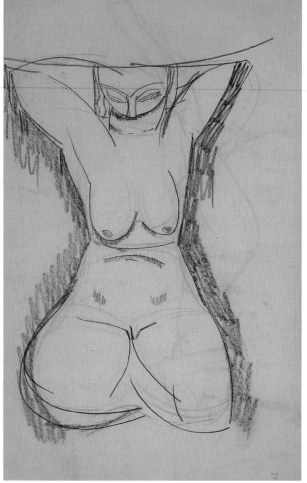

PLATE 98
*Caryatid (Cariatide
Monumentale)*, c. 1912–13
Crayon on paper, 17 x
10 ⁷⁄₈ in. (43.1 x 27.7 cm)
Musée des Beaux-Arts,
Rouen, Gift of Blaise
Alexandre, 2001 (2001.2.10)

PLATE 97
*Woman Dressed with a
Loincloth,* c. 1908
Red chalk on paper, 16 ⁷⁄₈ x
11 ¹⁄₈ in. (43 x 28.3 cm)
Musée des Beaux-Arts,
Rouen, Gift of Blaise
Alexandre, 2001 (2001.2.5)

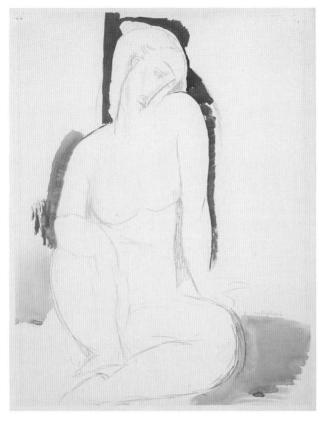

(top left)

PLATE 99
Seated Nude, 1914
Pencil and wash, watercolor
on paper, 21 ¼ x 16 ⅜ in.
(54 x 41.6 cm)
The Museum of Modern
Art, New York, Gift of Mrs.
Saidie A. May (29.1932)

(top right)

PLATE 100
Male Nude, 1916
Pencil and watercolor on
paper, 17 ⅛ x 10 ¼ in.
(43.5 x 26 cm)
Musée Calvet, Avignon
(22300)

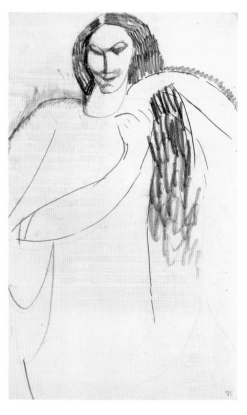

PLATE 101
Anadiomena, 1914
Graphite and crayon on white wove paper,
13 ⅜ x 10 ½ in. (33.9 x 26.5 cm)
Princeton University Art Museum,
Bequest of Dan Fellows Platt, Class of 1895
(1948-390)

PLATE 102
Woman Combing Her Hair, n.d.
Crayon on paper, 10 ⅝ x
7 ⅞ in. (26.9 x 19.9 cm)
Courtesy Galerie Cazeau-
Béraudière, Paris

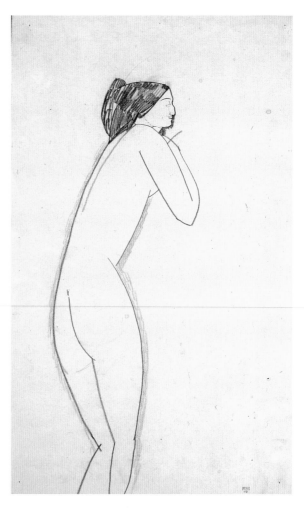

PLATE 104
Standing Female Nude (Anna Akhmatova), c. 1911
Blue crayon heightened with red gouache on paper, 16 ¾ x 10 ½ in. (42.6 x 26.5 cm)
Private collection, Paris

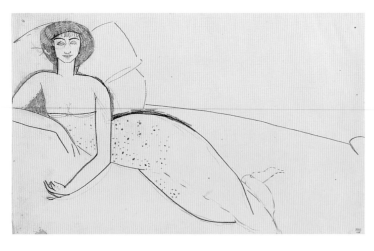

PLATE 103
Woman in a Low-Cut Gown, Reclining on a Bed, n.d.
Crayon on paper, 10 ⅜ x 16 ⅞ in. (26.4 x 43 cm)
Courtesy Galerie Cazeau-Béraudière, Paris

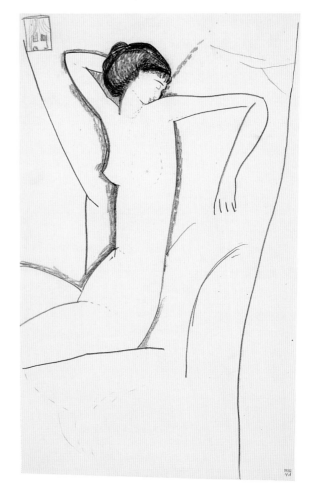

PLATE 105
Anna Akhmatova Seated, c. 1910–11
Crayon on paper, 16 ⅞ x 10 ⅜ in. (42.8 x 26.5 cm)
Musée des Beaux-Arts, Rouen, Long-term loan from Blaise Alexandre, 2002 (2002.1.1)

172

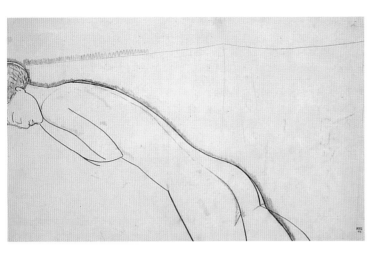

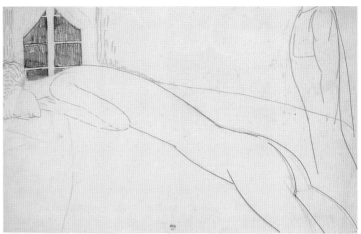

PLATE 106
*Female Nude Asleep (Anna
Akhmatova)*, c. 1910–11
Crayon on paper, 10 ⅜ x
16 ⅞ in. (26.5 x 43 cm)
Private collection, Paris

PLATE 107
*Female Nude Asleep, with
Standing Male Figure (Anna
Akhmatova)*, c. 1910–11
Crayon on paper, 10 ⅜ x
16 ⅞ in. (26.5 x 43 cm)
Musée des Beaux-Arts,
Rouen, Gift of Blaise
Alexandre, 2001 (2001.2.25)

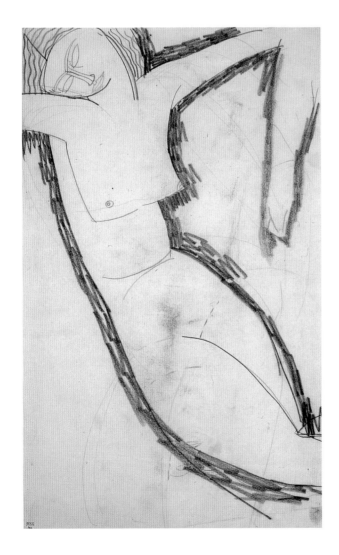

PLATE 108
*Female Nude Placed
Diagonally*, n.d.
Crayon on paper, 16 ⅞ x
10 ⅜ in. (43 x 26.5 cm)
Private collection, Paris

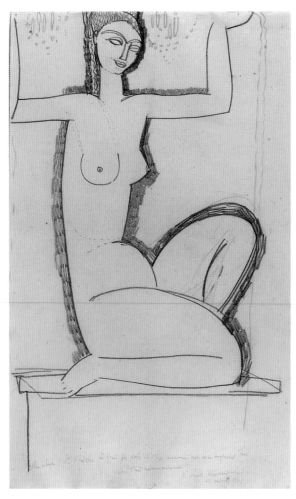

PLATE 109
Caryatid, c. 1912–13
Crayon on paper, 16 ⅞ x
10 ⅜ in. (43 x 26.5 cm)
Uzi Zucker, New York

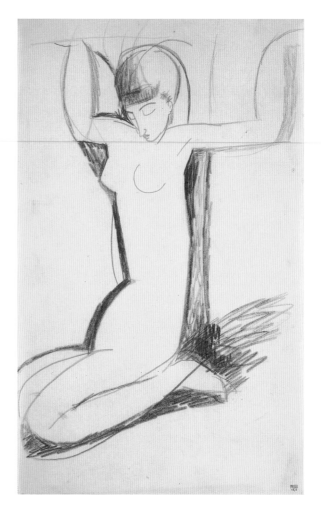

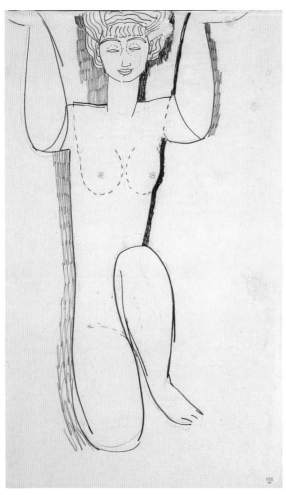

PLATE 110
*Kneeling Caryatid Sitting on
Her Heels*, 1911–12
Blue crayon on paper, 17 x
10 ½ in. (43 x 26.5 cm)
Courtesy Richard
Nathanson, London

PLATE 111
*Caryatid Kneeling on Right
Knee*, n.d.
Crayon on paper, 16 ⅞ x
10 ⅜ in. (43 x 26.5 cm)
Private collection, Paris


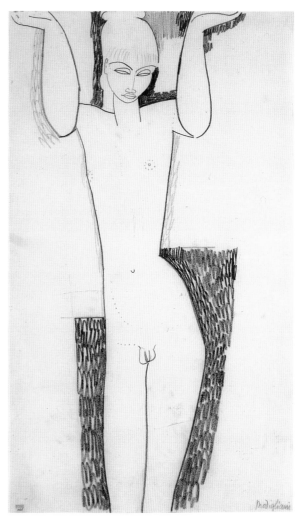

PLATE 113
Hermaphrodite Caryatid, 1911
Crayon on paper, 16 ⅞ x
10 in. (42.8 x 25.5 cm)
Patrick Derom Gallery,
Brussels

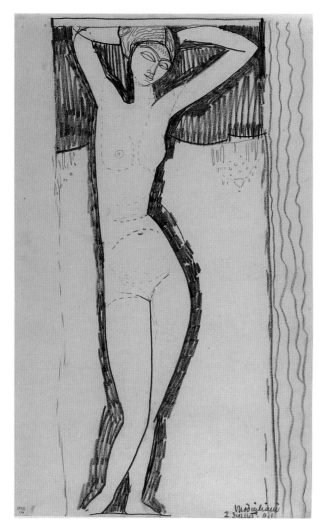

PLATE 112
*Caryatid, Hands Behind Her
Head*, 1911
Crayon on paper, 16 ⅞ x
10 ⅜ in. (42.8 x 26.4 cm)
Courtesy Galerie Cazeau-
Béraudière, Paris

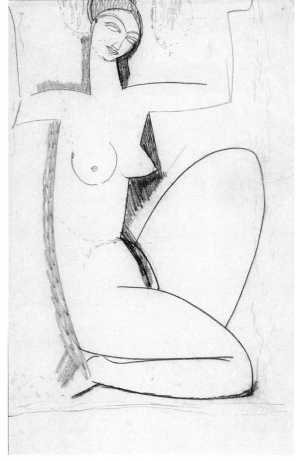

PLATE 114
Caryatid, c. 1912–13
Crayon on paper, 15 ⅝ x
10 ⅛ in. (39.7 x 25.7 cm)
Musée des Beaux-Arts,
Dijon (DG 244)

PLATE 116
The Cellist, c. 1909
Ink on paper, 10 ⅝ x
8 ¼ in. (27.1 x 21.1 cm)
Musée des Beaux-Arts,
Rouen, Gift of Blaise
Alexandre, 2001 (2001.2.36)

PLATE 115
L'Estatico, 1916
Graphite on paper, 16 ¾ x
10 ⅜ in. (42.5 x 26.5 cm)
Private collection

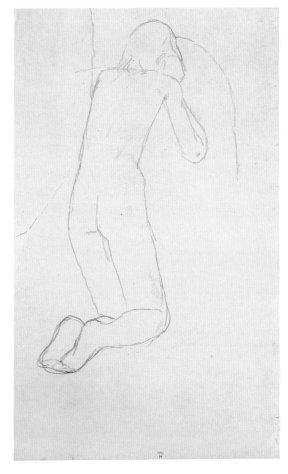

PLATE 117
Old Man in Prayer, 1910–11
Pencil on paper, 12 ¼ x
7 ⅞ in. (31.2 x 20 cm)
Private collection, Paris

PLATE 119
Motherhood, 1916
Pencil on paper, 14 ¼ x
10 ⅜ in. (36.2 x 26.5 cm)
The Museum of Modern
Art, New York, The John S.
Newberry Collection
(380.1960)

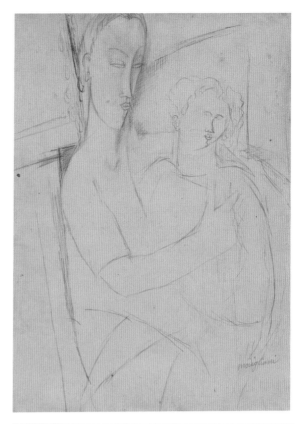

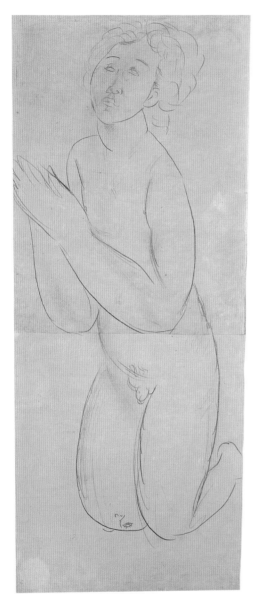

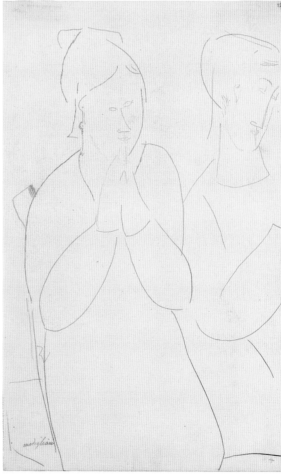

PLATE 118
Man in Prayer, 1916
Crayon on paper, 17 ⅛ x
10 ⅜ in. (43.4 x 26.5 cm)
Galleria Nazionale d'Arte
Moderna, Rome (5386-5)

PLATE 120
Two Young Peasants in Prayer, c. 1916
Graphite on paper, 16 ⅝ x 10 ⅜ in. (42.2 x 26.4 cm)
The Metropolitan Museum of Art, Gift of Mr. and Mrs. Sol
Fishko, 1981 (1981.33)

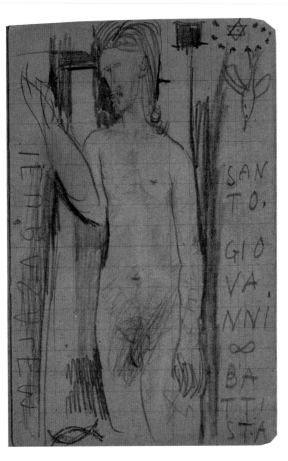

PLATE 121
St. John the Baptist, 1918
Pencil on notebook paper,
5 ⅝ x 3 ⅝ in. (14.3 x 9.3 cm)
Fondazione Antonio Mazzotta,
Milan

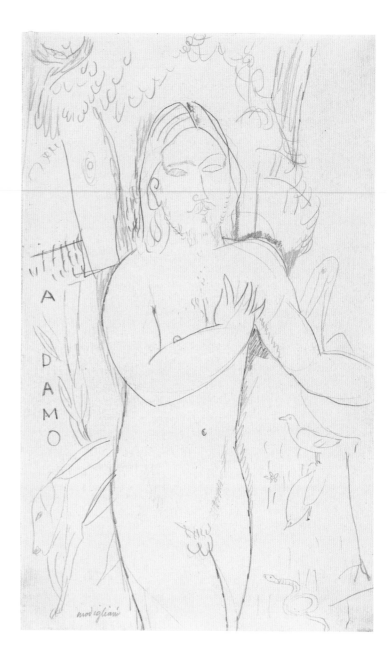

PLATE 122
Adam, 1915–16
Pencil on paper, 16 ⅞ x
10 ¼ in. (42.8 x 26 cm)
The Museum of Modern
Art, New York, The Joan
and Lester Avnet Collection
(135.1978)

PLATE 124
Self-Portrait (?), c. 1916
Pencil on paper, 13 ¼ x
10 ⅜ in. (33.8 x 26.5 cm)
Courtesy Galerie Cazeau-
Béraudière, Paris

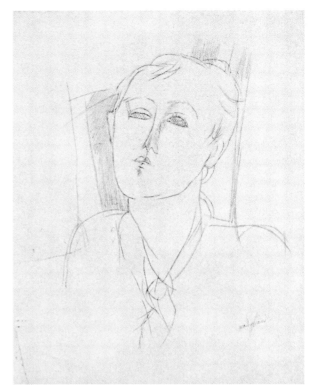

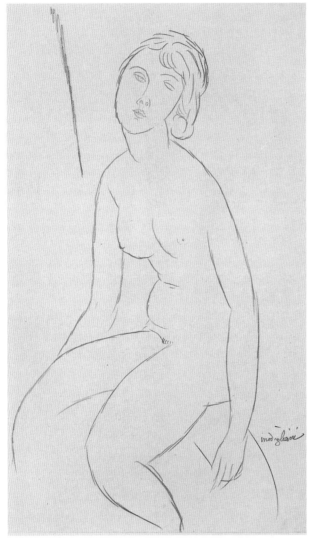

PLATE 123
Seated Nude, 1918
Graphite on tan wove paper,
16 ¾ x 9 ⅞ in. (42.5 x
25 cm)
The Art Institute of
Chicago, Given in Memory
of Tiffany Blake by Claire
Swift-Marwitz (1951.22)

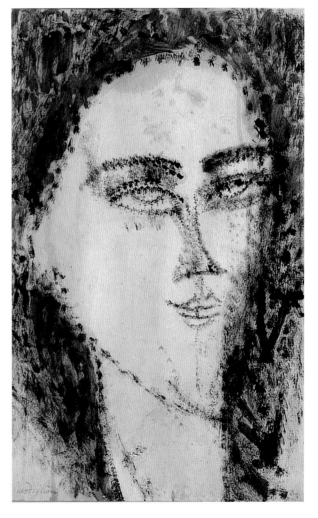

PLATE 125
Head, 1915
Oil on paper, 16 ⅜ x 10 ⅜ in.
(41.5 x 26.5 cm)
Musée Calvet, Avignon (22291)

179

PLATE 127
Portrait of Jeanne Hetenval, n.d.
Crayon and charcoal on
paper, 16 x 10 ¼ in.
(40.5 x 26.2 cm)
Private collection, New York

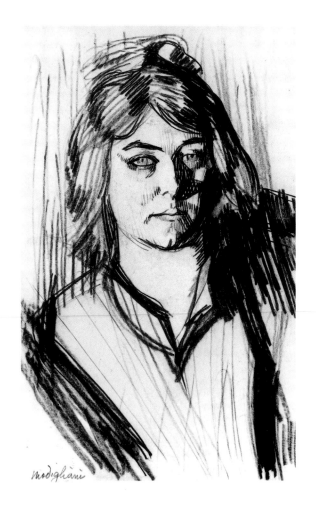

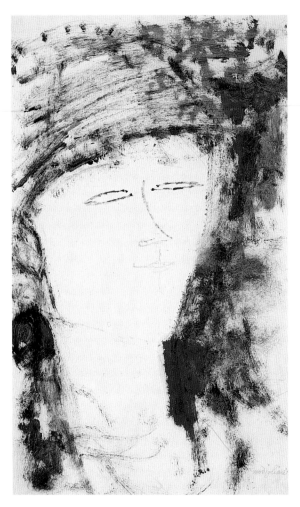

PLATE 126
Portrait of Beatrice Hastings,
1916
Oil and pencil on paper,
17 ⅛ x 10 ½ in.
(43.5 x 26.7 cm)
Private collection

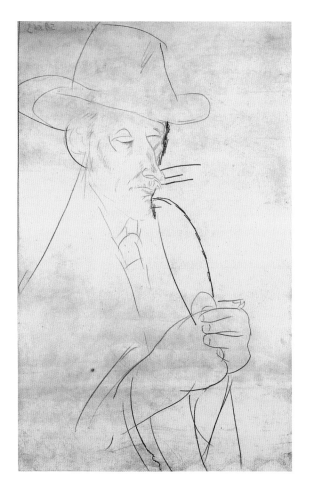

PLATE 128
The Caballero, n.d.
Graphite on paper, 16 ⅝ x
10 ¼ in. (42.2 x 26 cm)
Courtesy Galerie Cazeau-
Béraudière, Paris

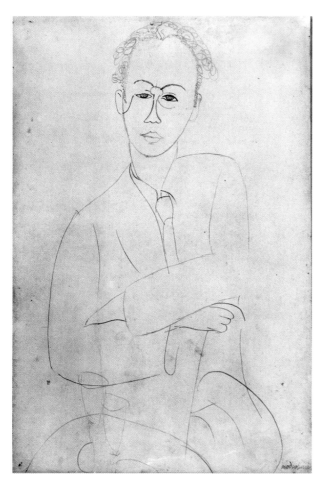

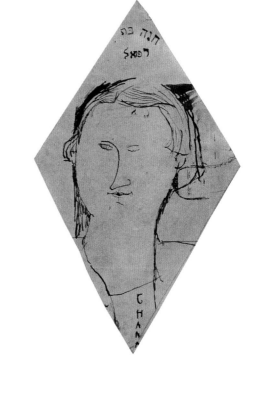

(above)

PLATE 129

Portrait of Michel Kikoïne,
c. 1917
Pencil on paper, 14 ½ x
10 in. (36.8 x 25.5 cm)
Justman-Tamir Collection,
Paris

(above right)

PLATE 130

Portrait of Chana Orloff, 1916
Ink on paper, 11 ¼ x
6 ⅞ in. (28.5 x 17.5 cm)
Justman-Tamir Collection,
Paris

PLATE 131

Diego Rivera, 1914
Blue crayon on paper,
13 ¾ x 9 in. (35 x 23 cm)
Private collection

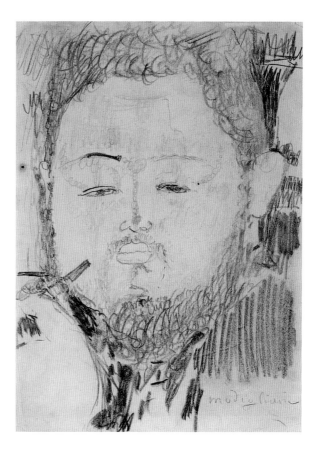

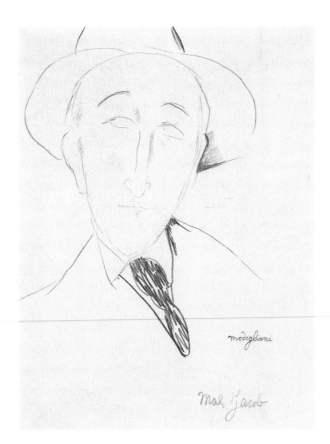

PLATE 132
Portrait of Max Jacob, 1915
Pencil on paper, 11 ¾ x
8 ¾ in. (29.5 x 22.5 cm)
Courtesy Galerie Cazeau-
Béraudière, Paris

PLATE 133
Portrait of Kisling, 1916
Pencil on parchment paper,
16 ¼ x 10 ⅛ in.
(41.3 x 25.7 cm)
Courtesy Galerie Cazeau-
Béraudière, Paris

PLATE 134
Portrait of Picasso, 1914–15
Graphite on vellum, 8 ⅞ x
10 ½ in. (22.6 x 26.8 cm)
Musée Picasso, Antibes
(MPA 1982.2.8)

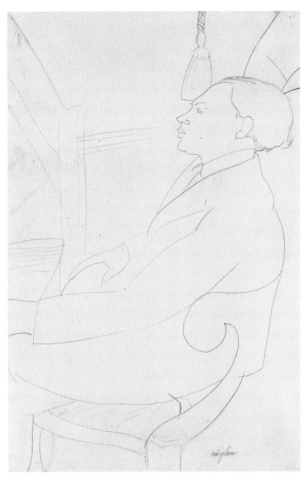

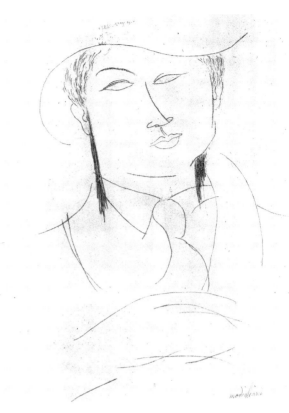

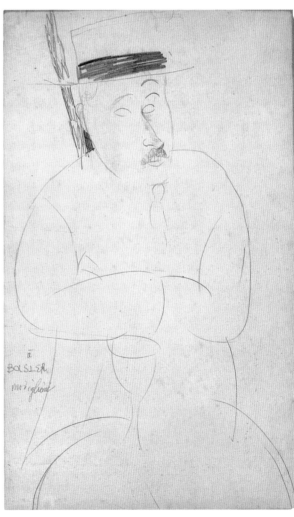

(above)
PLATE 135
Oscar Miestchaninoff, 1918
Pencil on paper, 18 ¾ x
12 ¼ in. (47.5 x 31.2 cm)
The Museum of Modern
Art, New York, Gift of Mrs.
Donald B. Strauss (708.1976)

(above right)
PLATE 136
*Portrait of a Man with Hat
(Paul Guillaume)*, c. 1918
Pencil on paper, 15 x 11 in.
(38 x 28 cm)
Courtesy Galerie Cazeau-
Béraudière, Paris

PLATE 137
Portrait of Adolphe Basler, n.d.
Graphite pencil on card-
board, 19 ¼ x 11 ¾ in.
(48.8 x 29.8 cm)
The Phillips Collection,
Washington, D.C., Gift of
Jean Goriany, 1943
(1988.9.7)

(left)

PLATE 138

Portrait of Jacques Lipchitz,
1916
Pencil on paper, 17 x
10 ½ in. (43.2 x 26.7 cm)
Private collection

(right)

PLATE 139

Portrait of Frank Burty
Haviland, 1914
Pencil on paper, 10 ⅞ x
8 ½ in. (27.5 x 21.5 cm)
Musée d'Art Moderne de
la Ville de Paris

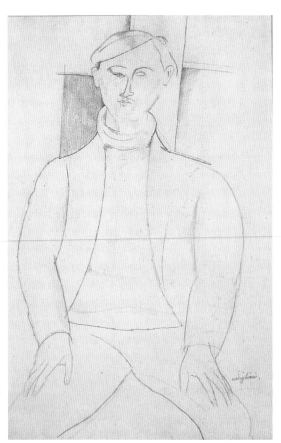

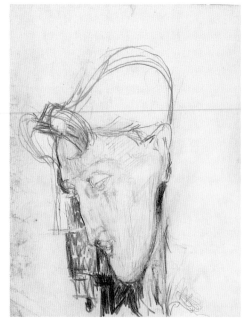

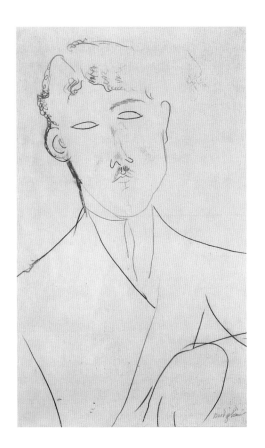

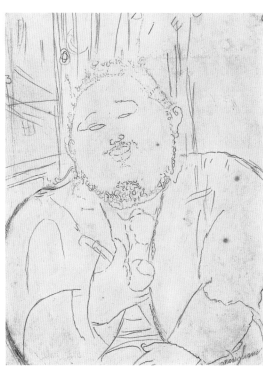

(left)

PLATE 140

Portrait of Paul Guillaume, n.d
Pencil on paper, 16 ½ x
9 ⅞ in. (42 x 25 cm)
Courtesy Galerie Cazeau-
Béraudière, Paris

(right)

PLATE 141

Portrait of Diego Rivera, 1914
Pencil on paper, mounted
on board, 13 ⅜ x 10 ⅜ in.
(34 x 26.5 cm)
Courtesy Galerie Cazeau-
Béraudière, Paris

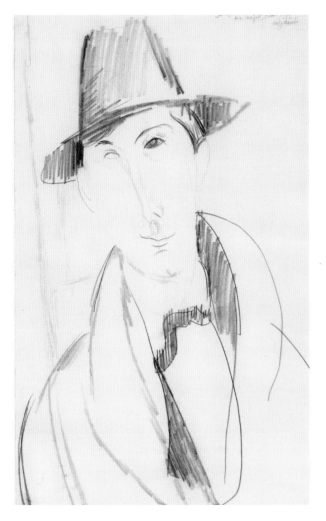

Chronology

Barbara Paltenghi

Translated by Alexandra Bonfante-Warren

Amedeo Modigliani's parents,
Eugenia Garsin and Flaminio
Modigliani, in Livorno in 1884.

Modigliani with nurse, c. 1886.

1884

Amedeo Clemente Modigliani is born in Livorno (Leghorn),
Italy, on July 12, the fourth child of Flaminio Modigliani and
Eugenia Garsin. The Modigliani family, Sephardic Jews, left
Rome for Livorno, a political and religious haven, around
the middle of the century. In 1870, the Modiglianis met the
Garsins, in Marseilles since 1835, with whom they had previ-
ously had business contacts. A marriage was arranged for
Flaminio and Eugenia; the wedding took place in 1872. Their
first child, Giuseppe Emanuele, was born that year, followed
by Margherita Olimpia in 1874 and Umberto Isacco in 1878.

The Modigliani family lives well, even luxuriously, but
in 1884, business failures—they own zinc and coal mines in
Sardinia, and have lumber interests in northern Italy—force
them to declare bankruptcy. According to one story, officers
assigned to take away the family's furniture arrive at the house
moments before Amedeo's birth; aware of an ancient law that
forbids the appropriation of anything from the bed of a
woman in childbirth, the Modiglianis manage to transfer their
most valuable possessions to Eugenia's room.

After this financial ruin, Flaminio opens a small office
and moves the family from their large house at 33 via Roma
to a more modest one at number 4 in the quiet via delle Ville.
Amedeo's father, a weak man who is often away on business,
plays only a minor role in the lives of his wife and children.

1886–93

In 1886, Amedeo's maternal grandfather, Isaac Garsin, a wid-
ower, moves to Livorno to live with his daughter, joining her
sisters Laura and Gabriella, who have lived with her since
1874. Flaminio cannot provide for such a large group, so
Eugenia resolves—over her in-laws' protests—to go into busi-
ness herself in order to increase the family's income. With
Laura's help she starts giving English and French lessons at
home. Raised in a liberal household, Amedeo's mother had an
English Protestant governess and attended a French Catholic
school. This background has given her, besides a mastery of
the two languages, a remarkable open-mindedness. Her enter-
prise soon grows into a full-fledged private school. On May
17 of this year, Eugenia begins a diary, which today is one of
the few useful sources for reconstructing Amedeo Modigliani's
early life.

Gabriella looks after the house, while Isaac Garsin
looks after little Amedeo, nicknamed Dedo. A brilliant man,
interested in history and philosophy, and an expert chess

player, Isaac knows not only French and Italian, but Spanish, Greek, English, and Arabic as well. Grandfather and grandson spend time together and become very attached. It is Isaac who takes Amedeo on his first visits to museums, where he admires paintings by Domenico Ghirlandaio and Titian, and by local artists such as Giovanni Fattori and Vittorio Corcos. In Livorno at that time, Italians, Germans, English, Scots, Swiss, Greeks, Arabs, and Armenians live side by side; every faith has its place of worship; and tourists—in particular wealthy Florentine families—pour in during the summers.

1894–97

Amedeo is ten years old when his grandfather Isaac dies, in 1894: because of this painful loss he closes in on himself and enters a state of deep sadness. In 1895, he falls seriously ill with pleurisy, but the illness does not keep him from passing school exams the following year. Among the visitors to the house in via delle Ville in this period are Amédée Garsin, Eugenia's generous and enthusiastic brother, and Rodolfo Mondolfi, one of Amedeo's teachers, whose son Uberto becomes Amedeo's best friend.

1898

On May 4, Giuseppe Emanuele, who holds a law degree from the University of Pisa and sits on the Livorno city council, and who is active in the Socialist movement, is arrested and jailed for political activities and fined a considerable sum. This widens the rift between the Garsins and the Modiglianis, and Eugenia is obliged to turn to her brother Amédée for money to pay the fine; she will often have to ask him for financial assistance.

Laura has left Livorno the previous year, and in July Gabriella leaves. That month, Dedo does not do well on school exams: the news surprises no one, since during the preceding year he has not devoted himself to his studies. Nevertheless, in August—thanks in part to his uncle Amédée, who picks up the tab—Dedo's dream comes true: Eugenia gives him permission to take drawing lessons, hoping that this will help him out of his apathy. The classes are held at Villa Baciocchi in Livorno, in the atelier of Guglielmo Micheli, a former student of Giovanni Fattori.

After his aunt Laura returns from Marseilles, Amedeo falls ill again. The symptoms are high fever and hallucinations, the diagnosis is typhoid infection. A long illness is followed by a long convalescence. Amedeo's sister, Margherita, gradually

Modigliani (second from right) and painting class, 1898.

replaces Laura as a teacher in her mother's school, since Laura now spends her time writing articles on philosophy and sociology.

1899

Having received his mother's approval to quit his regular school, Amedeo begins to study at Micheli's atelier daily, not occasionally as before. Among his fellow students are Benvenuto Benvenuti, Gino Romiti, Llewelyn Lloyd, Renato Natali, Manlio Martinelli, Oscar Ghiglia, Lando Bartoli, and Aristide Sommati. Gino Romiti has his own studio, and the students, who one by one will be leaving Micheli, often meet there; at other times, they go to the countryside to paint. Modigliani and Ghiglia, his best friend during this period, feel imprisoned in Livorno; in their dissatisfaction, they become critical of their teacher, and engage in increasingly transgressive behavior.

Amedeo grows closer to his aunt Laura and, with her, studies Gabriele D'Annunzio, Friedrich Nietzsche, Henri Bergson, and Pyotr Kropotkin. All in all, Dedo's adolescence is not very playful, unfolding, as it does, within an adult sphere. In the stretches of solitude and inactivity due to frequent illness, he reads a great deal, especially Dante, Petrarch, Ludovico Ariosto, Giacomo Leopardi, and Giosuè Carducci, revealing himself as very precocious.

Around this time, on a trip to Florence with his mother, Amedeo visits the Uffizi Gallery and Palazzo Pitti. The trip arouses in him a desire to see more, especially Rome and Venice. But after he suffers a renewed bout of pleurisy, doctors discern the symptoms of a chronic and far more worrisome condition.

1900–1901

In September 1900, Amedeo's illness is conclusively diagnosed as tuberculosis. Eugenia again asks her brother for help, and he offers to pay all the expenses of a necessary period of convalescence. In November, she and her son leave for the south, with Eugenia determined also to distance him from the undesirable company he has been keeping lately. At this time, Oscar Ghiglia decides to leave Livorno, intending to continue his studies in Venice and Florence, where Amedeo secretly hopes to join him before too long.

The first stop on Eugenia and Dedo's journey is Naples, where they visit the National Archaeological Museum, with its collections of Greek and Roman sculpture,

and the churches of Santa Chiara, San Domenico, and San Lorenzo. They spend two months at nearby Torre del Greco; here Amedeo draws while he convalesces. In March 1901 they are on Capri, where Amedeo writes a letter to Ghiglia that speaks of his dissatisfaction and his desire to head directly for Rome. Eugenia, though, prefers to stop for a while on Anacapri, where they arrive in April, and where Dedo writes his friend another letter.

After a visit to Amalfi, mother and son finally arrive in Rome. They see the Borghese Gallery, Palazzo Doria, the Vatican, the Sistine Chapel, Villa Giulia, and various ruins. Amedeo pours out his feelings in yet another letter to Ghiglia. Eugenia and Amedeo go on to Florence, where the museums, galleries, and churches strike the young Modigliani's imagination and sensibility powerfully—as evidenced by his next letter to his friend. The artistic wealth of Naples, Rome, and Florence underlines to Amedeo how "poor" Livorno is, and that notion fuels his yearning to get away. Venice, the last stop on the trip, represents to him the most fitting conclusion to what has been his grand tour. The city stimulates him in important ways, and he experiences a new, mature awareness as an artist.

Shortly after they return to Livorno, Eugenia permits her son to begin his own life, away from home, to initiate his real academic training in places that for centuries have been dedicated to the study of art. The enormous expense will, once more, be assumed by Uncle Amédée Garsin. And so Modigliani leaves for Florence, where on May 7, 1901, he enrolls in the Scuola Libera di Nudo, for life studies. He shares a studio with Ghiglia, who has moved to Florence to study with Giovanni Fattori. Modigliani spends the winter in Rome, where he obtains permission to make copies in the museums.

Modigliani at age seventeen, 1901.

1902

Modigliani meets the Chilean painter Manuel Ortiz de Zárate, who tells him about his time in Paris and the Impressionists and other painters there: Edgar Degas, Pierre-Auguste Renoir, Édouard Manet, Claude Monet, Camille Pissarro, Alfred Sisley, Berthe Morisot, Henri de Toulouse-Lautrec, Paul Gauguin, Vincent van Gogh, Paul Cézanne.

During the summer, when he returns to Livorno, Modigliani declares his wish to dedicate himself to sculpture, and persuades Eugenia to lend him money to go to Carrara, site of marble quarries. He settles in Pietrasanta, near Carrara,

in the studio of Emilio Puliti, who teaches him a few basic techniques. But sculpting marble proves extremely tiring, given Modigliani's poor health. His favorite sources in this period are Andrea del Verrocchio, the Michelangelo of the Medici Chapel in Florence, and the thirteenth-century Sienese sculptor Tino di Camaino.

Under the influence of Zárate's conversations, Modigliani expresses a strong desire to move to Paris; Eugenia insists that he continue his studies in Florence. Convinced that there is nothing more for him to learn there, and determined to pursue his artistic development on his own, without teachers, Modigliani tries to talk Ghiglia into joining him. Ghiglia, faithful to Fattori's teachings, does not support Modigliani, who considers this a profound betrayal and breaks off the friendship with a violent argument. Amedeo resolves to move to Venice alone.

1903–5

Modigliani arrives in the lagoon city in the spring of 1903, and on May 19 enrolls in the Scuola Libera di Nudo, at the Istituto di Belle Arti. He attends few classes, judging them almost immediately as too academic, but he draws a great deal on his own, inspired by the enthralling life around him. He admires the paintings of Vittore Carpaccio and the Bellinis, and associates with young intellectuals who, like him, feel confined in an Italy that to them is nothing more than a museum of faded and exhausted glories. Whenever he returns to Livorno, Modigliani repeats his dissatisfaction and his determination to leave the country at the first opportunity. His friends in Venice are the printer and book illustrator Umberto Brunelleschi; the writer Giovanni Papini; the Futurist painter and sculptor Umberto Boccioni; the sculptor and painter Fabio Mauroner, with whom Modigliani shares a studio in the San Barnaba quarter in 1904; and the artists Mario Crepet, Cesare Mainella, Guido Marussig, Ardengo Soffici, and Guido Cadorin, who introduces him to hashish. Modigliani neglects his lessons, going instead to bars and nightspots to draw.

His dream of moving to Paris is growing unbearably urgent; only in the French capital, he feels, will he be able to develop his own personal artistic language and realize his artistic ambitions. But Amédée Garsin, the uncle who might have paid for at least part of this longed-for sojourn, dies in 1905; his death seems to represent the end of Modigliani's hopes. Late in the year, though, Eugenia visits and gives him a

limited amount of money, but enough to make his dream come true.

1906

In January, a restored Modigliani takes the train from Livorno to Paris. His first home is a hotel near the Madeleine. He enrolls in the Académie Colarossi, famous for its former students of the caliber of Paul Gauguin, James Abbott McNeill Whistler, and Auguste Rodin. Modigliani's choice of school means that for the time being he will pursue a classical curriculum. He spends his first months as a tourist, visiting churches, museums, and monuments: he admires the Louvre's Greek and Roman sculptures, and the Impressionists at the Durand-Ruel gallery; at Berthe Weill's gallery he sees the work of Pablo Picasso for the first time.

Everything is very different from Italy, fresh and exciting. Modigliani frequents the Montparnasse tavern Chez Rosalie and replaces his bourgeois costume with artists' dress. He eventually leaves Montparnasse for Montmartre, where he lives on rue Caulaincourt. At the Lapin Agile tavern, he meets Maurice Utrillo, who becomes one of his closest friends. The more he studies the works of Picasso and Henri Matisse, the more aware Modigliani is that his technique does not measure up to what he wants to achieve. At the Bateau-Lavoir—the center of Cubism, at 13 rue Ravignan—he meets, among other artists, Picasso, André Derain, Maurice de Vlaminck, Kees van Dongen, Henri Laurens, Louis Marcoussis, and Francis Picabia; the charismatic poet and painter Max Jacob; the writer André Salmon; the critic Maurice Raynal; and the poet Guillaume Apollinaire. At this time, Picasso, Jacob, Vlaminck, and others are discovering non-European art, particularly Oceanic art and African sculpture.

Modigliani feels that at last he is in the right place, even if he has spent almost all his money. He draws a great deal, and concentrates on painting; sculpting has given him a bad cough, and it tires him. His sitters include children and women; one of his models is Mado, a former lover of Picasso's. Dissatisfied with his first efforts, Modigliani continues to search for his own style, one that combines the ancient and the new, and that above all reveals the human.

At the Lapin Agile, he meets Ludwig Meidner, a German artist who shares his love for the old masters, and one of the few people whom Modigliani allows to spend time in his studio. Modigliani confides to Meidner his great respect for Whistler, Oscar Wilde, and D'Annunzio, and his wish to

emulate these singular talents who live, or have lived, life intensely and with tremendous elegance.

In the fall Modigliani visits the Salon d'Automne, where the Fauves are exhibiting, and where a Gauguin retrospective greatly impresses him. He frequents a group of Italian artists and critics then in Paris, among them Gino Severini, Mario Buggelli, Gino Baldi, and Anselmo Bucci. In December, he has three paintings displayed at Laura Wylda's art gallery in rue des Saints-Pères; they go unsold. At year's end he moves to the Hôtel Bouscarat in place du Tertre; still having sold nothing, he is in need of funds.

1907

Modigliani rents a studio at 7 place Jean-Baptiste Clément and begins working with a notable drive. He paints, draws, sculpts, carries on love affairs, and makes the rounds of better-known galleries in what proves a vain attempt to sell something. In October, he shows seven works at the Salon d'Automne: two oils—*Portrait of L. M.* and *Study of a Head*—and five watercolors. At the Salon, a room is dedicated to forty-eight oils by Cézanne, while the Galerie Bernheim-Jeune is showing a large selection of his watercolors. Modigliani is a heartfelt admirer of the work of the master of Aix. At the Bateau-Lavoir he sees Picasso's *Les demoiselles d'Avignon* and is amazed.

Around this time, frustrated and insecure about how different his own art is, Modigliani takes to abusing drugs and alcohol. Many in Montmartre use them; his excesses damage his weak constitution, already undermined by tuberculosis. In November, he meets Paul Alexandre, who will be a patron during the next seven years. Alexandre, a physician at the Hôpital Lariboisière, is cultivated and elegant, a *bourgeois* and art lover. With his dentist brother, Jean, he has founded an artists' colony, run by the sculptor Maurice Drouard and the painter Henri Doucet, in a ramshackle house at 7 rue du Delta, its purpose to give artists a place to live and work cheaply. With Paul Alexandre, Modigliani visits the ethnographic museum, the Asian collections of the Musée Guimet, and the ethnographic galleries of the Trocadéro; the doctor encourages the painter and regularly buys his work. One of Modigliani's paintings in particular resonates with Alexandre: *The Jewess (La juive)*, which shows the influence of both Cézanne and the Expressionists.

1908

Modigliani spends a great deal of time at the artists' colony in rue du Delta. Paul Alexandre persuades him to join the Société des Artistes Indépendants and to exhibit in their Salon at the end of the year. Modigliani continues to frequent Montmartre, eating and drinking with his old friends in place du Tertre, at the Coucou or À l'Ami Émile. Many of the new modern artists at this time are attracted either by Cubism, and gather around Picasso, or by Fauvism, and gather around Matisse. Modigliani is unwilling to ally himself with any group; in 1909, even Severini—a friend of Boccioni and, like him, a student of Giacomo Balla, and in touch with Carlo Carrà, Luigi Russolo, and Filippo Tommaso Marinetti in Italy—will fail to win Modigliani over to Futurism.

At the twenty-fourth Salon des Indépendants, Modigliani shows *The Jewess*; two nudes; a study, *Idol*; and a drawing. After his work attracts virtually no attention, he turns his efforts entirely to sculpture. His works in this medium are composed and mysterious, with stylized elements derived mostly from primitive and archaic art, and from Picasso. Alexandre, however, is not interested in Modigliani's sculpture; after quarreling with Drouard, Modigliani leaves the rue du Delta colony.

Paul Alexandre, 1909.

1909

Modigliani departs Montmartre for Montparnasse just when a new artists' group is emerging in the latter, centered around the artists' residence La Ruche and the cafés La Rotonde, Le Dôme, and La Closerie des Lilas. He stays at the Hôtel du Poirier, or at the houses of friends, or in the waiting room of the train station Gare St.-Lazare. He meets Constantin Brancusi, a simple, courteous, and generous man. The Romanian sculptor's quest for a pure and essential line in his works fascinates Modigliani, and Brancusi profoundly influences Modigliani's sculpture. Because marble is expensive, Modigliani is obliged to use cheaper, softer stone to try out what he wants to realize later in final form. He also draws and paints occasional portraits.

He takes lodgings at 14 Cité Falguière, and rents a studio and uses a small courtyard there for sculpting. In April, Paul Alexandre introduces Modigliani to his family. The encounter results in three commissions for portraits: one of Jean-Baptiste Alexandre and one of each of his sons, Paul and Jean. In the same month, at the Galerie Druet, Modigliani views the work of Polish sculptor Elie Nadelman; he is reinvigorated.

Constantin Brancusi (Romanian,
1876–1957), *Self-Portrait in the
Studio*, n.d. Gelatin-silver print.
Musée National d'Art Moderne,
Centre Georges Pompidou, Paris.

In July, he goes to Italy with money his aunt Laura has
given him on a visit to Paris. In Livorno, where he lives in via
Giuseppe Verdi, he paints studies for heads, which will be
exhibited at the 1910 Salon des Indépendants; a portrait of his
sister-in-law Vera; and other studies. Bice Boralevi, a young
woman with a long, sinuous neck, poses for him. He meets
his old friends Sommati and Benvenuti at Caffè Bardi, and
goes to Romiti's atelier. Modigliani's copy of a seventeenth-
century Neapolitan painting, *The Beggar of Livorno*, attests to
Cézanne's influence, while *The Beggar Woman* displays strongly
sculptural qualities; he paints both of these while in Livorno.
With his aunt Laura, Modigliani writes articles on philosophy,
but he has not abandoned his desire to work in marble in
Carrara. His brother Giuseppe Emanuele finds him a job in
the quarries; the labor is too fatiguing for his weakened state,
and Modigliani, discouraged, gives up the job.

In September, he returns to Paris with his production
from Livorno: Paul Alexandre buys *The Beggar of Livorno*, and
Modigliani gives Jean Alexandre *The Beggar Woman*, probably
in exchange for dental work. The artist resumes smoking,
drinking, taking hashish, and leading a hectic love life; he
alternates between painting and sculpture. He shows Brancusi
his preparatory studies and drawings for a series of caryatids,
and initiates a portrait of him. A few months later, on the
back of the same canvas, Modigliani does a study for *The
Cellist*, which shows the influence of Toulouse-Lautrec,
Cézanne, and the Fauvist palette.

1910

In the spring, Modigliani exhibits six works at the twenty-
sixth Salon des Indépendants: four—*The Cellist*, *Lunaire*, and
two studies of Bice Boralevi—are for sale, while *The Beggar of
Livorno* and *The Beggar Woman* are already in the collections of
the Alexandre brothers. Most of the critics and press do not
take note, but he is mentioned by Guillaume Apollinaire in
L'intransigeant and by André Salmon in *Paris journal*. While
Paul Alexandre still takes an interest in Modigliani's work, no
gallery owners or art dealers do—they consider it too individ-
ual and therefore difficult to sell.

Now begins the most frustrating and unproductive
period of Modigliani's life, circumstances that will continue,
on and off, until 1914. His extreme poverty and his escalating
consumption of alcohol and drugs justify his inclusion in the
artistes maudits, so called because of their dissolute and trans-
gressive behavior. His companions are Max Jacob, Brancusi,

and artists who frequent the Portuguese artist Amadeu de Souza-Cardoso's atelier in Cité Falguière. Souza-Cardoso rents another studio in Montparnasse, in rue du Colonel Combes, where Modigliani often goes to work. During the winter, though, he is inactive and bitter; his art has yet to find a public.

1911

Forced to leave the studio in place Jean-Baptiste Clément because he can no longer afford it, Modigliani burns what he considers insignificant youthful studies. He moves for a time to the Couvent des Oiseaux, an abandoned convent, in pursuit of an actress who lives there with her company; he is proud of the nudes and portraits he paints of her. His life is chaotic. He is often drunk, and spends nights in jail for assault and other infractions. His health worsens perceptibly: pale and thin, he suffers from a chronic bad cough.

From April 21 to June 13 he has six works on display at the twenty-seventh Salon des Indépendants. During the summer he finds a room in Montmartre, at 39 passage de l'Élysée-des-Beaux-Arts; around this time, perhaps urged by Jacob, Apollinaire pays more attention to Modigliani's work. Apollinaire, a member of Picasso's circle, is very influential; he is able to sell some of Modigliani's works and to promote him enough that his financial situation improves, if only temporarily.

Modigliani's aunt Laura, concerned about his health, arranges a trip to Normandy in the autumn. In September, Modigliani joins her in Yport—having spent nearly all the money she has lent him to pay his debts and buy materials. On his return to Paris, he sculpts four heads—which will be exhibited in Souza-Cardoso's atelier—and does studies for the caryatids. Modigliani befriends the Russian poet Anna Akhmatova and paints several commissioned works, including a second portrait of Paul Alexandre. In Montparnasse, the artist sees Zárate, who is now influenced by Cubism. Modigliani spends most of his time at La Rotonde and Chez Rosalie, where he tries to sell his drawings.

1912

Modigliani meets the sculptors Léon Indenbaum, a Russian; Jacques Lipchitz, a Lithuanian; and the American-born Jacob Epstein, whose artistic originality and vigorous personality appeal to him. Modigliani returns to his studio at the Cité Falguière, and spends most of his time drawing and sculpting.

The Cubist room in the Salon d'Automne exhibition in Paris, 1912, featuring sculptures by Modigliani.

The Futurists' first Paris exhibition is a great success, and Cubism is commanding international attention. On his own, Modigliani continues his hopeless chase of success and money. Despite his meager earnings, he never ceases believing in his talent. Modigliani participates in the Salon d'Automne exhibition, where he shows seven sculptures.

In the winter, seriously ill, he collapses in Montmartre. After a stay in the hospital, he rents an atelier at 216 boulevard Raspail, where he keeps his sculptures.

1913

In February, Modigliani misses the chance to exhibit with other European artists at the Armory Show in New York. The show's organizer has combed Paris for art, but Modigliani has no dealer, and his work is not on display in any gallery windows. In April, before leaving for Livorno for a period of recuperation, he visits Paul Alexandre with a group of drawings he has selected for him, and some sculptures that he plans to collect on his return. It is only because the English painter Augustus John buys a few of his works that Modigliani can afford the train ticket to Italy.

In his native city, he meets up with old friends; with Gino Romiti and Renato Natali he talks almost exclusively about sculpture, and he shows them photographs of his sculpted heads. Having obtained stone and a room to sculpt in, he executes several works, which—so the legend goes—he throws into a canal because he cannot transport them to Paris.

He returns to France rested and apparently in good health, but before long he resumes his dissolute ways. In late spring, he paints a third portrait of Paul Alexandre and meets the Russian sculptor Ossip Zadkine. His friends and fellow artists in Montparnasse include Zárate; Zadkine; Moïse Kisling, a Polish Jew and exuberant fellow reveler, and therefore close to Modigliani's heart; Tsugouharu Foujita, a Japanese artist of Picasso's group; and Chaim Soutine, a nineteen-year-old Russian Jewish painter. Modigliani, who instantly feels paternal toward the shy, unhappy, and poverty-stricken Soutine, is one of the first to appreciate his talent.

This year Modigliani at last finds a dealer—Guillaume Chéron, who has him under contract for a few months. The artist, with little if any choice, accepts his conditions: in exchange for working at Chéron's, in rue de la Boétie, he receives materials, drink, and a daily stipend. But before long, the situation is intolerable; Modigliani leaves and is once again obliged to support himself.

1914

Max Jacob arranges a meeting with the art dealer Paul
Guillaume, an intellectual who is just becoming interested in
the art market. Impressed with Modigliani's drawings, he buys
some of his paintings and promotes his art. He also rents a
studio for him at 13 rue Ravignan, at the Bateau-Lavoir,
although Modigliani is almost immediately thrown out.
Modigliani meets one of the great loves of his life, Elvira
(known as La Quique), who is depicted in many of his paint-
ings and with whom he has a brief but passionate affair.

He moves to 16 rue Saint-Gothard, where he rents a
studio, and still tries to sell his drawings door to door, princi-
pally to the patrons of La Rotonde. He befriends the rebel-
lious Mexican painter Diego Rivera, a friend also of Picasso
and Apollinaire; Rivera is going through his Cubist phase. For
a while they share a studio, and Modigliani paints Rivera's
portrait. Modigliani meets the English painter Nina Hamnett,
who has recently arrived in Paris and soon meets with other
Montparnasse artists; the two attend parties together. In July,
he meets the South African–born writer Beatrice Hastings,
with whom he has an intense love affair.

Modigliani in tavern with
soldiers, 1914.

War breaks out in Europe during the summer: France
mobilizes its armies, and the conflict affects the attitude of the
French toward foreigners, who must now be registered. Many
bars are closed down, some alcoholic beverages banned, and
newspapers are suspended. Several of Modigliani's friends and
acquaintances enter the military ranks: Kisling the Foreign
Legion, Apollinaire the artillery, and Paul Alexandre the med-
ical corps. Many, however, remain in Paris: Zárate, Jacob,
Soutine, Foujita, Lipchitz, Brancusi, Rivera, Utrillo;
Modigliani is declared unfit for military service because of his
health. In August, Paris is bombed, and Modigliani moves in
with Beatrice at 53 rue de Montparnasse. He makes a number
of drawings and portraits of her; with stone increasingly diffi-
cult to obtain and debilitating to sculpt, he has turned again
to painting.

1915

In March, Beatrice leaves Montparnasse, moving to 13 rue
Norvins in Montmartre. She is leading a dissolute life, and she
and Modigliani fight often. Even though he is living with her,
Modigliani has abandoned none of his old habits; he spends
time at La Rotonde and Chez Rosalie and sees the usual
friends, with whom he indulges in the usual excesses. Beatrice
is more than a model, she is a source of support: to help the

Modigliani in his studio, c. 1915.

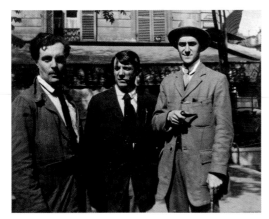

Modigliani, Picasso, and
Salmon, photographed by Jean
Cocteau, 1916.

Modigliani, Jacob, Salmon, and
Zárate, photographed by Jean
Cocteau, 1916.

man she loves, she often contacts Paul Guillaume, who this
year and the next is the only buyer of Modigliani's work. The
artist paints many portraits, of friends and others—Frank
Burty Haviland, an artist and follower of Picasso; Kisling,
Laurens, and Picasso himself. His relationship with Beatrice
deteriorates, with infidelities on both sides. In August, shortly
after the end of their affair, Modigliani collapses; he is found
unconscious in a studio at the Bateau-Lavoir. Alcoholic and
malnourished, he is nursed back to health by friends; Soutine,
despite his poverty, takes him in for a time.

1916

At Paul Guillaume's urging, Modigliani resumes painting. In
June, Fernande Barrey, Foujita's wife, introduces him to
Leopold Zborowski, who at once expresses his great esteem
for Modigliani's work. Born in 1890 in Poland, a graduate of
Kraków University, Zborowski came to Paris in 1913 to study
French culture at the Sorbonne. A fervent art lover, he
becomes Modigliani's close friend, as well as his patron and
dealer. His wife, Hanka, and their friend Lunia Czechowska
appear in Modigliani's work from this time. In this very pro-
ductive year, Modigliani paints many portraits. In November,
Zborowski guarantees him a regular weekly wage; in order to
do so, Zborowski has committed himself to earning an addi-
tional fifteen francs a day, which he can give Modigliani in
exchange for his works.

Modigliani moves to 13 place Émile Goudeau. Fifteen
of his portraits are displayed at Émile Lejeune's atelier, along-
side paintings by friends. He spends time with Lunia
Czechowska, who comes to be a favorite model. Every after-
noon he works at Zborowski's; besides materials, his contract
provides for models, drink, a room in a small hotel in rue de
Buci, and twenty francs a day. At the end of the year, the
Zborowskis and Lunia move to 3 rue Joseph Bara, and it will
be in that apartment that Modigliani paints a series of splen-
did nudes.

He meets Simone Thiroux, who has suffered from
tuberculosis since her early childhood. She supports herself by
giving English lessons and working as a nurse but loves the
bohemian life of Montparnasse. Modigliani paints multiple
portraits of her, and they become lovers. When Simone tells
him she is pregnant, Modigliani—who consistently denies that
he is the father of the baby—ends their relationship. Serge
Gérard will be born in May 1917.

1917

In the spring, during the students' carnival, Modigliani meets Jeanne Hébuterne, a nineteen-year-old student at the Académie Colarossi and the École Nationale des Arts Décoratifs. The daughter of a middle-class family, Jeanne is melancholy, reserved, but with a strong personality. Her blind adoration of Modigliani sets her apart from the other women with whom he has been involved, and Zborowksi, who is committing himself to supporting art and especially Modigliani, is pleased with the relationship; he believes that the young woman will succeed in bringing Modigliani to the straight and narrow.

Although his art has become clearer and more serene, apparently as a result of Jeanne's presence, Modigliani does not really alter his ways, and his health inexorably worsens. When the room that Zborowski is paying for at the Hôtel des Mines proves inadequate for the couple's needs, they move to an old apartment building at 8 rue de la Grande Chaumière. Modigliani now has a home of his own where he can paint, although he often works at Kisling's in rue Joseph Bara, and at Zborowski's, where he often finds Soutine (whom Zborowski, at Modigliani's request, has taken under his wing). The critic Francis Carco buys some of Modigliani's nudes, and follows his art. Others, too, are buying paintings from Zborowski.

Modigliani contributes a portrait to the Dada magazine *Cabaret Voltaire* and is asked to exhibit his work at the Galerie Dada in Zurich. He receives a commission for a portrait of Léon Bakst, the set designer for Serge Diaghilev's Ballets Russes. Michel Georges-Michel, who witnesses the painting of the portrait, will transform Modigliani (who will be called "Modrulleau") and Jeanne ("Haricot-Rouge," or "Red Bean") into the heroes of his novel *Les montparnos*. It does not take long for people to notice that Jeanne has inspired no fundamental changes in Modigliani's behavior. Loving him absolutely, she defers to him in everything and asks nothing in return. He drinks and stays out late, and in the autumn his health and state of mind decline considerably.

Zborowski persuades Berthe Weill to present an exhibition of Modigliani's work in her gallery in December. One of the most remarkable of the works, a nude, is put in the window to attract passersby, but the police, considering it an offense against public decency, close the show temporarily. Zborowski, overwhelmed with debts, wants to send Modigliani out of Paris before his health is irrevocably com-

Leopold Zborowski, 1916.

Paul Guillaume and
Modigliani on the Promenade
des Anglais in Nice, 1918.

promised. Despite his incessant cough, Modigliani continues
to smoke, drink, and take hashish.

1918

Thanks to the scandal at Weill's gallery, Zborowski makes
some good sales. In March, Paris is bombed: an exodus
ensues, and the art market collapses. That same month, Jeanne
announces she is pregnant, and Modigliani's health declines.
Zborowski, hoping to do better in the south, plans a move to
the Côte d'Azur with his wife, Modigliani, Jeanne, and
Jeanne's mother, Eudoxie; before leaving, Zborowski invites
Soutine, Foujita, and Foujita's wife to join them.

In April, they settle in Cagnes-sur-Mer, in the villa of
an eccentric old gentleman, Papa Curel. Modigliani engages
in violent disputes with Eudoxie, and in the local artists' tav-
ern he drinks and incurs more debt. Zborowski moves him to
the house of his friends Anders and Rachel Osterlind. During
his stay with them Modigliani has the opportunity to visit
Renoir, but the meeting, which the painter Osterlind has
arranged, is a source of embarrassment; after an initial silence,
Modigliani manifests a complete lack of interest in the mas-
ter's work.

In July, with sales extremely poor, Zborowski lacks
money to pay the rent. Foujita, his wife, and Soutine return
to Paris, and Zborowski goes with the others to Nice.
Modigliani is put up at the Hôtel Tarelli, at 4 rue de France;
Leopold and Hanka are nearby; and Jeanne and her mother
are in rue Masséna. Modigliani meets old friends: the Swiss
writer Blaise Cendrars, the Ukrainian sculptor Alexander
Archipenko, and the Russian-born painter Léopold Survage,
in whose apartment he often paints.

The armistice is concluded on November 11; shortly
after, upon yet another violent argument, Jeanne's mother
leaves her daughter with Modigliani and moves to the
Californie neighborhood. On November 29, little Jeanne is
born, and it is at once obvious that a baby nurse is needed, for
the mother is in no state to take care of the infant. Zborowski
and his wife return to Paris, followed a few weeks later by
Eudoxie Hébuterne.

Guillaume in his apartment
with sculptures and paintings
by Modigliani, c. 1918.

1919

Having been robbed of his money and his documents, and
thus unable to leave Nice, Modigliani moves to 13 rue de
France. He paints a great deal, pressed by a new sense of
responsibility toward Jeanne, their daughter, and Zborowski, to

whom he must send four paintings a month. He paints the
only four landscapes in his entire body of work, as well as
portraits of local children and of his beloved companion.

On May 31, Modigliani returns to Paris alone, to the
apartment in rue de la Grande Chaumière. Jeanne will follow
once a nanny is found in Paris. An already burdened Jeanne
discovers she is pregnant again. Modigliani negotiates a new
agreement with Zborowski: besides materials and the rent
paid on his studio, Modigliani is to receive a substantial
monthly sum, which will allow him to establish a settled life.
Still, his vices are causing progressive self-destruction.

During the summer, Zborowski is in London to over-
see a group exhibition at the Mansard Gallery in Heale,
which features Modigliani, Picasso, Matisse, Derain, Vlaminck,
Marcoussis, Fernand Léger, Raoul Dufy, Survage, Suzanne
Valadon, Utrillo, Soutine, and Kisling. The show is a success,
and Zborowski manages favorable prices for many works. The
English critics praise Modigliani's offerings, but this does
nothing for his image in Paris.

In autumn, despite ill health, Modigliani is able to
meet Matisse, who sits for him. Modigliani visits Valadon in
Montmartre to obtain news of her son Maurice Utrillo, and
sees Derain and Brancusi. He does portraits of Morgan
Russell, an American painter, and of Jeanne Hébuterne and
Lunia Czechowska. But his worsening condition, which
Zborowski hopes to arrest by sending him to a sanatorium,
spurs him to plan another trip to Livorno in the following
spring for another period of convalescence. In November, his
illness even more severe, it is harder for him to work. Four of
his paintings are exhibited at the Salon d'Automne; they
receive neither attention from the public nor mention from
the critics. That winter, Modigliani wanders drunkenly
through the cold city from bistro to bistro.

1920

Paler, emaciated, and more debilitated than ever, Modigliani
allows Jeanne—but only Jeanne—to look after him; he will
not see a doctor. After a further decline, Jeanne consults
Zborowski; he consults a doctor, who orders Modigliani to be
hospitalized. On January 22, Modigliani is brought uncon-
scious to the Hôpital de la Charité. Jeanne, about to give birth,
remains in the Grande Chaumière apartment awaiting news.

On January 24, at eight-fifty p.m., Modigliani dies of
tubercular meningitis. The following morning, Jeanne goes to
the hospital to bid a final good-bye. She agrees to return to

Jeanne Hébuterne, 1919.

Chaim Soutine on the ground
floor in his farmhouse in Le
Blanc, France, in 1926.

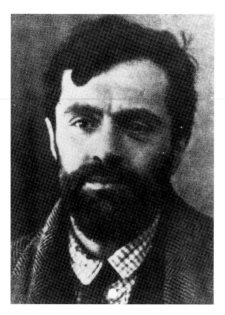

Modigliani near the end of his life, c. 1920.

her parents and the house where she was born, on rue Amyot.

While her parents argue about their unfortunate daughter's future, Jeanne shares a bed with her brother, André. In the night, she throws herself out a fifth-story window to her death. The Hébuternes refuse a joint funeral, choosing instead to hold a small, private ceremony in the cemetery at Bagneux.

On January 27, at Modigliani's funeral, mourners gather to follow the coffin to Père-Lachaise cemetery: Jacob, Kisling, Salmon, Soutine, Brancusi, Zárate, Indenbaum, van Dongen, Severini, Survage, Derain, Lipchitz, Picasso, Carco, Léger, Valadon and her husband André Utter, Vlaminck, Zborowski, Foujita, and others.

Little Jeanne is taken in by her aunt Margherita Modigliani. In 1930 the Hébuternes—pressured by Giuseppe Emanuele Modigliani, then exiled in Paris after Benito Mussolini's rise to power—allow for Jeanne's remains to be buried beside Modigliani's.

Tombstone of Modigliani and Jeanne Hébuterne in Père-Lachaise cemetery in Paris.

Exhibition Checklist

Unless otherwise indicated, works were shown at all venues of the exhibition. For works not included at all locations, venues are indicated as follows:

NEW YORK = The Jewish Museum
TORONTO = Art Gallery of Ontario
WASHINGTON = The Phillips Collection

PAINTINGS

Small Tuscan Road, 1898
Oil on cardboard, 8 ¼ x 14 in. (20.8 x 35.7 cm)
Museo Civico Giovanni Fattori, Livorno
PLATE 1

Head of a Woman in Profile, 1906–7
Oil on canvas, 14 x 11 ⅝ in. (35.5 x 29.5 cm)
Private collection, Paris
TORONTO
PLATE 6

The Jewess (La juive), 1908
Oil on canvas, 21 ⅝ x 18 ⅛ in. (55 x 46 cm)
Re Cove Hakone Museum, Kanagawa
NEW YORK
PLATE 2

Maud Abrantes (verso), 1908
Oil on canvas, 31 ⅞ x 21 ¼ in. (81 x 54 cm)
Reuben and Edith Hecht Museum, University of Haifa, Israel
(Ca. No. p-226a-b)
PLATE 4

Nude with a Hat (recto), 1908
Oil on canvas, 31 ⅞ x 21 ¼ in. (81 x 54 cm)
Reuben and Edith Hecht Museum, University of Haifa, Israel
(Ca. No. p-226a-b)
PLATE 3

Joseph Levi, 1909
Oil on canvas, 21 ¾ x 19 ¾ in. (55 x 50 cm)
Private collection, New York
TORONTO AND WASHINGTON
PLATE 5

Bust of a Young Woman, 1911
Oil on canvas, 21 ⅝ x 15 in. (55 x 38 cm)
Frances I. and Bernard Laterman, New York
NEW YORK
PLATE 7

Caryatid, c. 1911
Oil on canvas, 28 ½ x 19 ¾ in. (72.5 x 50 cm)
Kunstsammlung Nordrhein-Westfalen, Düsseldorf (128)
TORONTO
PLATE 17

Antonia, c. 1915
Oil on canvas, 32 ¼ x 18 ⅛ in. (82 x 46 cm)
Musée de l'Orangerie, Paris, Walter-Guillaume Collection
(RF: 1963-70)
NEW YORK
Page xiv, fig. 1

Beatrice Hastings in Front of a Door, 1915
Oil on canvas, 32 x 18 ¼ in. (81.3 x 46.4 cm)
Private collection, courtesy Ivor Braka Ltd., London
PLATE 44

La Fantesca, 1915
Oil on canvas, 31 ⅞ x 18 ⅛ in. (81 x 46 cm)
Courtesy Galerie Cazeau-Béraudière, Paris
WASHINGTON
PLATE 32

Head of a Young Woman (Tête rouge), 1915
Oil on cardboard, 21 ¼ x 16 ⅜ in. (54 x 42.5 cm)
Musée National d'Art Moderne, Centre Georges Pompidou, Paris (AM 4286P)
TORONTO
Page 50, fig. 7

Madam Pompadour, 1915
Oil on canvas, 23 ⅞ x 19 ½ in. (60.6 x 49.5 cm)
The Art Institute of Chicago, Joseph Winterbotham Collection (1938.217)
PLATE 35

Moïse Kisling, 1915
Oil on canvas, 14 ⅝ x 11 ⅜ in. (37 x 28 cm)
Pinacoteca di Brera, Milan (Emilio and Maria Jesi Donation)
NEW YORK
PLATE 38

Nude (Portrait in Red), 1915
Oil and ink wash on paper, 14 x 10 ⅜ in. (35.6 x 26.2 cm)
Minneapolis Institute of Arts, Bequest of Putnam Dana
McMillan, 1961 (61.36.22)
Page 42, fig. 1

Paul Guillaume, 1915
Oil on board, 29 ½ x 20 ½ in. (74.9 x 52.1 cm)
Toledo Museum of Art, Gift of Mrs. C. Lockhart McKelvy
(1951.382)
TORONTO AND WASHINGTON
PLATE 37

Pierre Reverdy, 1915
Oil on canvas, 16 x 13 ¼ in. (40.6 x 33.7 cm)
Baltimore Museum of Art, Private Collector (BMA
L.1967.10.1)
PLATE 30

Pierrot, 1915
Oil on cardboard, 16 ⅞ x 10 ⅝ in. (43 x 27 cm)
Statens Museum For Kunst, Copenhagen, Collection J. Rump
(KMSR88)
NEW YORK AND TORONTO
PLATE 36

Portrait of Mrs. Hastings, 1915
Oil on paperboard, 21 ⅞ x 17 ⅞ in. (55.5 x 45.4 cm)
Art Gallery of Ontario, Toronto, Gift of Sam and Ayala Zacks,
1970 (71/260)
Page 74, fig. 1

Portrait of Paul Guillaume (Novo Pilota), 1915
Oil on cardboard mounted on plywood, 41 ⅜ x 29 ½ in.
(105 x 75 cm)
Musée de l'Orangerie, Paris, Walter-Guillaume Collection
(RF: 1960-44)
NEW YORK
PLATE 39

Red Haired Girl, 1915
Oil on canvas, 16 x 14 ⅜ in. (40.5 x 36.5 cm)
Musée de l'Orangerie, Paris, Walter-Guillaume Collection
(RF: 1960-46)
NEW YORK
PLATE 31

Jean Cocteau, 1916–17
Oil on canvas, 39 ½ x 32 in. (100.4 x 81.3 cm)
The Henry and Rose Pearlman Foundation, Inc.
NEW YORK
PLATE 52

Léon Indenbaum, 1916
Oil on canvas, 21 ½ x 18 in. (54.6 x 45.7 cm)
The Henry and Rose Pearlman Foundation, Inc.
PLATE 33

Portrait of Anna (Hanka) Zborowska, 1916
Oil on canvas, 30 x 17 ¾ in. (76.2 x 45.1 cm)
Courtesy of The Metropolitan Museum of Art, lent by The
Alex Hillman Family Foundation, New York (L.1991.19.24)
TORONTO AND WASHINGTON
PLATE 42

Portrait of Manuello, c. 1916
Oil on canvas, 26 x 20 ⅛ in. (66 x 51 cm)
Los Angeles County Museum of Art, Gift of Mr. and
Mrs. William Wyler (51.22)
TORONTO AND WASHINGTON
Page 26, fig. 2

Portrait of Max Jacob, 1916
Oil on canvas, 28 ¾ x 23 ⅝ in. (73 x 60 cm)
Kunstsammlung Nordrhein-Westfalen, Düsseldorf (1036)
NEW YORK AND TORONTO
PLATE 41

Portrait of the Painter Manuel Humbert, 1916
Oil on canvas, 39 ½ x 25 ¾ in. (100.2 x 65.5 cm)
National Gallery of Victoria, Melbourne, Australia, Felton
Bequest, 1948 (1854-4)
PLATE 43

Portrait of a Young Woman (Ragazza), 1916–19
Oil on canvas, 25 ½ x 19 ¾ in. (64.8 x 50.2 cm)
Dallas Museum of Art, Gift of the Meadows Foundation
Incorporated (1981.126)
TORONTO AND WASHINGTON
Page 37, fig. 16

Reclining Nude on a Blue Cushion, 1916
Oil on canvas, 23 ⅝ x 36 ¼ in. (60 x 92 cm)
Private collection
NEW YORK
PLATE 50

Anna Zborowska, 1917
Oil on canvas, 51 ¼ x 32 in. (130.2 x 81.3 cm)
The Museum of Modern Art, New York, Lillie P. Bliss
Collection, 1934 (87.1934)
PLATE 70

Blue Eyes (Portrait of Madame Jeanne Hébuterne), 1917
Oil on canvas, 21 ½ x 16 ⅞ in. (54.6 x 42.9 cm)
Philadelphia Museum of Art, The Samuel S. White 3rd
and Vera White Collection, 1967 (1967-30-59)
PLATE 55

Doctor Devaraigne (Le beau major), 1917
Oil on canvas, 21 ¾ x 18 ⅛ in. (55 x 46 cm)
Alice Warder Garrett Collection, The Evergreen House
Foundation and The Johns Hopkins University, Baltimore
(1952.1.32)
WASHINGTON
PLATE 34

Elena Povolozky, 1917
Oil on canvas, 25 ½ x 19 ⅛ in. (64.6 x 48.5 cm)
The Phillips Collection, Washington, D.C. (1396)
PLATE 53

Hanka Zborowska, 1917
Oil on canvas, 21 ⅝ x 15 in. (55 x 38 cm)
Galleria Nazionale d'Arte Moderna, Rome (4731)
NEW YORK AND TORONTO
PLATE 46

The Italian Woman, 1917
Oil on canvas, 40 ⅜ x 26 ⅜ in. (102.6 x 67 cm)
The Metropolitan Museum of Art, Gift of the Chester Dale
Collection, 1956 (56.4)
PLATE 68

Nude, 1917
Oil on canvas, 28 ¾ x 45 ⅞ in. (73 x 116.7 cm)
The Solomon R. Guggenheim Museum, New York,
Gift of Solomon R. Guggenheim, 1941 (41.535)
NEW YORK
PLATE 48

Nude with Coral Necklace, 1917
Oil on canvas, 26 3/16 x 39 ⅛ in. (64.4 x 99.4 cm)
Allen Memorial Art Museum, Oberlin College, Ohio,
Gift of Joseph and Enid Bissett, 1955 (AMAM 1955.59)
WASHINGTON
PLATE 47

Oscar Miestchaninoff, 1917
Oil on canvas, 18 ⅛ x 13 in. (46 x 33 cm)
Helly Nahmad Gallery, New York
PLATE 54

Portrait of a Girl (Victoria), c. 1917
Oil on canvas, 31 ¾ x 23 ½ in. (80.6 x 59.7 cm)
Tate Gallery, London, Bequeathed by C. Frank Stoop, 1933
(NO4723)
PLATE 40

Reclining Nude (La rêveuse), 1917
Oil on canvas, 23 ½ x 36 ¼ in. (59.7 x 92.1 cm)
Collection of William I. Koch
NEW YORK
PLATE 49

Reclining Nude with Loose Hair, 1917
Oil on canvas, 23 ⅝ x 36 ¼ in. (60 x 92.2 cm)
Osaka City Museum of Modern Art, Japan (125)
NEW YORK
PLATE 51; page 63, fig. 11

Seated Nude, 1917
Oil on canvas, 32 x 25 ⅝ in. (81.2 x 65 cm)
Private collection
NEW YORK
PLATE 77

Young Woman in a Striped Blouse, 1917
Oil on canvas, 36 ¼ x 23 ⅝ in. (92 x 60 cm)
Helly Nahmad Gallery, New York
TORONTO AND WASHINGTON
PLATE 57

La belle épicière, 1918
Oil on canvas, 39 ⅜ x 25 ⅝ in. (100 x 65 cm)
Helly Nahmad Gallery, New York
PLATE 76

Boy in Short Pants, 1918
Oil on canvas, 39 ½ x 25 ½ in. (100.3 x 64.8 cm)
Dallas Museum of Art, Gift of the Leland Fikes Foundation,
Inc. (1977.1)
TORONTO AND WASHINGTON
PLATE 60

Leopold Zborowski, 1918
Oil on canvas, 18 ⅛ x 10 ⅝ in. (46 x 27 cm)
Private collection
NEW YORK
PLATE 45

The Little Peasant, c. 1918
Oil on canvas, 39 ⅜ x 25 ⅜ in. (100 x 64.5 cm)
Tate Gallery, London, Presented by Miss Jenny Blaker
in memory of Hugh Blaker, 1941
Page 47, fig. 4

Lunia Czechowska, c. 1918
Oil on canvas, 31 ½ x 20 ½ in. (80 x 52 cm)
Museu de Arte de São Paulo Assis Chateaubriand
PLATE 73

Portrait of Jeanne Hébuterne, c. 1918
Oil on canvas, 18 x 11 in. (45.7 x 28 cm)
Yale University Art Gallery, Bequest of Mrs. Kate Lancaster
Brewster (1948.123)
TORONTO AND WASHINGTON
Page ix

Portrait of a Student, c. 1918–19
Oil on canvas, 24 x 18 ⅛ in. (61 x 46 cm)
The Solomon R. Guggenheim Museum, New York (94.44.82)
TORONTO AND WASHINGTON
PLATE 62

Portrait of a Woman, 1918
Oil on canvas, 24 x 18 ⅛ in. (61 x 46 cm)
Denver Art Museum, Charles Francis Hendrie Memorial
Collection (1966.180)
WASHINGTON
PLATE 61

Seated Man with a Cane, 1918
Oil on canvas, 49 ⅝ x 29 ½ in. (126 x 75 cm)
Helly Nahmad Gallery, New York
TORONTO AND WASHINGTON
PLATE 58

Seated Man with Orange Background, 1918
Oil on canvas, 39 ⅜ x 25 ⅝ in. (100 x 65 cm)
Private collection
PLATE 69

The Servant Girl, c. 1918
Oil on canvas, 60 x 24 in. (152.4 x 61 cm)
Albright-Knox Art Gallery, Buffalo, New York, Room of
Contemporary Art Fund, 1939 (RCA1939:6)
PLATE 63

The Young Apprentice, c. 1918
Oil on canvas, 39 ⅜ x 25 ⅝ in. (100 x 65 cm)
Musée de l'Orangerie, Paris, Walter-Guillaume Collection
(RF:1963-71)
NEW YORK
PLATE 64

Young Seated Boy with Cap, 1918
Oil on canvas, 39 ⅜ x 25 ⅝ in. (100 x 65 cm)
Private collection
PLATE 65

Young Seated Girl with Brown Hair, 1918
Oil on canvas, 36 ¼ x 37 ⅝ in. (92 x 95.5 cm)
Musée National Picasso, Paris, Donated by Picasso
(R.F. 1973-81)
WASHINGTON
PLATE 59

Young Woman of the People, 1918
Oil on canvas, 39 ⅜ x 25 ⅜ in. (100 x 64.5 cm)
Los Angeles County Museum of Art, Frances and Armand
Hammer Purchase Fund (M.68.46.2)
WASHINGTON
PLATE 56

Jeanne Hébuterne, 1919
Oil on canvas, 39 ⅜ x 25 ⅜ in. (100 x 64.5 cm)
The Metropolitan Museum of Art, Gift of Mr. and
Mrs. Nate B. Spingold, 1956 (56.184.2)
NEW YORK AND WASHINGTON
PLATE 74

Landscape at Cagnes, 1919
Oil on canvas, 18 ⅛ x 11 ⅜ in. (46 x 29 cm)
Private collection
WASHINGTON
PLATE 79

Leopold Zborowski, 1919
Oil on canvas, 39 ⅜ x 25 ⅝ in. (100 x 65 cm)
Museu de Arte de São Paulo Assis Chateaubriand
PLATE 72

Paulette Jourdain, 1919
Oil on canvas, 39 ⅜ x 25 ⅝ in. (100 x 65 cm)
Mr. A. Alfred Taubman
NEW YORK
PLATE 80

Portrait of Thora Klinckowström, 1919
Oil on canvas, 39 ¼ x 25 ½ in. (99.7 x 64.8 cm)
The Estate of Evelyn Sharp
PLATE 75

Roger Dutilleul, 1919
Oil on canvas, 39 ⅜ x 25 ⅝ in. (100 x 65 cm)
Private collection
PLATE 78

Portrait of Max Jacob, c. 1920
Oil on canvas, 36 ½ x 23 ¾ in. (93 x 60 cm)
Cincinnati Art Museum, Gift of Mary E. Johnston (1959.43)
NEW YORK
Page 16, fig. 15

SCULPTURE

Head of a Woman, 1910–11
Limestone, 25 ¾ x 7 ½ x 9 ¾ in. (65.2 x 19 x 24.8 cm)
National Gallery of Art, Washington, D.C., Chester Dale
Collection (1963.10.241)
WASHINGTON
PLATE 16

Head, c. 1911
Stone, 15 ½ x 12 ¼ x 7 ⅜ in. (39.4 x 31.1 x 18.7 cm)
Fogg Art Museum, Harvard University Art Museums,
Gift of Lois Orswell (1992.254)
PLATE 8

Head, 1911–12
Limestone, 29 x 12 x 9 in. (73.7 x 30.5 x 22.9 cm)
Latner Family Private Collection, Toronto
PLATE 11

Head, 1911–12
Limestone, 19 ⅝ x 7 ¼ x 9 in. (49.5 x 18.4 x 22.8 cm)
Hirshhorn Museum and Sculpture Garden, Smithsonian
Institution, Gift of Joseph H. Hirshhorn, 1966 (66.3582)
PLATE 12

Head, 1911–13
Limestone, 28 ¼ x 7 ¼ x 8 ⅛ in. (71.8 x 18.4 x 20.6 cm)
The Solomon R. Guggenheim Museum, New York, Gift,
Solomon R. Guggenheim (55.1421)
NEW YORK
PLATE 13

Head, 1912–13
Stone, 18 ½ x 9 ⅞ x 11 ¾ in. (47 x 25 x 30 cm)
Musée National d'Art Moderne, Centre Georges Pompidou,
Paris, Purchase of Melle Contamin (Paris), 1950 (AM 903 S)
NEW YORK
PLATE 9

Head, 1912
Limestone, 27 ¾ x 9 ¼ x 6 ½ in. (70.5 x 23.5 x 16.5 cm)
Philadelphia Museum of Art, Gift of Mrs. Maurice J. Speiser
in memory of her husband (1950-2-1)
NEW YORK
PLATE 14

Head of a Woman, 1912
Limestone, 22 ⅞ x 4 ¾ x 6 ¼ in. (58 x 12 x 16 cm)
Musée National d'Art Moderne, Centre Georges Pompidou,
Paris, Purchase of M. Poyet in 1949 (AM 876 S)
NEW YORK
PLATE 15

Head, 1914
Limestone, 16 ½ x 4 ⅞ x 6 ¾ in. (41.8 x 12.5 x 17 cm)
The Henry and Rose Pearlman Foundation, Inc.
NEW YORK
PLATE 10

WORKS ON PAPER

Young Male Nude, 1896
Pencil on cardboard, 23 ⅜ x 16 ¾ in. (59.3 x 42.5 cm)
Museo Civico Giovanni Fattori, Livorno
PLATE 81

Portrait of a Woman Taking Part in a Spiritualist Séance, c. 1905–6
Ink and watercolor over pencil on paper,
18 ⅞ x 12 ⅝ in.
(48 x 32 cm)
Musée des Beaux-Arts, Rouen, Gift of Blaise Alexandre, 2001
(2001.2.1)
NEW YORK
Page 4, fig. 3

Sketchbook, 1906–7
Pencil and crayon on paper, 9 ¼ x 5 ⅞ x ⅝ in.
(23.5 x 15 x 1.6 cm)
Patrick Derom Gallery, Brussels

Woman Dressed with a Loincloth, c. 1908
Red chalk on paper, 16 ⅞ x 11 ⅛ in. (43 x 28.3 cm)
Musée des Beaux-Arts, Rouen, Gift of Blaise Alexandre, 2001
(2001.2.5)
TORONTO
PLATE 97

The Cellist, c. 1909
Ink on paper, 10 ⅝ x 8 ¼ in. (27.1 x 21.1 cm)
Musée des Beaux-Arts, Rouen, Gift of Blaise Alexandre, 2001
(2001.2.36)
NEW YORK
PLATE 116; page 21, fig. 19

Crouched Nude, c. 1909–14
Graphite and colored pencil over chalk on paper,
23 ¼ x 17 ¾ in. (59 x 45 cm)
Baltimore Museum of Art, The Cone Collection, formed by
Dr. Claribel Cone and Miss Etta Cone of Baltimore (BMA
1950.12.43)
WASHINGTON
PLATE 22

Face and Column, c. 1910
Black and blue chalk on paper,
13 ¼ x 10 ⅜ in. (33.8 x 26.3 cm)
Öffentliche Kunstsammlung Basel, Kupferstichkabinett,
Karl August Burckhardt-Koechlin-Fonds (1961.141)
NEW YORK
PLATE 89

Female Acrobat, c. 1910
Pencil on paper, 20 ½ x 14 ⅝ in. (52 x 37 cm)
Courtesy Galerie Cazeau-Béraudière, Paris
NEW YORK
PLATE 82

Female Nude Asleep (Anna Akhmatova), c. 1910–11
Crayon on paper, 10 ⅜ x 16 ⅞ in. (26.5 x 43 cm)
Private collection, Paris
NEW YORK
PLATE 106

*Female Nude Asleep, with Standing Male Figure (Anna
Akhmatova)*, c. 1910–11
Crayon on paper, 10 ⅜ x 16 ⅞ in. (26.5 x 43 cm)
Musée des Beaux-Arts, Rouen, Gift of Blaise Alexandre, 2001
(2001.2.25)
NEW YORK
PLATE 107

Heads, c. 1910
Blue chalk on paper, 13 ¼ x 10 ⅜ in. (33.8 x 26.3 cm)
Öffentliche Kunstsammlung Basel, Kupferstichkabinett,
Karl August Burckhardt-Koechlin-Fonds (1961.137)
NEW YORK
PLATE 90

Kneeling Caryatid with Halo, c. 1910–13
Crayon on paper, 16 ⅞ x 10 ½ in. (43 x 26.7 cm)
Musée des Beaux-Arts, Rouen, Gift of Blaise Alexandre, 2001
(2001.2.7)
NEW YORK
Page 12, fig. 11

Old Man in Prayer, 1910–11
Pencil on paper, 12 ¼ x 7 ⅞ in. (31.2 x 20 cm)
Private collection, Paris
NEW YORK
PLATE 117

Round Face, c. 1910–14
Blue chalk on paper, 13 ¼ x 10 ⅜ in. (33.8 x 26.3 cm)
Öffentliche Kunstsammlung Basel, Kupferstichkabinett,
Karl August Burckhardt-Koechlin-Fonds (1961.134)
NEW YORK
PLATE 88

Round Face in Circle, c. 1910–14
Red chalk on paper, 13 ¼ x 10 ⅜ in. (33.8 x 26.3 cm)
Öffentliche Kunstsammlung Basel, Kupferstichkabinett,
Karl August Burckhardt-Koechlin-Fonds (1961.133)
NEW YORK
PLATE 87

Standing Nude, c. 1910
Graphite on paper, 16 ⅞ x 10 ¼ in. (43 x 26 cm)
The Metropolitan Museum of Art, Robert Lehman
Collection, 1975 (1975.1.381)
WASHINGTON

Woman in Profile, 1910–11
Charcoal and pastel on paper, 17 x 10 ½ in. (42.9 x 26.7 cm)
The Museum of Modern Art, New York, The Joan and Lester
Avnet Collection (134.1978)
TORONTO AND WASHINGTON
PLATE 95

Caryatid, Hands Behind Her Head, 1911
Crayon on paper, 16 ⅞ x 10 ⅜ in. (42.8 x 26.4 cm)
Courtesy Galerie Cazeau-Béraudière, Paris
WASHINGTON
PLATE 112

Head and Shoulders with Fringe, 1911
Crayon on paper, 16 ¾ x 10 ¼ in. (42.7 x 26.2 cm)
Courtesy Galerie Cazeau-Béraudière, Paris
NEW YORK
PLATE 93

Hermaphrodite Caryatid, 1911
Crayon on paper, 16 ⅞ x 10 in. (42.8 x 25.5 cm)
Patrick Derom Gallery, Brussels
PLATE 113

Standing Female Nude (Anna Akhmatova), c. 1911
Blue crayon heightened with red gouache on paper,
16 ¾ x 10 ½ in. (42.6 x 26.5 cm)
Private collection, Paris
NEW YORK
PLATE 104

Kneeling Caryatid Sitting on Her Heels, 1911–12
Blue crayon on paper, 17 x 10 ½ in. (43 x 26.5 cm)
Courtesy Richard Nathanson, London
PLATE 110

Standing Nude with Crossed Arms, 1911–12
Oil on cardboard, 32 ⅝ x 18 ⅞ in. (82.8 x 47.9 cm)
Nagoya City Art Museum, Japan

The Acrobat (Le pitre), c. 1912
Crayon on paper, 17 x 10 ¼ in. (43.2 x 26 cm)
Private collection
TORONTO AND WASHINGTON
PLATE 83

Caryatid, c. 1912–14
Blue crayon and graphite on paper, 24 x 18 in. (61 x 45.7 cm)
Philadelphia Museum of Art, Given by Arthur Wiesenberger
(1950-134-150)
TORONTO AND WASHINGTON
PLATE 21

Caryatid, c. 1912–13
Crayon on paper, 15 ⅝ x 10 ⅛ in. (39.7 x 25.7 cm)
Musée des Beaux-Arts, Dijon (DG 244)
WASHINGTON
PLATE 114

Caryatid (Cariatide monumentale), c. 1912–13
Crayon on paper, 17 x 10 ⅞ in. (43.1 x 27.7 cm)
Musée des Beaux-Arts, Rouen, Gift of Blaise Alexandre, 2001
(2001.2.10)
TORONTO
PLATE 98

Head in Profile, 1912
Blue crayon on paper, 17 ⅜ x 10 ½ in. (44 x 26.7 cm)
Musée National d'Art Moderne, Centre Georges Pompidou,
Paris, Gift of Marguerite Arp-Hagenbach, 1973 (AM 1973-18)
TORONTO
PLATE 91

Rose Caryatid with Blue Border, c. 1912
Watercolor on paper, 21 ⅞ x 17 ¾ in. (55.6 x 45.1 cm)
Private collection
PLATE 24

Sheet of Studies with African Sculpture and Caryatid, c. 1912–13
Pencil on paper, 10 ⅜ x 8 ⅛ in. (26.5 x 20.5 cm)
Steve Banks Fine Arts, San Francisco
PLATE 96

Caryatid, 1913–14
Oil on cardboard, 23 ⅝ x 21 ¼ in. (60 x 54 cm)
Musée National d'Art Moderne, Centre Georges Pompidou,
Paris, purchase, 1949 (AM2929P)
NEW YORK
Page 8, fig. 4

Caryatid, c. 1913–14
Watercolor over graphite on buff wove paper,
21 ⅛ x 16 ⅛ in. (53.5 x 41 cm)
The Art Institute of Chicago, Amy McCormick Memorial
Collection (1942.462)
WASHINGTON
PLATE 20

Large Red Bust, 1913
Oil on cardboard, 32 ⅛ x 20 ⅛ (81.5 x 51 cm)
Courtesy Galerie Cazeau-Béraudière, Paris
NEW YORK
PLATE 18

Red Bust, 1913
Oil on cardboard, 31 ⅞ x 18 ⅛ in. (81 x 46 cm)
Private collection
PLATE 19

Anadiomena, 1914
Graphite and crayon on white wove paper, 13 ⅜ x 10 ½ in.
(33.9 x 26.5 cm)
Princeton University Art Museum, Bequest of Dan Fellows
Platt, Class of 1895 (1948-390)
TORONTO
PLATE 101

Caryatid, 1914
Gouache, brush, and ink on paper, 22 ¾ x 18 ½ in.
(57.8 x 47 cm)
The Museum of Modern Art, New York, Mrs. Harriet H.
Jonas Bequest (439.1974)
NEW YORK
PLATE 23

Caryatid, c. 1914
Gouache on wove paper, mounted on canvas, mounted
on wood panel, 55 ⅜ x 26 ⅛ in. (140.7 x 66.5 cm)
The Museum of Fine Arts, Houston; Gift of Oveta Culp
Hobby (84.412)
NEW YORK AND TORONTO
PLATE 25

Caryatid, c. 1914–15
Blue crayon and graphite on paper, 28 ⅞ x 23 ⅜ in.
(73.3 x 59.4 cm)
Philadelphia Museum of Art (1943-101-2)
WASHINGTON
PLATE 27

Caryatid, 1914
Mixed media on cardboard, 29 x 19 ½ in. (73.5 x 49.5 cm)
Private collection
PLATE 28

Caryatid, 1914
Gouache and graphite on paper, 19 x 12 ½ in. (48 x 32 cm)
Courtesy Galerie Cazeau-Béraudière, Paris
NEW YORK
PLATE 29

Diego Rivera, 1914
Blue crayon on paper, 13 ¾ x 9 in. (35 x 23 cm)
Private collection
NEW YORK
PLATE 131

Portrait of Diego Rivera, 1914
Pencil on paper, mounted on board, 13 ⅜ x 10 ⅜ in.
(34 x 26.5 cm)
Courtesy Galerie Cazeau-Béraudière, Paris
WASHINGTON
PLATE 141

Portrait of Frank Burty Haviland, 1914
Pencil on paper, 10 ⅞ x 8 ½ in. (27.5 x 21.5 cm)
Musée d'Art Moderne de la Ville de Paris
NEW YORK
PLATE 139

Portrait of the Painter Eduardo García Bénito, c. 1914–15
Pen and ink with wash on graph paper, 8 x 4 in.
(20.3 x 10.2 cm)
The Metropolitan Museum of Art, Robert Lehman
Collection, 1975 (1975.1.378)
WASHINGTON

Portrait of Picasso, 1914–15
Graphite on vellum, 8 ⅞ x 10 ½ in. (22.6 x 26.8 cm)
Musée Picasso, Antibes (MPA 1982.2.8)
PLATE 134

Portrait of the Sculptor Pablo Gargallo, c. 1914–15
Pen and ink with wash on graph paper, 8 ¼ x 5 ¼ in.
(21 x 13.3 cm)
The Metropolitan Museum of Art, Robert Lehman
Collection, 1975 (1975.1.379)
WASHINGTON

Rose Caryatid, 1914
Gouache and crayon on paper, 23 ¾ x 17 ⅞ in.
(60.3 x 45.4 cm)
Norton Museum of Art, West Palm Beach, Florida, Bequest
of R. H. Norton (53.132)
WASHINGTON
PLATE 26

Seated Nude, 1914
Pencil and wash, watercolor on paper, 21 ¼ x 16 ⅜ in.
(54 x 41.6 cm)
The Museum of Modern Art, New York, Gift of Mrs. Saidie
A. May (29.1932)
PLATE 99

Adam, 1915–16
Pencil on paper, 16 ⅞ x 10 ¼ in. (42.8 x 26 cm)
The Museum of Modern Art, New York, The Joan and
Lester Avnet Collection (135.1978)
PLATE 122

Head, 1915
Oil on paper, 16 ⅜ x 10 ⅜ in. (41.5 x 26.5 cm)
Musée Calvet, Avignon (22291)
WASHINGTON
PLATE 125

Portrait of Max Jacob, 1915
Pencil on paper, 11 ¾ x 8 ¾ in. (29.5 x 22.5 cm)
Courtesy Galerie Cazeau-Béraudière, Paris
NEW YORK
PLATE 132

Woman, Heads, and Jewish Symbols, 1915
Pencil and watercolor on paper, 21 ½ x 16 ⅞ in.
(54.5 x 43 cm)
Private collection, Italy
PLATE 86

Bénito, 1916
Graphite on paper, 17 x 10 ⅛ in. (43.1 x 25.6 cm)
The Art Institute of Chicago, Bequest of Mary & Leigh Block
(1988.141.34)
WASHINGTON
PLATE 143

L'Estatico, 1916
Graphite on paper, 16 ¾ x 10 ⅜ in. (42.5 x 26.5 cm)
Private collection
NEW YORK
PLATE 115

Male Nude, 1916
Pencil and watercolor on paper, 17 ⅛ x 10 ¼ in.
(43.5 x 26 cm)
Musée Calvet, Avignon (22300)
TORONTO
PLATE 100

Man in Prayer, 1916
Crayon on paper, 17 ⅛ x 10 ⅜ in. (43.4 x 26.5 cm)
Galleria Nazionale d'Arte Moderna, Rome (5386-5)
TORONTO
PLATE 118

Motherhood, 1916
Pencil on paper, 14 ¼ x 10 ⅜ in. (36.2 x 26.5 cm)
The Museum of Modern Art, New York, The John S.
Newberry Collection (380.1960)
PLATE 119

Portrait of Beatrice Hastings, 1916
Oil and pencil on paper, 17 ⅛ x 10 ½ in. (43.5 x 26.7 cm)
Private collection
TORONTO AND WASHINGTON
PLATE 126

Portrait of Chana Orloff, 1916
Ink on paper, 11 ¼ x 6 ⅞ in. (28.5 x 17.5 cm)
Justman-Tamir Collection, Paris
PLATE 130

Portrait of Jacques Lipchitz, 1916
Pencil on paper, 17 x 10 ½ in. (43.2 x 26.7 cm)
Private collection
TORONTO AND WASHINGTON
PLATE 138

Portrait of Kisling, 1916
Pencil on parchment paper, 16 ¼ x 10 ⅛ in. (41.3 x 25.7 cm)
Courtesy Galerie Cazeau-Béraudière, Paris
NEW YORK
PLATE 133

Self-Portrait (?), c. 1916
Pencil on paper, 13 ¼ x 10 ⅜ in. (33.8 x 26.5 cm)
Courtesy Galerie Cazeau-Béraudière, Paris
WASHINGTON
PLATE 124

Two Young Peasants in Prayer, c. 1916
Graphite on paper, 16 ⅝ x 10 ⅜ in. (42.2 x 26.4 cm)
The Metropolitan Museum of Art, Gift of Mr. and Mrs.
Sol Fishko, 1981 (1981.33)
WASHINGTON
PLATE 120

Portrait of Jacques Lipchitz, 1917
Pencil on paper, 13 ¾ x 10 ¼ in. (35 x 26 cm)
Courtesy Galerie Cazeau-Béraudière, Paris
NEW YORK
PLATE 144

Portrait of Michel Kikoïne, c. 1917
Pencil on paper, 14 ½ x 10 in. (36.8 x 25.5 cm)
Justman-Tamir Collection, Paris
PLATE 129

Oscar Miestchaninoff, 1918
Pencil on paper, 18 ¾ x 12 ¼ in. (47.5 x 31.2 cm)
The Museum of Modern Art, New York, Gift of
Mrs. Donald B. Strauss (708.1976)
PLATE 135

Portrait of a Man with Hat (Paul Guillaume), c. 1918
Pencil on paper, 15 x 11 in. (38 x 28 cm)
Courtesy Galerie Cazeau-Béraudière, Paris
WASHINGTON
PLATE 136

St. John the Baptist, 1918
Pencil on notebook paper, 5 ⅝ x 3 ⅝ in. (14.3 x 9.3 cm)
Fondazione Antonio Mazzotta, Milan
PLATE 121

Seated Nude, 1918
Graphite on tan wove paper, 16 ¾ x 9 ⅞ in. (42.5 x 25 cm)
The Art Institute of Chicago, Given in Memory of Tiffany
Blake by Claire Swift-Marwitz (1951.22)
WASHINGTON
PLATE 123

Torso of a Nude Woman, c. 1918
Graphite on paper, 17 ⅛ x 10 ⅜ in. (43.5 x 26.4 cm)
The Metropolitan Museum of Art, Gift of Bella and Sol
Fishko, 1982 (1982.503)
WASHINGTON

Portrait of a Young Woman, 1919
Graphite on paper, 11 ⅛ x 7 ⅜ in. (28.3 x 18.7 cm)
Fogg Art Museum, Harvard University Art Museums, Bequest
of Meta and Paul J. Sachs (1965.398)
WASHINGTON

Mario the Magician, 1920
Pencil on paper, 19 ¼ x 12 in. (48.9 x 30.5 cm)
The Museum of Modern Art, New York, Gift of Abby Aldrich
Rockefeller (116.1935)
TORONTO AND WASHINGTON
PLATE 142

The Caballero, n.d.
Graphite on paper, 16 ⅝ x 10 ¼ in. (42.2 x 26 cm)
Courtesy Galerie Cazeau-Béraudière, Paris
TORONTO
PLATE 128

Caryatid, Frontal View, Half-Figure, n.d.
Crayon on paper, 16 ¾ x 10 ¼ in. (42.5 x 26.3 cm)
Courtesy Richard Nathanson, London
PLATE 94

Caryatid Kneeling on Right Knee, n.d.
Crayon on paper, 16 ⅞ x 10 ⅜ in. (42.8 x 26.4 cm)
Private collection, Paris
NEW YORK
PLATE 111

Dancer, n.d.
Pencil on paper, 15 ¾ x 10 ½ in. (40 x 26.6 cm)
Private collection, New York
PLATE 84

Faun, n.d.
Crayon on paper, 15 ¾ x 10 ¼ in. (40 x 26.2 cm)
Private collection, New York
PLATE 85

Female Nude Placed Diagonally, n.d.
Crayon on paper, 16 ⅞ x 10 ⅜ in. (43 x 26.5 cm)
Private collection, Paris
NEW YORK
PLATE 108; page 12, fig. 12

Head in Left Profile, n.d.
Crayon on paper, 16 ¾ x 10 ¼ in. (42.5 x 25 cm)
Courtesy Galerie Cazeau-Béraudière, Paris
NEW YORK
PLATE 92

Portrait of Adolphe Basler, n.d.
Graphite pencil on cardboard, 19 ¼ x 11 ¾ in.
(48.8 x 29.8 cm)
The Phillips Collection, Washington, D.C., Gift of Jean
Goriany, 1943 (1988.9.7)
TORONTO AND WASHINGTON
PLATE 137

Portrait of Jeanne Hetenval, n.d.
Crayon and charcoal on paper, 16 x 10 ¼ in. (40.5 x 26.2 cm)
Private collection, New York
TORONTO AND WASHINGTON
PLATE 127

Portrait of Paul Guillaume, n.d
Pencil on paper, 16 ½ x 9 ⅞ in. (42 x 25 cm)
Courtesy Galerie Cazeau-Béraudière, Paris
NEW YORK
PLATE 140

Woman in a Low-Cut Gown, Reclining on a Bed, n.d.
Crayon on paper, 10 ⅜ x 16 ⅞ in. (26.4 x 43 cm)
Courtesy Galerie Cazeau-Béraudière, Paris
NEW YORK
PLATE 103

Notes

MODIGLIANI AGAINST THE GRAIN

Epigraphs: Quoted in Pierre Sichel, *Modigliani: A Biography* (London: W. H. Allen, 1967), p. 56; Hannah Arendt, "The Jew as Pariah: A Hidden Tradition," in Hannah Arendt, *The Jew as Pariah: Jewish Identity and Politics in the Modern Age* (New York: Grove, 1978), pp. 67–68.

1. Just how religiously indoctrinated the Modiglianis were is a matter of some conjecture, although the family had been, at least through the time of the artist's paternal grandfather, strict Orthodox Jews. Modigliani could write in Hebrew and made his bar mitzvah. More important, and incontestable, is the claim by the artist's daughter, Jeanne Modigliani, that "the practice of passionate Talmudic discussion was still very much alive in the family during my childhood." Jeanne Modigliani, *Modigliani: Man and Myth* (New York: Orion Press, 1958), p. 7. Despite such assertions and the widespread acknowledgment of Modigliani's Jewish identification, the historians' indifference to it is perplexing. Jeanne Modigliani also mentions that during the eighteenth century a Garsin had become well-known in Tunisia as an expert on the Sacred Books and as the founder of a school for Talmudic studies that was still operating at the end of the nineteenth century.

2. It has been suggested that Chaim Soutine's animated, obsessively singular examination of such subjects as chicken carcasses was his insurgent reaction to his religious upbringing. Maurice Tuchman, *Chaim Soutine*, exh. cat. (Los Angeles: Los Angeles County Museum of Art, 1968), p. 11ff.; quoted in Avram Kampf, *Jewish Experience in the Art of the Twentieth Century* (South Hadley, Mass.: Bergin and Garvey, 1984), p. 94. See also Arthur A. Cohen, "From Eastern Europe to Paris and Beyond," in Kenneth E. Silver and Romy Golan, *The Circle of Montparnasse: Jewish Artists in Paris, 1905–1945*, exh. cat. (New York: Universe and The Jewish Museum, 1985), p. 61.

3. According to Émile Schaub-Koch, Modigliani referred to himself as a *"juif du patriciat,"* and felt that the Jews of Livorno were placed in exceptionally good lineage: "The patrician Jew is poor not only because he scorns riches, but because the feeling for money is lacking in him. This is understood. The heirs of the race of David have in their veins since birth all the splendors which money brings—and which are the object of the appetites of men today—and by this very fact they have all the beauties and all the refinements. But what is sad is that,

although we have no money, we have kept the instinct which impels us to use it as if we had a lot. It's a matter of old habit." See Sichel, *Modigliani,* p. 86; originally quoted in Émile Schaub-Koch, *Modigliani* (Paris: Mercure Universal, 1933), p. 12. The archive in Modigliani's case is especially lacking because of his brief life and the absence of records, which were destroyed along with the Livorno synagogue during World War II.

4. The exhibition was *Modigliani and the Artists of Montparnasse*, organized by Kenneth Wayne and held at the Albright-Knox Art Gallery in Buffalo, New York, October 20, 2002–January 12, 2003; a catalogue by the same title accompanied the exhibition (New York: Harry N. Abrams, 2002).

5. Modigliani, *Modigliani*, p. 8. Jeanne Modigliani notes further that her father's maternal family, in Marseilles and Livorno, "had never met with anti-Semitism." Although anti-Semitism of course existed in Italy, it was less manifest, as a result of the ability of the polyglot Sephardim to blend in linguistically without dialect. Moreover, the prejudice of the post-Risorgimento period was directed more toward Zionism, which was perceived as a threat to the patriotic loyalty of Italian Jewry and as a vehicle by which Jews could become politically viable in lands held sacred by the Catholic Church. See Mario Toscano, "The Jews in Italy from the Risorgimento to the Republic," in Vivian B. Mann, ed., *Gardens and Ghettos: The Art of Jewish Life in Italy* (Berkeley: University of California Press, 1989), p. 30.

6. Alfred Werner, "The Life and Art of Modigliani," *Commentary* 85 (May 1953), p. 475.

7. Two excellent essays on this illuminating period of Italian Jewish history are: Arthur Kiron, "Livornese Traces in American Jewish History: Sabato Morais and Elia Benamozegh," and Richard A. Cohen, "Benamozegh and Lévinas on Jewish Universalism," both in Alessandro Guetto, ed., *Per Elia Benamozegh* (Milan: Thálassa De Paz, 2000), pp. 45–66 and pp. 89–105.

8. An exception to this is Emily Braun, "From the Risorgimento to the Resistance: One Hundred Years of Jewish Artists in Italy," in Mann, *Gardens and Ghettos*, pp. 137–89.

9. See Arnaldo Momigliano, "The Jews of Italy," *New York Review of Books*, October 24, 1985, pp. 22–26.

10. For more on these two figures, see Kiron, "Livornese Traces in American Jewish History: Sabato Morais and Elia Benamozegh." On idealism and the Sephardim, see José Faur, "Sephardim in the Nineteenth Century: New Directions and Old Values," *Proceedings of the American Academy for Jewish Research* 44 (1977), pp. 29–52; and "Vico, Religious Humanism and the Sephardic Tradition," *Judaism* 27 (Winter 1978), pp. 63–71.

11. Melancholia's fundamental embodiment in the Symbolists' femme fatale is consistent with the late-nineteenth-century trope of the feminine as an allegory of the modern, which numerous artists and historians, from Charles Baudelaire to Walter Benjamin, have echoed in their work and reading of the period. See, for example, Christine Buci-Glucksmann, "L'utopie féminine," in *La Raison baroque: De Baudelaire à Benjamin* (Paris: Galilée, 1984). Also, in the near-exclusion of his own self-portrait, one may align Modigliani with the Baudelairean tradition of distancing oneself from the crowd, as Walter Benjamin has famously framed the poet: "When Victor Hugo was celebrating the crowd as the hero in the modern epic, Baudelaire was looking for a refuge for the hero among the masses of the big city. Hugo placed himself in the crowd as a citoyen, Baudelaire sundered himself from it as a hero." Walter Benjamin, *Charles Baudelaire: A Lyric Poet in the Era of High Capitalism*, trans. Harry Zohn (New York: Verso, 1997), p. 66.

12. Quoted in Sichel, *Modigliani*, p. 28.

13. One family legend tells of a Modigliani who lived in Rome, where in the nineteenth century Jews were restricted from owning land within the papal state. When this relative, who was prosperous enough to have lent money to a cardinal in the Vatican, invested in a vineyard, Church authorities viewed his act as defiant and forced him to sell. His response was to leave for Livorno, in 1849. See ibid., p. 26.

14. Livorno had an extraordinary history of Jewish support, beginning with Duke Cosimo I de' Medici in the sixteenth century, who invited foreigners, including Marranos, to the new port in order to increase its economic importance. In 1587, Ferdinando de' Medici succeeded his father as duke, and he, too, encouraged merchants of all nations to move to Livorno and Pisa. A more explicit expansion of tolerance came in the set of charters put forth in 1593, which offered asylum to all Levantines, and to Spanish, Portuguese, Germans, and Italians, as well as total religious freedom, pardon from previous crimes, full Tuscan citizenship, and recourse to special civil and criminal courts. Jews who moved to Livorno were guaranteed safe passage and protection of their goods. They no longer had to wear identifying badges; they could own and inherit houses and property, carry arms, open shops and conduct business in all parts of the city, employ Christian servants and nursemaids, study at the university, and work as doctors.

15. Modigliani's refusal to compromise his youthful artistic idealism, as articulated in a letter to his friend and fellow artist Oscar Ghiglia in 1901, rings with zealotry: "People like us . . . have different rights, different values [from those of] normal, ordinary people because we have different needs which put us—it has to be said and you must believe it—above their moral standards. Your duty is never to waste yourself in sacrifice. Your *real* duty is to save your dream. Beauty herself makes painful demands; but these nevertheless bring forth the most supreme efforts of the soul." Quoted in Sichel, *Modigliani*, p. 55.

16. Giuseppe Emanuele's activism, after he joined the Socialist Party, led to his arrest in 1898 for subversive activities, and a fine and an eight-month incarceration. For biographical accounts, see Modigliani, *Modigliani*, and Sichel, *Modigliani*. Although Modigliani did not share his brother's activism, he was not apolitical. His views were expressed in his idealist, bohemian unwillingness to compromise and in his disdain and intransigence toward the bourgeois "business" of life, his refusal to work for a living or please his sitters when he was given a commission. Jean Alexandre, the brother of his patron Paul Alexandre, attempted to assist Modigliani in finding work as a caricaturist, something many of his artist friends did. Alexandre introduced him to the editor of *L'assiette au beurre,* an illustrated weekly magazine of political satire, but apparently to no avail. Noel Alexandre, *The Unknown Modigliani: Drawings from the Collection of Paul Alexandre* (New York: Harry N. Abrams, 1993), pp. 88–89. As the painter Henri Gazan once wrote to Jean Alexandre: "It's the end of the road. I shall have to go back to 'business.' . . . Modigliani, on the other hand, would have nothing to do with 'bread-winning expedients.' " Ibid., p. 86. He refused to earn money other than from selling his work, and even this he seems to have often undermined.

17. This fully realized emancipation paralleled the movement's various triumphant stages, the second war for Italian independence, in 1859, and the proclamation of the Kingdom of Italy, in 1861. The artist's sense of optimism was a product of numerous factors, not least among them the full benefits of the rapid emancipation of Italian Jewry, the greater national identity that both Jews and non-Jews felt as Italy experienced a cultural and organizational renewal, and an independence from foreign interests.

18. For a discussion of the art historical morass, see Maurice Berger's essay "The Modigliani Myth" in this volume.

19. The significant disproportionately large influence of the Garsin family over the young artist was exemplified by Eugenia and her sister Laura, both of whom engendered in him a literary and philosophical perspective. It is evident that Eugenia and her family made every effort to compensate for the lack of cultivation they saw in the Modiglianis. See Sichel, *Modigliani*, p. 28.

20. Jacob Epstein recalls seeing a variety of books in Modigliani's decrepit room at the Cité Falguière, including works by Stéphane Mallarmé and Baudelaire, Petrarch's sonnets, Dante's *Vita nuova,* Spinoza's *Ethics,* and an anthology of Henri Bergson. Ibid., p. 200.

21. See Kenneth E. Silver, "Jewish Artists in Paris, 1905–1945," in Silver and Golan, *The Circle of Montparnasse,* pp. 18–19.

22. Ibid.

23. The legend was maintained on the basis of the name of Amedeo's great-great-grandmother, Regina Spinoza Garsin. Since Spinoza had no children, such a relationship could have been only distant at best.

24. Carlo Carrà, "André Derain," *Valori plastici* 3, no. 3 (March 1921), pp. 67–68; quoted in translation in Ezio Bassani, "Italian Painting," in William Rubin, ed., *"Primitivism" in 20th Century Art,* exh. cat. (New York: The Museum of Modern Art, 1984), p. 406.

25. Umberto Boccioni, "Fondamento plastico della scultura e pittura futuriste," *Lacerba* 1, no. 6 (March 15, 1913), p. 51; quoted in translation in Bassani, "Italian Painting," p. 405. Such hegemonic views were echoed by another Italian Futurist, Carlo Carrà, who the following year, in a tirade against the Cubists, wrote that the cultural influence of *"art nègre"* was "a gross error and [an] unwitting fraud into which the major artists of contemporary France had fallen . . . [their] mistakes attributable to the fallacy of thinking that they could artificially create for themselves an innocence and a modern sensibility by turning to the remote center of Africa to find ready-made the inspirations and archaic motifs for their plastic constructions, which for whatever reason, were then supposed to respond, through a kind of cultural suggestion, to the aesthetic needs of our very modern sensibility." Carlo Carrà, "Vita moderna e arte popolare," *Lacerba* 2, no. 11 (June 1, 1914), p. 167; quoted in translation in Bassani, "Italian Painting," p. 406.

26. See Alan G. Wilkinson, "Paris and London: Modigliani, Lipchitz, Epstein, and Gaudier-Brzeska," in Rubin, *"Primitivism" in 20th Century Art,* p. 423.

27. Werner Schmalenbach, *Amedeo Modigliani: Paintings, Sculptures, Drawings* (Munich: Prestel, 1990), p. 10.

28. The first was Solomon Alexander Hart (1806–1881), who after his election was introduced with these words: "This is Mr. Hart whom we have just elected Academician. . . . Mr. Hart is a Jew, and the Jews crucified our Savior, but he is a very good man for all that, and we shall see something more of him now." Quoted in Anthony Julius, *Idolizing Pictures: Idolatry, Iconoclasm and Jewish Art* (New York: Thames & Hudson, 2000), p. 52.

29. *Jewish Quarterly Review,* July 1901, n.p.; cited in *Solomon J. Solomon RA,* exh. cat. (London: Ben Uri Art Gallery, 1990), p. 8.

30. Consider two paintings by Liebermann of 1879, *Christ in the Temple* and *The Twelve-Year-Old Jesus in the Temple.* In the former, Liebermann animates Christ, who is seen forcefully gesticulating. The latter proved far more problematic, and created a sensation when it was shown at an international art show in Munich, because of the non-Aryan manner in which Christ is depicted. Liebermann evidently later repainted the figure to render him less "Jewish," lightening his hair and making him look generally less unruly. The artist subsequently recalled that "the nastiest newspaper feuds ensued. Nauseated by all the clamor that now . . . is incomprehensible, I made the decision never again to paint a biblical subject. In the meantime, [*The Twelve-Year-Old Jesus in the Temple*] gave rise to the new style of religious painting." See Emily Bilski, ed., *Berlin Metropolis: Jews and the New Culture 1890–1918* (Berkeley: University of California Press, 1999), pp. 153–55. Not only did the well-known anti-Semite Kaiser Wilhelm II later declare that he attributed his anti-Semitism to this painting, but the response to the work indicates that, as Bilski states, the German public "simply believed that a Jew should not paint 'their' Jesus—and especially not as a Jew." Ibid., p. 156. For more on the emphasis of Christ's martyrdom in Jewish art, see Ziva Amishai-Maisels, "Chagall's *White Crucifixion,*" in *The Art Institute of Chicago Museum Studies* 17, no. 2, pp. 139–81.

31. In the sense, for example, that Joséphin Péladan had aligned mystical, occult, and Catholic ideals in the Salon de la Rose + Croix.

32. Alexandre, *The Unknown Modigliani,* pp. 90–93. Marc Restellini poses the question of the artist's philosophical inclination, for instance, and even cites the 1907 sketchbook passage as well as Alexandre's reference to its Jewish context, yet does not pursue the question. Kenneth Wayne, while he suggests that Modigliani's focus on the figurative relates to his Jewishness, also does not pursue the subject.

33. For an extended iconographical reading of the alchemical and Kabbalistic signs and references in the 1913 note, and especially its references to the complementary character of the sexual duality in Modigliani's work, see Arturo Schwarz, "Modigliani: His Art, His Interest in the Esoteric and His Jewishness," in the catalogue of the exhibition *The Unknown Modigliani: Drawings from the Paul Alexandre Collection* (Tel Aviv: Tel Aviv Museum of Art, 1995), p. 10.

34. In addition to these, other examples include a drawing of a woman (inspired perhaps by a circus performer or dancer) that dates from 1909 or 1910, where the word "Venus" appears and the alchemical symbols of Venus, mercury, and salt are drawn; the well-known study for his portrait of Max Jacob, which includes several esoteric and philosophical notations; and two early watercolors of a man and a woman participating in a spiritualist séance. See Alexandre, *The Unknown Modigliani,* p. 93.

35. See Gerald Kamber, *Max Jacob and the Poetics of Cubism* (Baltimore: The Johns Hopkins University Press, 1971), p. xvi.

36. Schmalenbach, *Amedeo Modigliani*, p. 26.

37. Kamber, *Max Jacob and the Poetics of Cubism*, pp. xx–xxi.

38. For more on his nudes after Botticelli, Giorgione, and Titian, see Griselda Pollock's essay "Modigliani and the Bodies of Art: Carnality, Attentiveness, and the Modernist Struggle" in this volume.

39. Her whirling limbs are animated as in many of the artist's drawings of dancing figures, which relate to this basic dynamic. It is such an anthropomorphized and dynamic scheme of hidden knowledge as the Kabbalah that Modigliani's fixation on the figure, or his caryatids' centrifugal dynamic, or even his Dantean ascent/descent may be further related. Moreover, his one and only *Standing Figure* (1912–13; National Gallery of Australia, Canberra) may be organized according to a pattern of circular forms reminiscent of the anatomical scheme of the Kabbalistic sefirotic tree.

40. These bouts of illness were pivotal in determining his artistic vocation, according to his mother, whose diary, as recounted by Jeanne Modigliani, tells of a feverish delirium with pleurisy during which Amedeo announced his aspirations to become an artist. His mother may have encouraged this because she did not want her precious "Dedo" to define himself in the mercantile terms that led to the family's undoing.

41. Both pages are framed as one, as are many of the artist's larger drawings.

42. See Sichel, *Modigliani*, p. 372.

43. See Cohen, "From Eastern Europe to Paris and Beyond," p. 66.

44. Noting the prolific diversity of the School, or citing its members' formal similarities or mutual influences, does little to provide the basis for broadening critical understanding of someone like Modigliani. Typical of this continuing tradition is the exhibition *École de Paris* mounted in 2000 by the Musée d'Art Moderne de la Ville de Paris, which failed to distinguish the various critical social and intellectual contexts and to treat the inadequacy of the nomenclature in the first place. More recently, the exhibition *Modigliani and the Artists of Montparnasse* (see note 4) avoided the problem altogether, stressing instead the viability of Modigliani's career during his lifetime, arguing for his extensive interaction with and influence on other members of the avant-garde.

45. For more on the evolution of the "school," and its underlying xenophobia, see Romy Golan, "The 'École Française' vs. the 'École de Paris,'" in Silver and Golan, *The Circle of Montparnasse*, pp. 81–87.

46. In referring to the return to naturalism that emerged at the close of World War I, Kenneth Silver has written: "There can be no artist in the Parisian avant-garde who did not know in his innermost heart that the new classicism was a lament rather than a celebration. It was a style of loss, a shadow play of mythic images that spoke more articulately of disillusionment than of tradition, stability, civilization, or hope." Kenneth E. Silver, *Esprit de Corps: The Art of the Parisian Avant-Garde and the First World War, 1914–1925* (Princeton, N.J.: Princeton University Press, 1989), pp. 297–98.

47. See Elia Benamozegh, *Morale juive et morale chrétienne* (Paris: InPress, 2000); the original was written in French.

48. One may think of this as the equivalent of a reformed Judaism, which never took root in Italy. Mario Toscano has written of this period's shift in belief: "Rather than expressing decided choices, [Italian Jews] demonstrated a vocation for cultural and religious compromise, an autonomous search for solutions to problems faced by world Jewry." Toscano, "The Jews in Italy from the Risorgimento to the Republic," p. 29.

49. See Cohen, *Benamozegh and Lévinas on Jewish Universalism*, p. 94.

THE FACES OF MODIGLIANI

This essay was written while in residence at the Dorothy and Lewis B. Cullman Center for Scholars and Writers at the New York Public Library. Research in Italy was conducted with the able assistance of Sergio Cortesini, Barbara Geremia, Lindsay Harris, Gaby Lewin, and Francesca Morelli. I thank Laura Mattioli and Paola Mola for their precious expertise, and Kenneth Wayne, curator of modern art, Albright-Knox Art Gallery, for critical information in ascertaining the identity of Modigliani works shown at the 1930 Venice Biennale. I am grateful also to Adina Loeb; to Stefano Valeri, Archivio Lionello Venturi, Università di Roma "La Sapienza"; and for the use of "Alberto G. Atri's Research Material on Amedeo Modigliani, 1948–58," in the Archives of American Art at the Smithsonian Institution. All translations are my own unless otherwise noted. When given, Ceroni catalogue numbers refer to Ambrogio Ceroni, *I dipinti di Modigliani* (Milan: Rizzoli, 1970).

1. Despite his use of African masks as a facial model, Modigliani did not depict any blacks, and for this there is some historical explanation: There were no African, African-American, or Caribbean artists or writers in the circle of Montparnasse, although Jules Pascin employed such models as the Martinique-born Julie Luce and Simone, her daughter, in the 1920s. Josephine Baker and the Revue Nègre arrived in Paris in 1925, five years after Modigliani's death. With very few exceptions, African-American artists did not study in Paris until after World War I. See Theresa Leininger-Miller, *New Negro Artists in Paris: African American Painters and Sculptors in the City of Light 1922–1934* (New Brunswick, N.J.: Rutgers University Press, 2001). Further, Italy had no empire until the

conquest of Libya in 1912, and only with Ethiopia in 1935–36 did Italy colonize in black Africa. The lack of a colonial empire aggravated Benito Mussolini's rivalry with the European powers—France, England, Germany, and Belgium. There is no evidence that Modigliani saw African sculpture in Italian ethnographic collections before he went to Paris in 1906.

2. Nelson Moe, *The View from Vesuvius: Italian Culture and the Southern Question* (Berkeley: University of California Press, 2002).

3. Marie Lathers, *Bodies of Art: French Literary Realism and the Artist's Model* (Lincoln: University of Nebraska Press, 2001), especially chap. 1, "Paris Qui Pose," pp. 21–59.

4. On modern stereotypes of the Jew see Sander Gilman, *Difference and Pathology: Stereotypes of Sexuality, Race, and Madness* (Ithaca, N.Y.: Cornell University Press, 1985); *The Jew's Body* (New York: Routledge, 1991); and *The Visibility of the Jew in the Diaspora: Body Image and Its Cultural Context* (The B. G. Rudolph Lectures in Judaic Studies, Syracuse University, May 1992). Modigliani's Italian contemporaries in Paris emphasize his physical beauty, for example, Osvaldo Licini, "Ricordo di Modigliani," *L'orto* 4 (January–February 1934), pp. 9–10; Umberto Brunelleschi, "Modigliani: Storia vera di Umberto Brunelleschi," *Il giovedì*, October 16, 1930.

5. Giorgio de Chirico, *Il meccanismo del pensiero*, ed. Maurizio Fagiolo dell'Arco (Turin: Einaudi, 1985), p. 281.

6. Donatella Cherubini, *Giuseppe Emanuele Modigliani: Un riformista nell'Italia liberale* (Milan: Franco Angeli, 1990); Vera Modigliani, *Esilio* (Milan: Garzanti, 1946).

7. Raffaello Franchi, "Alle Belle Arti: Amedeo Modigliani," *La fiera letteraria*, May 27, 1928, p. 3.

8. Gino Severini, *The Life of a Painter: The Autobiography of Gino Severini*, trans. Jennifer Franchina (Princeton, N.J.: Princeton University Press, 1995), p. 34. According to Severini—and in contrast to de Chirico's opinion noted earlier—in Paris, "Modigliani and I were the only Italians considered avant-garde artists." Ibid., p. 207.

9. Anselmo Bucci, "Ricordi d'artisti: Modigliani," *L'ambrosiano*, May 27, 1931. Bucci recalls what Modigliani told him in 1919 at the Café de la Rotonde in Paris:

> "I'm Jewish you know," he declared.
> "I had never thought about it."
> "It's true. In Italy, there is no Jewish question. I'm Jewish, and you know the family bond we have among us. I can say that I have never been destitute, my family has always helped me. Even if the money order was for five francs, they have never abandoned me."

10. The Italian section was curated by the artist Enrico Prampolini, who selected works by his fellow Futurists as well as by Modigliani and de Chirico. Marinetti later bragged about the Futurists' primacy in recognizing Modigliani (see note 22).

11. *Catalogo della XIII Esposizione Internazionale d'Arte della Città di Venezia* (Milan: Bestetti e Tumminelli, 1922), p. 57. Although the official Biennale catalogue contained more than one hundred illustrations, not one Modigliani was reproduced.

12. Enrico Thovez, *Il filo d'Arianna* (Milan: Corbaccio, 1924), pp. 318–19.

13. Arturo Lancellotti, *Le Biennali veneziane del dopoguerra* (Rome: E. Loescher, 1924), pp. 87–88; Ardengo Soffici, "Gli italiani all'Esposizione di Venezia," *Il resto del carlino*, June 16, 1922, p. 3; Ugo Ojetti, "La XIII Biennale veneziana. Il re che torna," *Corriere della sera*, May 27, 1922; Carlo Carrà, "L'arte mondiale alla XIII Biennale di Venezia," *Il convegno*, June 1922, pp. 289–92. See also Enrico Somaré, "Note sulla XIII Esposizione Internazionale d'Arte della Città di Venezia," *L'esame* 1 (May 1922), pp. 145–46.

14. D. [Paolo D'Ancona], "Peintres maudits (Modigliani–Utrillo)," *Le arti plastiche*, May 1, 1925, which is a review of Gustave Coquiot's then recent book *Des peintres maudits*; and P. [Paolo] D'Ancona, "A proposito di Modigliani," *Le arti plastiche*, May 16, 1925, with a letter from Margherita Modigliani. On D'Ancona, see Emily Braun, "From the Risorgimento to the Resistance: One Hundred Years of Jewish Artists in Italy," in Vivian B. Mann, ed., *Gardens and Ghettos: The Art of Jewish Life in Italy* (Berkeley: University of California Press, 1989), p. 138. The Archivio Centrale di Stato in Rome, Casellario Politico Centrale, busta 3328, holds the 1932–40 file on Margherita Modigliani *"antifascista,"* which contains intercepted personal letters and documents pertaining to passport requests for her and for the artist's orphaned daughter Giovanna (Jeanne), for whom Margherita was guardian.

15. "Arte parigina," *Le arti plastiche*, June 1, 1927; Adolphe Basler, *La peinture…religion nouvelle* (Paris: Librairie de France, 1926). Basler was a Polish-born Jewish critic in Paris. As late as 1934, in the official Fascist *Enciclopedia italiana*, the entry on Modigliani does not mention that he was Jewish. Palma Bucarelli, "Amedeo Modigliani," *Enciclopedia italiana di scienze, lettere ed arti* 23 (Rome: Istituto della Enciclopedia Italiana, 1934), pp. 526–27.

16. Published in Milan early in 1930, on the occasion of the tenth anniversary of the death of the artist, and dedicated to his daughter, *Omaggio a Modigliani (1884–1920)* was issued in a limited edition of two hundred copies at Scheiwiller's personal expense. The volume offered three poems by the artist, an introduction by Sergio Solmi, and brief testimonies by Ugo Bernasconi, Georges Braque, Carlo Carrà, Felice Casorati, Blaise Cendrars, Jean Cocteau, Pierre Courthion, Giorgio de Chirico, Filippo de Pisis, André Derain, André Dunoyer de

Segonzac, Othon Friesz, Waldemar Georges, Paul Guillaume, Max Jacob, Moïse Kisling, Jacques Lipchitz, Eugenio Montale, Ezra Pound, Giuseppe Raimondi, André Salmon, Alberto Savinio, Gino Severini, Chaim Soutine, Maurice de Vlaminck, and Leopold Zborowski. Reviews of the book were positive (see the section "Commentary on Modigliani" in the bibliography in this volume) and added to Modigliani's fame in Italy and to the eagerness for his retrospective at the Biennale that spring.

17. Giovanni Scheiwiller, *Amedeo Modigliani. Arte moderna italiana* 8 (Milan: Ulrico Hoepli, 1927), pp. 5–13, with the text dated 1925. On the history of the Scheiwiller publications, see *Giovanni and Vanni Scheiwiller: Seventy Years of Publishing 1925–1995* (Milan: Scheiwiller, 1996), the catalogue for an exhibition held at the Italian Academy for Advanced Studies, Columbia University, New York.

18. Lamberto Vitali, *Disegni di Modigliani. Arte moderna italiana* 15 (Milan: Ulrico Hoepli, 1929), pp. 5–11. See also Vitali's "Amedeo Modigliani," *Domus*, March 1934, pp. 40–42; and his "Modigliani" (1946), in *Preferenze* (Milan: Domus, 1950), pp. 95–102.

19. *La Biennale di Venezia: Storia e statistiche* (Venice: Ufficio Stampa dell'Esposizione, 1936), p. 124; Lionello Venturi, "Mostra individuale di Amedeo Modigliani, Sala 31," *Catalogo illustrato della XVII Esposizione Biennale Internazionale d'Arte*, 2nd ed. (Venice: Carlo Ferrari, 1930), pp. 116–21. In the catalogue (p. 121), twenty-eight of the forty drawings are listed as coming from the collection of Michaux [*sic*; Michaud], Paris; two were lent by Giovanni Scheiwiller. Ettore Tito was the other Italian to receive a retrospective, and the stark contrast between Modigliani and this Belle Époque painter, beloved by the public, was commonly observed by the critics.

20. For the history of the Venturi–Gualino collaboration, the latter's Modigliani collection, and the cultural milieu of Turin between the wars, I am indebted to the scholarship of Maria Mimita Lamberti; see her "Un sodalizio artistico: Venturi, Gualino, Casorati," in Maria Mimita Lamberti, ed., *Lionello Venturi e la pittura a Torino 1919–1931* (Turin: Fondazione Cassa di Risparmio di Torino, 2000), pp. 16–47; and "La raccolta Gualino d'arte moderna e contemporanea," in AA.VV. [various authors], *Dagli ori antichi agli anni Venti: Le collezioni di Riccardo Gualino* (Milan: Electa, 1982), pp. 25–34. See also Riccardo Gualino, *Frammenti di vita* (Verona: Arnaldo Mondadori, 1931); and Lionello Venturi, "The Collection of Modern Art of Signor Gualino and the Modigliani Room at the Venice Biennale Exhibition," *Formes* 7 (July 1930), pp. 9–10.

21. Lionello Venturi, "Risposta a Ugo Ojetti," *L'arte* 33 (January 1930), p. 97. On Venturi's antagonistic position with respect to other Italian critics (both conservative and progressive) of contemporary art, see Giulio Carlo Argan, "Le polemiche di Lionello Venturi," *Studi piemontesi* 1 (March 1972), pp. 118–24.

Ojetti, a staunch nationalist and chief art critic of *Corriere della sera*, supported Modigliani, but only by virtue of the artist's innate *italianità* (and because Ojetti could not ignore his reputation abroad). Ojetti refuted Venturi's Francophile perspective; see his "Risposta a Lionello Venturi," *Pegaso* 2 (February 1930), p. 225; and "Seconda risposta a Lionello Venturi," *Pegaso* 2 (May 1930), p. 610. For Ojetti's reviews of the Modigliani exhibitions, see the section "Commentary on Modigliani" in the bibliography in this volume.

22. F.T. [Filippo Tommaso] Marinetti, "Modigliani e Boccioni," *La gazzetta del popolo*, February 27, 1930. For the larger debate involving Marinetti, the Futurists, and Venturi, see "Il futurismo e la scuola in una conferenza polemica di F.T. Marinetti," *La gazzetta del popolo*, December 12, 1929; Lionello Venturi, "Il professore Lionello Venturi risponde a Marinetti," *La stampa*, December 18, 1929; F.T. Marinetti, "Risposta a Lionello Venturi," *La gazzetta del popolo*, January 4, 1930.

23. Venturi, "Il professore Lionello Venturi risponde a Marinetti."

24. Gigi Chessa, "Per Amedeo Modigliani," *L'arte* 33 (January 1930), p. 30.

25. Lamberti, "Un sodalizio artistico," p. 41.

26. Chessa, "Per Amedeo Modigliani," p. 30. The fact that Chessa's article reproduces only six of the Modiglianis in Gualino's collection suggests that the seventh, *Ritratto di ragazza* (Biennale cat. no. 7; Ceroni 138; fig. 4 in this essay, seventh from left), had not yet been acquired. One of the Gualino paintings, *Ritratto di donna* (Biennale cat. no. 6; fig. 4 in this essay, second from left), is not in Ceroni's catalogue raisonné.

27. The exhibition featured also a canvas recently acquired by Pier Giuseppe Gurgo Salice, Gualino's brother-in-law, which would be exhibited at the Biennale as *Ritratto di donna* (Biennale cat. no. 8; fig. 4 in this essay, first from left). Clearly a portrait of Hanka Zborowska, this work was donated anonymously to the Museum of Art, Rhode Island School of Design, in 1933. It does not appear in Ceroni; a variant of the painting is reproduced as *La Zborowska* in J. [Joseph] Lanthemann, *Modigliani: Catalogue raisonné* (Barcelona: Condal, 1970), p. 265, no. 400.

28. Waldemar Georges, "Appels d'Italie, Sala 23," *Catalogo illustrato della XVII Esposizione Biennale Internazionale d'Arte*, 2nd ed. (Venice: Carlo Ferrari, 1930), pp. 92–93. Mario Tozzi, another Italian artist in Paris, organized the show, which included Christian Bérard, Eugène and Leonid Berman, Roger de la Fresnaye, Philippe Hosiasson, Onofrio Martinelli, Amédée Ozenfant, René Paresce, Pierre Roy, Léopold Survage, and Pavel Tchelitchew.

29. Unpublished letter from Antonio Maraini to Lionello Venturi, dated January 1, 1930. Courtesy Archivio Lionello Venturi, Università di Roma "La Sapienza," file CXCII—Modigliani II.

30. Letter from Adolfo Venturi to Lionello Venturi, of 1930, reprinted in Lamberti, *Lionello Venturi e la pittura a Torino,* pp. 40–41.

31. For his part, Maraini, an archnationalist, blindsided any view of foreign influence on Modigliani's art, using a metaphor of the poor emigrant that unwittingly implied Italy's inferiority with respect to the modernized West: "Of all peoples, Italians are closest to and most like the French, but have absorbed the least from them. So it is with us Italians. Like the emigrants who suffer far from home with nostalgia in their hearts, and who return with their hoard to construct the most expensive, beautiful houses and can only know happiness here, so our artists who have been forced into exile reap the full benefits of toil in foreign lands only upon their return. Carrà, Soffici, Bucci—it is all the same story. And Modigliani undoubtedly understood this as he died on the eve of his repatriation, invoking Italy with his last words." Antonio Maraini, *Scultori d'oggi* (1930), reprinted in Paola Barocchi, *Storia moderna dell'arte in Italia. III. Dal Novecento ai dibattiti sulla figura e sul monumentale 1925–1945* (Turin: Einaudi, 1990), p. 113.

32. In the early twenties in Turin, Felice Casorati had been championed in print by the liberal activist Piero Gobetti, who was close to the Communist Antonio Gramsci. In 1926, the exiled Gobetti died in Paris after an attack by Fascist *squadristi*; that same year the Fascists sentenced Gramsci to prison, where he died in 1937. The other critical spokesman for the Gruppo dei Sei, Edoardo Persico, was also an anti-Fascist. See Anna Bovero, ed., *Archivio dei Sei Pittori di Torino* (Rome: De Luca, 1965).

33. Marco Fini, "Per una biografia di Riccardo Gualino come capitano d'industria," in AA.VV. [various authors], *Dagli ori antichi agli anni Venti,* pp. 253–56.

34. Venturi, "Mostra individuale di Amedeo Modigliani," pp. 116–18.

35. Venturi, "Risposta a Ugo Ojetti," p. 97. When pushed to defend himself against accusations of *esterofilia* (xenophilia), especially in a heated polemic with the formidable conservative Ojetti, Venturi opined: "The art of Amedeo Modigliani is more Italian than that of Antonio Canova, because Canova did not have the strength to overcome his neoclassicism of a rather German taste, whereas . . . Modigliani achieved a wholly Italian balance of antithetical cosmopolitanism." Venturi, "Divagazioni sulle mostre di Venezia e di Monza, con la risposta ad Ojetti," *L'arte* 33 (July 1930), p. 405.

36. See the appendix to this essay.

37. Among the negative reviews that characterized Modigliani's "deformations" as unhealthy or infantile were: Alfredo Borghesi, "Amedeo Modigliani," *Il giornale dell'arte,* June 15, 1930; Alberto Neppi, "Alla XVII Biennale di Venezia. Il caso Modigliani," *Il lavoro fascista,* May 16, 1930; Cipriano E. Oppo, "Amedeo Modigliani," *La tribuna,* May 14, 1930; Ettore Rigo, "Amedeo Modigliani," *Il giornale dell'arte* 4, no. 48 (November 30, 1930); Guglielmo Zatti, "Amedeo Modigliani e l'arte," *Regime fascista,* November 4, 1930; and Vincenzo Costantini, "La XVII Biennale veneziana," *Le arti plastiche,* May 16, 1930; and *Pittura italiana contemporanea dalla fine dell'800 ad oggi* (Milan: Ulrico Hoepli, 1934), pp. 157–64. Qualified, though in the end positive, reviews included those by Filippo de Pisis, "La pittura di Modigliani," *Il corriere padano,* January 16, 1934; and Giorgio Castelfranco, "Modigliani," *La pittura moderna 1860–1930* (Florence: Luigi Gonnelli, 1934), pp. 82–84.

38. See, for example, Virgilio Guzzi, *Pittura italiana contemporanea* (Milan: Bestetti e Tumminelli, 1931), pp. 26–28.

39. Emilio Zanzi, "'Modì,' l'ebreo mistico e sregolato," *La rassegna filodrammatica,* July 1, 1930.

40. Vincenzo Cardarelli, "Un pittore maledetto," *Il resto del carlino,* March 30, 1932.

41. Giuseppe Marchiori, "Modigliani italiano," *Il corriere padano,* February 21, 1931.

42. Aniceto Del Massa, "Amedeo Modigliani e la critica moderna," *La nazione,* July 4, 1930; Enrico Galassi, "Dall'ex Caffè d'Europa: Modigliani," *L'Italia letteraria,* February 9, 1936.

43. Margherita Sarfatti, *Storia della pittura moderna* (Rome: Paolo Cremonese, 1930), pp. 79–80; and "Spiriti e forme nuove a Venezia," *Il popolo d'Italia,* May 4, 1930.

44. Raffaello Franchi, "Modigliani alla Biennale," *Il corriere padano,* May 31, 1930. Exceptionally, the critic Baccio Maria Bacci, in "Uomini del Novecento: Amedeo Modigliani," *Nuova Italia* 1 (May 20, 1930), pp. 183–86, gave an in-depth account of Modigliani's Livornese Jewish background; Bacci read his work in the context of the Jewish "pathetic" art and defined him as an expressionist, but one with the gift of "Italian clarity."

45. Marziano Bernardi, "Amedeo Modigliani," *La stampa,* January 24, 1930; Mario Tinti, "Omaggio a Modigliani," *Il resto del carlino,* February 7, 1930. Duccio, Andrea Orcagna, Vittore Carpaccio, and Cosimo Tura are also frequently mentioned as influences on Modigliani.

46. Marchiori, "Modigliani italiano."

47. Venturi, "Mostra individuale di Amedeo Modigliani," p. 117.

48. Tinti, "Omaggio a Modigliani."

49. See, for instance, Giovanni Costetti, "Amedeo Modigliani," *L'illustrazione toscana*, October 1930, pp. 11–14; Diego Valeri, "I veneti alla Biennale," *Le Tre Venezie*, July 1930, pp. 10–16; Italo Cinti, "Amedeo Modigliani," *Vita nova*, August 1930, pp. 662–66; Carlo Carrà, "Amedeo Modigliani," *L'ambrosiano*, July 2, 1930; Emilio Zanzi, "Amedeo Modigliani e i facili seguaci," *La gazzetta del popolo*, May 8, 1930; Michele Guerrisi, "Modigliani," in *La nuova pittura: Cézanne, Matisse, Picasso, Derain, de Chirico, Modigliani* (Turin: Erma, 1932), especially pp. 86–87; Vincenzo Cardarelli, "Un pittore maledetto," *L'italiano* 8, no. 23 (November 1933), p. 364.

50. Alberto Savinio, in *Omaggio a Modigliani*, n.p.

51. Zanzi, "Amedeo Modigliani e i facili seguaci."

52. Fini, "Per una biografia di Riccardo Gualino," p. 253. Gualino was arrested on January 20, 1931, after the failure of his major financial lenders; he was fifty-two years old. He served two years of his sentence, and although under constant surveillance, rebuilt his fortune during the regime and into the postwar period. In Paris until 1939, Venturi wrote and lectured, while working actively with anti-Fascist organizations. Upon the Nazi invasion of France, he went to the United States and taught at several universities. He returned to Italy in 1945, going first to the University of Turin, and then to the University of Rome, where he was head of the art history department. Carlo Levi survived the period of the Holocaust in Italy and continued his career as a writer and a painter after the war.

53. See Stephanie Barron, ed., *"Degenerate Art": The Fate of the Avant-Garde in Nazi Germany* (Los Angeles: Los Angeles County Museum of Art, 1991), pp. 12–13. *Testa di donna* (Biennale cat. no. 4; Ceroni 223) is currently in a private collection in Switzerland.

54. See Barron, *"Degenerate Art,"* p. 165. *Ragazza* (Biennale cat. no. 32; not in Ceroni; fig. 4 in this essay, fifth from left) was lent to the 1930 Biennale by Georges Bernheim; it is now in the collection of the Dallas Museum of Art.

55. *Catalogue illustré de l'Exposition de l'Art Italien des XIX e XX Siècles au Jeu de Paume* (Paris: Jeu de Paume, 1935), pp. 103–4. The main lenders were Jones Netter and Roger Dutilleul.

56. Ugo Bernasconi, "Equivoco interno alla pittura," *Broletto* 2 (December 1937), pp. 12–13.

57. See the exhibition catalogue, *Omaggio a sedici artisti italiani* (Rome: Galleria di Roma della Confederazione Nazionale Fascista Professionisti e Artisti, 1937). On the fracas that ensued between Pensabene and Dario Sabatello, the Jewish director of the Galleria di Roma, see Braun, "From the Risorgimento to the Resistance," p. 180.

58. See Laura Mattioli, "The Collection of Gianni Mattioli from 1943 to 1953," in Flavio Fergonzi, ed., *The Mattioli Collection: Masterpieces of the Italian Avant-Garde* (Milan: Skira, 2003), pp. 18–19. Vitali later wrote the Giorgio Morandi catalogue raisonné, *Morandi dipinti: Catalogo generale* (1983; 2nd ed., Milan: Electa, 1994). *L'enfant gras* (Ceroni 74) is now in the Pinacoteca di Brera, Milan.

59. This survey considered the periodicals *Quadrivio*, *Il Tevere*, *Difesa della razza*, and *La vita italiana*, and books by Giuseppe Pensabene, *La razza e le arti figurative* (Rome: Cremonese, 1939), and Telesio Interlandi, *Contra judaeos* (Rome and Milan: Tumminelli, 1938), and *La condizione dell'arte* (Rome: Quadrivio, 1940). See H. G. and G. P. [Giuseppe Pensabene], "L'influenza degli ebrei sul mondo contemporaneo," *Quadrivio* 5, no. 29 (May 16, 1937), p. 6, for a rare disparaging of Modigliani in light of international Expressionism and its "reflection of the sadistic spirit of the Jewish race." Here, too, Picasso, Wassily Kandinsky, and others are indiscriminately lumped together as Jews.

60. H. G. and G. P. [Giuseppe Pensabene], "La 'tradizione moderna' nella pittura e nella scultura," *Quadrivio* 5, no. 34 (July 18, 1937), p. 7.

61. Letter to the editor from Alberto Sartoris and Giuseppe Terragni, *Origini*, January 1939, p. 8. See also Richard Etlin, *Modernism in Italian Architecture, 1890–1940* (Cambridge, Mass.: The MIT Press, 1991), especially chap. 15, "Italian Rationalism and Anti-Semitism," pp. 569–97.

62. Raffaello Giolli, "Come nasce una galleria d'arte moderna," *Quadrivio* 10, no. 18 (March 1, 1942), p. 3, lists three Modiglianis in the collection of Rino Valdameri. See note 63 on another private collector, Feroldi.

63. Luigi Bartolini, "Visita al collezionista Feroldi," *Quadrivio* 5, no. 23 (April 4, 1937), pp. 5–6; and "Diario variatissimo di Luigi Bartolini," *Quadrivio* 5, no. 27 (May 2, 1937), p. 7.

64. See note 4.

65. Caryl Phillips, *The European Tribe* (New York: Vintage, 2000), p. 53.

MAKING AND MASKING

I am grateful to Isabelle Alfonsi for her research assistance, and to students in my "Sexuality and Subjectivity in French Portraiture" class at University College London, with whom I have tried out my ideas on portraiture over the past two years. I also thank Adrian Rifkin and Briony Fer, who continue to feed me with new ideas and new materials.

Epigraph: Jean Cocteau, *Modigliani* (Paris: Fernand Hazon, n.d.), n.p. (my translation).

1. See Martin Warnke, "Individuality as Argument: Piero della Francesca's Portrait of the Duke and Duchess of Urbino," in Nicholas Mann and Luke Syson, eds., *The Image of the Individual: Portraits in the Renaissance* (London: The British Museum, 1998), pp. 81–214.

2. For an interesting discussion of the difference between the portrait and the nude, see Jean-Luc Nancy, *Le Regard du portrait* (Paris: Galilée, 2000), p. 19.

3. On Modigliani's use of African sources in his sculpture, see Alan G. Wilkinson, "Paris and London: Modigliani, Lipchitz, Epstein, and Gaudier-Brzeska," in William Rubin, ed., *"Primitivism" in 20th Century Art: Affinity of the Tribal and the Modern*, exh. cat. (New York: The Museum of Modern Art, 1984), vol. 2, pp. 417–23.

4. See, for instance, Werner Schmalenbach, "The Portraits," in Marc Restellini, ed., *Modigliani: The Melancholy Angel* (Turin: Skira, 2002), pp. 45–46.

5. This information is provided by Gotthard Jedlicka and related in Alfred Werner, *Amedeo Modigliani* (London: Thames & Hudson, 1967), p. 33.

6. For the reception of Henri Matisse's *Woman with the Hat* and its assault on conventional portrayals of the feminine in portraiture, see John Klein, *Matisse Portraits* (New Haven: Yale University Press, 2001), pp. 78–81.

7. Modigliani's portraits are discussed against the context of the early-twentieth-century crisis of portraiture in Werner Schmalenbach, "The Portraits," in his *Amedeo Modigliani: Paintings, Sculptures, Drawings* (Munich: Prestel, 1990), pp. 25–45.

8. See, for example, the views of Ilya Ehrenburg, quoted in Janet Hobhouse, *The Bride Stripped Bare: The Artist and the Nude in the Twentieth Century* (London: Jonathan Cape, 1988), p. 149.

9. On the significance of masking as a strategy for containing deviant sexualities, see Robert S. Lubar, "Unmasking Picasso's Gertrude: Queer Desire and the Subject of Portraiture," *Art Bulletin* 79, no. 1 (March 1997), pp. 57–84.

10. For a discussion of Picasso's return to naturalism, see Pierre Daix, "Picasso and Modigliani," in Restellini, *Modigliani*, pp. 68–69.

11. See Marc Restellini, "Modigliani and Paul Guillaume," in his *Modigliani*, pp. 167–71.

MODIGLIANI AND THE BODIES OF ART

Epigraphs: From *L'art vivant*, quoted in Francis Carco, *Le nu dans la peinture moderne 1863–1920* (Paris: G. Crès, 1924), p. 112; Quoted in Jean-Paul Crespelle, *Modigliani: Les femmes, les amis, l'oeuvre* (Paris: Presses de la Cité, 1969), p. 160; Kenneth Wayne,

Modigliani and the Artists of Montparnasse, exh. cat. (New York: Harry N. Abrams, 2002), p. 47.

1. Anette Kruszynski, *Amedeo Modigliani: Portraits and Nudes* (Munich and New York: Prestel, 1996), p. 95, suggests that this is the first painting of the major series of nudes.

2. From an editorial in *Art News*, quoted in H. Lester Cooke, "Modigliani's *Nude on a Blue Cushion*," *Burlington Magazine* 107 (September 1965), p. 488.

3. Clive Bell, "The French Pictures at Heal's," *Nation* (London), August 16, 1919; quoted in Wayne, *Modigliani and the Artists of Montparnasse*, p. 70. Roger Fry, "Line as a Means of Expression in Modern Art," *Burlington Magazine*, 34 (February 1919), p. 69. According to Fry: "Two qualities save Modigliani from the dryness and deadness which might result from so deliberately mathematical a conception of the nature of form. One is the delicate sensibility which he shows in the statements of this simplified form. . . . The other saving grace is . . . the sense of movement and life that comes from the arrangements of his plastic units."

4. The portrait of Berthe Weill (fig. 2) is by Émilie Charmy, who was also a painter of the female nude in poses indicative of both sexuality and frankness about the female body in its nakedness. For a discussion of women painters of the modernist nude, see Gill Perry, *Women Artists and the Parisian Avant-Garde* (Manchester, England: Manchester University Press, 1995), pp. 118–39. The classic discussion remains Carol Duncan, "Virility and Male Domination in Early Twentieth Century Vanguard Art," first published in *Artforum* in 1973, and reprinted in Duncan's *The Aesthetics of Power: Essays in Critical Art History* (Cambridge, England: Cambridge University Press, 1993), pp. 81–108.

5. The quoted adjectives are Berthe Weill's, translated from her memoirs. See her *Pan! Dans l'oeil! Ou trente ans dans les coulisses de la peinture contemporaine 1900–1930* (Paris: Lipschutz, 1933), p. 227. The quantities (few, several) are from Carco, *Le nu dans la peinture moderne*, p. 187.

6. Weill, *Pan! Dans l'oeil!*, pp. 227–29. Weill, who opened her gallery at 24 rue Victor Massé in 1901, was the first to sell Picasso, in 1900. In 1904 she exhibited Matisse.

7. For a balanced study of the nudes in detail, see Kruszynski, *Amedeo Modigliani*.

8. Carco's *Le nu dans la peinture moderne* (see epigraph note) surveys the path of the modernist nude from Édouard Manet's *Olympia*, and reiterates André Salmon's assessment in *L'art vivant* of Modigliani as the supreme exponent of the genre; see Carco, *Le nu dans la peinture moderne*, p. 112.

9. "During a recent exhibition of his works in rue Taitbout, Modigliani was ordered by the police to remove several of his

nudes because they were scandalizing the passers-by. The exhibition continued, nonetheless, but although a few admirers could be found to buy some of the infamous canvases, the venture was less successful than had been hoped. It is really not surprising. And the intervention of the police cannot be blamed. For it served only to excite the curiosity of those involved and to increase their interest." Francis Carco, "Modigliani," *L'éventail*, July 15, 1919; reprinted in *L'éventail: Revue de littérature et de l'art* (Geneva: Slatkine, 1971), and quoted in translation in Werner Schmalenbach, *Amedeo Modigliani: Paintings, Sculptures, Drawings* (Munich: Prestel, 1990), p. 187.

10. Wayne, *Modigliani and the Artists of Montparnasse*, p. 67. In her memoir, Weill says she took down all the paintings: Did she take down the nude from the window, from the wall, or did she take down all the works in the show? Carco makes it clear that the last was not the case, but we cannot be sure whether any works were permanently removed. It seems not.

11. The literature on Modigliani mentions other instances in which his nudes caused public problems, the most notable being the outcry over the Guggenheim's postcard.

12. Carol Mann, *Modigliani* (London: Thames & Hudson, 1980), p. 42.

13. I agree with Werner Schmalenbach, who asks us to replace "a rather sweeping collective impression of Modigliani's nudes" for an attentive reading of variations and divergences. See Schmalenbach, *Amedeo Modigliani*, p. 50.

14. Kruszynski, *Amedeo Modigliani*, p. 111.

15. Quoted in Mann, *Modigliani*, p. 145.

16. Griselda Pollock, *Avant-Garde Gambits: Colour and the Gender of Art History* (London: Thames & Hudson, 1992), pp. 12–16.

17. Ibid., pp. 70–73.

18. Modigliani saw the retrospective of Gauguin's works at the Salon d'Automne in 1906; Ludwig Meidner confirmed the impact of the encounter in his article "The Young Modigliani," *Burlington Magazine*, 82 (April 1943), pp. 87ff. Kenneth Wayne is one of the first art historians to explore Modigliani's relation to Matisse; see his *Modigliani and the Artists of Montparnasse*, p. 32.

19. Wayne, *Modigliani and the Artists of Montparnasse*, p. 70, fig. 32.

20. Osvaldo Patani, *Amedeo Modigliani: Catalogo generale*, 3 vols. (Milan: Leonardo, 1991–94).

21. Mann, *Modigliani*, p. 145. The painting in question was *Le nu blond* (1917).

22. Billy Klüver and Julie Martin, *Kiki's Paris: Artists and Lovers 1900–1930* (New York: Harry N. Abrams, 1989).

23. To name but a few: Hermine David and Jules Pascin, Fernande Barrey and Tsuguhara Foujita, Renée Gros and Moïse Kisling, and later, Jeanne Hébuterne and Amedeo Modigliani.

24. Anna Akhmatova, *Poem Without a Hero* (1940–62), cited in Schmalenbach, *Amedeo Modigliani*, p. 184.

25. I do not want to engage with the legend or the "character" Amedeo Modigliani as he is constructed for us through memoirs of his contemporaries. Nevertheless, complex issues are raised in the study of an artist who, we are informed, practiced regular physical violence against women and who imposed his sexual desires on others without solicitation. It would take another paper to investigate the complexity of the ethical relation between a historical subject and that person's work. We can no longer hide behind the bohemian myth that tolerates sexual or physical violence, but it is equally wrong to reduce the artwork to the biographically produced persona. As Anette Kruszynski has written, Modigliani's work is characterized by an orderliness and an attentiveness to the human that are completely at odds with the image of the disorderly and vicious man the memoirs produce; see Kruszynski, *Amedeo Modigliani*, passim. In a note at the conclusion of André Salmon's *Modigliani: A Memoir* is a long citation from Dr. Tony Kunstlich, who treated Modigliani's friend Moïse Kisling in the 1950s. He interpreted the evidence on Modigliani's health to suggest that the artist was dying slowly from tubercular meningitis, which develops gradually and asymptomatically. Indications of the underlying disease do appear, though, in the form of headaches, visual and auditory hallucinations, irritability, and—this is significant here—outbreaks of violent anger and unsociability; see Salmon, *Modigliani: A Memoir* (London: Jonathan Cape, 1961), pp. 207–8. In such a case of disease-generated personality changes, who may judge the victim? I feel that we should neither ignore nor take account of the social and sexual behavior of the artist. His case remains an undecidable. I read the work itself not just formally but also without any biographical reductionism. The artist should be considered an author created by artistic texts and their intertextual "work."

26. T. J. Clark, "Preliminaries to a Possible Treatment of Manet's *Olympia*," *Screen* 21, no. 1 (1980). See also T. J. Clark, *The Painting of Modern Life: Paris in the Art of Manet and His Followers* (New York: Alfred A. Knopf, 1983).

27. Duncan, "Virility and Male Domination," pp. 81–108.

28. See Griselda Pollock, "Painting, Feminism, History," in Griselda Pollock, *Looking Back to the Future: Essays on Art, Life and Death* (London: Routledge, 2000), pp. 73–112.

29. The most articulate statement of this is Lynda Nead, *The Female Nude: Art, Obscenity and Sexuality* (London and New York: Routledge, 1992).

30. Akhmatova, *Poem Without a Hero*, cited in Schmalenbach, *Amedeo Modigliani*, p. 184.

31. *Nude on the Divan*, of 1916 (Patani 344), now in the Musée des Beaux-Arts, Dijon.

32. For an important analysis of the meaning of the so-called Pudica pose and the origins of the Venus iconography, see Nanette Salomon, "The Venus Pudica: Uncovering Art History's Hidden Agendas and Pernicious Pedigrees," in Griselda Pollock, ed., *Generations and Geographies of the Visual Arts: Feminist Readings* (London and New York: Routledge, 1996), pp. 69–87.

33. Modigliani was known also to Ludwig Meidner and Jacob Epstein. Wayne, *Modigliani and the Artists of Montparnasse*, p. 43, confirms that both Paul Guillaume and Paul Alexandre commented on the importance to Modigliani of his Jewish heritage. Guillaume wrote: "Amedeo Modigliani, born in Livorno, was a Jew and liked to think of himself and his art as Jewish." Quoted in Enzo Maiolino, ed., *Modigliani vivo* (Turin: Fògola, 1981), p. 169; trans. in Schmalenbach, *Amedeo Modigliani*, p. 194.

34. Wayne, *Modigliani and the Artists of Montparnasse*, p. 47.

35. An association made and endorsed by Roger Fry, "Modern French Painting at the Mansard Gallery II," *Athenaeum*, August 15, 1919, p. 755.

36. See note 4.

37. André Salmon observed: "Modigliani is our only painter of nudes. . . . And yet what spirituality glows forth from so much beautiful, rich, plump material, slimmed down by the controlled magnificence that the artist has striven hard to refine, he who admired naïvety and the resourcefulness of the Italian artisan painters." Quoted in Schmalenbach, *Amedeo Modigliani*, p. 200.

38. The inspiration for this line of thought is Daniel Boyarin's *Carnal Israel: Reading Sex in Talmudic Culture* (Berkeley: University of California Press, 1993). Boyarin turns the Christian negative designation of Judaism as a carnal religion on its head to argue that Talmudic culture offered a specific and empowering view of human sexuality. Estelle Roith's *The Riddle of Freud: Jewish Influences on His Theory of Female Sexuality* (London: Tavistock, 1987) offers a second source for this argument by exploring the ambivalence toward attitudes to and indeed emphases on sexuality in Jewish tradition and in the sociohistoric specificities of late-nineteenth-century Jewish family and cultural life. The conclusion I am offering is not the imposition of a new interpretation on Modigliani's

paintings, but something more methodological. By stressing the need to "read" the paintings as part of an evolving practice, situated in a dynamic and challenging artistic milieu, I want to inflect general questions of the body in modernist art with the specificity rather than the difference of an artist who brings to this melting pot elements of non-Christian cultural, personal, and intellectual experiences. By balancing the feminist and postcolonial critiques against the differences posited by Boyarin and Roith between Christian and Judaic legacies around sexuality and the body, another level of complexity is opened, as we encounter images that challenge in their many-leveled negotiation of carnality, attentiveness, and the body in/of art.

EPILOGUE: THE MODIGLIANI MYTH

1. My reconstruction of *l'affaire Modì*, including all quotations, was gleaned from four articles in the *New York Times*, all from 1984: "Italians Hope to Find Modigliani Sculptures," July 17, p. C18; "Modigliani Dredgers Find 2 Heads in Canal," July 25, p. C22; Henry Kamm, "Two Found Sculptures May Be by Modigliani," July 26, p. C19; and "Modigliani Dredgers Find 3rd Sculpture," August 10, p. C22; from Patricia Corbett, "The Modigliani Affair," *Connoisseur*, January 1985, pp. 32–34; and from Paul Berton, "Crimes and Connoisseurs," *Maclean's*, October 22, 1984, pp. 72–73. I thank Shira Brisman of The Jewish Museum in New York for tracking down these and other sources for this essay.

2. Quoted in Pierre Sichel, *Modigliani: A Biography* (London: W. H. Allen, 1967), p. 56.

3. Claude Roy, *Modigliani*, trans. James Emmons and Stuart Gilbert (Paris: Skira, 1958), p. 26.

4. June Rose, *Modigliani: The Pure Bohemian* (London: Constable, 1990), p. 53.

5. One day while dining at a Paris restaurant, it is recounted, Modigliani "overheard a group of noisy young men at the next table shouting anti-Semitic slogans and pounding the table. . . . Suddenly he heard enough. He got to his feet, strode to the table and stood over the party, a small man shaking with passion: 'Je suis Juif et je vous emmerde' [I am a Jew, to hell with you]. Stunned by his furious anger, the royalists were subdued that time, but anti-Semitism was not always so crude or so open." Rose, *Modigliani*, p. 54. Also of note is the fact that one of the first paintings Modigliani exhibited, at the Salon des Indépendants in 1908, was a portrait titled *The Jewess (La juive)*.

6. For an important consideration of Modigliani's conception of the self and personal identity, with emphasis on his Sephardic Jewish heritage as well as his relationship to Spinoza, see Mason Klein, "Modigliani Against the Grain," in this volume. For more on the Jewish question in his art and in his life, see Kenneth E. Silver, "Jewish Artists in Paris, 1905–1945," in Kenneth E. Silver and Romy Golan, *The*

Circle of Montparnasse: Jewish Artists in Paris, 1905–1945, exh. cat. (New York: Universe and The Jewish Museum, 1985), pp. 19–20.

7. Marc Restellini, ed., "Modigliani: Avant-Garde Artist or 'Schizophrenic' Painter?" in Marc Restellini, *Modigliani: The Melancholy Angel* (Milan: Skira, 2002), p. 17. Although the phrase "*visage grave*" comes from Modigliani's own writings, it is used out of context, in this case, to define the artist through the tired and ubiquitous myth of the tragic bohemian rather than to illuminate anything new about him or his work.

8. Craig Owens, "Honor, Power, and the Love of Women," in Craig Owens, *Beyond Recognition: Representation, Power, and Culture*, ed. Jane Weinstock et al. (Berkeley: University of California Press, 1992), p. 151.

9. See, for instance, T. J. Clark's analysis of Seurat's painting in *The Painting of Modern Life: Paris in the Art of Manet and His Followers* (Princeton, N.J.: Princeton University Press, 1994), pp. 259–68. Clark suggests that the artist's pointillist technique—his use of dotlike brushstrokes—resulted in a visual field of shimmering and stark contrasts that were, among other things, a metaphor for the deep and newly formed divisions and alliances of class emerging in Paris at the end of the nineteenth century. These divisions could be readily observed among the weekend bathers at La Grande Jatte.

10. Sichel understood his mission as one of historical accuracy, correction, and recovery: "I have taken pains not to alter, blur, or distort the essential spirit of Modigliani in this account of his troubled life set against his untroubled art. While pointing out what is admittedly verifiable, I have tried to show that Modigliani was much more than the monstrous masquerade character romantic legend makes him; much more than a grotesque bohemian, a stereotype cheapened, warped, and ridiculed in print as a poseur, a swaggerer, and a seducer of women, as a man who was always drunk, crazy-drugged or both; much more than an irresistibly handsome god always penniless, starving, and in rags as he wandered the streets of Montmartre or Montparnasse either truculent or, in a stupor, mumbling Dante. Modigliani was perhaps all these things, but not *constantly*, not *always*. . . . Besides, when could so debauched a man have found time to paint, carve statues, and make so many thousands of drawings?" Sichel, *Modigliani*, pp. 18–19.

11. Rosalind E. Krauss, "In the Name of Picasso," in Rosalind E. Krauss, *The Originality of the Avant-Garde and Other Modernist Myths* (Cambridge, Mass., and London: MIT, 1985), p. 25.

12. Christian Parisot, *Modigliani* (Paris: Pierre Terrail, 1992), p. 73.

13. Krauss, "In the Name of Picasso," p. 28.

14. The names are those of Picasso's lovers and wives Olga Picasso, Marie-Thérèse Walter, Dora Maar, Françoise Gilot, and Jacqueline Roque. For cases of this biographical approach to Picasso, see Mary Mathews Gedo, "Art as Exorcism: Picasso's *Demoiselles d'Avignon*," *Arts*, 15 (October 1980), pp. 70–81; John Richardson, "Your Show of Shows," *New York Review of Books*, July 17, 1980, pp. 43–46; and Arianna Stassinopoulos Huffington, *Picasso: Creator and Destroyer* (New York: Simon & Schuster, 1988).

15. Restellini, "Modigliani: Avant-Garde Artist or 'Schizophrenic' Painter?" p. 22.

16. Ibid., p. 31.

17. Ibid., p. 20.

18. Quoted in ibid.

19. Ibid., p. 30.

20. Ibid., p. 21. On Modigliani's social and ideological bearing, see Sichel, *Modigliani*, pp. 38–39, 54–56, 63–64; Rose, *Modigliani*, pp. 15–21, 53–54; and Mason Klein, "Modigliani Against the Grain," in this volume.

21. Krauss, "In the Name of Picasso," p. 25.

22. For more on this, see Rose, *Modigliani*, pp. 13, 216–25.

23. In one passage, Modigliani utters cliché after cliché as he shares his feelings of anguish and desperation with Zborowski: "I'm not even alive! I've been pouring shit into myself the last six years just so I could paint—just so I could sculpt! Brandy—whiskey—ether! And every time I got high—I sold my work. Every painting. Every stone. But then I'd wake up the next morning—spitting—vomiting—and they'd still be there. Every painting. Every stone. But—all of a sudden—I'd remember the sale on hash—the four heads I sold on whiskey—the eight sketches somebody bought on ether—and I'd start one more face. One more! But I'm out of hash. I'm out of brandy. I can't paint. I can't sculpt. I can't finish a line. I haven't had an original idea in a year. I need a sale. Any sale. I need recognition." Dennis McIntyre, *Modigliani: A Play in Three Acts* (New York: Samuel French, 1968), p. 44.

24. The film starred Gérard Philipe as Modigliani, Lilli Palmer as Beatrice Hastings, and Anouk Aimée as Jeanne Hébuterne. It was reissued in the United States in 1961 (with English subtitles) as *Modigliani of Montparnasse*. For a similar literary approach to the artist, see Anthony Wilmot, *The Last Bohemian: A Novel About Modigliani* (London: Macdonald and Jane's, 1975).

25. Michael Baxandall, *Patterns of Intention: On the Historical Explanation of Pictures* (New Haven and London: Yale University Press, 1985).

26. One concept derived from the "vulgar" Lockeanism of the period was of considerable importance to Chardin and other artists and intellectuals: the idea that the eye does not capture three-dimensional space instantaneously but scans through scattered and abstract sensations of color, shape, and light that the brain must reconfigure into a logical and ordered perception of reality. Rejecting many of the by then predictable devices of Renaissance illusionism and linear perspective, Chardin designed a composition of multiple, often divergent directional cues and focal points. Thus the viewer's eye, instead of being directed into a seamless illusion of three-dimensional space, is forced to stop and refocus as it makes its way across the picture plane. Ibid., pp. 74–104.

27. Ibid., p. 75.

28. Ibid., pp. 41–73.

29. Writers concerned with connoisseurship often view the identity of Modigliani's sitters as irrelevant to paintings that involve finding "something new to say in the structure of form, the style, and harmony of color" or investigating the expressive potential of "Fauve color." (These observations refer to Modigliani's portraits of Beatrice Hastings; see Parisot, *Modigliani*, p. 37, and Jacqueline Munck, "Modigliani's Dangerous Grace," in Restellini, *Modigliani*, p. 59.) Writers interested in analyzing Modigliani's art through his biography have rarely also been interested in the bigger social and cultural picture. In any case, few writers have gotten past the distortions and clichés written into a personal history that is itself built on a mythic and circumscribed view of the artist.

30. Rose, *Modigliani*, p. 109.

31. Ibid.

32. Werner Schmalenbach, *Amedeo Modigliani: Paintings, Sculptures, Drawings* (Munich: Prestel, 1990). In the same volume, see Schmalenbach's catalogue of personal reminiscences about the artist (pp. 184–206), including comments of Anna Akhmatova, Brancusi, Carlo Carrà, Cocteau, Alberto Giacometti, Lipchitz, Ludwig Meidner, Eugenio Montale, Picasso, Gino Severini, and Ossip Zadkine.

33. Alan G. Wilkinson, "Paris and London: Modigliani, Lipchitz, Epstein, and Gaudier-Brzeska," in William Rubin, ed., *"Primitivism" in 20th Century Art*, exh. cat. (New York: The Museum of Modern Art, 1984), pp. 415–21.

34. Silver, "Jewish Artists in Paris, 1905–1945," pp. 19–20.

35. Tamar Garb, "Making and Masking: Modigliani and the Problematic of Portraiture," in this volume.

36. Klein, "Modigliani Against the Grain."

37. See Baxandall, *Patterns of Intention*, pp. 136–37.

Selected Bibliography

BOOKS ON MODIGLIANI

Alexandre, Noël. *The Unknown Modigliani: Drawings from the Collection of Paul Alexandre*. New York: Harry N. Abrams, 1993.

Ceroni, Ambrogio. *Amedeo Modigliani: Dessins et sculptures*. Milan: Edizioni del Milione, 1965.

———. *Amedeo Modigliani: Peintre*. Milan: Edizioni del Milione, 1958.

———. *I dipinti di Modigliani*. Introduction by Leone Piccioni. Milan: Rizzoli, 1970.

Chiappini, Rudy, ed. *Amedeo Modigliani*. Exh. cat. Lugano: Museo d'Arte Moderna della Città di Lugano, and Milan: Skira, 1999.

Douglas, Charles [Douglas Goldring]. *Artist Quarter: Reminiscences of Montmartre and Montparnasse in the First Two Decades of the Twentieth Century*. London: Faber and Faber, 1941.

Kruszynski, Anette. *Amedeo Modigliani: Portraits and Nudes*. Munich and New York: Prestel, 1996.

Lanthemann, J. [Joseph]. *Modigliani, 1884–1920: Catalogue raisonné*. Barcelona: Condal, 1970.

Lipchitz, Jacques. *Amedeo Modigliani*. Commentaries by Alfred Werner. New York: Harry N. Abrams, 1954.

Mann, Vivian B., ed. *Gardens and Ghettos: The Art of Jewish Life in Italy*. Berkeley: University of California Press, 1989.

Modigliani, Jeanne. *Modigliani: Man and Myth*. New York: Orion, 1958.

Parisot, Christian. *Modigliani: Catalogue raisonné*. 2 vols. Livorno: Graphis Arte, 1990–91.

Patani, Osvaldo. *Amedeo Modigliani: Catalogo generale*. 3 vols. Milan: Leonardo, 1991–94.

Restellini, Marc, ed. *Modigliani: The Melancholy Angel*. Milan: Skira, 2002.

Rose, June. *Modigliani: The Pure Bohemian*. London: Constable, 1990.

Salmon, André. *Modigliani: A Memoir*. London: Jonathan Cape, 1961.

Schaub-Koch, Émile. *Modigliani*. Paris: Mercure Universal, 1933.

Schmalenbach, Werner. *Amedeo Modigliani: Paintings, Sculptures, Drawings*. Munich: Prestel, 1990.

Sichel, Pierre. *Modigliani: A Biography*. London: W. H. Allen, 1967.

Silver, Kenneth E., and Romy Golan. *The Circle of Montparnasse: Jewish Artists in Paris, 1905–1945*. Exh. cat. New York: Universe and The Jewish Museum, 1985.

Wayne, Kenneth. *Modigliani and the Artists of Montparnasse*. Exh. cat. New York: Harry N. Abrams, 2002.

Werner, Alfred. *Amedeo Modigliani*. London: Thames & Hudson, 1967.

COMMENTARY ON MODIGLIANI PUBLISHED IN ITALY, 1922–1944

The Italian literature written on Modigliani between the world wars, though not generally consulted by international scholars, contains a wealth of information, pertinent not only to reception history but also to specifics of the artist's works and their provenance. The Italian bibliography also includes reminiscences by his Italian peers who knew him in Paris and suggests particular examples of the influence of early Renaissance masters on him. Many articles were generated on the occasion of the publication of *Omaggio a Modigliani* by Giovanni Scheiwiller and by the Modigliani retrospective at the XVII Venice Biennale, both in 1930.

"Arte parigina." *Le arti plastiche* (Milan), June 1, 1927.

Bacci, Baccio Maria. "Uomini del Novecento: Amedeo Modigliani." *Nuova Italia* (Florence) 1 (May 20, 1930), pp. 183–86.

Barbantini, Nino. "Modigliani." *Gazzetta di Venezia*, September 9, 1930, p. 3.

Bartolini, Luigi. "Visita al collezionista Feroldi." *Quadrivio* (Rome) 5, no. 23 (April 4, 1937).

———. "Diario variatissimo di Luigi Bartolini." *Quadrivio* (Rome) 5, no. 27 (May 2, 1937).

Benco, Silvio. "Oggi s'inaugura la XVII Biennale d'Arte ai Giardini Pubblici di Venezia: Esposizione grande, bella, confortante per l'arte italiana." *Il piccolo di Trieste*, May 4, 1930.

Bernardi, Marziano. "Amedeo Modigliani." *La stampa* (Turin), January 24, 1930, p. 3.

———. "Clima italiano alla Biennale." *La stampa* (Turin), May 8, 1930, p. 3.

Bernasconi, Ugo. "Equivoci intorno alla pittura." *Broletto* (Como) 2 (December 1937), pp. 10–13.

Biancale, Michele. "Di Amedeo Modigliani e d'altre cose." *Il popolo di Roma*, February 15, 1930, p. 3.

———. "La XVII Biennale d'Arte di Venezia." *Il popolo di Roma*, May 4, 1930, p. 3.

La Biennale di Venezia: Storia e statistiche. Venice: Ufficio Stampa dell'Esposizione, 1936.

Borghese, Leonardo. "Gli equivoci del signor Waldemar George [*sic*] pro domo sua." *Le arti plastiche* (Milan), June 16, 1930.

Borghesi, Alfredo. "Amedeo Modigliani." *Il giornale dell'arte* (Milan), June 15, 1930.

———. "Ancora a proposito di Amedeo Modigliani." *Il giornale dell'arte* (Milan), December 21, 1930.

Bottinelli, Gege. "Modigliani." *Belvedere* (Milan) 2, no. 1 (January 1930), p. 3.

Brunelleschi, Umberto. "Rosalie l'ostessa di Modigliani." *L'illustrazione italiana* (Milan), September 11, 1932.

———. "Modigliani: Storia vera di Umberto Brunelleschi." *Il giovedì* (Milan), October 16, 1930.

Bucarelli, Palma. "Amedeo Modigliani." *Enciclopedia italiana di scienze, lettere ed arti* 23. Rome: Istituto della Enciclopedia Italiana, 1934, pp. 526–27.

Bucci, Anselmo. "Ricordi d'artisti: Modigliani." *L'ambrosiano* (Milan), May 27, 1931.

Cantatore, Domenico. "Parigi e i disegni alla 'Grande Chaumière.'" *L'ambrosiano* (Milan), March 16, 1935.

———. "Incontri a Firenze." *L'ambrosiano* (Milan), May 23, 1936.

Cardarelli, Vincenzo. "Modigliani." *Il Tevere* (Rome), March 12, 1932, p. 3.

———. "Un pittore maledetto." *Il resto del carlino* (Bologna), March 30, 1932, p. 2.

———. "Un pittore maledetto." *L'italiano* (Bologna) 8, no. 23 (November 1933), pp. 364–67.

Carrà, Carlo. "L'arte mondiale alla XIII Biennale di Venezia." *Il convegno* (Milan), June 1922, pp. 289–92.

———. "I punti a posto." *Belvedere* (Milan) 2, no. 3 (March 1930), p. 2.

———. "La XVII Biennale di Venezia: Amedeo Modigliani." *L'ambrosiano* (Milan), July 2, 1930.

———. "Dal barocco all'età contemporanea." *L'ambrosiano* (Milan), October 19, 1932.

———. "Modigliani." In *Artisti moderni.* Florence: Le Monnier, 1944, pp. 36–38.

Carrieri, Raffaele. "San Lazzaro o della gastronomia." *L'Italia letteraria* (Rome) 10, no. 4 (March 25, 1934), p. 3.

———. "Taccuino segreto di Montparnasse." *L'ambrosiano* (Milan), June 27, 1936.

Castelfranco, Giorgio. "Modigliani." In *La pittura moderna 1860–1930.* Florence: Luigi Gonnelli, 1934, pp. 82–84.

Catalogo della XIII Esposizione Internazionale d'Arte della Città di Venezia. Milan: Bestetti e Tumminelli, 1922.

Catalogo illustrato della XVII Esposizione Biennale Internazionale d'Arte, 2nd ed. Venice: Carlo Ferrari, 1930.

Catalogue illustré de l'Exposition de l'Art Italien des XIX e XX Siècles au Jeu de Paume. Paris: Jeu de Paume, 1935.

Cervesato, Arnaldo. "La Biennale d'Arte veneziana." *Regime fascista* (Cremona), August 14, 1930.

Chessa, Gigi. "Per Amedeo Modigliani." *L'arte* (Turin) 33 (January 1930), pp. 30–40.

Cinti, Italo. "Amedeo Modigliani." *Vita nova* (Bologna), August 1930, pp. 662–66.

Claris. "Contro un insulto a Modigliani." *Il popolo di Trieste,* September 7, 1930, p. 5.

———. "Punto fermo a una polemica d'arte." *Il popolo di Trieste,* September 14, 1930, p. 5.

Costantini, Vincenzo. "Omaggio a Modigliani." *L'Italia letteraria* (Rome), January 26, 1930.

———. "La XVII Biennale d'Arte a Venezia: A. Modigliani." *L'Italia letteraria* (Rome), May 11, 1930.

———. "La XVII Biennale veneziana." *Le arti plastiche* (Milan), May 16, 1930.

———. *Pittura italiana contemporanea dalla fine dell'800 ad oggi.* Milan: Ulrico Hoepli, 1934, pp. 157–64, 230, 337.

Costetti, Giovanni. "Amedeo Modigliani." *L'illustrazione toscana* (Florence), October 1930, pp. 11–14.

"Costumi di Ojetti." *Belvedere* (Milan) 2, no. 3 (March 1930), p. 2.

"Cronaca londinese: Modigliani." *Le arti plastiche* (Milan), December 1, 1926.

[D'Ancona, Paolo]. "Peintres maudits (Modigliani–Utrillo)." *Le arti plastiche* (Milan), May 1, 1925, p. 3.

———. "A proposito di Modigliani." *Le arti plastiche* (Milan), May 16, 1925.

———. "Cinque lettere di Modigliani ad Oscar Ghiglia." *L'arte* (Turin), May 1930.

———. "Per conservare a Torino l'autoritratto di Modigliani." *La stampa* (Turin), December 21, 1937.

de Libero, Libero. "Pittura italiana contemporanea." *L'Italia letteraria* (Rome), July 25, 1934.

de Pisis, Filippo. "La pittura di Modigliani." *Il corriere padano* (Ferrara), January 16, 1934, p. 3.

Del Massa, Aniceto. "Omaggio a Modigliani." *L'illustrazione toscana* (Florence), February 1930.

———. "Amedeo Modigliani e la critica moderna." *La nazione* (Florence), July 4, 1930.

Franchi, Raffaello. "Alle Belle Arti: Amedeo Modigliani." *La fiera letteraria* (Milan), May 27, 1928, p. 3.

———. "Modigliani alla Biennale." *Il corriere padano* (Ferrara), May 31, 1930.

H. G. and G. P. [Giuseppe Pensabene]. "La 'tradizione moderna' nella pittura e nella scultura." *Quadrivio* (Rome) 5, no. 34 (July 18, 1937), pp. 1–7.

Galassi, Enrico. "Dall'ex Caffè d'Europa: Modigliani." *L'Italia letteraria* (Rome), February 9, 1936.

Giolli, Raffaello. "Come nasce una galleria d'arte moderna." *Quadrivio* (Rome) 10, no. 18 (March 1, 1942), p. 3.

Grande, Adriano. "Modigliani." *Il secolo XIX* (Genoa), May 6, 1930.

———. "Modigliani, il gruppo dei '6,' i lombardi." *Il secolo XIX* (Genoa), May 8, 1930, p. 3.

Gualino, Riccardo. *Frammenti di vita.* Verona: Arnaldo Mondadori, 1931.

Guerrisi, Michele. "Modigliani." In *La nuova pittura: Cézanne, Matisse, Picasso, Derain, de Chirico, Modigliani.* Turin: Erma, 1932.

Guzzi, Virgilio. *Pittura italiana contemporanea.* Milan: Bestetti e Tumminelli, 1931, pp. 22, 25–30, 36, 58.

Licini, Osvaldo. "Ricordo di Modigliani." *L'orto* (Bologna) 4 (January–February 1934), pp. 9–10.

Lo Duca. "Precisazioni su l'Ottocento e l'arte contemporanea." *Il piccolo* (Rome), August 14, 1935.

——. "Ricordi del 'Jeu de Paume': Medardo Rosso e Amedeo Modigliani araldi del rinnovamento." *Il piccolo* (Rome), August 14, 1935.

Luzzatto, G. L. "Il gusto del disegno moderno." *La casa bella* (Milan) 5, no. 59 (November 1932), pp. 53–54.

m. "Un omaggio al pittore Modigliani." *Il popolo d'Italia* (Milan), January 25, 1930.

Mafai, Mario. "Arte nuova a Parigi: I 'Surindipendents.'" *L'Italia letteraria* (Rome), August 3, 1930.

Malabotta, Manlio. "L'inaugurazione della diciassettesima Biennale d'Arte." *Il popolo di Trieste*, May 4, 1930, p. 3.

——. "Omaggio a Modigliani." *Il popolo di Trieste*, September 12, 1930, p. 3.

Maraini, Antonio. *Scultori d'oggi* (1930). In Paola Barocchi, *Storia moderna dell'arte in Italia. III. Dal Novecento ai dibattiti sulla figura e sul monumentale 1925–1945*. Turin: Einaudi, 1990.

Marchiori, Giuseppe. "Modigliani italiano." *Il corriere padano* (Ferrara), February 21, 1931.

Margotti, A. "Ettore Tito e Amedeo Modigliani." *Il giornale d'Oriente* (Alexandria, Egypt), June 28, 1930.

Marinetti, F. T. [Filippo Tommaso]. "Modigliani e Boccioni." *La gazzetta del popolo* (Turin), February 27, 1930.

Marino. "Modì." *Campo di Marte* (Florence), August 15, 1938, p. 2.

Mercurio. "Decimo anniversario della morte di Modigliani." *Le arti plastiche* (Milan), February 1, 1930.

"Modigliani." *Belvedere* (Milan) 2, February 1930, p. 10.

"Modigliani: Lettere." *Belvedere* (Milan) 2 (May–June 1930).

"Modigliani." *L'Italia letteraria* (Rome), July 13, 1935.

Nebbia, Ugo. *XVII Esposizione Internazionale d'Arte Venezia 1930*. Milan: Anonima Editrice Arte, 1930.

——. "I pittori italiani alla XVII Biennale veneziana." *Emporium* (Bergamo), June 1930, pp. 267–72.

Neppi, Alberto. "Alla XVII Biennale di Venezia. Il caso Modigliani." *Il lavoro fascista* (Rome), May 16, 1930.

"Notes (La Biennale veneziana)." *L'italiano* (Bologna) 5, no. 9–10 (June 1930), p. 10.

i.o. "Omaggio al pittore Amedeo Modigliani." *Il giornale dell'arte* (Milan), January 26, 1930.

Ojetti, Ugo. "La XIII Biennale veneziana. Il re che torna." *Corriere della sera* (Milan), May 27, 1922.

——. "Amedeo Modigliani." *Corriere della sera* (Milan), January 28, 1930, p. 3.

——. "La XVII Biennale di Venezia: Pittori e scultori italiani." *Corriere della sera* (Milan), May 4, 1930.

Omaggio a sedici artisti italiani. Rome: Galleria di Roma della Confederazione Nazionale Fascista Professionisti e Artisti, 1937.

Oppo, Cipriano E. "Amedeo Modigliani." *La tribuna* (Rome), May 14, 1930.

——. "Una mostra postuma di Modigliani" (1922). In *Forme e colori nel mondo*. Lanciano: R. Carabba, 1931, pp. 287–95.

Pavolini, Corrado. "Modigliani e altri artisti." *Il Tevere* (Rome), May 20, 1930, p. 3.

Pettinato, Concetto. "Pittura, cataloghi ed altro." *La stampa* (Turin), March 3, 1926, p. 3.

Pica, Vittorio. "Amedeo Modigliani." In *Catalogo della XIII Esposizione Internazionale d'Arte della Città di Venezia*. Milan: Bestetti e Tumminelli, 1922, p. 57.

——. "Una lettera di Pica." *Belvedere* (Milan) 2 (February 1930), p. 10.

Poligono 4 (February 1930). Special issue devoted to Modigliani.

Prezzolini, Giuseppe. "Modigliani." In *La cultura italiana*. Milan: Corbaccio, 1930, p. 422.

Raimondi, Giuseppe. "Modigliani." *L'italiano* (Bologna) 2, no. 12–13 (September 30, 1927).

Rigo, Ettore. "Amedeo Modigliani." *Il giornale dell'arte* (Milan) 4, no. 48 (November 30, 1930), p. 1.

Rosai, Ottone. "Richiami all'uomo." *L'universale* (Florence), February 3, 1931.

Sapori, Francesco. "Amedeo Modigliani." In *La tredicesima esposizione d'arte a Venezia*. Bergamo: Istituto Italiano d'Arti Grafiche, 1922, p. 24.

Sarfatti, Margherita. *Storia della pittura moderna*. Rome: Paolo Cremonese, 1930, pp. 78–84.

——. "Spiriti e forme nuove a Venezia." *Il popolo d'Italia* (Milan), May 4, 1930.

Scheiwiller, Giovanni. *Amedeo Modigliani* (Arte moderna italiana 8). Milan: Ulrico Hoepli, 1927.

——, ed. *Omaggio a Modigliani (1884–1920)*. Milan: Giovanni Scheiwiller, 1930.

Soffici, Ardengo. "Gli italiani all'Esposizione di Venezia." *Il resto del carlino* (Bologna), June 16, 1922, p. 3.

——. "Ricordo di Modigliani." *La gazzetta del popolo* (Turin), January 16, 1930.

Soldati, Mario. "Modigliani a New York." *L'Italia letteraria* (Rome), January 12, 1930.

Somaré, Enrico. "Note sulla XIII Esposizione Internazionale d'Arte della Città di Venezia." *L'esame* 1 (May 1922), pp. 145–46.

Spaini, Alberto. "Il ritorno di Amedeo Modigliani." *Il resto del carlino* (Bologna), May 29, 1930, p. 3.

Tinti, Mario. "Omaggio a Modigliani." *Il resto del carlino* (Bologna), February 7, 1930.

Valeri, Diego. "I veneti alla Biennale." *Le Tre Venezie* (Venice), July 1930, pp. 10–16.

"Venezia XVII." *Belvedere* (Milan) 2, no. 5–6 (May–June 1930), pp. 1–2.

"Venezia. La XVII Biennale." *L'arca* 1 (May–June 1930), pp. 1–2.

Venturi, Lionello. "Risposta a Marinetti." *La stampa* (Turin), December 18, 1929.

——. "Mostra individuale di Amedeo Modigliani, Sala 31." In *Catalogo illustrato della XVII Esposizione Biennale Internazionale d'Arte*, 2nd ed. Venice: Carlo Ferrari, 1930, pp. 116–21.

——. "Risposta a Ugo Ojetti." *L'arte* (Turin) 33 (January 1930), pp. 93–97.

——. "Amedeo Modigliani e risposta a Ugo Ojetti." *L'arte* (Turin) 33 (April 1930), p. 212.

————. "Modigliani a Venezia." *Belvedere* (Milan) 2, no. 5–6 (May–June 1930), pp. 3–4.

————. "The Collection of Modern Art of Signor Gualino and the Modigliani Room at the Venice Biennale Exhibition." *Formes* 7 (July 1930), pp. 9–10.

————. "Divagazioni sulle mostre di Venezia e di Monza, con la risposta ad Ojetti." *L'arte* (Turin) 33 (July 1930), pp. 396–405.

Vitali, Lamberto. *Disegni di Modigliani* (Arte moderna italiana 15). Milan: Ulrico Hoepli, 1929.

————. "Amedeo Modigliani." *Domus* (Milan) 75 (March 1934), pp. 40–42.

Zanzi, Emilio. "Amedeo Modigliani e i facili seguaci." *La gazzetta del popolo* (Turin), May 8, 1930, p. 5.

————. "'Modì,' l'ebreo mistico e sregolato." *La rassegna filodrammatica* (Turin), July 1, 1930.

Zatti, Guglielmo. "Amedeo Modigliani e l'arte." *Regime fascista*, November 4, 1930.

Contributors

Mason Klein is a critic, an art historian, and a curator at The Jewish Museum, where he served as coordinating curator for *Berlin Metropolis: Jews and the New Culture, 1890–1918* and *Charlotte Salomon: Life? or Theater?*, and as co-curator of *Voice, Image, Gesture: Selections from The Jewish Museum's Collection, 1945–2000*. He has written criticism for such publications as *Artforum*, *Frieze*, and *World Art*, and curatorial essays for the Wexner Center for the Arts, Philadelphia Museum of Art, American Folk Art Museum, and other institutions. His book *The Waiting Room: Duchamp and Contemporary Art* is forthcoming.

Maurice Berger is a senior fellow at the Vera List Center for Art and Politics of the New School for Social Research in New York and curator of the Center for Art and Visual Culture at the University of Maryland. He is the author of *White Lies: Race and the Myths of Whiteness* (1999), which will be adapted as a television documentary for PBS, as well as *Postmodernism: A Virtual Discussion* (2003), *The Crisis of Criticism* (1998), *Constructing Masculinity* (1995), *Modern Art and Society* (1994), *How Art Becomes History* (1992), and *Labyrinths: Robert Morris, Minimalism, and the 1960s* (1989).

Emily Braun is professor of art history at Hunter College and the Graduate Center at the City University of New York. Her numerous publications on modern Italian art include *Mario Sironi and Italian Modernism: Art and Politics Under Fascism* (2000). As a contributing author, she has twice received the annual Henry Allen Moe Prize for Catalogues of Distinction in the Arts for her essays in *Northern Light: Realism and Symbolism in Scandinavian Painting* (1982) and *Gardens and Ghettos: The Art of Jewish Life in Italy* (1990). Most recently, she has published articles on Gustav Klimt, James Rosenquist, and Sol LeWitt.

Tamar Garb is professor of art history at University College London. Her publications include *Bodies of Modernity: Figure and Flesh in Fin-de-Siècle France* (1998) and *Sisters of the Brush: Women's Artistic Culture in Late Nineteenth-Century Paris* (1994). She is also the editor, with Linda Nochlin, of *The Jew in the Text: Modernity and the Construction of Identity* (1996), and has written widely on late-nineteenth- and early-twentieth-century French art and on contemporary women's art practice.

Barbara Paltenghi is a curator at the Museum of Modern Art in Lugano, Switzerland. She has collaborated on exhibitions about Egon Schiele (2003), Marc Chagall (2001), Amedeo Modigliani (1999), and Edvard Munch (1998), and has published essays and biographical material in art journals and exhibition catalogues. Her documentary films for Swiss television have focused on the artists Constant Permeke, Georges Rouault, Fernando Botero, and Ernst Ludwig Kirchner. She earned a Ph.D. degree in the history of contemporary art at the University of Pavia, Italy.

Griselda Pollock is professor of social and critical histories of art, and director of the AHRB Centre for Cultural Analysis, Theory, and History at the University of Leeds. Her most recent publications include *Looking Back to the Future: Essays on Art, Life, and Death* (2000). She is currently writing a book on Charlotte Salomon and is completing a study titled "The Case Against 'Van Gogh,'" as well as essays on Artemisia Gentileschi, Agnes Martin, Louise Abbema, and Mary Kelly. Her major areas of current writing are cultural trauma and cultural memory, with a special focus on the work and theories of Bracha Ettinger.

Index

Illustration Credits

Boldface numerals refer to page numbers.

ABBREVIATIONS

AIC	The Art Institute of Chicago. All rights reserved
AKAG	Albright-Knox Art Gallery, Buffalo, New York
ARS	© 2004 Artists Rights Society, New York
CNAC	CNAC/MNAM/Dist. Réunion des Musées Nationaux/Art Resource, New York
EB	Emily Braun
FAM	Fondazione Antonia Mazzota, Milan
GCB	Galerie Cazeau-Béraudière, Paris
GNAM	Galleria Nazionale d'Art Moderna, Rome
HNG	Helly Nahmad Gallery, New York
HUAM	© President and Fellows of Harvard College
JTC	Justman-Tamir Collection, Paris
KMA	Courtesy of Klüver/Martin Archive
KNW	Kunstsammlung Nordrhein-Westfalen, Düsseldorf
LACMA	Los Angeles County Museum of Art
MAC	Museu de Arte Contemporañea da Universidade de São Paulo
MASP	Museu de Arte de São Paulo Assis Chateaubriand
MBAR	© Musée des Beaux-Arts de Rouen
MCGF	Museo Civico Giovanni Fattori, Livorno
MMA	Metropolitan Museum of Art
MoMA	© 2004 The Museum of Modern Art, New York
MVR	© Musées de la Ville de Rouen
NGA	Image © 2004 Board of Trustees, National Gallery of Art, Washington, D.C.
OKB	Öffentliche Kunstsammlung, Basel, photograph by Martin Bühler
PDG	Patrick Derom Gallery, Brussels
PMA	Philadelphia Museum of Art
RISD	Museum of Art, Rhode Island School of Design
RMN	© Réunion des Musées Nationaux/Art Resource, New York
SRG	© The Solomon R. Guggenheim Foundation, New York
TG	© Tate Gallery, London/Art Resource, New York

Cover: Courtesy Ivor Braka, Ltd., London
Frontispiece: The Phillips Collection, Washington, D.C.
Back Cover: CNAC
Page ix: Yale University Art Gallery

Klein Essay: **Frontispiece** RMN. **2** MAC. **4** MBAR. **8** CNAC (top), MoMA (bottom). **9** Photograph courtesy of Palm Springs Desert Museum. **10** TG (top left), MoMA (top right), photograph by David Heald, SRG, ARS/ADAGP, Paris (bottom). **11** AIC. **12** Photograph by Catherine Lancien/Carole Loisel, MBAR (left). **13** Photograph by Didier Tragin/Catherine Lancien, MBAR. **16** Cincinnati Art Museum. **18** Courtauld Institute of Art Gallery. **19–20** MCGF. **21** Photograph by Catherine Lancien/Carole Loisel, MBAR.

Braun Essay: **Frontispiece** © Christie's Images. **26** © 1998 Museum Associates, LACMA. **30** EB (top), RISD (bottom). **31** EB. **33** Photograph by Riccardo Lodovici, Carlo Levi Foundation (left), EB (right). **34** Pinacoteca Nazionale, Siena (left), Erich Lessing/Art Resource, N.Y. (middle), Bridgeman-Giraudon/Art Resource, N.Y. (right). **35** Erich Lessing/Art Resource, N.Y. **36** From Stephanie Barron, *"Degenerate Art": The Fate of the Avant-Garde in Nazi Germany*, exh. cat. (Los Angeles: Los Angeles County Museum of Art, 1991), pp. 12–13. **37** © Dallas Museum of Art, 1981. **38** EB.

Garb Essay: **Frontispiece** Minneapolis Institute of Arts. **44** Photograph © 2003 MMA. **46** © Christie's Images. **47** TG. **48** © 2004 Succession H. Matisse, Paris/ARS. **49** RMN. **50** CNAC. **51** Photograph © 1996 MMA, © 2004 Estate of Pablo Picasso/ARS. **52** Courtesy of Galerie Schmit, Paris.

Pollock Essay: **Frontispiece** NGA. **56** From Gill Perry, *Women Artists and the Parisian Avant-Garde* (Manchester: Manchester University Press, 1995), pl. 8, ARS/ADAGP, Paris. **57** Photograph courtesy of Richard Nathanson, London. **58** Alinari/Art Resource, N.Y. (left), From Marc Restellini, ed., *Modigliani: The Melancholy Angel* (Milan: Skira, 2002), p. 384 (right). **59** Gemäldegalerie Alte Meister, Dresden. **60** Koninklijk Museum Voor Schone Kunsten, Antwerp. **61** From Restellini, *Modigliani*, p. 301. **61** Staatsgalerie Stuttgart (top). **63** Osaka City Museum of Modern Art, Japan. **64** Photograph by Studio Monique Bernaz, Petit Palais, Musée d'Art Moderne, Geneva, ARS/ADAGP, Paris. **66** MoMA. **67** From Restellini, *Modigliani*, p. 309 (top), Scala/Art Resource, N.Y. (bottom). **70** © Rheinisches Bildarchiv. **71** From J. Lanthemann, *Modigliani, 1884–1920: Catalogue raisonné* (Barcelona: Condal, 1970), p. 197. **72** Karin Maucotel © Paris-Musées 2000, ARS/ADAGP, Paris.

Berger Essay: **Frontispiece** Art Gallery of Ontario. **76** CNAC. **77** The Jewish Museum, New York. **78** AIC. **79** Museo Nacional Centro de Arte Reina Sofia Photographic Archive, Madrid, © 2004 Estate of Pablo Picasso/ARS. **81** Photograph by Robert Lapin (left), Photofest (right). **82** Hunterian Art Gallery, University of Glasgow, Scotland/Bridgeman Art Library. **83** AIC, © 2004 Estate of Pablo Picasso/ARS. **84** Staatsgalerie Stuttgart.

Plates: **Frontispiece** CNAC. **88** MCGF. **89** Re Cove Hakone Museum, Kanagawa. **90** Reuben and Edith Hecht Museum, University of Haifa, Israel. **91** Photograph by H. Maertens, Bruges (bottom). **92** Photograph by John Parnell, The Jewish Museum, New York. **93** Photograph by Katia Kallsen, HUAM. **94** CNAC. **95** Photograph by Bruce M. White © 2003 Trustees of Princeton University. **96** Latner Family Private Collection, Toronto. **97** Hirshhorn Museum and Sculpture Garden, Smithsonian Institution, Washington, D.C. **98** SRG. **99** Photograph by Graydon Wood, 1993, PMA. **100** CNAC. **101** NGA. **102** © Walter Klein, KNW. **105** © 1992, AIC. **106** PMA. **107** Baltimore Museum of Art. **108** MoMA. **110** Museum of Fine Arts, Houston. **111** Norton Museum of Art, West Palm Beach, Florida. **112** PMA. **114** GCB. **115** Baltimore Museum of Art. **116** RMN. **117** GCB. **118** Photograph by Bruce M. White © 1998 Trustees of Princeton University. **119** The Evergreen House Foundation, The Johns Hopkins University, Baltimore. **120** AIC. **121** Photograph by Hans Petersen, Statens Museum For Kunst, Copenhagen. **122** Toledo Museum of Art. **123** Pinacoteca di Brera, Milan. **124** Photo by Daniel Arnaudet, RMN. **125** TG. **126** KNW. **127** MMA. **128** National Gallery of Victoria, Melbourne, Australia. **129** Courtesy Ivor Braka, Ltd., London. **131** GNAM. **132** Photograph by John Seyfried, June 1990, Allen Memorial Art Museum, Oberlin College, Ohio. **133** Photograph by David Heald, SRG. **134** William I. Koch (top). **135** Osaka City Museum of Modern Art, Japan. **136** Photograph by Bruce M. White © 2000 Trustees of Princeton University. **137** The Phillips Collection, Washington, D.C. **138** HNG. **139** PMA. **140** © 2002 Museum Associates/LACMA. **141–2** HNG. **143** Musée National Picasso, Antibes. **144** © Dallas Museum of Art. **145** Denver Art Museum. **146** Photograph by David Heald, SRG. **147** AKAG. **148** Photograph by David Arnaudet, RMN. **151** Cincinnati Art Museum. **152** © 1985 MMA. **154** MoMA. **155** Photograph by David Heald, SRG. **156–7** Photographs by Luiz Hossaka, MASP. **158** © 1985 MMA. **159** The Estate of Evelyn Sharp. **160** HNG. **165** MCGF (left), GCB (top right). **167** OKB. **168**

OKB (left), CNAC (top right), GCB (bottom). **169** GCB (left), photograph courtesy of Richard Nathanson, London (top right), MoMA (bottom right). **170** Steve Banks Fine Arts, San Francisco (top left), photograph by Catherine Lancien/Carole Loisel, MVR (bottom left, right). **171** MoMA (top left), Musée Calvet, Avignon (top right), photograph by Bruce M. White © 2003 Trustees of Princeton University (bottom left), GCB (bottom left). **172** GCB (left), photograph by H. Maertens (top right), photograph by Catherine Lancien/Carole Loisel, MBAR (bottom right). **173** Photograph by Catherine Lancien/Carole Loisel, MBAR (top right). **174** Uzi Zucker (top left), photograph by H. Maertens (bottom left), photograph courtesy of Richard Nathanson, London (right). **175** GCB (left), photograph by Vincent Everarts, PDG (top right), photograph by Michel Bourquin, Musée des Beaux-Arts, Dijon (bottom, right). **176** MBAR (top right), photograph by H. Maertens (bottom right). **177** GNAM (left), MoMA (top right), © 2003 MMA (bottom right). **178** FAM (left), MoMA (right). **179** © 1992 AIC (left), GCB (top right), Musée Calvet, Avignon (bottom right). **180** GCB (bottom right). **181** JTC (left, top right). **182** GCB (left, top right), Musée Picasso, Antibes. **183** MoMA (left), GCB (top right), The Phillips Collection, Washington, D.C. (bottom right). **184** © Phototèque des musées de la ville de Paris/Cliché: Delepelaire (top right), GCB (bottom). **185** MoMA (left), © 1989 AIC (top right), GCB (bottom right).

Chronology: **186** From Christian Parisot, *Amedeo Modigliani 1884–1920: Biographie* (Turin: Canale Arte, 2000), p. 27 (top), From Restellini, *Modigliani*, p. 19 (bottom). **187** From Rudy Chiappini, ed. *Amedeo Modigliani* (Lugano: Museo d'Arte Moderna della Città di Lugano, and Milan: Skira, 1999), p. 208. **189** From Restellini, *Modigliani*, p. 20. **193** From Restellini, *Modigliani*, p. 95. **194** CNAC/ARS/ADAGP, Paris. **196** KMA. **197** From Restellini, *Modigliani*, p. 28 (top), p. 16 (bottom). **198–199** KMA. **200** Courtesy of Alain Bouret (top), KMA (bottom). **201** From Restellini, *Modigliani*, p. 386 (top), KMA (bottom). **202** From Christian Parisot, *Modigliani* (Paris: Pierre Terrail, 1992), p. 40 (top), Courtesy of Christian Parisot (bottom).